The Parthenon
and
Liberal Education

SUNY series in Ancient Greek Philosophy

Anthony Preus, editor

The Parthenon
and
Liberal Education

Geoff Lehman & Michael Weinman

Cover art: *Façade and North Colonnade of the Parthenon on the Acropolis, Athens,* daguerreotype, 1842, Joseph-Philibert Girault de Prangey (French, 1804–1892).

Published by State University of New York Press, Albany

© 2018 State University of New York

All rights reserved

No part of this book may be used or reproduced in any manner whatsoever without written permission. No part of this book may be stored in a retrieval system or transmitted in any form or by any means including electronic, electrostatic, magnetic tape, mechanical, photocopying, recording, or otherwise without the prior permission in writing of the publisher.

For information, contact State University of New York Press, Albany, NY
www.sunypress.edu

Library of Congress Cataloging-in-Publication Data

Names: Lehman, Geoff, 1971– author.
Title: The Parthenon and liberal education / Geoff Lehman and Michael Weinman.
Description: Albany, NY : State University of New York, 2018. | Series: SUNY series in ancient Greek philosophy | Includes bibliographical references and index.
Identifiers: LCCN 2017013762 (print) | LCCN 2017059383 (ebook) | ISBN 9781438468433 (ebook) | ISBN 9781438468419 (hardcover) | ISBN 9781438468426 (pbk.)
Subjects: LCSH: Philolaus, of Croton, approximately 470 B.C.– | Mathematics—History. | Plato. | Philosophy, Ancient. | Parthenon (Athens, Greece)
Classification: LCC B235.P44 (ebook) | LCC B235.P44 L44 2018 (print) | DDC 182/.2—dc23
LC record available at https://lccn.loc.gov/2017013762

10 9 8 7 6 5 4 3 2 1

Contents

LIST OF ILLUSTRATIONS vii

ACKNOWLEDGEMENTS xi

INTRODUCTION
Thinking the Parthenon and Liberal Arts Education Together xiii

PART I
Plato on Dialectic and the Problem-Based Study of Mathematics

CHAPTER 1
Dialectic and the Mathematical Arts in *Republic* (9.587b–588a): Philolaus's Scale and the Final Bout between the Just and Unjust Souls 3

CHAPTER 2
Dialectic and the Mathematical Arts in *Timaeus* (35b–36c): Philolaus's Scale in the Construction of the World-Soul 23

CHAPTER 3
Platonic Dialectic, Pythagorean Harmonics, and Liberal Arts Education 39

PART II
Harmonia and *Symmetria* of the Parthenon

CHAPTER 4
The Parthenon and the Musical Scale 61

CHAPTER 5
The Corner Problem 105

CHAPTER 6
Refinements and the Question of Dialectic 129

AFTERWORD 157

APPENDIX A
Pythagorean Musical Ratios 165

APPENDIX B
Principal Measurements of the Parthenon 167

APPENDIX C
Elements of the Doric Order 169

APPENDIX D
Ground Plan of the Parthenon 171

APPENDIX E
Glossary of Technical Terms 173

NOTES 177

WORKS CITED 211

INDEX 223

Illustrations

Figures

4.1	The Parthenon, Athens (447–432 BCE): view from the northwest	67
4.2	The Parthenon: view from the southeast	67
4.3	Model of the Acropolis as it looked around 400 BCE (Royal Ontario Museum, Toronto)	69
4.4	Ground plan of the Acropolis in the fifth century	69
4.5	The Parthenon: column capital and entablature, west façade	71
4.6	Battle of a Lapith and a Centaur: metope from the south flank of the Parthenon	72
4.7	Diagram of the Doric order as it appears in the Parthenon	73
4.8	Diagram of the Ionic order	74
4.9	Erechtheion, Athens (421–406 BCE): Capital and architrave from the east façade	75
4.10	The Temple of Athena, Paestum (late sixth century BCE): view from the southwest	77
4.11	The Temple of Hera Lacinia, Akragas (begun ca. 460 BCE): view from the southeast	79
4.12	The Temple of Hera Lacinia, Akragas: ground plan	79
4.13	The Temple of Concord, Akragas (begun ca. 440 BCE): view from the southeast	80

4.14	The Temple of Zeus, Olympia (begun ca. 457–56 BCE): east façade elevation	81
4.15	The Temple of Zeus, Olympia: ground plan	81
4.16	The Temple of Poseidon (or Hera II), Paestum (begun ca. 460 BCE): west façade	82
4.17	The Temple of Aphaia, Aegina (ca. 490s BCE): view from the southeast	83
4.18	Photograph of Le Corbusier on the Acropolis, September 1911	85
4.19	The Parthenon: interior of the south peristyle	86
4.20	The Parthenon: view of the southwest corner	87
4.21	The Parthenon: west façade	89
4.22	The Parthenon: ground plan	91
4.23	The Parthenon: section, showing the Doric and Ionic orders of the interior	98
4.24	Parthenon replica, Nashville (begun 1920s): interior of the naos	99
4.25	Figures K, L, and M from the Parthenon's east pediment	102
4.26	Figure M (Aphrodite?) from the Parthenon's east pediment, detail	103
5.1	The Parthenon: northeast corner	108
5.2	The Parthenon: entablature, northwest corner	109
5.3	The Brandenburg Gate, Berlin (1788–1791): entablature, northwest corner	109
5.4	The Parthenon: east façade, south side of the entablature	112
5.5	The Parthenon: east façade	117
5.6	The Parthenon: east façade, north side of the entablature	117
5.7	*Doryphoros*, ancient Roman copy in marble of a bronze original of ca. 450–440 BCE by Polykleitos	121

5.8	The Temple at Segesta (420s BCE): view from the southeast	124
5.9	The Temple at Segesta: view from the southwest corner, showing curvature	126
6.1	The Parthenon: view from the northeast corner, showing curvature	132
6.2	The Parthenon, west façade, Ionic frieze: beginning of the Panathenaic procession (?)	135
6.3	Diagram of the column inclinations of the Parthenon	137
6.4	Joseph-Philibert Girault de Prangey, *Façade and North Colonnade of the Parthenon on the Acropolis, Athens*, daguerreotype, 1842	137
6.5	The Parthenon, west façade: detail showing Doric capitals and Ionic frieze with Doric guttae underneath	142
6.6a and 6.6b	Jacques Carrey, drawings of the south and north sides of the east pediment of the Parthenon, 1674 (Paris, Bibliothèque Nationale)	153
6.7a and 6.7b	Jacques Carrey, drawings of the north and south sides of the west pediment of the Parthenon, 1674 (Paris, Bibliothèque Nationale)	154
6.8	The Parthenon, Ionic frieze, depicting the Panathenaic procession (?): south side, bulls being led to sacrifice	155
6.9	The Parthenon, Ionic frieze, depicting the Panathenaic procession (?): east side, central scene (ritual with the peplos of Athena, or sacrifice of the daughters of Erechtheus and Praxithea?)	155

Acknowledgments

Every book is the work of more than one person. The truth of this claim is self-evident when, like this one, the book is signed by two people. There are many others, however, without whose efforts these words would not have seen the light of day, and it is a privilege and a pleasure to express our gratitude to them.

First and foremost, we are indebted to Robert Hahn and Anthony Preuss, whose interest and belief in our attempt to harmonize discourses not often pursued in concert has inspired and challenged us to live up to the standard of the SUNY series in Ancient Greek Philosophy. We also thank those friends, colleagues, students, and former students whose careful and considerate reading of parts of this book have improved its expression and helped us avoid numerous missteps. Claudia Baracchi, David Hayes, Dmitri Nikulin, Bill Pastille, and Gregory Recco merit special mention in this regard. Linda Eggert, Oumaïma Gannouni, and Lindsay Parkhowell, our peerless student assistants at Bard College Berlin during various stages of the research and writing this project demanded, have more than earned our enduring gratitude for their efforts.

The origins of the book, in many ways, lie in an interdisciplinary core course we taught together, with other colleagues, at Bard College Berlin, Plato's *Republic* and Its Interlocutors, and we would like to thank the students and colleagues with whom we worked in the course's various incarnations over the years. Also, much of the foundation for this book was laid in our design and execution of an international conference, Pythagorean Harmonics from Philolaus to Leibniz, held at Bard College Berlin (then ECLA of Bard) in October 2013. We are grateful to the conference participants, the college, its leadership (Dean Catherine Toal and then-Rector Thomas Rommel), our colleagues at the college who worked so hard to make the event a success, and all who attended. We are likewise indebted to David McNeill, Jon Mikalson, Dmitri Nikulin,

and Michalis Sialaros for inviting us to present our work, and to the audiences at the University of Essex, the New School for Social Research, the University of Virginia, and University College London for helpful and challenging responses.

Robert Hannah and Vassilis Petrakis, our (initially anonymous) reviewers for SUNY Press, made essential suggestions in the review and revision process. Indeed, their responses modified the overall structure of the book and we made countless reformulations of expression and of content because of their responses. Andrew Kenyon, Ryan Morris, and Anne Valentine at SUNY Press have been ideal partners as we bring this book to completion. Their insights into materializing our intellectual labor and their professionalism have been invaluable.

Geoff Lehman would like to thank his parents, John and Elizabeth, and his sister, Julie, for their continuing support and encouragement. He also would like to thank David Rosand, who was his main support in the study of art over the years, and with whom he often discussed, among countless other topics, the Art Humanities course at Columbia University, where he first began thinking about the Parthenon.

Michael Weinman would like to acknowledge the unflagging and invaluable support he receives from Irit Dekel, a source of intellectual energy, an honest critic, and a life mate who is truly without parallel or shared measure.

Needless to say, with all the thanks we owe to so many people, we alone are responsible for whatever faults remain.

Introduction

Thinking the Parthenon
and Liberal Arts Education Together

MICHAEL WEINMAN AND GEOFF LEHMAN

This work is simultaneously expansive and narrow in its scope. It is expansive in that it takes up three objects that would generally be thought to diverge widely: (1) the early history of Greek mathematics; (2) Plato's *Republic* and *Timaeus*, in conversation with the program of study in the early Academy; and (3) the Parthenon. It is narrow in that it investigates each of these objects with respect to Philolaus's interdisciplinary research into number theory, astronomy, and harmonics. This narrow thematic focus allows us to say something quite distinct about each of our objects, and then to relate them to one another. In this introduction, we discuss possible connections between sixth- and seventh-century BCE Greek mathematics and earlier Near-Eastern predecessors to show the possible origins of Philolaus's insights in these fields. In part I, we investigate Plato's reception of Philolaus's work to understand how dialectic and mathematics function both in *Republic* and *Timaeus* and in the intellectual environment of the early Academy. In part II, we will present our reading of the Parthenon as a "vanishing mediator"[1] between the earliest developments in Greek mathematics and the sophisticated extension of those early developments in Plato's dialogues and the early Academy. Specifically, we will be concerned to show how the themes of Philolaus's work (fl. ca. 440–410 BCE), roughly contemporary with the construction of the Parthenon, embodied in *symmetria* (commensurability) and *harmonia* (harmony; joining together), relate to the design features of the Parthenon (447–432 BCE) as they make manifest the theological (ontological)

and civic (educational) meaning of the building. A brief afterword will advance an understanding of the relationship between humanist learning and technical achievement through procedural knowledge that we believe shows how one might see a continuous development from the earliest advances of Greek mathematics through fifth-century developments such as Philolaus and the Parthenon through to Plato's Academy, looking also at the analogous situation in the Renaissance.

1. The Parthenon as an Institution of Liberal Arts Education

We propose here to pursue a method of speculative reconstruction to detail what can be learned about the "state of the art" in the early development of "liberal education" in fifth-century Greece. One needs to be cautious in speaking about such a development at such a time, which predates the establishment of any independently operating institution that might naturally be thought to pursue such an educational project in today's terms. The Parthenon, the foremost example of the practical application of mathematical knowledge in the mid-fifth century, insofar as it displays the cultural milieu in which mathematical knowledge was growing in both sophistication and in audience at the relevant time, can be understood as such an institution for liberal arts education. Specifically, coming to see the Parthenon as a manifestation in material form of the quest to achieve a formal integration of the mathematical arts points to a way in which liberal education has been, and could now be, a vital part of the civic life of a democratic society. The Parthenon is both the work of a well-educated group of theoretician-practitioners of mathematical knowledge and a work for the cultivation of a certain kind of generally educated citizen. Understood in this light, it helps us see the roots of the *trivium* and *quadrivium*[2] as they later came to be classically conceived.

Before we attempt the comparative analysis of the Parthenon's design features as a mediator between the earliest, scarcely documented sources of Greek mathematics and the liberal arts curriculum in the Academy, we ought perhaps to say a word about why its status as such a mediator did in fact vanish. That is, if the elements that emerge from our reading of the Parthenon are really there, why don't the innovations in the Parthenon produce an explicit and immediate textual response? We feel this dilemma relates directly to the nature of the building as art object and as sacred space. As we will discuss with specific reference to elements we focus on later, the building does "theoretical work" in ways specific

to the experience of a work of art, ways that need not, and ultimately cannot, be fully articulated in words. In that sense, we would not expect to find contemporaneous textual discussion of the theoretical work that the building is doing. Rather, as we see in Plato's dialogues, analogous theoretical problems emerge in later texts, not so much through direct "influence" but through broader and more indirect connections that arise from their shared intellectual culture. This is similar to the situation in Renaissance Europe, when perspective pictures, made for a sacred context, involve specifically pictorial theological interpretations (i.e., not merely duplicating what texts can do), and also implicate epistemological paradigms that would emerge in more fully theorized and elaborated forms in later centuries (e.g., in Cartesian epistemology).

With so much said for the basic orientation we bring to the Parthenon, let us now reflect briefly on the history of the liberal arts as Plato came to give them determinate form. "Pythagoras introduced the *quadrivium* to Greece." This traditional understanding—this "creation myth"—of Pythagoras as the first philosopher is attested very early in the classical canon.[3] Indeed, though the text is very understated, Plato's observation in Book 10 of the *Republic*[4] that Pythagoras, like Homer, was hailed as a "master of education" seems to point to an already-established view that holds Pythagoras as a model of what Aristotle already refers to as "liberal education."[5] Our suggestion is that the procedure we will follow in our analysis—testing a formal understanding (here: the mathematical theme of reconciling arithmetic and geometry through harmonics) against a material object (here: the Parthenon itself in its architectural and sculptural program)—is precisely the model that Pythagoras introduced as a "model educator," and the one that inspired the design of the Parthenon.

To cite just one (especially illuminating) example: if we look at the dimensions of the Parthenon's stylobate, we see that they were quite likely determined by a method, standard for Doric architecture in the first half of the fifth century, based on intercolumniations five times the width of the triglyph, that is, on a 5:1 (80:16) ratio of intercolumniation to triglyph. There is an important difference, however, in the case of the Parthenon: the continuous proportion from which the façades and flanks of the building were constructed gives a 81:16 ratio between these elements, as two elements in a continuous proportion of intercolumniation to lower column diameter to triglyph width, where the full expression is 81:36:16 (this is a *continuous* proportion since 81 and 36 are in the same ratio as 36 and 16).[6] The refinements involved with fitting these two slightly different constructive principles together—that is, these two different forms of *symmetria* (commensurability)—is a first instance, among many others

we will investigate in detail, where we encounter the problem of *harmonia* (harmony, i.e., "joining together") in the Parthenon.

One important consequence of the repeated use of this particular continuous proportion, at various scales, is that it allowed for the building's overall cubic proportions, in the continuous proportion of 81 (length) : 36 (width) : 16 (height) to have as its unit the real, visible triglyph module.[7] Focusing for the moment only on the two most remarkable features of this innovation—adapting the 5:1 (80:16) ratio to the mathematically much more interesting ratio of 81:16 and the even more remarkable offering of the visible triglyph module as the unit for the building as a whole—two points emerge. First, the remarkable sophistication of the theoretical reflection at work in the monument's design becomes in a literal sense visible. Still more strikingly, we believe, the designers made this sophistication accessible to the temple's audience, which is ultimately the whole city, by weaving these formal features into our sensory and embodied experience of the building.

Through this careful consideration of the educational program behind the design of the Parthenon and in its role as a form of civic education, we hope to show that the practical arts played a key part in the birth of liberal arts education. The well-rounded education that came to be programmatic in the Academy has as its proximal antecedent the practical, but not merely practical, education in the arts that the planners of the Parthenon brought to bear in and through its construction. More than anything else, this antecedence manifests itself in the elegant interrelation of the soon-to-be-canonized mathematical arts of arithmetic, geometry, astronomy, and harmonics in the building's constructive program.[8]

Both to shed light on the notion that the Parthenon is a vanishing mediator in this sense, and by way of concluding this statement concerning the significance of our project at large, we would like to address three fundamental criticisms to which our entire method of speculative reconstruction can reasonably be subjected.

First, a more hard-headed historian might object that even if we can "read" the Parthenon as it stands as being the site of the "integrated mathematical arts" as they are canonized in the fourth century, this does not, in light of the total absence of other primary source documentation, give us reason to be certain that any significant portion of the people who designed and built the temple had any awareness of the presence of these features or the capacity to appreciate them. Even less, the criticism could continue, do we have grounds to believe such features to be among the principles of its organization. In response, we would point to the intensity of the reflective awareness the design program displays, also in comparison

with Doric temple design before and after the Parthenon. This suggests that the problems we will discuss in detail below were on the minds of those responsible for the building, and are not a projection back onto it. If that is possible, then we hope to show it is also plausible that some significant portion of the "knowledge workers" assigned to this commission had a reasonably advanced understanding of principles not yet recorded in the works of theoretical mathematics from the mid-fifth century. We also aim to show that the Parthenon as designed intends for its audience—or at least a considerable part (the "educated" or cultivated part, those versed in *mousikē*, the works of the muses) of that audience—first, to recognize the presence of these problems, and then, having recognized them, to "educate themselves" in a manner not dissimilar to how Socrates defines dialectic as the "art of turning around the whole soul" (*Resp.*, 7.518d).

But, our interlocutor might insist, would it really have been the case that any number of people involved either in the design and the construction of the temple, or in visiting and making use of the space once built, would have had any access to, or interest in, the features on which we focus here? To this we would reply: the character of the Parthenon as a *work of art*, and not a theoretical written text, is crucial (and we mean "work of art" here in the broadest sense, not "art for art's sake" but an idea of art inclusive of the building's religious meaning and function). The building creates an encounter with every receptive viewer, whatever his or her educational background or degree of specialized knowledge, an encounter that is ultimately irreducible to an entirely verbal, or entirely mathematical, articulation. That encounter is first and foremost an embodied and sensory one, within which the mathematical and ontological questions the building raises are embedded, but it is never fully reducible to those questions. The analogy with music may be helpful here: in music, one can experience harmony, and have an emotional response to it, without understanding the mathematical principles involved; likewise, those mathematical principles themselves are not adequate to explain the ineffable character of music, even if they are its foundation. Thus, we can imagine that one viewer may experience *symmetria* and *harmonia* in a strictly intuitive way when encountering the Parthenon (*symmetria* in the well-ordered and pleasing proportions of the design, *harmonia* in the sense of a complex of parts holding together as one thing and in the beauty of the whole); another may connect those experiences to the religious and/or civic significance of the monument; another may speculate on the building's mathematical character and even be inspired to count and measure; and another may consider the relationship between arithmetic and geometry, reflect on the philosophical question of *harmonia*, and be led toward dialectical thought.

This last group would probably be a small number of people, and the first group would probably be the largest. Also, many of those involved in making the Parthenon may have had specific technical knowledge that need not have involved awareness of all the larger philosophical questions we raise in the book. Still, such knowledge—for instance, a stonecutter's knowledge of the required proportions and refinements of individual stones, and how to produce them—*is* a first step in that direction. Certainly, any account of the specific number of people who had access to these different kinds of knowledge would be purely speculative, at least within the scope of this project, but one's intuition that the fullest intellectual and philosophical engagement with the building would have inevitably involved a relatively small number of people (Pythagoreans or otherwise) seems right. All the same, the range of experiences that the building produces, from the most direct and unconscious to the most reflective and theoretical, seem crucially related.

Thus, understanding the Parthenon rightly is possible only when we appreciate the role of practical exposure to "problems in the arts" in a liberal education generally. This, we want to suggest, holds not only for this "institution of liberal education"; actually all institutions pursuing such a program of education have an interest in exposing the students in their care to such problems. Education in the liberal arts originated from a dialectical reflection on problems in the practical arts and more abstract thinking about them, as found in what we would now call "the exact sciences." Such education, in principle, ought always to be versed in such reflection. Or, more baldly still: humanities students ought to have enough quantitative competence to understand what questions in the exact sciences remain open and why they remain open. That, we believe, is the role of the problem-based study of mathematics in the Parthenon, and it is relevant as much for us today as for those who designed, built, and worshipped in the Parthenon.

Even if one is willing to accept our basic two-point hypothesis about the Parthenon as an institution of liberal education, and its corollary for liberal education more generally, though, there remains the following worry: what does the scholarly consensus tell us about the state of the art in Greek mathematical knowledge in the mid-fifth century, and does that consensus tell against our hypothesis? Is it really the case that much of what was known by the time Plato wrote the *Republic* (say 380 BCE) was in fact already known by a fair number of skilled artisans by the time the Parthenon was designed and built some sixty-five years earlier? Our reply begins by noticing that perhaps it was known but not demonstratively known, or put another way, known but not yet subject to deductive proof. This last concession is potentially decisive, as we hope to show.

INTRODUCTION xix

Scholarly consensus holds that formalized proof like what we read in Euclid was entirely absent from Greek mathematics until at least the time of Plato's death. This does not, however, tell against our hypothesis that many of the most important findings first *demonstrated* in *Elements*—and crucial among these for us would be the propositions concerning mean proportionality, continuous proportion, and how these relate to square and cubic numbers—were in fact widely but perhaps not "demonstratively" or "formally" known by the middle of the fifth-century.[9]

Finally, even if our less-given-to-speculation colleague is convinced that our approach survives these two plausibility tests, there remains the following concern: such a well-developed community of practitioners of such knowledge would surely have produced some kind of traceable work that should inform us of who they were and what their research problems and possible solutions were. Why then, the objection would go, are we entirely without any documentation of these groups, of their participants' names and their findings? To this objection, we have two replies. First, the Parthenon itself is the primary source documentation of the community of researchers, whose research method was to work on the problem by designing the structure, and thus "publishing" their results not in a journal for specialists, but for everyone to experience in their civic, religious, and individual encounter with the building (which was a temple, built for the city as a whole with funding that the city secured from a mix of public and private sources). Second, while we believe that existence of one or more treatises having been written by the principal designers is entirely unnecessary to the argument, since the Parthenon speaks for itself, it does merit notice that Vitruvius refers to a book on the Parthenon by Iktinos and "Karpion" among a list of ancient architectural treatises, all now lost, at the beginning of Book VII of *De architectura*.[10] We will probably never know, but it is not impossible that this treatise was (or was in part) something like a guidebook to understanding the Parthenon as a site for solving problems in the interdisciplinary practice of mathematical arts. If this is so, then the formal analysis we will provide in part II might best be understood as akin to what this treatise would have presented. In short, we hope to show that the designers of the Parthenon saw their creation this way, and that they did so because of their vision of what we might call a liberal education.

2. The Parthenon and the Historiography of Greek Mathematics

If we are right in what we say elsewhere, then the relevant historiography needs to be amended at least to acknowledge that there was a *foundational*

understanding of (at least) two mathematical objects generally thought to be understood in a reflective way for the first time in the mathematics of the first decades of the fourth century: continuous proportion (and its non-reducible-to-a-unit-or-multiples-of-a-unit correlate, *anthyphairesis*) and the relationship of the geometric and harmonic mean (a reflection that seems to arise from thinking about the double square and the issue of incommensurability).[11] Also, as we show in the work on the building itself (part II), its design entails a substantial theoretical reflection on the nature of the unit as constructed or discovered. Our suggestion in what follows amounts to this: if these features are present in the building, then it seems likely that Szabó (1978) was not mistaken in his central suggestion. We thus explore how it can be shown that more was known, in some sense on a theoretical level, at an earlier date than the standard story, offered by Knorr (1975), holds.

We very much share the view of Cuomo (2001) and Netz (1999, 2002) that the history of Greek and ancient mathematics cannot be pursued without constant back-and-forth attention to theoretical understanding and actual, practical use, as reflected in artefacts related to specific contexts, like the marketplace and the temple, the household, the state administration, and the library.[12] Drawing on this methodological perspective, our contribution to the historiography of Greek mathematics proceeds in three movements. First, we recall the general contours of the debate between Szabó (1978 [1969]) and Knorr (1975), both presenting a few of their key disagreements and discussing the rough consolidation of a position more or less like Knorr's. We will flag the somewhat provisional nature of this consolidation and the fact that all agree we could understand the pre-Euclidian period better—here following Cuomo (2001), Christianidis (2004), and Netz (2002, 2014). Next, we explore the possibility that both sides of the debate have an overly narrow view of the relationship between practical mathematical knowledge and its theoretization. This can be ameliorated, first, by attending to the central suggestion of Fowler (1999) regarding *logistikē* (and *anthyphairesis* in particular) in the theoretical mathematics of the early Academy and, second, by reopening the question of possible "legacies" of Near-Eastern mathematics in the *theory* as well as the *practice* of mathematical procedures. In the third and final movement of this section, we present an open-minded reading of the features that we elsewhere claim to be at the heart of the design of the Parthenon. By the end of this effort, we hope it will be accepted as *possible* that the Parthenon was designed by skilled artisans whose *theoretical* understanding of "cutting-edge mathematics" was great enough to have accomplished

something that the present-day historiography of mathematics believes to have only been possible after the work of Theaetetus, Archytas and Eudoxus.

A return to the Szabó-Knorr debate is crucial for telling a story about the historical development of the theory of incommensurability, which itself seems central to pre-Euclidian mathematical knowledge. Two central components of Szabó's analysis are relevant. The first is his thesis that there was much more of a theoretical development in Greek mathematics during the fifth century than is acknowledged by the (then, and mostly now) conventional view that theoretically advanced mathematics began only in the early fourth century.[13] The second is his view of the chronological and doxagraphical priority of music theory; while all parties agree that the integration of work on number and work on geometry belongs to the early decades of the fourth century, Szabó (1978: 108–78) insists that this theoretical integration and advance was built on the basis of a prior theoretical achievement within music theory that developed out of musical practice and was already mature in the first half of the fifth century.

Through attention to the development of the three central mathematical disciplines (harmonics, geometry, and number), Szabó aims to show that even if nothing like the formal proof had developed in the mid-fifth century, by the time of Philolaus and Hippocrates there was already a rich tradition of truly theoretical mathematics. In particular, Szabó (1978: 14–33) argues that the crucial step in proving incommensurability dates to Hippocrates, whom he dates to having been active in Athens around 430 BCE.

This claim hinges on three subsidiary claims. First, according to Szabó (1978: 14), the construction of the mean proportional on a straight line—recorded as Proposition VI.13 in *Elements*—was already known by the time of Hippocrates. Second, the oldest demonstrative reasoning in proving mathematical truth is Epicharmus's theory of odd and even, dated "fairly accurately" (Szabó 1978: 25) to ca. 500 BCE. This is crucial because "this theory clearly culminated in the proof of the incommensurability of the diagonal and sides of a square." Third, provided sufficient attention is given to the integration of the three mathematical disciplines (Szabó 1978: 26–28), a chronology can be established (Szabó 1978: 28–29) that proceeds thus:

1. Musical theory of proportion, from which the terms of Eudoxan proportionality were borrowed. This first stage has two phases: (a) experiments with the monochord, giving rise to terminology for 2:1, 3:2, 4:3; (b) development, by

this means, of the technique of *anthyphairesis* (which Szabó translates as "successive subtraction").

2. Application of the "musical theory of proportions" to arithmetic (along the lines of what is formalized and recorded in *Elements*, Books 7–9).

3. Application of this proportion theory to geometry. This was done "of course" at "the time of the early Pythagoreans," working with the construction of the mean proportional.

4. Development of "mathematics within a deductive framework," here speaking of *Elements* and its concomitant theory of proof.

Szabó (1978: 29) stresses two points about this chronology. First, if things did proceed this way, then quadratic incommensurability "must have been known well before the time of Archytas." Second, "the discovery of incommensurability is due to a problem which arose originally in the theory of music." Of course, "knowing well" can mean a number of things, as critics of Szabó have pointed out. In proceeding, we suggest that "knowing well" be taken to mean that there was a deep theoretical engagement with this issue, embracing its relevance for all three emergent mathematical disciplines—geometry, arithmetic, and harmonics.

Szabó's chronology, and the "priority argument" in the development of a proof of incommensurability that it entails, involves Szabó (1978: 33–84) in a very extended argument to the effect that it is a mistake to attribute to Theodorus and to Theaetetus the decisive role in the proof of incommensurability in the period 410–370 BCE. Szabó's claim rests primarily on two grounds: (1) a philological argument focused on his understanding of the use of the term *dunamis* (as "square," "power," and so on) in mathematical texts from the earliest surviving fragments down to Euclid; (2) an interpretive argument concerning Plato's complicated intentions in associating the discovery of a *proof* of incommensurability with these two men in the dialogue that bears the younger man's name. Without entangling ourselves too much in these arguments—which have not proven persuasive[14]—let us briefly state the decisive moment in each of these arguments for Szabó. We will then discuss the basis of criticism thereof, and why we think we ought to consider this an open question.

Szabó (1978: 48) summarizes the philological argument this way: "Thus our previous conjecture to the effect that *dynamis* and *tetragonismos* originated at the same time inevitably leads to the conclusion that the

creation of the concept of *dynamis* must have coincided with the discovery of how to *construct a mean proportional between any two line segments*." This is the crucial link for Szabó (1978: 50–54), insofar as he holds that Hippocrates (and not Archytas) originated the proofs about mean proportionality. In other words, Szabó believes the term "*dunamis*" began signifying "extent-in-square" at the same time that it was learned that one could *practically* construct a square by means of the mean proportional between two line segments. If this is true,[15] and if it is also true that Hippocrates was the first to publicize "proofs" (perhaps only informal proofs) concerning the mean proportional, then we can be confident that the crucial step in *proving* incommensurability in fact dates to around 430 BCE and not 410–370 BCE.

The second support for his chronology is the doubt cast on the centrality of Theodorus and Theaetetus. These arguments have not been well received, but we believe this has to do with hermeneutical questions involving the Platonic dialogue rather than any preponderance of historical evidence. We will re-present Szabó's three main points in the hopes of showing that if we keep an open mind about how to read a Platonic dialogue—and see, for instance, Gadamer (1980, 1986, 1991), Griswold (2002), and Nikulin (2010, 2012a) and our discussion of them in chapter 1, 1, on why we ought to—then we really ought to consider this matter very much open. We do not believe that Szabó "proves" that Theodorus and Theaetetus are not crucial for the development of a *proof* of the *theory* of incommensurability; we do believe, however, that he provides good reasons to doubt what reasons we have to accept their centrality in this story. First, Szabó (1978: 68–71) deploys a reading of the pun on "*dunamei dipous*" in *Statesman* 266a5–b1 to confirm that what Theaetetus describes in discussion with "young Socrates" (who also appears together with Theaetetus in *Theaetetus*) was common knowledge.[16] Second, Szabó (1978, 76) argues that the mistaken attribution of significance mostly derives from two sources, which he spends five pages trying to debunk: first, an ancient Scholium on *Elements* X.9; second, "a report which probably stems from Pappus' commentary on Book X and survives only in an Arabic translation."[17] Since both of these sources themselves rely mostly on a wrong-minded reading of the mathematics section (147c–148b[18]) of *Theaetetus*, Szabo (1978: 79) argues, there is no reason to see this attribution as anything other than a "false tradition." Finally, Szabó (1978: 79–84) presents a hermeneutical and philological analysis of the dialogue in the service of this answer: Plato presents Theaetetus as a very talented researcher, but also as young, naive, and overeager. The relevant section about the discovery of a theory of irrationals must be read in this light.

These arguments are surely not decisive, but neither are they decidedly wrong, we suggest. With them in mind, let us turn to Szabó's second major concern: the central importance and chronological priority of musical theory, which inspired an analytical program in number theory, which in turn inspires a reflection on the (im)possibility of fully integrating number theory and geometry—the latter having developed separately, without prior integration with the other two disciplines. Szabó's (1978: 108–78) account is that music theory arrives at the three means, and realizes there is no geometrical mean for the fourth, fifth, and octave. Then, approaching the double square, (Pythagorean) mathematicians discover mean proportionality between two lengths, whether numbers or not. Thus: music then arithmetic, then geometry.[19]

Knorr (1975: 9), unlike Szabó, believes that "by the time of Hippocrates both [the theory of congruence and the theory of similarity (based on proportion)] were already well developed," but that the combination of these two traditions (cf. Knorr [1975: 7]) began "only about fifty years later," with the contributions of Eudoxus. Knorr (1975: 49) insists that "evidence in the pre-Socratic literature discourages dating [the] discovery [of the theory of incommensurability] before ca. 430. One may recognize only after that time signs of a dialectical interest in the problem of incommensurability." The center of the debate, again, is in the interpretation of Plato's *Theaetetus*.[20] Knorr (1975: 116–7) argues against Szabó as follows. (1) Even if (the idea demonstrated in) Euclid VIII.18 is at work here, this only shows that "there is no *integer* which is the mean proportional between two terms that are not similar numbers," which is not enough to establish incommensurability. (2) Szabó's "view of the antiquity of the mathematics of the dialogue is an assumption," against which Knorr (1975: 82–86) has offered an argument, and which is not well supportable by the available documentary evidence. (3) Given Knorr's own view of the relative novelty of any theoretical understanding (and certainly proof) of incommensurability, it is "at least a reasonable counter-assumption that the number-theoretic foundation, upon which Theaetetus and his successors built their theory of incommensurability, had not yet achieved an advanced form at Theodorus' time." Knorr here underscores what Szabó himself acknowledges: that the relative novelty or antiquity of the discovery is a matter of speculation that—so far as extant documentary sources go now, as then—will never be definitively settled.

Given that the participants in the debate both acknowledge that definitive knowledge is impossible here, and that the matter is really about "who knew what when" within a fairly narrow research program in a relatively short time period, this might seem like a moot question—even

more so because there is not a "world of difference" between these two positions. Nevertheless, determining which, if either, is correct would be very telling for the argument we make about the Parthenon, because if Knorr is right that the kind of integration Szabó sees in Hippocrates was only done in the time of Eudoxus, then it becomes difficult to impossible to believe that this integration, which we argue is integral to the design of the temple, would even have been thinkable, let alone doable, in the period 447–432 BCE.

So, we look for a way to advance this deadlock, and we turn to the role of *anthyphairesis*. Fowler (1999), asking different questions for different reasons, nevertheless focuses on just this knowledge procedure, and finds in it a suspicion of the "standard story" in the historiography of Greek mathematics. Fowler (1999: 4) notes that Knorr agrees with Szabó that "the theory of incommensurability will be perceived as contributing to important aspects of every part of the *Elements*, save for the oldest geometrical materials contained in Books I and III." They do so because they are both committed to "the standard story" about the history of Greek mathematics, which runs something like this: "The early Pythagoreans based their mathematics on commensurable magnitudes (or on rational numbers, or on common fractions m/n), but their discovery of the phenomenon of incommensurability (or the irrationality of $\sqrt{2}$) showed that this was inadequate. This provoked problems in the foundation of mathematics that were not resolved before the discovery of proportion theory that we find in Book V of Euclid's *Elements*," while Fowler (1999: 4) "disagrees with everything in this line of interpretation."

For all that his account clearly owes to Knorr, Fowler's work actually serves as a reason to believe that the kind of sophistication that Szabó sees as present a few generations earlier than Knorr really is manifest—albeit with the crucial revision that it is not that "theoretical" advances occurred earlier than Knorr allows and as Szabó insists, but rather that mathematical *practice* was well "ahead" of its theorization and formalization, and thus that *anthyphairesis* and its insights were familiar to those working on the Parthenon in the middle of the fifth century. It may be that Fowler is entirely correct that much of what is traditionally viewed as "Pythagorean" mathematics had nothing to do with Pythagoras and his followers.[21] It may also be true that nothing like (1) the formal theory of proportion in *Elements*, V[22], or (2) the formal system of deductive proof presented in *Elements* as a whole[23] had been seriously developed during the fourth century, let alone the fifth. All the same, by underscoring the centrality of *anthyphairesis* as a *practice*—especially in addressing problems in geometry (Theaetetus), in music theory (Archytas), and in astronomy

(Eudoxus)—Fowler provides welcome corroboration of our suggestion that the practicing mathematicians and mathematically informed artisans of the generations working at the time of the Parthenon's construction used *anthyphairesis* as a means by which to test, geometrically, solutions to problems in harmonics. The "chronology debate" turns out to be intertwined with a much more fundamental debate about the very nature of Greek mathematics and its logical and methodological and ontological foundations. It becomes advisable, then, to reconsider the "foundations" of Greek mathematics. Christianidis (2004) provides the best overview of this issue, while Netz (1999, 2002) offers the most thoroughgoing analysis.[24]

Our own view is that a more solid understanding of Greek mathematics depends on a better understanding of its relation to Near-Eastern precedents. We wish to ask: What can we learn concerning the novelty or "revolutionary character" of classical Greek mathematics from the practice of *anthyphairesis* as it developed from the earliest (scantily) recorded sources of the sixth century through to its presentation in Euclid's *Elements*? In answering this question, it is worth noting that while much is controversial about the degree of novelty in Greek mathematics, no one denies that there are some indications of contacts between Greek mathematicians (especially astronomers) and Near-Eastern counterparts, certainly by the fifth century (Meton), maybe even earlier (Hesiod).[25] The best-established point of similarity is interest in dates of appearance of stars and constellation during the year, comparable to material in MUL.APIN, and already present in Greek sources of the eighth century.[26] Given this evidence of overlap of "research problems" and particularly of calculative techniques and knowledge procedures, we will suggest that the early theoretical advances in Greek mathematics are unlikely to have developed sui generis, but rather built on the work of Near-Eastern antecedents.

Netz (1999, 2002) and others are surely right that the formal-deductive framework of Greek mathematics beginning in the fourth century and proceeding therefrom is absolutely internal to the Greek tradition. All the same, we submit that both theoretical objects of mathematical knowledge and intricate mathematical procedures of great importance for the Parthenon were studied to a high degree of comprehension already by the mid-fifth century. If this is plausible, we further suggest that this is so not because of a burgeoning influence of "Greek-style" systematic, proof-theoretical knowledge procedures at that time, but rather through the reception of Near-Eastern antecedents. Specifically, interest in theoretical issues such as mean proportionality and periodicity and facility with practices such as *anthyphairesis* seem unlikely to have developed *after* the development of "Greek-style" mathematics that is largely a "fourth-century and later"

phenomenon, as in Knorr (1975) and Bowen (1984). It is also relevant that scholars generally accept Proclus's account of Oenopides of Chios (fl. around and after 450 BCE) as the first to distinguish between theorems and problems, insist on geometry done only with a compass and a straight edge, and draw a perpendicular straight line from a given point to a given straight line. If this is true, it certainly signals a functioning and fairly mature context of theoretical mathematical knowledge production *in Athens*—that is, knowledge pursued solely for its own interest and without relation to physical and practical production—by the time of the design of the Parthenon.[27]

It is impossible to avoid controversy in pointing in this direction[28] because the possibility of Near-Eastern influences on Greek mathematics of the Euclid type is very difficult to establish, partly because of the chronology (most of the evidence for Babylonian mathematics is early second millennium BC) and partly because the Greek deductive-demonstrative style of mathematics seems very remote from the algorithmic problem-oriented style of the Babylonian texts. The current orthodoxy is that Babylonian mathematics is not closely relevant to the development of Euclidean mathematics. Specifically, this "orthodox account" holds that the "rediscovery" of the putatively unique and transformative nature of the progress in mathematical knowledge in and around Plato's Academy during his lifetime and the century after, was integral to the develop of "mathematics as we know it," which essentially began in this period. Integral to the development of this account in the nineteenth century— and those works that followed through the middle decades of the last century—was the conviction that while practical mathematical understanding was developed much earlier and to a much greater extent in other places (especially Mesopotamia and Egypt) than in classical Greece, it was the Greeks alone who sought to develop a proper "theoretical" understanding of these mathematical objects.

The orthodoxy, though, has been challenged, most directly and fully by Friburg (2007). As he notes in his preface, in searching for connections between Babylonian and Greek mathematics, he was compelled to offer very new interpretations of some of the thorniest issues in the debates internal to the historiography of Greek mathematics. Among other things, he comes to propose a new understanding of Book 2 of *Elements* that would (if true) resolve the debate about "geometrical algebra" by showing that what is at work in these propositions is not geometrical algebra, but an "abstract, non-metric reformulation" of "systems of equations in Babylonian metric algebra."[29] Similarly revisionist arguments are made with respect to some of the problems relevant for our project, such as Book

10 propositions on irrationals (addressed by Friburg in chapters 3–5), and possible Babylonian sources for Hippocrates's work (chapter 12)—which is especially interesting for a possible full rehabilitation of Szabó's argument concerning "Hippocrates v. Archytas" in the first elaboration of mean proportionality. Like Friburg, we would suggest that this approach seems reasonable since grounds for rejecting influence seem to us (as to him) more based on prejudice than reason.

Philolaus (ca. 475–ca. 385 BCE[30]) is a central figure for the questions raised in this section, and thus makes for an excellent case study in attempting to address them. First, his intellectual career closely coincides with, if largely slightly postdates, the design of the Parthenon, and shows a concern for precisely the kind of integration of the mathematical disciplines organized thematically around "harmony" that we find there. Moreover, while we will primarily focus on another discovery or invention that is attributed to him, the "Pythagorean Tuning" that is classically preserved in (what Huffman [1993] refers to as) Fragments 6/6A of Philolaus's *On Nature* is integral to the mathematics of the Parthenon, as we show elsewhere. Finally, his work carries a distinct trace of what Babylonian mathematics did best and the field in which the best evidence of contact between Greek and Near-Eastern mathematics has been located: astral science—specifically, in the theory of the moon, the theory of the sun, and the position of the ecliptic.

Take the case of Philolaus's "great year." Huffman (1993: 276–79) provides a thorough account of what is known about this intellectual achievement, which purports to name the period within which solar years coincide with lunar months: namely, 59 solar years (where each solar year has a value of 364½ days), or 729 lunar months (where each lunar month has a value of 29½ days). As Huffman (1993: 277) pointedly says: "The crucial question is how did Philolaus arrive at this set of numbers?" Huffman considers two main alternatives, one in which Philolaus is adopting and adapting the value that Oenopides (mentioned above, and a slightly older contemporary of Philolaus) had arrived at: 730, and the other in which he derives it directly from recorded observations. If he revised an earlier value, the supposition goes, this could be either because of some preference in working with the observations—like the value it gives for the solar year (of 364½ days, rather than $365^{22}/_{55}$ days—or because of the inherent attractiveness of 729 as the square of the cube of 3.[31]

This all seems quite right as far as it goes. But it also seems clear that the central motivation of the entire enterprise that would lead you to posit a "great year"—which Huffman (1993: 276) identifies as "an attempt to harmonize two important ways of measuring time, the lunar month

and the solar year"—is not sui generis within Philolaus's cosmology, or within Pythagoreanism. Both the observational data and the idealized values with which Philolaus and his Greek contemporaries were working came to them from Egypt and Mesopotamia. Given this fact, Huffman's analysis leaves aside a possibility worth serious consideration. Namely, is it not possible that solar year and lunar month periodicity presses itself on these fifth-century Greek sources through the determination of the same issue in the Babylonian astronomical work of the seventh and sixth centuries?

While it is difficult to establish connections for the reasons stated above, here is an instance where we have Babylonian source materials—specifically "goal-year tablets," which make predictions of where certain heavenly bodies will be at certain times in a given year, and "lunar prediction tablets," which focus on the moon over long periods—from the time in question. Since the 1990s, a great deal of work[32] has been done on exemplars of this tradition that have been definitively dated to the period (e.g., tablets from ca. 642–640 BCE, 593 BCE, 523 BCE) and others whose dating is not precisely known but date from some time not earlier than the fifth century BCE and not later than the third century BCE. These texts display two features that relate directly to the question Huffman raises concerning Philolaus's process in arriving at his value for the Great Year.

The first is an interest in what Huffman (1993) calls, with respect to Philolaus, the "harmonization" of the solar year and the lunar month. In the case of Mesopotamian astral science,[33] there was a long tradition of interest in this. While the underlying motivation of the Near-Eastern precedent displays a significant difference from what we can glean as being Philolaus's motivation, the observational data with which Philolaus and his contemporaries could seek out significant number patterns is surely owed to this earlier tradition. But Greek astronomers and mathematicians probably received a good deal more than just the data. For instance, bearing in mind the work of Huber and Steele (2007) on the so-called "Saros function"—an eighteen-year solar cycle—that is transmitted in lunar prediction tables dated to 642–640 BCE, and also the work of Britton (2002) on a lunar prediction table (dated to ca. 620 BCE) that uses a twenty-seven-year solar cycle, one detects a strong consonance between Philolaus's interest in powers of three and the repeated thematic and methodological use of multiples (and especially powers) of three in these Near-Eastern antecedents of which Philolaus or those with whom he worked might well have been aware.

The second noticeable similarity in the research projects of Philolaus and Near-Eastern astronomy of the seventh through fifth centuries is the

direct interpretation of data as itself an object of observation. This appears to have been the hallmark of Babylonian astral science in particular: already by the seventh century, we see the development of what is called the "linear zigzag function," which describes the pattern that emerges on a table inscribed on these tablets, given the values for mean speed (for moon, sun, or both) through the phases of the moon over a period of solar years. From especially the fifth century on, this sort of function is used to give sequences of numbers tabulated for equidistant intervals of time, from which periods could be calculated, and eclipses could be predicted. This back-and-forth procedure from tabular data to worldly phenomena became integral to Greek mathematics, especially astronomy. For instance, as Evans (1998) relates, Hypsicles (in a lost astronomical work) used Greek mathematical rhetoric of a Euclidian kind to present precisely Babylonian values of the "linear zigzag function" for the mean speed of the sun and the moon. We do not have a record of precisely when Greek mathematicians began working with the periodic functions of Babylonian astronomy. But given the contacts we know to have been established between the seventh and fifth centuries, there is no reason to believe that Hypsicles or his contemporaries were receiving the zigzag function for the first time. In any case, the interest in periodicity, and the habit of noticing periodicity in data directly, and *then* bringing it to objects of observation or construction is shared by the Near-Eastern astral science of the seventh century and Philolaus.

This brief investigation of how Philolaus's "Great Year" calculation can at best provide a test case for both the plausibility of a development in fifth-century Greek mathematics that is continuous with Near-Eastern predecessors and the interpretive possibilities this allows within the framework of contextualizing the (very scantily recorded) Greek mathematics of this period; it does not, we know, *prove* anything. It does suggest that the current, and continuing, inquiry about the development of Greek mathematics at the time of the design of the Parthenon could benefit from a more extended comparative analysis of the kind we have initiated here. What's more, it should at least be clear that the kind of knowledge procedures employed in the "algorithmic problem–oriented" style of Babylonian mathematics of these centuries is significantly similar to Greek mathematical procedures prior to the formalization and introduction of deductive proof in the fourth century.

Noticing the relevance of a problem-based, "trial and error" approach to theoretical mathematics that links the work of Philolaus to mathematical practice in the seventh- and sixth-century BCE Near-Eastern astral science provides insight into how mathematical knowledge procedures

functioned in the Parthenon. We see in the temple's design precisely the kind of "algorithmic problem–oriented style" we know to be the hallmark of Near-Eastern approaches. Analyzing the mathematically informed features of the Parthenon design, it seems quite likely that the *process* of coming to these design features is through the *reflective* deployment of a variety of instruments derived from "algorithmic problem–oriented style" mathematical practice. If that was happening in Athens at the time of the temple's design, it seems natural to ask: How did they know how to do this? Why did they choose to do so thus? We conclude this introduction with a first approximation of an answer to this question, which serves as the basis for the sustained analysis offered in part II.

On the hypothesis (1) that the mathematical features we find in the Parthenon are really there, and (2) the central findings of this introduction so far are plausible, we now close with an account of why the mathematical features in question might have been introduced to the design of the Parthenon. We begin by recalling the "Plato and the mathematicians" discussion,[34] in which the use of the difference in methodology between one kind of mathematics and another is key for understanding Plato's critique of the (Greek) mathematicians (of his time) in *Republic* 6 and 7 (510c–d, 528b–d, 529b–c, 529e–30b, 531b–c).[35] What light is shed on these conversations by the findings of the second section of this introduction concerning "Babylonian-style" math and "Greek-style" math? Plato argues that by simply applying their procedures, which they treat as granted setting-stones (hypotheses), without questioning their principles, they are guilty of doing least what mathematics has the greatest possibility to achieve: leading us to the forms. Interpreters will probably continue to debate the exact nature of Plato's critique and what it means about his own mathematical understanding and the actual practice of the mathematicians of his time, and we offer a fuller treatment of this in chapter 3. Here, we simply note that the determination of what exactly the mathematical practice is that Plato's Socrates critiques in Book 7 of the *Republic* shines a light on the question of possible continuities between the mathematicians Plato is criticizing and the Near-Eastern mathematicians that the second section has tried to show at least might have had an influence on them.

Further contextual light is thrown on this matter by thinking through Proclus's account of the debate between what we can call the "constructivist" and the "realist" philosophies of mathematics within the Academy. By teasing out the background of these positions with the epistemology and ontology of mathematical objects, we can see how the constructivist approach maps onto the practical-procedural approach we have explored with respect to the Near-Eastern precedents of early Greek

mathematics, while the realist approach relates to the development of formal-deductive procedures that decisively break with such practices. Nikulin's (2012b) work on "indivisible lines" and Negrepontis's work on periodic *anthyphairesis* draw this in deeper relief. What emerges here is that key features of periodic *anthyphairesis* as described by Negrepontis (2012) correlate strongly with the design of the Parthenon as a mathematical construction. This vindicates Negrepontis's explanation—itself an echo of Knorr (1975) and Szabó (1978), as reconstructed by Fowler (1999)—of Aristotle's claim from *Topics* (158b22f.) about a pre-Eudoxan approach to proportions in Greek mathematics through finite and infinite *anthyphairesis*.[36] This itself points toward the possibility of a robust, *theoretical* reflection on recursive procedures, like those used in the construction of the Parthenon, having already existed by the time of the Parthenon's design. Such a reflection would have addressed, for instance, the question of why some recursive expansions in square yield continuous proportions of whole numbers, while others arrive at the "infinite *anthyphairesis*" Plato is worried about in dialogues such as *Theaetetus*, *Philebus*, and *Statesman*.

A synoptic rehearsal of three crucial elements of the temple's design described above demonstrates this.[37] First is periodicity itself. As we saw in comparing the dimensions of the Parthenon's stylobate with standard Doric intercolumniation, a 5:1 (80:16) ratio of intercolumniation to triglyph, the Parthenon's continuous proportions give a ratio of 81:16 between these elements. The refinements involved with fitting these two slightly different things together is a first instance of the problem of *harmonia* in the Parthenon. Second, the construction of the unit. As described above, using this particular continuous proportion, at various scales, allowed for the building's overall cubic proportions, in the continuous proportion of 81 (length) : 36 (width) : 16 (height) to have as its unit the real, visible triglyph module. Last, the harmony of the whole. As in the construction of the ancient Greek musical scale, and as Nikulin (2012b) details in his discussion of the divided line and its importance to Plato, so too in the building of the Parthenon, the consideration of a geometric object in arithmetical terms as a means of forging an aesthetic (and ontological) whole gave rise to an irreducible tension between magnitude and multitude. This tension is made productive in all three cases as the decisive factor in the thinking-through of harmonics (*harmonia*), that is, in the joining together of conflicting elements to create a unity. In Doric architecture, this problem emerges most fully in the need for a harmonious articulation of the building's corner, an issue engaged with unique intensity in the Parthenon, via a unique (to our knowledge) approach to a "distribution of the difference" problem.

However much might remain undecidable in what we have presented, it should be clear why the interpretation of the mathematical features of the Parthenon opens up large questions about the development of Greek mathematics in the first decades of the second half of the fifth century. The advanced state of *practical* mathematics in mid-fifth-century Athens rekindles the old but not extinguished flame in debates concerning the sui generis nature of theoretical mathematics in fourth-century Greece and the possibility that there was real continuity between Greek mathematicians and their Near-Eastern predecessors. This suggests that we would do well to develop a deeper appreciation of the "algorithmic problem–oriented style" of many pre-Euclidian Greek mathematicians—at least, we would maintain, of those knowledge practitioners involved in the design of this building, and also for those (in both the western colonies and on the mainland) with whom they were obviously in productive contact. This finding seems consistent with Netz's (2002) account of Greek "counter culture" as a *practical* affair in the "cognitive history" of the sixth and fifth centuries. But if there is a conscious attempt to introduce this mathematics into this building in a thematized and programmatic way, what is the intellectual background of that attempt? We attempt an answer by investigating the state of the art in Greek mathematics during Plato's long intellectual career in part I; we then move on in part II to critically reconstruct the work the Parthenon was doing as a "vanishing mediator" between the seventh- and sixth-century Near-Eastern mathematics we have seen exemplified in the solar and lunar tables above and the work of Plato and his contemporaries in and around the early Academy.

Part I

Plato on Dialectic and the Problem-Based Study of Mathematics

MICHAEL WEINMAN

Three things must be true for the central argument in this book—that the Parthenon is the most important "vanishing mediator¹" between the archaic and largely "illegible" reception of Near-Eastern knowledge practices in Greece during the seventh and sixth centuries BCE and the creation of Plato's Academy—to hold. First, it must be true both that there was such a reception of earlier technical, especially practical mathematical, Near-Eastern knowledge and that it was of real importance to the development of Greek mathematical thought in the fifth century and after. Second, it must be true that the design of the Parthenon is a principal site in which we can read this legacy; that is, it must be possible to find in the principles of the organization of the temple clear links to the objects and practices in earlier Greek mathematics, which themselves must be clearly connected to the Near-Eastern antecedents. Finally, we must be able to show that those features of the Parthenon that prove its connection to the Near-Eastern legacy are themselves integral to the kind of education Plato set out to offer in the Academy.

It was the work of the introduction to demonstrate the first of these three claims, and it will be the work of part II to demonstrate the second. It is our present task here in part I to substantiate the third. To bring this about, we here provide an analysis of how the "constructivism vs. realism" debate about the foundations of mathematics and the nature of mathematical objects of knowledge that we can be confident (thanks to Proclus) was already raging in the Academy by the time of Plato's death

can be traced back to the "problems" that partially motivated the design of the Parthenon, about seventy years earlier.

The textual basis for our attempted reconstruction of this debate begins with the place[2] where Plato has Socrates argue that the life of the just man is exactly 729 times more pleasant than the life of the unjust man. In what follows, we will show why we find this seemingly comic and surely not literally intended claim at the moment of greatest drama in the dialogue, the place where Socrates will, once and for all, most decisively answer the central question of the *Republic*, which is not "What is justice?" but rather "Why be just?" In presenting our account, we offer a perspective on the broader problematic of the relationship between dialectic and mathematics in the dialogues, which we hold to be fundamentally linked with the debate in which Plato was participating about the reality and ideality of mathematical objects. To pursue the reading we hope to provide for this passage, we first bring it into conversation with (1) the interpretation of the *Republic* more generally (chapter 1) and (2) the account of the mathematical basis of physical reality in *Timaeus* (chapter 2), before reaching our conclusion concerning the "nesting" (or placement) of mathematics with respect to dialectic (chapter 3).

Chapter 1

Dialectic and the Mathematical Arts in *Republic* (9.587b–588a)

Philolaus's Scale and the Final Bout between the Just and Unjust Souls

Of all the major interpretive questions that face readers of Plato's dialogues, perhaps none are more pressing or less resolved[3] than the questions we aim to address here. First, just how mathematically inclined, and how mathematically able, were Plato and his followers in the Academy? Second, just how influential were the beliefs, practices, and methods of "the Pythagoreans" to Plato's views, as reported in the dialogues, and as (perhaps) otherwise or more expansively taught in the Academy? Indeed, we can already see the intertwinement of these questions, and their importance for the project of understanding Plato's influence, in Aristotle's presentation of Plato's views and those of the early Academics in *Metaphysics*.[4] Despite this long and persistent concern, there remain pockets of the corpus of dialogues that are both understudied and possibly telling—though surely not determinately so—for these questions.

One such pocket is our focus here: the passage of *Resp.* 9 (i.e., 587b–588a) that concludes the central argument of the dialogue, which stretches all the way back to the challenge to defend justice by means alone of what it brings about in the soul of the one who possesses it, put to Socrates by Adeimantus and Glaucon at the beginning of Book 2. Here Socrates reports that not only does the just man lead a more pleasant life than the unjust man, but precisely a 729 times more pleasant life. Given this placement at the conclusion of such a momentous stream of discourse, and that it immediately issues in the famous "image of the soul in speech," we should expect this passage to be relevant for "big picture"

interpretive questions like ours, all the more so since Plato here goes out of his way to "make math an issue" by attaching this coda in which we can precisely calculate the extent of the difference by which the just life is preferable to the unjust life.[5] All the same, this moment has received a good deal less notice than *Resp.* 7, 522–532, where the "mathematical disciplines" are discussed in detail,[6] and the *Timaeus*,[7] which seems to present—although very ambivalently—Plato's most sustained treatment of "the role of the mathematical arts" in the dialogues.

Given all the attention these interlocked interpretive problems have justly received in the service of trying to answer these profound questions about (1) the relevance of the dialogue form for the practice of dialectic and (2) the relationship of dialectic and mathematics for Plato,[8] and that such scholarly results have not always converged toward a consistent "state of the art," we cannot be utterly silent on *Resp.* 7 and *Timaeus*. We propose, however, to make our way (lightly) into these stormy seas by way of the manner in which (as it seems to us) the passage that is our focus here calls on and comments on this earlier discussion of the mathematical arts as "the prelude to the song of dialectic." Our focus will be on the manner in which the salience of the number 729 is elucidated for each of the five mathematical arts named in Book 7, with the crucial exception of what is presented in Book 7 as the highest art, harmony. The question, then, will not so much be "Why 729?," which we discuss to ask a more telling question; that question is, "Why does Plato have Socrates leave out the significance of 729 for harmony, after going pointedly through its relevance for arithmetic, geometry, solid geometry, and astronomy?"

We believe that the ultimate relevance of this number is that the ratio 729:512[9] is an excellent approximation of the ratio of $\sqrt{2} : 1$. That is, viewed with respect to harmonics, 729 is the best number to work with to show that "closing the circle" of the musical scale is impossible without introducing irrational numbers, which is precisely what was ruled out by the commitments, ontological rather than formal, of the Pythagorean harmonists who built the scale with which Plato is working here.[10] If so, we are faced with a question quite relevant for our overarching interpretive concerns: why did Plato leave this out? Our suggestion is that by doing so he inscribes into the dialogue the incompleteness that is integral to the progress of dialectic.[11] This brings us to our suggestion for how we ought to understand the relationship between philosophy and mathematics. Namely, mathematics provides the tools by which we can make ever more determinate the problems on which we wish to work—here, for instance, the problem of halving the whole tone as a special case of the problem of bringing into ratio (into *logos*) the irrational (*alogon*)—in the service

of dialectic. This is the relationship of mathematics to philosophy and the meaning of the suggestion that the mathematical arts are a "prelude" to the song of dialectic (*Resp.*, 7.531d).

There are, however, two relevant senses—call them the therapeutic and the transcendental—in which the impossibility of rationalizing the irrational as understood by mathematics might be the "prelude" to the "song" that would be the properly *dialectical* understanding of this impossibility. In both these senses the basic structure of the claim is the same: mathematics is something you must not fail to do before dialectic, but also something that you must not fail to move beyond. The difference between the two, though, is as follows. If the therapeutic sense is correct, then the point of the transition from mathematics to dialectic is one in which you "get beyond" the mathematical moment by *getting over* it, specifically by consciously rejecting the project of mathematics as the means by which the world of sense can be brought within the dominion of reason. If, on the other hand, the transcendental sense is correct, then the way the dialectical moment gets beyond the mathematical is one in which the project of mathematics as the means by which the world of sense can be brought within the dominion of reason is somehow preserved even as it is transcended.[12] We believe that our basic interpretive picture of Plato's reception of Philolaus's musical scale in both *Republic* and *Timaeus* holds regardless of which of these two senses that we consider of how, exactly, mathematics is the prelude to dialectic's song, and so we remain neutral concerning which of these two senses ultimately holds while offering our readings of *Resp.* 9.587b–588a and *Tim.*, 35b–36c. When offering our reading of Platonic dialectic as the cornerstone of his vision of liberal arts education in chapter 3, however, we offer grounds to believe that the "transcendental" interpretation of the prelude-song relationship between mathematics and dialectic is in fact closer to the spirit of Platonic dialectic.

If this is right, then this would mean that the answers to our biggest questions would be something like (1) Plato thinks that doing mathematics is important, even integral, to cultivating a philosophical disposition, but does not in itself constitute a philosophical disposition; (2) thus, we would best understand the legacy of the Pythagoreans as predecessors who helped articulate the problems that would-be philosophers should try to cope with, but not as models for philosophical practice itself. Put another way, we should acquaint ourselves as well as possible with figures such as Plato's philosopher-king and Timaeus, but if we want to be philosophers, we should understand our work as responding to them in a properly dialectical way, rather than as trying to emulate them.

1. The Two Interpretive Principles We Bring to Plato's Dialogues

Before descending into the details of this passage, we ought first to justify as far as possible our two interpretive principles in approaching it. First our reading follows in the wake of others that insist that we must pay careful attention to what Plato has Socrates (and other characters) *not* say in the dialogues in order to understand what he does say—especially when he has that character call attention to the fact that there is something that he has to say that he is in fact not saying. Call this the "leaving things out" principle. Second, our reading joins those that hold that it is impossible to understand what Plato is trying to establish argumentatively—that is, what he means by *dialectic*—without paying careful attention to the dramatic context in which those arguments are offered. Call this the "dialectic in and through drama" principle; this must be understood against another interpretative principle (call it that of the "dialectic in and through dogma" reading tradition) that holds that, however great a stylist Plato was, his philosophical positions (his *dogma*) can and must be isolated from the dramatic form in which he offered them, and the work of *philosophical* interpreters is to "get at" the philosophical content (the *dogma*) by stripping away, as it were, the dramatic context in which it is presented.

Leaving Things Out

Integral to our understanding of this passage is that Plato consciously chooses *both* to cast the passage in terms of the five mathematical arts articulated in Book 7 *and* to leave out the relevance of the fifth, and highest, of these arts: harmonics.[13] Making sense of this intentional leaving-out requires reflecting on Socrates's famously enigmatic statement, in a crucial moment of the dialogue immediately preceding the presentation of the divided line and the allegory of the cave, that contrary to Glaucon's wish that he give his account of the "likeness of the sun" (that is, the good) in full, leaving nothing out, "I, of course, am leaving out a throng of things [συχνά γε ἀπολείπω]" (*Resp.* 7.509c). One thing we cannot fail to notice is that this statement comes immediately before the presentation of the divided line, with which Book 6 concludes, and the image of the cave, with which Book 7 opens. Precisely what it means that these two justly famous moments in Plato's masterpiece immediately follow the claim that the account of which they are part is going to be *knowingly incomplete* remains a source of intense debate. Some commentators are quite happy to take the account of the

good in *Resp.* 6 and 7 as "more or less" Plato's view of the form of the good; others insist that what we have in the dialogue is a mere shadow of his true view, which he couldn't possibly provide in the dialogue for reasons that emerge in the conversation with Glaucon and Adeimantus, and also recur in other "late" dialogues and in the Seventh Letter.

What we will say about what is left out in "the 729 times more pleasantly" passage owes a lot to how Miller (2007), McNeill (2010), and Roochnik (2003) understand the role of "leaving things out" in (Plato's) Socrates's dialectical method more generally. Against this approach, there is a "stronger" reading of *Resp.*, 6.509c, which sees in it an express reference to the precise content of Plato's "unwritten teachings," which (according to this "Tuebingen School" reading) were the true views of Plato on metaphysics and epistemology, consciously obscured in the dialogues for pedagogical and political reasons.[14] And there is a more "deflationary" reading that holds that this concern with this passage is protesting too much and that Plato's understanding of the form of the good is more or less legible from *Resp.*[15] We hope that our particular interpretive path, a sort of "third way" between the deflationary and stronger readings of the "leaving things out" claim, will be vindicated by the results of our reading,[16] but let us add a last prefatory justification of the "leaving things out" principle.

We hold the following claims to be true:

1. A satisfactory answer to the puzzle "Why 729?" should be held to be a significant desideratum for readers of *Resp.*, given the passage's importance for the central argument of the dialogue.

2. There is, as yet, no such satisfactory answer, neither from those who advance a more "dialectical" (sometimes, "esoteric") reading, nor from those who offer a "literal" reading.

3. We intend to offer such an answer, which entails accounting for the legacy of "Pythagorean harmonics," which legacy is not fully present in the text of 587b–588a.

If (1), (2), and (3) are in fact all true, then all readers of the dialogue, however inclined or disinclined to "read much into" (Plato's) Socrates's insistence (at 509c, but also, for instance, at 531d and 533a)[17] that the conversation recorded in *Resp.* is not adequate to its subject matter, should accede to this final claim:

4. At least with respect to *Resp.* 9.587b–588a, and thus with respect to Socrates's discharge of the dialogue's central demand,[18] it is not possible to hear what Socrates is saying without thinking carefully about what he is *not* saying, and why this is so.

This brings us squarely to the second and further-reaching of our two interpretive principles: *Dialectic in and through drama*. An interpreter's attitude to the "leaving things out" principle is likely to have much to do with whether one believes that the dialogue form through which Plato communicates and the dramatic features that this form entails are intrinsic or extrinsic to the philosophical content that Plato's (Socrates's) dialectical inquiry communicates. Of course, any 0/1 dichotomy obscures, and so it is fairer to say "to what extent one believes" the content is extrinsic to the form than "whether one believes" it is extrinsic or intrinsic. Still, we hold, this dogmatic/dramatic distinction[19] is surely meaningful for it continues to be the case until today that this divide (sometimes captured as a distinction between interpretations that are "literal" as opposed to "esoteric," or "analytic" as opposed to "continental") functions meaningfully in the interpretation of Plato's dialogues.[20] Followers of the "dramatic" interpretive principle would embrace readers as different as classical, medieval, or early modern esotericists; post-Schleiermacher hermeneuticists; "Straussian" esotericists; and "Tuebingen" esotericists. The most paradigmatic of "dogmatic" interpreters must be Cornford, whose classical (1966 [1937]) treatment of *Timaeus* has been quite influential, even if his extreme view of the possibility and necessity of rewriting sections of the dialogues to make their argumentation clearer is not endorsed by contemporary interpreters of every stripe. This is true right down to the more moderate indicative example of the dogmatic approach found in Broadie (2011: 7), who "starts by accepting at face value the account Plato has given, and then attempts to understand why he wanted a Demiurge separate from the world."[21] From the first, then, this sort of interpreter reads the dialogue as though it is a treatise, "stripping away" the dialogue's "tragic gear."[22] Using this as a first principle, the dogmatic interpreter tries to make sense of whatever views are advanced in the conversation, which views are understood—as in this statement—simply as *Plato's* and not (Plato's) Timaeus's.

For such readers, alternative interpretations remain controversial or simply mistaken, obscuring from view the philosophical content that can best or only be accessed by simply taking up, as Broadie calls it, "the account Plato has given." Perhaps the most salient instance of this interpretive divide for our present purposes is the status of Timaeus in the dialogue

that bears his name. As Kalkavage (2001) shows,[23] the closer one comes to taking a wholly extrinsic (dogmatic) approach, the more impossible it becomes to ask this question. After all, one can only accept that there is a gap between views about the nature of things taken up in the dialogues and Plato's view (or views) if one is open to the possibility that the dramatic context in which those views are offered is relevant for their status as truth claims. Indeed, in the following sections we aim to show *both* that however seriously Plato is working with the views Timaeus expresses, this thinker does not in fact present "Plato's cosmology"[24] after all, *and* that this can only become clear when one adopts a "dramatic" approach to the philosophical argumentation concerning "Pythagorean harmonics" in *Tim.* (35b–36c) and *Resp.* (7.522–532, 9.587–588). In other words: if we want to understand *Plato's* position on the Pythagorean positions that *his* Timaeus offers, we cannot take Timaeus's words—or any single knowledge claim offered in the dialogues more generally—as Plato's "at face value"—any more than we can simply accept, say, Polonius's views as Shakespeare's, or Antigone's views as Sophocles's. We must, with respect to uncovering *Plato's* account, engage in both of two steps. First, we must secure, so far as possible, the account the interlocutor is offering through a deep engagement with the dogmatic context in which that account is grounded. But having done this, we must never believe that we simply have Plato's account. Rather, we then need to step back and look at how Plato the dramaturge means to deploy this intellectual engagement for his dialectical purposes.

We are of course not the first readers of Plato interested in spanning the breach between dramatic and dogmatic interpretations; rather, more and more readers have been doing so since Griswold (2002 [1988]). One could say that if "0" represents the view that in Plato's dialogues form and content are utterly extrinsic, while "1" insists that there is no way to conceive the content without its dramatic form, more and more interpreters and commentators self-consciously stake out a position that is, say, more like ".75"—for instance, Clay (2000), Griswold (1981), Kahn (1996), and Sayre (1995); or ".3"—for instance, Ferrari (2007), Horky (2013),[25] and Reeve (2013). In this light, we propose that getting the "Plato the Pythagorean" story right[26] can actually help resolve the dogma/drama chasm altogether. This is so because a reading of "our" passages that actually says something meaningful about the dogmatic commitments that rest behind their perplexing technical aspects *must also* have something to say about Plato's dramaturgical purpose in putting certain views associated with "Pythagoras" and/or "Pythagoreanism" in the mouths of certain characters. In this way, our response to the attempts of the last two

decades to "speak across the methodological divide" seeks to "harmonize" these two reading traditions. Our reading is one that harmonizes in the quite precise sense that a musical harmony does not replace one of the elements from which it is generated, or try to make one element "be more like" another, but rather somehow "bonds things that are unlike or not even related together in an order" (Philolaus, Fragment 6[27]). In what follows, we aim to read the technical "data" of these passages just like a dogmatic interpreter (approaching Plato's text with a "intellectual history/history of science" lens), and at the same time read the context in which that "data" are transmitted just like a dramatic interpreter (approaching Plato's text with a "hermeneutic" lens).

The claims with respect to the "dialectic-in-and-through-drama" principle that we aim to justify in what follows, then, are these:

1. The question of a Pythagorean legacy in *Resp.* and *Tim.* is one that can only be answered with an interpretive approach that harmonizes concern for the dogmatic context in which Plato has his characters make the arguments they do and the dramatic context in which he has them do so.[28]

2. This legacy cannot be understood without an account of Plato's reception of two contributions by Philolaus: (a) the Great Year, and (b) the construction of the musical scale from small whole-number ratios.

3. No account of Plato's reception of Philolaus is possible without both (a) an adequate account of *Resp.* 9.587b–588a, which has received comparatively little attention, and (b) *Tim.* 35b–36c, about which much more has been written and which we discuss in chapter 2.

4. The needed adequate account of "Why 729?" is not possible without attending to the "intentional gap" in the text left by the positive absence of exactly the art to which Philolaus's musical scale belongs: harmonics.

We turn now (2, below) to a defense of (3a) and (4), before turning (chapter 2) to a defense of (1), (2), and (3b). Part I concludes (in chapter 3) by stating the relevance of the findings of both sections for the broader debates outlined at the outset, connecting the reading of the "mathematical-political moment" in *Resp.* and *Tim.* with Proclus's account of the

inner-Academic debate concerning the ontological status of mathematical objects so that we can understand the status of the claims in both *Resp.* and *Tim.* in their historical as well as dialectical character.

2. Why 729? The Positive Absence of Harmony in *Resp.* 9.587b–588a

In this section, we aim to show both that (3a) no account of Plato's reception of Philolaus is possible without an adequate account of *Resp.* 9.587b–588a, which has received comparatively little attention, and that (4) such an adequate account itself is not possible without attending to the "intentional gap" in the text left by the positive absence of harmonics, named as the highest of the arts, the "prelude to the song of dialectic" (7.531d).

We begin with an appreciation of the number itself, which Plato has Socrates say is "true, and appropriate to lives as well."[29] As Reeve (2004) notes in his translation,[30] in order to arrive at 729 while working with the five regimes analysis, Plato's Socrates needs to do some "fast moves" to have this number at all. Why go to the trouble? Given that there are five regimes, why make the account "pivot" on the oligarch so that he counts twice? Having done that, why say that each step involves multiplication, rather than addition? Why *must* the answer come out to *729* times more pleasant, and not 4 times, or 5 times, or 125 times? Our most direct hints are these: the number 729 is described as both "true" and "appropriate to lives" and the reason given for this is the work of Philolaus. But what exactly is the relevance of the number 729 for Philolaus? Plato is making two references here: one obvious and expressly pointed to in the text, and the other "hiding in plain sight." The obvious reference (at *Resp.* 9.588a2–3), to Philolaus's "Great Year," has received ample attention in the literature on the *Republic*, on Philolaus, and on Plato and Pythagoreanism. But the second reference requires unpacking. We must first notice how the entire passage follows the curriculum in mathematical arts as the prelude to the song of dialectic in Book 7 only to leave out a reference to harmonics. Even then, this reference is harder to see because it is not physically there in the manuscript. It is a positive absence, something that is, so to say, absolutely on the mind of the dialogue, but not on its tongue. Plato has Socrates point directly to the relevance of Philolaus's work with the number 729 but leave out the number's relevance for Philolaus's harmonics. Why does he do so, especially since he works very closely with just this object in *Tim.* (35b–36c)?

In anticipation of the objection that comparing Plato's reception of Philolaus in *Republic* and *Timaeus* is unfounded because of the "relative dating" of the two dialogues, we note that Tarrant (2012a, 2012b) has recently offered a stylometric analysis of different versions of the six-book and standard ten-book *Republic*, the relevant consequence of which is that, stylistically, Books 8 and 9 differ most greatly from Book 1, and therefore there is good reason to believe that they might have been the last to be composed. If true, this means that 587b–588a might well have been composed at more or less the same time as *Timaeus*, especially if we accept the view he articulates in Tarrant et al. (2011). In that work, he and his colleagues show that *Timaeus-Critias* might well not be as "late" as is often presumed by those who are more likely to take on the "developmental" hypothesis. Overall, the suggestion is that even those who might be the least amenable in principle to our "intertextual reading" of the reception of Philolaus in these two dialogues, because of the dialogues' putatively differing dates, ought to temper their skepticism. We ourselves join Ferrari (2007) and Kahn (1996), among others, in being quite unsure to what extent it is possible to say very much with confidence about which dialogue was composed when, and especially in drawing from that data one or another story about a certain evolution or development in Plato's views. We find it much more likely that the many, frequent, and *methodical* differences in the views expressed in the dialogue have to do with what we are calling here the "dramatic" context. But even if our reader is not persuaded of this view, Tarrant's detailed and thoroughgoing analysis provides good reason to believe that the two passages read together here—*Resp.* 9.587b–588a and *Tim.* 35b–36c—were actually composed at a very similar time. Thus, "their different dates" cannot be a reason not to read them together, whatever one believes in principle about intertextual readings of the dialogues and their chronology.

Through a careful reading of the page-long passage, we hope to show three things: the number 729 has relevance for Philolaus's harmonics; Plato is aware of this while constructing Socrates's presentation of the number here; Plato consciously abstains from making this explicit. In concluding, we address why the relevance of 729 for harmonics is among the things that he has Socrates "leave out" and specifically "how it can be good" (*Resp.* 6.487e[31]) that he does so. There is, we aim to show, a specific pedagogical and ethical purpose in having the trajectory of the argument point (obliquely, but definitively) to Pythagorean harmonics, but also leave it unspoken: namely, to bring us interlocutors face-to-face with the temptation of the dream of a world reduced to measure in order that we may see for ourselves its ultimate impossibility.

From the Five Regimes to Philolaus's Great Year

The "729 times" passage comes at a point in *Resp.* 9 where we see the culmination of the analysis of the five regimes that can rule the city and the soul, called for in *Resp.* 4.445c–e[32] but actually given its full articulation only in *Resp.* 8.543c–544e.[33] As Kraut (1997: 312–14, 320–25) convincingly argued, the point of this analysis is not to provide a political science for its own sake, either theoretical or practical. Rather, the five regimes analysis is constructed for the sake of the defense of justice that Socrates must provide—not in the abstract—but actually operating in the life of a single human being. And this defense comes down to the three-bout wrestling match[34] between the just man and the unjust man on the question "Whose life is more pleasant?" The claim that the just man lives exactly 729 times more pleasantly is a coda to the third of the three falls (577c–580c, 580d–583a, 583a–587b). That there are three falls itself might seem excessive, but surely adding anything to the conclusion of the third of the three falls—Socrates's claim (*Resp.* 9.587b4): "And therefore, the tyrant will live most unpleasantly and the kind most pleasantly"—is gilding the lily. Commentators agree that Plato can't be *that* serious about the number 729 here. Why, then, really, is it *just* to say that we can determine just how much more pleasantly the king lives than the tyrant? It must be clear from the outset that no quantification is going to be the real and whole truth, so why engage in quantification at all? Given that Socrates has, presumably, met the brothers' demand not just to defend justice but to show its work in the soul of the one who possesses it, whether or not it escapes the notice of gods and men, what could possibly have been left unsaid?

To answer this nonrhetorical question, we must also ask why *this* particular number of times more pleasant. In short, we need to take this passage quite seriously indeed. We will follow Socrates very closely from this point, as he begins by introducing quantification, and then combines the five regimes analysis of Books 8 and 9 with the three pleasures analysis of Book 9, uses this combination to define a series of five terms with six positions, and then relates the key terms in this series (king/tyrant) to number and calculation, the first of the mathematical arts presented in *Resp.* 7.522–532; geometry, the second of those arts; solid geometry, the third; and astronomy, the fourth.

The quantitative coda emerges when Socrates (587c1–4) relates the five regimes with the three-pleasures analysis of Book 9 as follows: "There are, as it seems, three pleasures[35]—one genuine, and two bastard. The tyrant, going out beyond the bastard ones, once he has fled law and argument,

dwells with a bodyguard of certain slave pleasures; and the extent of his inferiority isn't at all easy to tell, except perhaps as follows." How we will carry out the quantitative comparison is not yet clear. We do however know that solving the problem of a true comparison of a just and unjust life requires that we understand how the souls of the perfectly just and unjust (the king and the tyrant) rule themselves, which itself entails understanding how these souls comport themselves with respect to pleasure. On the one hand, this is how we get the number three in what follows, and from there to 729 (which is $(3^2)^3$); on the other hand, this will be very telling for our most important interpretive labor in determining the "positive absence" of harmonics in this passage.

Socrates next (587c5–d1) deploys this fusion to define a series that links each of the regimes (taken here solely as "structures of rule in a soul," not a city) with the others, and also with its own proper pleasure, making it possible to compare them in "extent." This makes clear what was already implied just above: the principal justification of the separation-by-three is not the distance between the tyrant and the king (and the other regimes) in the list of regimes, but rather the way in which the tyrannical regime relates to the argument concerning the *being* of pleasure from earlier in Book 9. Specifically, the suggestion is that the forms of pleasure identified at the beginning of Book 9 are correlated with the proper pleasures of the king (true pleasures, in accord with *logos* and *nomos*), the oligarch (unnecessary, but not unnatural pleasures), and the tyrant (the unnecessary and unnatural pleasures). These three pleasures, taken twice, map onto the five regimes not through a slight of hand or a "quick move," but through a sort of *anthyphairesis* where the timocrat is deficient from the king (in terms of true pleasure) according to the same difference by which he exceeds the oligarch. Then, by repetition, the democrat is deficient from the oligarch according to the same difference by which he exceeds the tyrant—in the same terms of true pleasure by which the oligarch was deficient with respect to the timocrat, who was in turn deficient from the king.

Thus, the tyrant would be third-wise, for the second time, deficient from the king in true pleasure. The placement "third from the other" is proper to the pleasure that in turn is proper to the tyrant. It is by means of this correlation that we are going to be able to carry out a quantitative analysis of the extent of the gap between the pleasure that the tyrant's soul experiences and that experienced by the just soul.[36]

Having placed the two keys terms (tyrant and king) in their proper positions, Socrates expressly relates the calculation of the extent between the tyrant and the king in how *pleasantly* they live their lives to the first

four of the five mathematical arts in Book 7, beginning with what is called there (*Resp.* 7. 522c3) "the lowly business of separating out the one, the two, and the three,"[37] namely *number and calculation*, where Socrates says (587d2–3), "The oligarchic man, in his turn, is third from the kingly, if we count the aristocratic and kingly as the same. [. . .] Therefore, a tyrant is thus removed from true pleasure by a number that is three times three." As noted above, Reeve (2004) accuses Socrates of making two "fast moves" here—counting the oligarch twice and making this a multiplication problem—but if we pay careful attention to the way in which the problem of *how many times* more pleasantly one member of the series lives than another is calculated, we can see that Socrates could have *not* counted the king and aristocrat as the same if he had wanted to (thus getting to six terms that way), and also that the operation should well be multiplication, as the demarcation is by means of the three kinds of pleasure, which are different in kind. Since multiplication creates magnitudes that are different in kind (a one-dimensional line becomes a two-dimensional figure), it makes sense to multiply three by three, treating it as Socrates (587d4) does when he relates calculation with *geometry*: "[T]he phantom of tyrannic pleasure would, on the basis of the number of its length, be a plane."

Note again, and this is crucial, that it is the tyrant's phantom of pleasure, *figured as a length and then taken with respect to its number of units*, that is a plane number. We do not compare the tyrant to the king, or the tyrannical regime to the aristocratic regime; rather, our first measurement is of the pleasure itself that is proper to the human being whose soul is ruled as a tyranny. Only by means of this measurement does this exercise become possible and does the number "729 come to light. This, we believe, saves the passage from the excessive skepticism that has been expressed about its seriousness.[38] This passage is often read as though Socrates simply says, look, there are five regimes, let's list them, count the oligarch twice, and then make believe we ended up with the cube of the square of three because there are three steps from tyrant to oligarch and three steps from oligarch to king/aristocrat. If this were so, then, yes, it would be wrongheaded to try to take this too seriously.[39] But, in fact, Plato has Socrates say something far more worthy of consideration; he suggests that it really is possible to *quantitatively* measure the actual, physical distance between the *quality* of a tyrant's soul and that of the just person in units of "true pleasure."[40] This may or may not be true, and Plato may or may not have been willing to "go to the mat" for this idea (to keep with his wrestling analogy), but surely this is no joke. As Adam (1902) so judiciously puts it: "There is of course an element of playfulness in the episode, and we need not suppose that Plato set any particular store by

his calculations: but neither ought we on the other hand to dismiss the whole reckoning as a meaningless and foolish jest." Remarkable, then, that for a century and more since Adam's claim, and also despite the fact that Jowett (1894) is fairly sanguine about the seriousness of the number 729,[41] many English-language readings of Plato have nevertheless dismissed this passage in just the way they advise against and have even gone so far as to consider it a "continental" or "German" idiosyncrasy to do otherwise.

The project of physicalizing this abstract measurement of the qualitative condition in the tyrant's soul (with respect to true pleasure) comes to fruition with the move to the next of the arts from Book 7, namely *solid geometry*, as Socrates (587d5–e1) suggests: "If one turns it around and says how far the king is removed from the tyrant in truth of pleasure, he will find at the end of the multiplication that he lives 729 times more pleasantly." The account is moving fast here, but let us pause to notice two things: (1) one now needs to "turn it around [μεταστρέψας]" to measure (2) the distance between the king and the tyrant "*in truth of pleasure* [ἀληθείᾳ ἡδονῆς]." We must mark the "turning around" because this is how we can actually produce a solid number. That is, according to the canon of geometrical construction that was solidifying at the time Plato composed the dialogue, but that did not yet exist at the time of the dramatic date of dialogue, we must translate the surface in a direction perpendicular to it out to a distance equal to one of the sides, "turning it around" on its side.[42] In this case, the procedure is used to generate the cube of nine, and thus get to 729.[43] Secondly, we must mark "in truth of pleasure" here because, again, Socrates is *not* saying: (1) king, [timocrat,] oligarch = 3; oligarch, [democrat,] tyrant = 3; therefore the difference of extent between tyrant and king = 3 * 3. (2) 3 * 3 in cube = 729. Therefore (3) the king is 729 times the tyrant. No: the whole measurement is carried out with respect to "the truth of pleasure." To get where we are now, we begin by measuring how far the tyrant's phantom of pleasure is from the truth of pleasure, (perhaps) through this repeated procedure of measuring the deficiency in "truth of pleasure" by means of correlating the three forms of pleasure from the beginning of Book 9 with the longer story of the degeneration of *Kallipolis* told throughout Books 8 and 9. Then we take this result and combine it with the distance between his position in the series and that of the king, and this allows us to express the result as a plane number. This result, combining (by multiplication) the factor of the pleasure with the factor of the position in the series, is then rotated, and in this way generates a cube. This cube is measured, in terms of the original unit relative to the tyrant with respect to "pleasure in truth," by the number 729. If this is a joke, it is a very intelligent one

indeed. For seeing that, in truth, there are no "fast moves" in the passage after all, where are we left in terms of its positive contribution? If we bear in mind that other dialogues (principally *Philebus* and *Protagoras*) and also Aristotle's *Nicomachean Ethics* (7.11–14, but also 1.4–5 and 10.1–5) are centrally concerned with pleasure as an object of metaphysical analysis that can or cannot be quantified, the sober response to the passage must be to take it with real seriousness, even as we accept that the seriousness is being introduced playfully.

The number 729 acquires a still greater seriousness when the number is now given its worldly vindication, as we come to the fourth of the five arts, *astronomy*. It is important that Socrates bring this one forth alone in response to a substantial statement from Glaucon (587e2): "You've poured forth an unworkable [ἀμήχανον] calculation of the difference between the two men—the just and the unjust—in pleasure and pain." It is remarkable, we suggest, that the claim concerning the truth and the appropriateness of the number 729 is not a simple assertion by Socrates (as the account until now has been) but rather a response to Glaucon's own skepticism. This is best understood as Plato writing the skepticism of his later commentators and interpreters into the text, owning the implausibility that the quantitative comparison (an "unworkable [ἀμήχανον]" calculation) is in earnest, and answering as decisively as possible, in Socrates's voice, that the measurement is in earnest. Indeed, what Socrates (588a1–2) says next is very emphatic. He responds to Glaucon's incredulousness by "doubling down" on the results of the calculation to say "And yet the number is true, and appropriate to lives too, if days and nights and months and years are appropriate to them." As is well established,[44] "days and nights" refers to the solar year as calculated by Philolaus, which consisted of 364.5 days (and, in Socrates's reckoning here 364.5 nights as well), hence 729 "days and nights," while the "months" seems to be a reference to the same thinker's "Great Year," which consisted of 729 months, and the "years" might[45] be a reference to a year of years, or it might belong with "months," in which case "months and years" is a single reference to the Great Year of 729 months.[46]

Having reached this point, the passage closes without the reference to harmonics that we ought to have expected from it. This is a problem worth solving for two main reasons: (1) the passage has clearly followed the curriculum of the education in the arts detailed in Book 7, and so "leaving out" the last and highest of the disciplines seems noteworthy; (2) there is a clear relevance of the number 729 for the missing art—harmonics—specifically in the way that art was practiced by its most recent influential representative, Philolaus, whose work was directly cited in the

passage about the fourth of the five arts. So why not end the passage with an express reference to 729's relevance for harmonics? Why end with the number's appropriateness for days and nights and months and years? Our answer, pointing to the decisive advance of dialectic beyond the limits of mathematics, is that the final "purpose" of the number 729 is to point *not* to the possibility for the one who masters advanced mathematical analysis to place the irrational once and for all within the limits of reason but rather, precisely, to the *impossibility* of such a quantifiable solution to the stubborn irrationality of physical reality. In this way, the 729 times more pleasant passage comes to light as the antistrophe (the counterpoint) of the "nuptial number" (545c), which also points to the failure of even the most perfect mastery of mathematical knowledge to bring nature under the reign of reason.

The Unspoken Resonance of 729 for Philolaus

How do we begin to hear the unspoken resonance of the number 729 for harmonics, the fifth of the five arts that Socrates specifies as the training the "most precise guardians" (the philosopher-kings) must receive prior to their mastery of dialectic? We can begin by stating the unstated relevance of 729 in the fifth art, harmonics. The "appropriateness" of the number 729 emerges directly from the conclusion of Fragment 6A from Philolaus's *On Nature*, which Plato has Timaeus quote more or less exactly in his story of the founding of the cosmos (at 35b–36c[47]). Philolaus claims that the musical scale, the "*harmonia*" (fitting together) amounts to "five 9:8 ratios (tones) and two *dieses* [or *leimmata*, almost semitones]," where the "magnitude of the *harmonia* is the fourth (*syllaba* [or *diatessaron*]) and fifth (*di' oxeian* [or *diapente*])," and the "fifth is three 9:8 ratios and a *diesis*, the fourth two 9:8 ratios and a *diesis*." This means that the whole musical scale can be denominated in terms of the whole tone and the "*diesis*" (nearly a semitone), as the product of specific values for each of the fourth (4:3 [or $2^2:3^1$]) and the fifth (3:2), that is as powers of the ratio 3:2. Here we can see the relevance of the number 729 for the particular version of harmonics that is a "positive absence" in our passage. Namely, it is the first of the four terms out of which the *harmonia* is composed: "three 9:8 ratios" is the ratio 729:512 (9:8),[3] or in its most relevant formulation ($3^2:2^3$).[3] But, actually, we must stress that this ratio is at the heart of how Philolaus shows the cosmic harmony can *almost* be so expressed. The *harmonia* cannot actually be fully expressed in terms of the powers of the ratio 3:2, for the powers of three and the powers of two never quite line up; no matter how far you expand them in power, there will always

be a remainder. It is impossible, in fact, to close this gap—which means that it is impossible to divide an octave, or any sequence of octaves, into equal intervals (such as into fifths [3:2] or whole tones [$3^2:2^2$])—and this is what points to the problem of the irrational. The two *dieses* in Philolaus's scale are not quite full semitones, and thus do not add up to another whole tone (that is, to the interval that defines the rest of his scale), and the difference between two *dieses* and the whole tone is what came to be known as the Pythagorean *comma*. That irreducible remainder—giving rise to small intervals such as the *comma*, and (much) later to the Wolf Interval, but never theoretically resolved—would eventually give rise to equal temperament some two millennia later.[48] But the phenomenon at the center of the debate concerning the (in)divisibility of the octave into equal intervals, and in consequence the (im)possibility of halving the whole tone that lies between two tetrachords in the octave, at the heart of the work on harmonics in the time between Philolaus and Archytas[49] is, on our reading, the object of the passage: to remind us that objects of sense stubbornly resist the attempt to bring them into rational understanding (into *ratio*, into *logos*). In the language we shall use in chapter 6 to describe the way in which the refinements of the Parthenon are ontological, rather than optical, in their orientation, the silent reference to Philolaus's scale is aimed at stressing the ultimate impossibility of true *symmetria* in the world of sense, for the sake of pointing us toward a dialectical *harmonia*. It is a way of making good on the idea that mathematics must remain (no more than) a prelude to dialectic's song.

Remaining with the ratio 729:512, we would like to re-emphasize the most fundamental aspect of Plato's reception of Philolaus's integration of number theory and harmonics. Again, the ratio 729:512 is not only directly related to the possibility of halving the octave, and by consequence of halving the whole tone as stressed just above, but also to the broader issue of the relation of the rational and the irrational. To see this, build three consecutive rising whole tones (articulated as the interval 9:8), in the manner Philolaus suggests. You will produce 729:512 (or, $3^6:2^9$, which is to say $[3^2:2^3]^3$)—containing the number exactly as it is constructed—as $(3^2)^3$—in *Resp.*, 9. 587b–588a. This would be approximately equivalent to what, in modern equal temperament, is the tritone, which is exactly half the octave (and splits the middle whole tone of Pythagorean tuning). This precise halving, though, is a result of the irrational numbers out of which the ratios representing the tone in equal temperament are built (i.e., each semitone as the $\sqrt[12]{2}$). Such irrationality is ruled out by the commitments, ontological rather than formal, of the theorists who built the scale with which Plato is working here. While three whole-tone intervals

in succession would thus not represent a precise halving of the octave, it remains the case that the whole number ratio produced thereby (729:512) is an excellent approximation of $\sqrt{2} : 1$, the paradigmatic expression of incommensurability and the persistence of irrationality in number, within a margin of error of just above one half of one percent. What better way to show that mathematical operations, however advanced, will never alone display the rational wholeness that only the dialectical understanding of the good could possibly offer? This, we suggest, is the meaning of the "positive absence" of harmonics in the 729 passage.

Even if one agrees that this relevance of 729 for harmonics was known to Plato and on his mind in his reception of Philolaus's *hamornia*, though, it is far from self-evident why it would be better to suppress this, rather than simply stating it directly. Looking at what does, in fact, immediately follow the reference to Philolaus's work in astronomy and the "truth" and "appropriateness" of the number 729 can help us understand why a positive absence here could communicate the point about the ineluctable irrationality at the heart of the world of sense more fully than a direct statement. And what does follow is the "image of the soul in speech" (*Resp.* 9.588c–e), which is made—molded actually—out of, first, a "many-colored, many-headed-beast that has a ring of heads of tame and savage beasts and can change them and make them all grow from itself," then "another single *idea* of a lion," and "a single one for a human being." This is, of course, an echo of the tripartite soul from *Republic* 4, but with a crucial difference: while the soul of Book 4 is said to have three parts that have to be arranged in a harmony, here these three molds are actually molded together so that "they grow naturally together and with each other." Moreover, "in some way" growing together naturally, they also come to appear like "one animal, a human being."

Making sense of this "image of the soul in speech" with its naturalistic "growing" as *an appearance* of an organic unity, requires us to continue on to the end of Book 9, where this image yields to a "pattern." Specifically, a pattern laid up in heaven (592b1) that can be the basis for a "city within himself" that the just person founds in accordance with "the regime within him" (591e1). Recalling how this "pattern" is introduced— "He will always be seen adjusting the body's harmony for the sake of the accord in the soul" (591d1–2)—we follow Burnyeat (2001: 78–81), who suggests that the reference to the preparatory studies (of *Resp.* 7) in 587b–588a is meant to issue in the image, or pattern (paradigm) actually, of the harmonization of body and soul. Such a reading understands the brief remainder of *Resp.* 9 that follows the "729 times" passage as actually offering the unspoken place of harmony therein. The "image of the soul

in speech," that is, is the kind of object (i.e., a dialectical object) one takes up in harmony as Plato would have it practiced.

In making this suggestion, we pick up on Jowett's (1894) contention that it is crucial that Plato "characteristically designates" the number 729 as "nearly equivalent" to the number of days and nights in the year. In stressing this "nearness," Jowett suggests that Plato is emphasizing the "near, but not quite" nature of *any* attempt to quantify human experience, which ultimately remains outside the reach of the arts, accessible only to dialectic. Plato, continues Jowett, is "desirous of proclaiming that the interval between them is immeasurable, and invents a formula to give expression to his idea."[50] This, we believe, is why he wants us to hear the irrationality at the heart of 729's relevance for harmonics, while leaving his text silent on the matter in its letter. Plato performs the content here. We are to become aware of a gap between math and the world of sense. He expresses that gap with a gap. But the condition under which we can hear and appreciate the absence as an absence is the condition of someone who had advanced a certain way down a road of mathematics. Without this advancement, the best we can do is find the passage to be a fairly meaningless joke. Those who do so also "hear almost nothing" in 729; but they don't hear "the nothing that is," to quote Wallace Stevens.[51]

We have suggested that the 729-times-more-pleasant passage be read as a statement on the need to embrace mathematical precision to every possible extent, but also to remain clear that such technical sophistication will never attain to the highest truth, as this truth, the form of the good, is accessible only to dialectic. Let us now test this account of the relationship between dialectic and mathematics with reference to the two master passages on this subject: the world-construction according to Timaeus in the dialogue that bears his name (chapter 2) and the account of the mathematical arts in *Resp.* 7 (chapter 3).

Chapter 2

Dialectic and the Mathematical Arts in *Timaeus* (35b–36c)

Philolaus's Scale in the Construction of the World-Soul

Our interpretation of the 729-times-more-pleasant argument concerning the work of justice and injustice in the soul that possesses one or the other (*Resp.* 587b–588a) requires us to believe that Plato, at least sometimes or at least here, has the interlocutors present views other than by expressly stating them. We thus have a significant burden to show that Plato really does intend to make the musical scale of Philolaus, in which 729 shows up prominently, the true central object of his concern. Fortunately for us, Philolaus's scale has a place of great honor in *Timaeus*. Here, Plato has Timaeus offer this scale (in virtually precisely the same words and manner as we have it recorded in the surviving fragments of Philolaus) as the means by which the world is constructed. This is the focus of the current chapter. In chapter 3, we bring this reading of the relationship between Plato's dialectic and Timaeus's (which is to say, Philolaus's) art into conversation with the account of the arts and dialectic in *Resp.* 7, and then relate our argument about the presence and the purpose of the "positive absence" of harmony in the 729-times passage and the positive presence of same in *Tim.* to the inner-Academic debates concerning the ontological status of mathematical objects, so as to understand how the presentation of dialectic and the arts in *Resp.* and *Tim.* dramatically represents Plato's vision of a liberal education that embraces but outpaces education in the mathematical arts.

1. Our Interpretive Principles as Applied to Timaeus

Our reading of the "729-times-more-pleasant" argument (*Resp.* 9.587b–588a) centers on the function of Philolaus's musical scale that is only implicit in

that passage. Thus, we here address how this scale is presented when Plato explicitly places it in the mouth of his Timaeus, a fictional Pythagorean. We will find that fully appreciating Plato's reception of Philolaus's construction of the scale entails taking account of both his own appreciation of the Pythagorean interdisciplinary insight into the implications of number theory for harmonics and also his ultimate skepticism that a mathematical approach such as this will ever arrive at the highest truths. Our answer to the opening questions about "Plato and the mathematicians" are: he was in fact *both* seriously exercised by the advanced mathematics of his time, being especially impressed by the beliefs and the methods of Pythagoreans such as Philolaus, *and* ultimately unconvinced that a project like theirs can ever succeed. To establish this, we must come to terms with the Timaeus who speaks of a cosmology that cannot in fact be Plato's own view of the way the form of the good is manifest in the cosmos. We aim to do this through a reading of the "first founding" (*Tim.* 35b–36c), read together with the preceding account of the 729-times-more-pleasant passage, and the account of the relationship between mathematics and dialectic in *Resp.* 7 discussed in chapter 3.

Three interrelated claims about the dialogue as a whole must hold to establish our reading of the how and why Plato has Timaeus present Philolaus's musical scale in relating how the world-soul was constructed.

(1) *The "leaving things out" principle is crucial for understanding* <u>Timaeus</u> It should not be too difficult to persuade a reader of *Tim.* that the idea that "something is missing" is not merely relevant to the interpretation of *Tim.*, but is actually essential to it. After all, the dialogue as a whole begins with the fact that something—namely, someone but also someone unnamed—is missing. In fact, even the way the missing someone is made present by the first sentence alludes to the metaphysical depth of the problem of absence and presence, and the feature of "positive absence" we have argued is integral to the true intent of the 729-times-more-pleasant passage. For, the dialogue begins (17a1) thus: "One, two, three, but where is the fourth [Εἷς, δύο, τρεῖς· ὁ δὲ δὴ τέταρτος . . . ποῦ]?" As Kalkavage (2001: 40–41) points out, Socrates's phrasing here—playing on the difference between the cardinal numbers one, two, three, and the ordinal number, fourth—hints at the same gap that haunts the last sentence of the dialogue (92c2–5).[1] That is, here at the beginning of the dialogue, we already meet the gap between the cosmos as a whole (or all), and its being an *ordered* whole: to be a world in the true sense for the dialogue is both to be *full* (represented by the cardinal numbers one, two, three) and to be *in order* (the ordinal number, fourth). Indeed, here, right from the beginning, this fullness and this order are threatened by the positive

absence of he who should come fourth. Following Nikulin (2012b: 314), we want to suggest that this opening refers to Plato's mathematical ontology, in that "the first four numbers might be translated into geometric objects," specifically objects that establish the dimensions of material existence, in this way "putting everything in its place" within the cosmic order: one being the point, two the line, three the plane, and four the solid. The missing fourth here thus points to something that is missing in the ordering of the fullness of becoming in the physical world in its three-dimensionality and its solidity, its trustworthiness. In this way, the present absence of the fourth undermines the series of the first *tetraktys* (foursome) of cardinal numbers and disrupts the ordering named by means of the ordinal fourth. Further, it introduces the theme of positive absence as both an ontological (cosmological) and an ethical problem. According to Nikulin (2012b: 314 and n31), Speusippus explicitly avows such a view and Aristotle's critique of Plato in *Metaphysics* A.9 suggests that it might well have been a view Plato advanced in inner-Academic debates.[2] This resonates perfectly with the dialogue's conclusion, where we get "hung up on" the rift between the whole or all that Timaeus hopes to have shown is full and in which each thing is (as represented by the cardinal numbers one, two, three) and the series or order of things, in which there is a clear hierarchy (represented by the ordinal number fourth), whose nature is apparently known to the interlocutors but not to us, and who in any case is an unnamable positive absence.

This persistent doubleness—this fullness of the cosmos with respect to its constituent elements, but its inability to display that fullness in the proper order—pervades the dialogue. We can see this, as Sallis (1999: 1–3) stresses in his reading, in the fact that the cosmos is actually founded twice, in fundamentally contradictory ways. This doubling and doubling-back of the dialogue carries forth from its inception and right through each major step forward: the double-image of *Resp.* from which the project of the dialogue emanates (19a–c); the "first founding" of the cosmos from same, difference, and being (27c–47e); the "second founding" of the cosmos out of necessity and space (47e–69b); the constitution of the human and its well-being and disorder (69b–92c). All this makes the dialogue very strange. What makes this strangeness significant, especially this reliance on a present absence to drive the narrative and argumentative development of the dialogue?

To answer this, we must proceed a bit further into the "prologue" of the dialogue, to the second crucial moment where something is crucially left out, something that, not accidently, coincides precisely with what is left out in *Resp.* (6.509c).[3] We should, that is, have something to say about

the fact that Timaeus answers with an emphatic, "Not at all [Οὐδαμῶς]" when Socrates (19b) asks if "we are still yearning for something further in what was said [in *Resp.*]," something "that's being left out." This requires consideration because, as Kalkavage (2001: 49n1) and others note, a great deal—including many of what are surely considered the most important things, such as the ordering of the soul, the need for the philosopher-kings, the education of the philosopher-kings, and the relationship between dialectic and mathematics, among others—has in fact been left out of the account of Kallipolis in its retelling. Reflecting in particular on the most relevant part of *Resp.* that is being left out with respect to what we saw left out in that very part of *Resp.*—the relationship of dialectic and mathematics in Books 5–7—we can see that what Timaeus is exactly missing is the fact (asserted only in the part thus left out) that only a dialectical inquiry is truly capable of bringing us in touch with the truth. For this reason, as Kalkavage (2001: 9) notes, Socrates's "professed desire seems not to be directed at truth," for his goal, like that of Timaeus, "is beautification rather than truth-telling or truth-seeking."[4]

(2) *Correctly understanding the relevance of "leaving things out" in* Timaeus *entails attending to its (a) characterization and (b) mode of argumentation.* (a) Just as there is something strange about the characterization of *Resp.* that is allowed to stand in for the dialogue, *Tim.* also begins with a strange characterization of those who are willing to work with this shadow of the real thing. Taking our cue from this intriguing and troubling beginning, we must note how Socrates himself is characterized as though he were "someone who gazed upon beautiful animals somewhere, either produced by the art of painting or truly living but keeping their peace" and then overcome by a desire to "gaze upon them moving and contending in some struggle" (*Tim.*, 19b3–5). Bearing in mind the obvious reference to the treatment of mimesis and the presence of the forms in *Resp.* 10, the striking identification of an animal with its image in a painting here seems to underscore that even Socrates is not his dialectical self in this conversation. And if Socrates is not really interested in a disinterested pursuit of the truth (in and through the forms), this is even truer for his interlocutors. Timaeus, in particular, is presented to us in two respects. First, he is presented as someone who has been very successful at getting the greatest positions and honors (τὰς μεγίστας μὲν ἀρχάς τε καὶ τιμὰς) in his home city of Locri,[5] which itself is notable for having good laws and being in Italy (εὐνομωτάτης ὢν πόλεως τῆς ἐν Ἰταλίᾳ Λοκρίδος). Indeed, his very name itself seems to point to worldliness and success. Second, Timaeus is introduced as someone who has "*in my opinion*, reached the very peak of all philosophy [φιλοσοφίας δ' αὖ κατ' ἐμὴν δόξαν ἐπ'

ἄκρον ἁπάσης ἐλήλυθεν]" (*Tim.*, 20a1–4; emphasis ours). Combining these two features in one person is to combine the philosopher and the statesman, which Plato perhaps suggests is the goal of the Pythagoreans, who the stress on Italy is surely meant to reference. Is the Pythagorean, then, Plato's ideal of the philosopher, or is he the manifestation of the mathematical moment, a crucial site of insight into the nature of things, but one ultimately limited by its use of hypotheses and its willingness to proceed through the proclamation of opinion?

We believe that the critical point here is not the actual characterization "the very peak of all philosophy" and what Socrates means by casting Timaeus in this light. Rather, the key is that this characterization has been introduced *as an opinion*. Here we must recall the thoroughgoing treatment of opinion as opposed to knowledge, and the role of dialectic in achieving the latter in *Resp.* 5–7, and that this has been exactly left out of the recapitulation of *Resp.* from which we set out to search for the sources of becoming in *Tim.* Remembering both these facts, and concerning one's reading of Timaeus as the philosopher-and-statesman par excellence, we must now answer: Is Timaeus Plato's spokesman? And thus we must also decide whether Timaeus's "likely story" contains "Plato's cosmology" or not. We turn now to Plato's complex argumentative strategy in this dialogue that is almost a monologue, hoping to show why we believe the Pythagorean cannot be the true philosopher, just as *Resp.*'s philosopher-king cannot be. This is so, we argue, because both figures remain in the realm of mathematical philosophy, which will always only be the prelude to the song of dialectic.

Having this sensitivity to the characterization of Socrates and his interlocutors at the outset of the dialogue points directly to the crucial way in which this dialogue's (b) mode of argumentation is salient, that is, the absence of dialectic as the way the insights unfold, replaced with a series of pronounced opinions, a bunch of *dogma*. Precisely because Socrates (knowingly) and Timaeus (knowingly or otherwise) are "leaving out" precisely the dialectical pursuit of truth that is at least approximated in *Resp.*, as Kalkavage (2001: 10) notes, there is in the dialogue only "the repeated emphasis on the *pronouncement* of opinion," but no true dialogue, no "joint inquiry or direct *testing* of opinion." Here we see the crucial link between dialogue ("joint inquiry") and dialectic ("direct testing"), the heart of what Nikulin (2010) wants to stress about the relationship between dialectic and mathematics, about which more will be said in chapter 3. For this reason, as Kalkavage (2001: 11) also argues, "The desire of Socrates in the *Timaeus* signals the descent from the quest for eternal truth in the *Republic* to the preoccupation with Becoming." As it is

expressly concerned with becoming and not with being, then, the "likely story" of Timaeus cannot embrace the ultimate truth of things. For this reason, it can be methodologically permissible for the dialogue to proceed as opinion-making and not as dialectic. As Kalkavage (2001: 42) suggests, this is not done without reason, and it does not mean that the likely story is not seriously meant for consideration; the point, though, is that it is not meant to disclose the truth of the cosmos, but rather to situate one such story in a precisely political context so as to reflect "on what happens when the love of wisdom is replaced by what might be called *the will to order.*" That is, by satisfying himself with the proclamation of opinion, Timaeus makes it possible to tell a "likely story" about how the cosmos is both full and in order. But for the same reason, in excluding dialectic and replacing truth (the form of the good) with order as the highest orienting norm, both Timaeus and the dialogue named after him cannot pretend to disclose the very truth, but rather only a "likely story."

To conclude with the broad interpretive claims: If (1) leaving things out is integral to the basic orientation of the dialogue, and (2) specifically, dialectic and its treatment in *Resp.* is "the thing left out" that represents the central positive absence in *Tim.*, then it follows that (3) Timaeus's "likely story" is not "Plato's Cosmology." Put starkly: precisely because it is only a "likely story," and thus not subject to nor presented within the dialectical method, Timaeus cannot be taken to express Plato's views. Rather than presenting the truth of the physical world, Timaeus's account of creation must be read, as Kalkavage (2001: 152) argues, as "a sort of parable for statesmen who in their noble attempt to harmonize human nature in the context of political life, must constantly deal with that nature's recalcitrance to perfect order—the refusal of human nature to *stay in tune* with the *nomos* that is both law and song."

This bivalence of *nomos* is especially appropriate for understanding the valence of Timaeus's speech for Plato. Since Timaeus, in this view, shows how a *conventional* cosmos looks, his account is a "noble attempt" to fuse human institutions and natural phenomena, but it is not "Plato's cosmology." For, as Kalkavage (2001: 23) stresses, "*nomos* as song combines beautifully with *nomos* as law or custom," and it cannot be an accident that *Resp.* 7.531e–532a twice refers to the "song [*nomos*] of dialectic," in the same way that the whole cosmos, and the regular solids, are harmonized and dance and sing together in *Tim.* Plato wants us to reflect on the interrelation of cosmology and politics, between a cosmic *nomos* and our human *nomos*. The cosmic *nomos* might be understood, as in *Timaeus*, as a harmony of same, other, and being or, as in the *Republic*, as a pattern in heaven, that could always be—if we are ready to accept it

as such—our human *nomos* (a law, that we make for ourselves, either in the "city within himself" (*Resp.* 9.592b) or in our "fatherland," as in the fitting-together of Timaeus's account of the cosmos with Critias's account of the Athenians [*Tim.* 26e–27d]).

In so reading, we follow Kalkavage (2001: 3), who argues that Taylor (1928) was "right after all" to argue that Timaeus does not speak for Plato and that *Timaeus* does not announce "Plato's Cosmology." This despite the fact that the dialogue has generally been read as "a poetic presentation of Plato's teaching," all the more so after Cornford (1937) succeeded in persuading generations of especially English-speaking interpreters that this is so. Remarkably learned and insightful among such readings are recent monographs by Broadie (2011), Gregory (2000), and Johansen (2004). For all their erudition, however, if we read the dialogue to learn its opinions and without questioning the role of the positive absence of dialectic for the status of those opinions in Plato's thought, we emerge with a distorted view of Plato's vision of the relation of dialectic and mathematical philosophy.

Take, for instance, the question concerning to what extent it is possible to argue that Plato is or is not a scientific realist. Gregory (2000) wishes to show that he is; Johansen (2003, 2004) wishes to show otherwise. The debate, though, proceeds within the attitude so concisely put by Broadie (2011: 7) as "accepting at face value the account Plato has given." Our view is that precisely if we want to understand Plato as a natural philosopher *and* as a philosopher of science, we need to take better account of the dramatic context to see what attitude he wants his readers to take with respect to Timaeus's account. In this light, we believe, the debate about Plato and realism begins to become both clearer and closer to Plato's mindset. That is, the view is that a Timaeus-like attempt to find the cosmic order in opinions about nature expressed mathematically is where we begin, rather than complete, our approach to the investigation of the forms in the physical world. Timaeus's likely story does not approximate the truth; rather, precisely the way in which it is incapable of presenting the whole truth, settling only for a likely story, is meant to point us to the need for dialectic. We attempt to show what results from reading Plato's treatment of one crucial such opinion—the role of Philolaus's scale in the constitution of the world-soul in 35b–36c.[6]

2. Dialectic and the Debt to Philolaus

We begin by noticing how the construction of the world soul proceeds from two interesting instances of the basic Pythagorean *tetraktys* (foursome)

of numbers. This context is surely crucial for understanding the strangeness of the opening of the dialogue. These sets each begin from the unit, and then continue with (in set 1) the smallest even number, its square, and its cube, and (in set 2) the smallest odd number, its square, and its cube. In all, we have: 1, 2, 4, 8 and 1, 3, 9, 27. We then mix these two together, and we have the unit, the smallest even number, the smallest odd number, the smallest even square, the smallest odd square, the smallest even cube, and the smallest odd cube (or expressed numerically, 1, 2, 3, 4, 9, 8, 27). We must first note that they are presented in the order of their appearance with respect to crucial issues in mathematical ontology: first, of course, the unit, and then the even and the odd, and then that even and odd in square, and then the even and odd in cube. This means that nine comes before eight in the series, because we are generating them by their properties and not listing them with respect to their magnitude. We see this in how Timaeus's god composes them (35b1–c1):

> And having made a unity of the three [difference, same, being], again he divided this whole into as many parts as was fitting, each part being a blend of sameness, difference, and being. And he began the division in this way. First he took one portion (1) from the whole, and next a portion double this (2); the third half again as much as the second, and three times the first (3); the fourth double of the second (4); the fifth three times the third (9); the sixth eight times the first (8); and the seventh twenty-seven times the first (27).

Here we must note how the series is presented in such a way that each member of the series is referred back to the first item in the series, in a way that echoes the procedure in *Resp.* 9.587b–588a, and that we are working with the same quantities that Philolaus used to build the scale in Fragment 6/6a.

The debt to Philolaus is only clearer as Timaeus (35c1–36a4) continues:

> Next, he went on to fill up both the double and the triple intervals, cutting off yet more parts from the original mixture and placing them between the terms, so that within each interval there were two means, the one (harmonic) exceeding the one extreme and being exceeded by the other by the same remainder of the extremes, the other (arithmetic) exceeding the one extreme by the same number whereby it was exceeded

by the other. These links gave rise to intervals of 3:2, 4:3, and 9:8 within the original intervals.

The last sentence, placing each of the main musical elements (fifth, fourth, whole tone) within the octave, and (almost) denominated in tones, exactly replicates the relevant last sentence of the Philolaus fragment. As he continues, Timaeus explicitly—"This remaining interval of the remainder had its terms in the numerical proportion 256:243.[7] By this time the mixture from which he was cutting off these portions was all used up" (36a4–b1)—points directly to the "tiny remainder" known as the *leimma* (or *diesis* in the Philolaus fragment), and that gives rise, by extension, to the "Pythagorean *comma*" (see our discussion below), another of the small remainders that will always persist as one attempts to build a scale out of the small whole number ratios.

But there is more. By casting the passage in terms of the "three means," Plato has Timaeus clarify just how harmonics "crowns" the five mathematical arts of *Resp.* 7. Namely, our original lengths (31c–32a) were given using the geometrical mean, which is the "mean proportional," the magnitude bearing to the smaller of two given magnitudes the same ratio as the larger of the two bears to it (e.g., 4 is the geometric mean between 2 and 8). Now, in the construction of the scale, working with our original lengths given by the geometric mean, we use the harmonic mean to get the perfect fourth (4:3, reduced from 8:6, where we had two string lengths of 6 and 12 and took their harmonic mean), and we use the arithmetical mean to get the perfect fifth (3:2). To see it all at once: start with two lengths, the double of a unit and the unit itself, 2 and 1. Now, taking equimultiples to get 12:6, find the harmonic mean: 12:8::8:6. Reduce 8:6 to smallest terms and you have the perfect fourth (4:3). Now find the arithmetic mean of the same interval, which also produces a whole number as arithmetic mean, namely 9, since 9 is 3 less than 12 and 3 more than 6. Reduce 9:6 to smallest terms and you have the perfect fifth (3:2). The interval between the arithmetic and harmonic means thus obtained, 9:8, gives the whole tone. Here we have the octave (2:1), the fourth (4:3), the fifth (3:2), and the whole tone (9:8), all produced from two lengths and the application of each of the three means. Thus, we have used the operations of arithmetic, geometry, and harmonics. In this way, the art of harmonics—with which Timaeus has reached the very peak of philosophy—unites all the other arts, including astronomy (once this musical scale is used to describe the movement of the heavenly spheres as the likely story continues).

Plato here has Timaeus return to Philolaus's problem and try again to bring order into the cosmic *harmonia*. But does he do so to present his view of how things really are, to persuade us to believe that this is the constitution of the cosmos and the principle of its self-organization and its motion? It would take a book to argue one way or the other, and there have been a series of such works in just the past two decades that have argued each way. In so doing, they continue a debate that remains unresolved, for our reading, as when Taylor (1928) answered this question "no" and Cornford (1937) "yes." We agree with Taylor, but as we cannot try to independently substantiate this in the space allowed here, let us here briefly point to why we believe that the broader interpretative claims (1–3) with which we began this section corroborate our reading of "Plato's reception of Philolaus's musical scale."

We begin by noting that, as Heller-Roazen (2011: 33–37) shows, this passage must be read as Plato's way of responding to the magnitude-vs.-multitude debate, already long-ranging in harmonics by Plato's time. The details of this debate (dating from perhaps the sixth century through the work of Plato's contemporary and friend Archytas) are discussed in chapters 1 and 3, but the crucial outline that is relevant here involves four key interventions. First, if Boethius can be believed, Philolaus approximates the halving of the octave with the ratio 729:512 (so crucial for our reading of *Resp.* 9.587b–588a). Then, Archytas codifies the "Pythagorean" refusal to divide the whole tone, a consequence of their refusal to divide the octave (see chapter 1, section 2). Third, Aristoxenus (who was or was not a Pythagorean, depending on who you ask[8]) denies Archytas and defines the tetrachord in terms of "two and one half tones." Finally, the Pythagorean reply to Aristoxenus is the birth of the *comma*. First, rather than speaking of the division of the tetrachord with "two and one half tones," you compare the tone to the composition (256:243), the *leimma*, and then you get the *apotome* (2187:2048). Then compare this apotome to the *leimma* and get the *comma* (531,441:524,288). This is the context within which Plato has Timaeus weigh in. But is he doing so because he wants to argue *against* the splitting of the octave, and of the whole tone, or *for* splitting them against the necessary inclusion of that small remainder, the *comma*, at the heart of the scale? Or is he arguing against the attempt to integrate the musical scale into an account of the physical world altogether? Most abstractly: is or is not Plato making a comment here on the relationship between number and material, and if so, what kind of comment is he making?

The application of our interpretive principles helps here. Remembering that (1) leaving things out is integral to the "discursive space"

of the dialogue, and (2), specifically, there is no dialectical testing of the opinions that emerge, we see at once that this "beautiful compromise" Timaeus offers is just an opinion. As such, the whole of 35b–36c comes to light as the sort of practice of harmonics that seeks "the numbers in the heard accords and don't rise to problems, to the consideration of which numbers are concordant and which not, and why in each case" (*Resp.* 7.531c). In noticing this link between Timaeus's practice and the practice of the Pythagoreans that is expressly criticized in *Resp.* 7, we in part follow Mourelatos (1980), whose reading coincides with ours in placing the construction of the scale in *Tim.* of a piece with the discussion of harmony in *Resp.* 7. We differ, though, in that Mourelatos (1980: 51) holds that the main issue with the Pythagoreans in *Resp.* 7.531c is that they have not completed the "ascent to problems" because they have not yet "grasped that the aural concords of octaves, fifths, and fourths are aural manifestations, and merely approximate, of the purely mathematical propositions 2:1, 3:2, 4:3," and thus have not formulated "a mathematical rule or procedure that organises numerical proportions simply and coherently into some sort of series or system," which is what Plato himself "comes close to doing" in *Timaeus*. We, on the contrary, find that while Timaeus makes progress beyond the "actual Pythagorean practice" of Philolaus and others in his wake, he remains guilty of the charge of 531c, namely, he still hasn't really "ascended to the problems," for the truly theoretical problem is not accessible to mathematics at all, but can only be addressed by dialectic. So, Mourelatos (1980: 52) concludes that the correct kind of "why" question according to *Resp.* is exactly the kind of question that Timaeus is trying to answer in 35b–36c; that is, "Which of the pairs of small integers that ostensibly correspond to acoustic intervals have a certain intelligible relation one to another, and what common principle—the why question—applies as a generative rule to all number pairs that exhibit such a relation?" We, on the other hand, hold that this question itself is insufficiently deep, in that it takes the mathematical framework as competent to the task of solving the problem at stake, of telling us *why*.

Timaeus is, so to say, trying to make the math work, but he *suppresses*, to use a suitably political formulation, rather than *addresses*, the fundamental issue at stake here: the persistence of the irrational, as one encounters it in trying construct the musical scale, and the cause of that ineluctable irrationality. As Kalkavage (2001: 152) stresses, "The tuning of the scale functions as a technical paradigm for what it means to exercise good judgment or prudence in the establishment of a beautifully ordered whole." It is a "just so" story; its aim is not to pursue the truth (come what may), but rather to tell a story that allows us, or compels us,

to believe that the kingdom of God is full, and fully ordered. As such, Timaeus's scale "is haunted by what one might call the tragic necessity in the realm of tones," and must remain "not a complete victory but a beautiful compromise."[9] The word *compromise* is especially advised, and here we come back to our large interpretive claim (3): Timaeus does not and cannot offer "Plato's Cosmology," precisely because he is a statesman, a political actor who comes to the question of being and becoming with a political aim. Timaeus needs to bring the cosmos to order, and he will do so in his story, whether or not this brings him closer to the ultimate truth or not.

But is what is true of Timaeus the philosopher-statesman also true of his kin the philosopher-king of *Resp.*? This comparison returns us to the broadest questions of interpretive practice in reading Plato, especially with respect to the relationship between mathematics and dialectic. Sedley (2007: 270–71), for instance, argues that if not "for the dominant imagery of the cave," the "mathematical content" of the philosopher-kings' education "would have been seen to extend much further down the chain of transmission than the text of the *Republic* makes explicit." This, we believe, is quite true and we appreciate the stress on this point that the scientific-inclined interpreter is most likely to provide—all the more so given that Sedley (2007: 271) offers as an example that "an understanding of justice informed by a prior understanding of the Good would be far more technical and mathematical than the broad brush strokes of Book 4." As Sedley (2007: 271 n.23) adds in a footnote, the "only hint of this [more technical and mathematical understanding of justice] in *Resp.* is at 9.587b–e, the half-serious calculation that the just life is precisely 729 times pleasanter than the unjust."

Sedley here takes a step beyond the approaches to the importance of mathematical proportion for understanding what Plato has to say about justice and the education of the philosopher-kings offered by Ferrari (2000: xxix–xxxi, 2005: 59–65, 100–9) and Burnyeat (2001), who share the promise and the limitation analyzed here. His advance rests in the notice he gives to our "729-times-more-pleasant" passage here as the best place we could look for something like what Plato really wants his reader to believe concerning the role of the technical and the mathematical in the formation of the would-be dialectician, concerning, that is, what Mitchell Miller has been working out in a series of works[10] under the rubric of "the 'Longer Way.'" Sedley rightly recognizes that it is impossible to take Plato's flirtation with an endorsement of the mastery in 587b–e as wholly in earnest, just as (we have argued) we need to be careful in our interpretation of the claim that Timaeus has reached "the very peak of philosophy" at *Tim.*,

20a. However, the grain of salt needed here is not to see Plato's claim as "half-serious" (as Sedley has it), but rather to see both of these passages as Plato's very serious suggestion that one needs to immerse oneself very deeply in the fantasy of the "philosopher-as-master-of-all-things-technical-and-mathematical" precisely to reject that fantasy in order to become the "philosopher-as-dialectician," the philosopher as the one who knows precisely what it means to understand the breadth and depth of nature according to hypotheses, but who *turns around*, literally turning one's back on the hypothetical procedure, for the sake of a dialectic, which "making no use of anything sensed in any way, but using forms themselves, going through forms to forms, ends in forms too" (*Resp.* 6.511c).

It is in this light that we must understand Plato's stance with respect to Timaeus, who cannot be the former's "spokesman," precisely because his own vision is subject to the limitation of the puppeteers in the image of the cave: Timaeus's likely story has the epistemic status of the phantasmagoria to which the prisoners in the cave are subjected. Whatever in particular we are expected to believe as dialectical interlocutors with the figure of Timaeus, it cannot be that we should just accept the likely story. Precisely what it is that we are meant to do with the likely story, we hope just to have established that it is not meant to be simply believed, and hence that the specific role of Philolaus's musical scale in the dialogue is to introduce a problem for dialectical discussion and not to introduce the truth about the world. We can make sense of how and why Plato has Socrates present Philolaus's discoveries in both *Republic* and *Timaeus* only when we understand the aim of both "citations" as being to *place* mathematics as something both necessary and insufficient for the dialectical pursuit of the (form of the) good.

As Kalkavage (2001: 148) puts the matter: "Each of the impressive technical accomplishments of Timaeus has buried within it a deep problem that the technical construction in part copes with and in part conceals." We have just seen in detail how this works with respect to Pythagorean harmonics: the construction of the musical scale *almost* closes the circle made out of beautiful small whole number ratios, but leaves behind the ugly "Pythagorean *comma*," with its very large whole number ratio. Nikulin (2012a: 36) makes a related point with respect to the achievement of integrating the solids within a cosmological account, showing that to understand what Plato wants us to understand in Timaeus's account, we must see that the way in which the "geometrical is translated into the physical ... remains ultimately not explained mathematically ... but within a plausible 'mythological' account." The mathematical achievement here, as with the construction of the world-soul through Philolaus's

musical scale, is great. But the *dialectical*, philosophical, purpose in sharing this is not to gaze in wonder at the technical achievement, but rather to acknowledge how integrating pure geometrical material into the world of becoming comes at the necessary cost of speaking in mere likelihoods and proffering opinions. Thinking of Timaeus's likely story together with the achievements, but also the limits, of the mathematical curriculum offered to the philosopher-kings in *Resp.* 7, we can see that this "placement" of the mathematical arts in crucial conversation with, but ultimate subservience to, dialectic is a commitment that is not specific to one or the other of the dialogues; rather it is a principle at the heart of Platonic dialectic.

In the following chapter, we turn to the inner-Academic debates about mathematical ontology to further support this conclusion. For now let us see how, with respect to the solids in particular, this entails acknowledging that "these most perfect of plane-sided, three-dimensional figures have irrational lines as a necessary feature of their internal structure."[11] Bearing in mind Socrates's admonition (*Resp.* 7.534d3) that we will not have the philosopher-kings ruling the city while they are still "irrational as lines," the fact that Timaeus's project keeps coming back to irrationality in reaching "the very peak of philosophy" does not seem like an accident. A joint reading of the figure of the philosopher-king and of Timaeus in *Tim.* brings us to conceive of both *not* as the model for our own education, but rather as the model of a vision of education that brings us to the brink of dialectic but ends without ever achieving what dialectic alone can.

This reading allows us to make sense of Plato having Socrates and Timaeus both refer, in very different ways in different contexts, to the same work of Philolaus—in both cases neither "fully seriously" intending us to accept the Pythagorean attitude, nor "merely jesting." How does it stand, though, with respect to recent work on Plato's reception of Pythagoreanism? Specifically, can our reading find itself in a recent emerging consensus—see Cornelli (2013), Horky (2013), and Zhmud (2012 among others)—that what it means to say that Plato was a Pythagorean is *not* that Plato "adopts" views, already long established and Pythagorean in origin, as was commonly held since the Renaissance rediscovery of Plato's work and right up until Burkert (1972 [1962]), but rather that Plato "adapts" views—never really previously established, but present in various sources—and consolidates them under the moniker "Pythagorean," for which he (or members of the early Academy) is actually really responsible as an historiographical category. Our view may help decide between this consensus and another alternative view, associated with the "Tuebingen" school of Plato interpretation, which holds that Plato more or less created

a "Pythagorean" worldview, the content of which is actually a series of dogmas that were settled on in the early Academy and taught by Plato and his immediate successors as "esoteric teachings," conveyed in "unwritten teachings" alluded to by Plato (especially if the Seventh Letter is authentic) in various places in the received corpus.[12] For reasons that Horky (2013) summarizes neatly in his preface, it is unlikely that there will be—ever, or at the least soon—some "smoking gun" historiography that can produce a clear decision between these mutually exclusive interpretations. Thus, as Zhmud (2013: 1) notes, the "substantial divergence" among views as to "how great was the contribution of the Pythagoreans to Plato's philosophy" is likely to remain with us for some time, if not always, because "Plato himself is very reserved on this topic: even if he is indebted to the Pythagoreans for a great deal, his dialogues cleverly conceal it." Our suggestion here is that Plato's purpose might not be so much to conceal the debt as to make the debt of what is said in the dialogues crystal clear, but then to make terribly opaque what stance he takes, and we as readers ought to take, about the views that have been stated.

In this light, what *could* persuade us to take one view or another about "Plato the Pythagorean?" Our approach is to combine a dramatically sensitive reading of the dogmatic content of *Republic* and *Timaeus* (chapters 1 and 2) with the findings and likelihoods about the actual work of Philolaus and Archytas established by Huffman (1993, 2005, 2014) and others (introduction and chapter 4, section 1). In this way, we both provide an account of the "Pythagorean" influence on Plato, but also—and more crucially—make it possible to show exactly how Plato hopes to *critically* appropriate them in the service of his project of placing mathematics. Crucially, in our view Plato does not identify directly with the Pythagorean project of finding the highest truth (the good) through the application of the mathematical arts in understanding the cosmos, but rather places this approach in a subordinate role to the dialectical approach to the (form of the) good. Plato aims to place these insights as a serious but ultimately hopelessly incomplete attempt to answer, with mathematics, questions that can only be answered dialectically. This, we suggest, is the relationship of mathematics to philosophy and the meaning of the suggestion that the arts are a "prelude" to the song of dialectic (*Resp.* 7.531d); that is, mathematical analysis of problems raises, rather than resolves, the questions that dialectic alone can hope to answer.

Chapter 3

Platonic Dialectic, Pythagorean Harmonics, and Liberal Arts Education

Having situated the 729-times-more-pleasant argument (*Resp.*, 9.587b–588a) within debates concerning Plato and Pythagoreanism (chapter 1), and brought this reading into relation with the Pythagorean legacy of *Timaeus* (chapter 2), we are now ready to draw the lesson of this interpretive work for our central thesis: the Parthenon is the key vanishing mediator between the earliest development of philosophy as a dialectical response to interdisciplinary problems in mathematics in the sixth century and the systematic articulation of dialectic in Plato. That is, we will situate our understanding of the presentation of the mathematical arts in *Republic* 7 within its recent scholarly discussion[1] to show how the presentation of the relationship between the mathematical arts and the dialectical pursuit of the Good sheds light on the debate concerning the ontological status of mathematical objects Proclus tells us was ongoing in the Academy.

This concluding chapter of part I offers our account not just of the ontological commitments[2] behind the relationship between dialectic and mathematics but also the political commitments behind Plato's view that dialectic is, in the phrase that Recco (2010: 191–239) has carefully unpacked, "the science of the free." We then close with a comment on how and why this understanding of both the political and the ontological commitments behind Plato's view of liberal arts education is relevant for contemporary debates concerning the relation of liberal education and technical education.

Our central orienting question as we try to bring our analysis of the "mathematical passages" of *Republic* and *Timaeus* together with debates within the Academy concerning the theoretical issues exposed in those dialogues will be: Is dialectic an art? Or, in contemporary terms: Is philosophy a science? Or, perhaps less tendentiously, What is the relationship between

education as part of a project of liberation and an education as part of a project of knowledge of matters technical, between humanist learning and the knowledge that emerges through the recursive practice of technical procedure? Here, we uncover Plato's "holistic"[3] view.

1. Pythagorean Harmonics and Plato's Subordination of Mathematics to Dialectic in *Resp.* 7

The previous discussion of *Republic* and *Timaeus* offered an account of how to best understand the positive absence of Philolaus's scale in the former together with its express presence in the latter; that is, for all their differences, both dialogues place mathematics as integral to but also subsidiary to dialectic. Here, a reading of the "master text" on this subject in the Platonic corpus—the presentation of these arts as part of the education of the philosopher-kings in *Republic* 7—focused on how and why the arts follow a certain order in their presentation helps substantiate the claim that the positive absences of harmonics in the 729-times-more-pleasant passage (*Resp.* 587b–588a) and of dialectic in the construction of musical scale as the founding of the world-soul (*Tim.* 35b–36c) truly do correspond and thus shed (needed) interpretive light on one another.

We approach this passage with two overarching features chiefly in mind. First, these are presented not for the sake of providing a "discourse on the origins and proper operation of the mathematical arts," but rather for the sake of describing an educational program, specifically, the training of the philosopher-kings. This means that, as Mendell (2008) has argued, we cannot presume that by unpacking the status of mathematical procedures and the objects on which they work as presented in *Republic* we can arrive at a basically consistent picture of the actual practice of mathematics as it would have been understood by Plato and his contemporaries. Most importantly, we ought not to believe that the methodological and ontological presuppositions behind the mathematical arts of the first decades of the fourth century can be "read off" Socrates's very brief, even proleptic, remarks. Rather, as Mendell (2008: 125) concludes his opening methodological remarks, we must pay "careful attention to what Socrates says in the *Republic* and to what we do know of ordinary, contemporary scientific practice," so that we might "illuminate both." The stress here is on "ordinary"; as Mendell (2008: 129) insists with respect to calculation in particular, we must avoid the temptation to jump to the highest levels of meta-mathematical analysis in trying to understand the point of this curriculum and instead "approach Plato's contrast between the ordinary

practice of arithmetic and the advanced practice advocated for students in the ideal state that is to lead the guardians towards the Forms and the Good." Our back-and-forth reading of *Resp.* 9.587b–588a and *Tim.* 35b–36c with respect to the actual fifth- and fourth-century practice of harmonics, the fifth of the five mathematical arts in *Republic*, is meant to make good on exactly this approach, which Mendell (2008) himself applies only to the first of five arts: calculation.

This juxtaposition of our work on harmonics, the fifth of the arts, and Mendell's on number or calculation, calls our attention to a second overarching feature of this account: the fact that the arts are presented in a certain order. The order is as it is because the arts are presented as they are to be learned by the philosopher-kings, but this is just the proximal cause. Beneath the pedagogical ground of this ordering there is the ontological and epistemological ground. The philosophy of mathematics behind the understanding of the mathematical arts as an object of study to be conducted within a certain political order is opaque, and indeed the actual nature and purpose of that education and even that political order is far from easy to determine.

Why, then, consider the order of the presentation? It turns out that nothing less is at stake than what Burnyeat (2001: 6) calls the "essential question" with respect to the relationship of mathematics and dialectic: "[I]s the study of mathematics merely instrumental" to the Good, or does it "constitute a part of ethical understanding?" Like Burnyeat, we argue for the latter option, holding that the procedure of beginning with calculation and proceeding through geometry (plane and solid) to astronomy and finally ending with harmonics is in fact essential to understanding the relationship of mathematics and dialectic, both for the philosopher-kings in their fictional education and for us in our actual education. The lynchpin is one's progressively greater understanding of the theoretical significance of irrationality. For reasons accidental (i.e., historical, addressed above with respect to Philolaus's musical scale) and essential (i.e., ontological, addressed above with respect to the number 729 as an object of calculation, geometry, solid geometry, and astronomy, with the "positive absence" of the meaning for harmonics being the chief focus of the passage), one must engage in an interdisciplinary analysis of irrationality beginning with calculation and proceeding through geometry (plane and solid) and astronomy, before considering the relevance of irrationality for harmonics, which we hold is the "cutting edge" of where dialectic's engagement with the mathematical arts articulates itself.

By way of introducing the first of the mathematical arts, *calculation*, Socrates (*Resp.* 7. 523b) explains the difference between those occasions

when intellect is needed to engage with the world of sense and when not, maintaining that "some objects of sensation do not summon the intellect to the activity of investigation because they seem to be adequately judged by sense, while others bid it in every way to undertake a consideration because sense seems to produce nothing healthy." What exactly is "unhealthy" when we try and fail to take up an object of sensation as one that does not demand intellect in order to be accounted for properly? Mendell (2008: 150) suggests considering the example of one who calculates with an abacus, who, using "an image of a number" that is an actual "visual object" (a pebble on a counting board), must know how to use the sensible thing as a representation that abstracts from the things counted, whether these are "knights, fingers, pebbles representing units, or pebbles representing higher values, or even acrophonic numerals." In each case, "the only issue is what is actually being counted or calculated." For this understanding, what is "unhealthy" is that absent a clear distinction between the visible body to be counted and the visible body by which we count, we won't know what it is to count (or calculate). Moreover, this distinction is possible only when we abstract the "being-two" of the second pebble on the counting-board from its visible presence there in its array, and understand that this "being-two" is in fact an intelligible property that cannot be sensed. Having this abstracting capacity is being healthy, and lacking it is unhealthy.

But how, according to what Socrates says about perceiving this distinction (*Resp.* 7.525d), is it that this "lowly business" in fact "leads the soul powerfully upward and compels it to discuss numbers themselves," simply by removing the temptation of believing that the things countable are the things sensible? Mendell (2008) answers that the methodological principle of not allowing the numbers to be "attached" to the sensible bodies is not part of an advanced number theory to which we should understand this passage as obliquely referring. Rather, we commit to denying the identification of "worldly things that are countable" (the sensibles) with "that by which we count" (the numbers) simply to ensure that the unit is a unit. As Mendell (2008: 132) concludes, this discussion is meant to establish only "two pairs of criteria that Socrates mentions, whether or not one calculates with tangible or visible bodies and whether or not one is allowed to divide the unit." The "indivisibility of the unit" alone, and not any "advanced" work in the field of arithmetic (understood as number theory along the lines of what we find in Books VII–IX of Euclid's *Elements*) is the point here.

The shift from the visible fact that the sensible object has the quality of "being-a-certain-number of the counter" to that object "being-

a-representation-of-a-certain-number-of-abstract-units" is the condition of possibility for the unity of the unit. This unity of the unit points to the reason why, according to Socrates's characterization (*Resp.*, 7.527b), *geometry*—the second of the arts in order—contributes to the shift from sensation of visible objects to intellection of intelligible objects, namely when we work with geometrical objects and procedures "for the sake of knowing what is always, and not at all for what is at any time coming into being and passing away." The text here is very austere. Help is needed, then, to understand just how and why it is possible to err (and treat geometrical figures in such a way "that they are part of coming into being and passing away") or to understand geometrical objects properly, which is to say atemporally. Here, what Nikulin (2012b: 297) calls two "implicit suppositions" of "Plato's mathematical ontology"[4] are relevant: (1) "a geometrical unit should be considered analogous to an arithmetic unit," and (2) "arithmetic and geometry, although still different realms of mathematics, bear important similarities, which include indivisible units constitutive of their objects." Seen in this light, the move from the first to the second of the arts is perfectly intelligible: just as (when calculating) we needed to train ourselves to "see" the counting numbers not as the sensible counters we used to count, but rather as abstract masses of *indivisible* units, so do we need to understand lengths as being at all only insofar as they are measured by geometrical objects that are intelligible, not material, and thus do not "take part in coming to be and passing away" in any way, not even in what we might call the imagination.

What is most relevant with respect to the third of the arts, *solid geometry*, as Socrates presents it (*Resp.* 7.528b), is not the details of the object at stake—the introduction of a third dimension to the plane geometrical objects—but rather the fact that it is almost not taken up at all, since "after a plane surface, we went ahead and took a solid in motion before taking it up by itself." That is, in our hurry to account for the solids in motion (the art of astronomy), we forgot to take account of those solids at rest. Plato has Socrates (*Resp.* 7.528b) blame "the ridiculous state of the search for such an account" as the source of their mistake. Miller (2007) shows how this "difficulty" must be read on two levels. On the accidental level, as a reference to the relevant discoveries in this field of Archytas and Theaetetus and their impossible "dating" vis-à-vis the conversation between Socrates and Glaucon, and on the essential level, as a comment on the necessary role of the forms in allowing inquiry to turn back to the sensible (the solid figure) but only from the viewpoint of pure intelligibility. This, Miller (2007: 322) argues, is possible only when we recover the "pure intelligiblilty" of "the innermost structure of all

that becomes both the corporeal *and* the incorporeal." It is precisely this "recovery" of the intelligibility of the form out of the sensibility of the geometrical solid that is missing for the mathematical treatment of solids in motion—that is, astronomy—in its current "ridiculous" state.

This understanding of the awkward presentation of solid geometry is reinforced by what Socrates maintains (*Resp.* 7.529b) with respect to *astronomy*, namely that he is "unable to hold that any study makes a soul look upward other than the one that concerns what *is* and is invisible," and so finds that "if a man gaping up or squinting down, attempts to learn something of sensible things, I would deny that he ever learns." There is a commonplace of seeing this supposed anti-empiricism in Socrates's picture of proper geometry as very strange and indicative of a general Socratic and pre-Socratic refusal to grant observational data any place at all in astronomy, which would indeed be strange if true. Against this background, we need to attend to the central suggestion made by Graham (2013), especially in his closing chapter, "The Geometry of the Heavens," that the work of Parmenides and Anaxagoras had introduced an approach that both closely considered *and abstracted from* observational phenomena. Taken together with what Gregory (2000, 2011), referring to this passage of *Republic*, suggests concerning Plato's interest in the regularity of the motion that emerges from attention to the sensible heavenly bodies, but can be plausibly understood *not* to be "something of the sensible things" themselves, a much more coherent, and not very strange, picture of a positive but subsidiary role for observation comes into focus—especially if we bear in mind what Gregory (2011: 27n11) calls the "contrast between how one does astronomy and how it ought to be used in the education of the guardians."

This is especially so if we try to understand a bit more richly what is really meant by a "problem-based" approach to astronomy, and what exactly this entails with respect to the observable phenomena. Mueller (1992: 192) points out that this characterization of the proper "problematic" approach to astronomy entails that no one should expect to find the truth about ratios in the visible heavens or think that the periods of the various heavenly bodies will remain constant through time; that is to say, as sensible objects the heavens cannot perfectly embody scientific laws. This is the sense of Socrates's further conclusion that "true" astronomy involves not looking at the heavens and the sensible entities therein at all (*Resp.* 7.530b): "Therefore, by use of problems, as in geometry, we shall also pursue astronomy; and we shall let the things in the heaven go." This points to the chief difference between astronomy and geometry (including solid geometry) with respect to the distinction between the sensible and

the intelligible and the proper method of addressing mathematical objects solely as intelligible, and never as sensible. That is, as Mueller (1992: 193) concludes, "in geometry successful reductions or analyses of problems move to hypotheses and theorems, but in astronomy there are no such theorems; the task of analysis is to move to hypotheses-lemmas—in the case of Plato's astronomical problem, uniform circular motions." We shall return to these technical considerations about the difference between geometrical and astronomical problems in the next section. For now, let us note that—as with the "rush" to move past the study of the solid figure at rest before turning to the solid figure in motion—what articulates the arts with respect to each other in series is where they stand with respect to the distinction between the sensible and intelligible, where an advance in the series (from calculation to geometry, from plane geometry to solid, from solid geometry to astronomy) corresponds to a greater distance from the sensible and a deeper engagement with the purely intelligible. This points to the next and last of the arts precisely as the end of the series—namely, harmonics—as the necessary consummation of the investigation into mathematical problems with the intellect alone.

We have thus hit on a central methodological question crucial both for understanding mathematics and dialectic as presented in the dialogues and the views debated in the early Academy: How can the productive ("constructive") character of astronomy be reconciled with its analytic character, and what does this means for moving from the arts to a truly theoretical science? The contrast between the presentation of the mathematical arts as studied by the philosopher-kings and as they might have actually been studied in the Academy becomes relevant in this respect, as Mueller (1992: 172–73) attempts to draw the distinction by means of two examples of Platonic responses to contemporary mathematics (as practiced by Eudoxus, Menaechmus, and Archytas). The upshot is that whereas good mathematical practice within the education of the philosopher-kings is predicated on a problem-based approach, it is apparently the case that Plato in actual fact argued against approaching the objects of mathematical understanding (only?) this way, as the true path to mathematical understanding must come through theorems and not problems. Only when we confront the fundamental difference in the approach to the mathematical arts in the fictional and actual programs of study can we understand the role of Plato as "an architect of science," which for Mueller (1992: 175) means understanding Plato "as a source of challenge and inspiration to mathematicians and not as a mathematician of real significance."

Against this reading of the actual practice of mathematics in the Academy as indicative of Plato's role as a meta-mathematician who

provided methodological critiques to those working in advanced mathematics at the time that were salient and inspiring for them, we have Zhmud's (2006: 82–9) contention that the very idea that Plato was an "architect of the sciences" is fundamentally wrongheaded and merely an epiphenomenon of "Platonizing" in the doxographical tradition. At the same time, Hoesle (2012 [2004]) on the contrary argues that the very methodological convictions on which Mueller (referring to Plutarch) relies were nothing other than the inspiration of the chief methodological and ontological convictions—ontologically, the atemporality of geometrical objects, and methodologically the ban on mechanical constructions—from which Euclidean geometry was born. In short, there is great—even fundamental—disagreement concerning the actual practice in the Academy and what it tells us about the relationship of mathematics and dialectic "in the real world."

Where does this leave us, though, with respect to the interpretation of the education of the philosopher-kings and what it has to teach us about the analogy that the current section chiefly aims to unpack—namely, prelude : song :: mathematical arts : dialectic? It is helpful here to think about the picture of the "longer way" that Miller (2007: 341–42) provides in the postscript to his interpretation of the discussion of the mathematical arts. Arguing that we cannot really understand the relationship between the mathematical arts and the actual practice of dialectic from the text of the dialogue, precisely because Socrates says that we wouldn't be able to understand what this means given our current state of understanding, Miller turns to the unwritten teachings that Aristotle credits to Plato in *Metaphysics* and finds there a six-part characterization of the tasks we need to accomplish on the "longer way." They are as follows: (1) conceiving the Forms in their proper being as Forms; (2) understanding the interrelations of the Forms; (3) identifying the modes and processes of dialectic; (4) understanding the relationships between figures, ratios, forms (here we ask: Can we actually give an account of the sensible world that the intelligible structure of the mathematical arts implies?); (5) expanding the breadth of the "longer way," meaning investigating how the five arts could apply not just to the physical world as an object of sense, but also to politics and ethics; and (6) understanding the Good, which is clearly the ultimate destination of dialectical education.

With this framework for understanding the difference between the trajectory that we follow together with the philosopher-kings through the prelude that is the mathematical arts and the trajectory that one would actually follow on the "the longer way" that is a true dialectical education, we can now turn to the presentation of the last of the mathematical arts:

harmonics. Harmonics consummates the progression through the mathematical arts, because as Miller (2007: 321) notes, the "overall trajectory" of the five disciplines constitutes a "series of purgations" by which, bringing out in each later phase what is essential in the earlier, thought leaves the visible and the spatial behind and arrives at the "most purely intelligible referent short of the Forms themselves." But why, precisely, is this so? Why is it that harmonics has this greatest proximity to the dialectical pursuit of the forms? It is because harmonics, so to say, determines the contours of the mathematical arts as the prelude to dialectic's song by placing front and center the persistence of the irrational magnitude as an object of intellection that cannot be reduced to mathematical understanding, but is undeniably present to sensation. It does this to a greater extent than the earlier arts because more than any of the others, it is with the study of problems in harmonics that we are forced to shift from a procedure based on *dianoia* (thought) to a procedure based on *noēsis* (intellection). As Burnyeat (2001: 47, 73–4) stresses, it is harmonics that shows how "mathematics and meta-mathematics" (which is how he understands dialectic, on this more shortly) can be integral to the ethical training of the philosopher-kings, because only harmonics displays the "kinship" of the structure of these studies. Harmonics doesn't study "ratios of audible sounds" but rather ratios "of a non-sensible motion," that is, the "movements of thought" by which the heavens are constituted, which harmonics alone can disclose. This is because they are based on taking up the sensible objects of the other mathematical arts precisely as pure intelligible objects to be examined not in themselves, but as Socrates describes (*Resp.* 7.531d), in "their community and relationship with one another." Thus harmonics, unlike the other arts, "draws conclusions as to how [the other objects of the other mathematical arts] are akin to one another." Harmonics alone of the arts has already made the transition from investigating sensible objects *as relating* to investigating *the relations among sensible objects*. In so doing, harmonics has already crossed an ontological and epistemological threshold that the other arts have not. This is what it means to see the Parthenon, with its harmonic principle of construction, as already itself engaging in dialectic (or something dialectical) in Plato's sense—as we will argue is the case in the conclusion to part II.

Thinking of our investigation of the number 729 as an example, one begins by considering a number with respect to calculation (three time three), then in terms of its features as a length (three times three as a line), as a plane figure (the square number), and then a solid figure (the square then rotated to create a cube), before considering it with respect to the motions of the heavens (the solar year of 729 days and nights and

the Great Year of 729 months). In each of these respects, we are still treating it on the basis of bodies of knowledge resulting from the belief in hypotheses. It is when we take the last step of attending to the number as part of the musical scale that we are able to understand it as a number, as an extended figure, as a figure with depth, and as something audible. Precisely because it is each of these things (in some sense), it is none of these things, and therefore nothing sensible. It is not that harmonics is privileged with respect to its own object, the heard accords; rather, the investigation of the problems arising from harmonics implicates the other arts in a way that is not reversible.

This is the point of the contrast Socrates draws (*Resp.* 7.531b) when he says: "I will put an end to the image by saying that it isn't these men I mean, but those whom we just now said we are going to question about harmony. They do the same as the astronomers do. They seek the numbers in these heard accords and don't rise to problems, to the consideration of which numbers are concordant and which not, and why in each case." Two related aspects of harmonics are presented here, both of which point to how and why it is more integrative than the other mathematical arts, and thus why harmonics is the closest of the arts to dialectic. First, focusing on "why in each case," we see the "ontological priority" of the fact *that* such-and-such numbers are concordant and others not, and *why* in each case is intelligible only when we have reached a place where we are considering the mathematical object already outside its own hypothetical frame. This is true only of problems in harmonics, and is the source of its placement as the last of the arts, and its greater proximity to dialectic. Second, attending to the claim that in this way Socrates will "put an end to the image," we see the crucial role of getting beyond the imagination in articulating the problems mathematics raises in such a way that dialectic can really work on them. For as long as the mathematical objects are taken up in the imagination, they can only be worked on through hypotheses. But dialectic is precisely antihypothetical; its founding moment rests in the destruction of the hypotheses from which the learned conversation begins. Therefore, however much less reliant on hypotheses harmonics is than the other mathematical arts, by so much is it closer to dialectic.

With this last claim about dialectic's nonhypothetical nature, we have arrived at the terminus of the journey that, together with Socrates and Glaucon, we can make together with the would-be philosopher-kings. To go any further, to hear what Socrates (*Resp.* 7.532a) calls the "song itself that dialectic performs," which can be sung only when one "attains to each thing itself that *is* and doesn't give up before he grasps by intellection itself that which is good itself, [such that] he comes to the very end of

the intelligible realm," is beyond us. The depiction of dialectic we receive is necessarily incomplete and oblique, for we could not have understood it, we are told, had we been given the whole story. The point of what we do have is surely the recapitulation of the difference between *dianoia* and *noēsis*, something we already saw in the divided-line passage. Mueller (1992: 184) parses the distinction between *dianoia* and *noēsis* thus: "*Dianoia* is compelled to study its objects by proceeding from a hypothesis toward an ending, but *noēsis* studies its objects by proceeding from a hypothesis to an unhypothetical beginning (principle)." In other words, mathematicians move from hypothesis to a finishing point, whereas dialectic starts from hypothesis and moves to a nonhypothetical "starting point" or foundation of everything, namely the form of the Good as the source of being, truth, and beauty. This underscores both the uniqueness of harmonics, as the mathematical art that comes closest to engaging in *noēsis*, but also the ontological and epistemological frame within which harmonics, too, is placed as preliminary.

Our access to the curriculum of the philosopher-kings ends here, consummated by the mastery of harmonics. But why is this as far as we can go along with the philosopher-kings, as Socrates insists? Why are we "no longer able to follow, my dear Glaucon, although there wouldn't be any lack of eagerness on my part" (*Resp.* 7.533a1)? It is because, as Socrates continues, "You would no longer be seeing an image of what we are saying, but rather the truth itself, at least as it looks to me" (*Resp.* 7.533a2–3), and Glaucon (and we) are simply not in a position to see that. But, again, why? To ask this question is really to raise the question of the difference between an education in dialectic as it is depicted in *Resp.* 7, in a manner that is (for whatever reason) explicitly incomplete, and the education in dialectic that the Socratic dialogue as such provides and that might be a lens on the practice of dialectic. This is the subject matter of the following section, which also serves as the conclusion for part I as a whole. For the moment, consider what Socrates stresses (*Resp.* 7.533c5–d2) is the true ground of his inability to communicate the truth of dialectic to Glaucon and Adeimantus: that "only the dialectical way of inquiry proceeds in this direction, destroying the hypotheses, to the beginning itself in order to make it secure; and when the eye of the soul is really buried in a barbaric bog, dialectic gently draws it forth and leads it up above." And so we are left, jarringly, with an *image* of nonimaginary intellection being the work of dialectic.

To pretend that we know what we are talking about when we talk about dialectic within the frame of Kallipolis and the education of the philosopher-kings is to act as though we could arrive at *noēsis* through *dianoia*, and this is precisely ruled out by the express meaning of the text.

But surely it is neither acceptable to "settle for" what we already know about dialectic and how it actually operates. How can we possibly go on singing the prelude when we know it is only a prelude? We need, in short, to learn how to sing the song of dialectic and not merely how to know that it is the song and we only so far know its prelude. To achieve this, we have no choice but to speculate about what the education in dialectic, for the philosopher-kings and/or for those who engaged in dialectic in the Academy, really looked like; to this we turn now.

2. Plato and the Liberal Arts: Epistemic Closure in Mathematics and the Openness of Dialectic

We hope now to have established that the pedagogical and ontological principles behind the ordering of the series of mathematical arts, proceeding from calculation to harmonics as the "prelude to the song of dialectic" (*Resp.* 7.531d), show us both which things get "left out" at critical moments of *Resp.* or *Tim.*, and why. With this reading of the "nested" relationship between mathematics and dialectic in mind, we turn now to the "central orienting question" with which this chapter began: Is dialectic an art? More fully: Is the ultimate aim of the Platonic pedagogical enterprise (of Plato's vision of "liberal arts education") to bring about knowledge of a certain kind, or to bring about a certain kind of orientation to the world? Is dialectic a science involving the repeated application of certain methods, in which one is educated after having mastered the mathematical arts, which methods bring one to certain knowledge about the proper objects of dialectic? Or is dialectic not a science but rather something more like a (musical) mode, a way of life that is defined not by the knowledge procedures through which dialectical results are achieved, but rather through the constant cultivation of an attitude that is at once critical toward that which is built on the presupposition that there is a way to represent the deepest truths of being within the hypothetical-deductive structure of the mathematical arts and still desirous of a presentation of the very being of things within this structure?

Since it is clear that the education of the philosopher-kings itself lends itself more to the former view than the latter, the question again becomes one of interpretation: How far does this really reflect the self-understanding of the meaning and the purpose of a Platonic education in the real world? For some, what Mueller (1992) calls the "Platonic program" in liberal arts education is to be largely identified with the education of the philosopher-kings, as reflected in certain key passages

of *Theaetetus* and *Epinomis*, albeit with some doctrinal modifications such as the point noted above concerning construction and the contrasting roles of problems and theorems in learning mathematics on the way to practicing dialectic. For others—like Nikulin (2010) and Miller (1999, 2003, 2007)—there are important differences. Through a critical analysis of Plato's reception of Pythagorean mathematical knowledge as presented in the earlier sections, we hope here to show that Nikulin and Miller are closer to the truth.

Burnyeat (2001: 8) presents the clearest version of a view in which dialectic is an art, or, in his term, a science, for which the meaning of the mathematical arts being a prelude to the song of dialectic is that they "are the ones that tell us how things are objectively speaking, and they are themselves sciences of value." For this reading, the education of the philosopher-kings is to be identified with the education of the true dialectician, and so the figure of the philosopher-king and the figure of the true philosopher converge. As Burnyeat (2001: 9) concludes: "The moral of the Cave is that Utopia can be founded on the rulers' knowledge of the world as it is objectively speaking, because that includes the Good and the whole realm of value." Given all that was said concerning our commitment to the leaving-things-out principle (chapter 1, 1) and the positive absence of harmonics in the 729-times-more-pleasant passage (chapter 2, 2), it is clear that we fundamentally differ from this reading. We hold that Books 6 and 7 more generally, and the function of the image of the cave in particular, must be seen as just one moment along the way to the introduction of the "image of the soul in speech" (*Resp.* 7.588c) that immediately follows the 729-times-more-pleasantly argument.

Burnyeat (2001) reads the mathematical curriculum as the means by which the philosopher-kings are brought in touch with "knowledge of the world as it is objectively speaking," and suggests that this objective world "includes the Good and whole realm of value." Thus, obviously, he sees the achievement of the philosopher-kings as something that Plato means for us to attempt to emulate. We, on the other hand, have offered our reading of the conclusion that the just man lives 729 times more pleasantly than the unjust precisely as grounds to believe (1) that what Burnyeat calls the "objective world" that "includes the Good and whole realm of value," which we have preferred to call "the dialectical pursuit of the (form of the) good," is actually beyond the reach of the mathematical arts, and for this reason, (2) we must understand the philosopher-kings' program as inherently inadequate rather than an object of highest esteem. In short, one can say that while Burnyeat holds that the relation of the would-be real-life practitioner of dialectic to the philosopher-king as a

practitioner of dialectic would be one of *identification*, we hold that this relation is one of *self-othering*. He holds that we are meant to *identify* with the philosopher-king precisely because the philosopher-king learns that the mathematical objects, properly understood, lead us to the "whole realm of value," and we are supposed to want to be like that. We hold that we are meant to distance ourselves (to *make ourselves other*) from the philosopher-king precisely because the philosopher-king learns that mathematical objects, properly understood, lead us to the space where the pursuit of the Good could begin, but fails to learn that they cannot take us any further than that, and we are *not* supposed to (want to) be like that.

Notwithstanding these very real differences, nothing prevents us from being absolutely in accord with what we hold to be Burnyeat's (2001: 42) central conclusion concerning the relationship of mathematics and dialectic as such: "In sum, mathematics is not criticised but *placed*. Its intermediate placing in the larger epistemological and ontological scheme of the *Republic* will enable it to play a pivotal, and highly positive, role in the education of future rulers." And, in fact, we believe we are wholly agreed with Burnyeat on this point. Given that the answer to the question "Why 729?" is meant to conclude the argument that generated the city-soul analogy in the first place, and that this analogy gives rise to the possibility of (a) Kallipolis, and that this possible Kallipolis gives rise to the possibility of (b) rearing the philosopher-kings, it should not be controversial to say that it is only when one has some reading of "Why 729?" that one can have a theory of the status of the image of the cave in relation to the achievement of the philosopher-kings.

But what exactly is the role that the dialectical education of the philosopher-kings plays in the picture of "dialectical education as such" that ought to arise through our experience of the education of the philosopher-kings, which we are arguing is meant to be one of self-othering, rather than identification? To answer this question, we need to contextualize what was said above concerning our inability to read out of the explicitly insufficient understanding of dialectic that results from the presentation of the philosopher-kings' mathematical curriculum in *Republic* 7 with Proclus's account of the debates about "mathematical ontology" going on within the walls of the Academy. For Proclus (1970: 64), the basic nature of the rift between the realists (led by Speusippus) and the constructivists (as represented by Menaechmus[5]), as Detlefsen (2005: 243) neatly characterizes it, concerns whether it is right to say that geometrical objects are understood (but not made) by the intellect when "taking eternal things as if they were in the process of coming to be" or if one must (with Eudoxus) say that geometrical objects are the

result of a construction. It is surely relevant, as Detlefsen (2005: 244) stresses, that we learn from Proclus of this rift between the constructivists and the realists in the context of his own attempt to reconcile the two. Proclus hopes, that is, to show both sides to be right by saying that the constructed figure is in fact constructed, but also that it is constructed in the imagination and not the understanding, so that there is an understanding (that operates according to Speusippus's realist ontology) and an imagination (that follows Menaechmus's constructivism) at the same time. Leaving aside whether or not Proclus's reconciliation is persuasive or not, what is crucial for us is that we can see the express statements of these views as part of an early inner-Academic debate.

But just what light does this shed on the relationship between mathematics and dialectic in the dialogues? For this, we need to further unravel the thread, connecting this constructivist vs. realist debate concerning the nature of geometrical constructions *as* demonstrations, to what Detlefsen (2005: 244n12) calls Proclus's mention of "a genetic tradition extending from Oenopides through Zenodotus to Poseidonius that saw a problem as a query concerning the condition under which a thing exists." Two points are especially interesting here. First, we must note that geometrical problems are articulated as inherently linked to ontological questions in and of themselves, just as, in *Republic*, the proximity of attending to problems and the dialectical inquiry into the forms is crucial. Second, we see that, according to Proclus, this strain of meta-mathematical thought goes back to Oenopides,[6] who is believed to have been born in the first years of the fifth century, and (quite possibly) to have worked in Athens[7] around the time of the construction of the Parthenon. This lends credence to an overarching contention of this book as a whole: that the Parthenon is at work on interdisciplinary problems in mathematics precisely as a way to dialectically approach the most fundamental ontological questions. In their approach to the "visible unit" and to the "distribution of the difference" method in the corner problem, and in their commitment to "wrapping" continuous proportionality around the building within a canon of small whole-number ratios drawn from harmonics, the temple's designers were setting into stone exactly the philosophical and moral principles behind the meta-mathematical arguments Proclus records as being offered in this generation or soon after by the realists against the constructivists. Here we see how reflection on ontological considerations relevant for considering geometrical problems as either purely intelligible objects or objects of the imagination was inescapably linked with the world of sense as part of a dialectical examination, in light of which alone the Parthenon's methodical examination of proportionality and its limits comes into view.

We have suggested that Plato's presentation of dialectic is a proximal consequent of the interdisciplinary study of problems in mathematics as part of a development already underway at the time of the Parthenon's construction. What light can this shed on the inner-Academic debates about mathematical ontology such that the latter can help us establish the best possible picture of dialectical education? To answer this, we must attend to the crucial point that Nikulin (2010: 29–30) stresses concerning the *telos* of dialectic, which concerns not merely "rules for the operation of reason" but, more fundamentally, "rules for living well." This underlying connection between the role of dialectic in securing the best possible procedures for solving problems through intellection without reference to sensation and the fundamental ethical project of learning how to live well is behind Kahn's (1996: 42) "unitarianism," as an interpreter of Plato. This unitarianism opposes "developmentalism," the idea that there is a major break from the early dialogues to the metaphysical doctrine in the *Phaedo* and *Republic* within Plato's own thought. It is just this provenance of dialectic that is relevant for properly understanding the difference between the interdisciplinary education in mathematical problems the philosopher-kings receive and the actual educational project in which Plato was engaged, both as an author and as a schoolmaster.

This is why, as Nikulin (2010: 30) concludes, "Platonic dialectic still recognizes a whole *plurality* of methods, yet has no intention of becoming (as one might say today) the general methodology of all the sciences."[8] It is with this conception that we wish to respond to Zhmud's (2006, 2013) skepticism concerning both the sophistication of the mathematics curriculum in the Academy and the development of specific diverging ontologies within inner-Academic debates responding to Pythagorean ideas. It is, we hold with Nikulin (2010) and Kahn (1996), the crucially pluralist methodological commitments of Platonic dialectic, as a set of procedures by which we might make clear the essential incapacity of the mathematical arts to solve the problems to which they alone can give rise, that make dialectical education promising as a preparation of the soul for ethical life. Nikulin (2010: 30–35, and especially 160n20) shows precisely how the multiplicity of methods inherent in Platonic dialectic came to be systematized—through Aristotle and later through Hellenistic and Neoplatonic philosophers—into a single set of (four, five, six, or ultimately seven) methods. In this way, in time, the *trivium* and *quadrivium* of the classical "liberal arts" were born. Our central suggestion here is that following through the procedure by which the 729 passage raises and then leaves unresolved the fundamental problem of incommensurability can help us imagine how Plato might have arranged a pedagogically sen-

sitive introduction to just this kind of "liberal arts education." When we do so, we can see just how far that education resembles the education of the philosopher-king and also where and how it differs radically from it.

What then is the *logical* function of Platonic dialectic, as it emerges from the dialogues? Dialectic, as Nikulin (2010: 38) points out, "can be used for the formal justification (of a logical and mathematical kind) of what is already known but is not yet formulated as true (and sometimes never is)." In other words, dialectical procedures in their methodological mode can be used to analyze the results of the mathematical arts on which they operate, but they cannot generate the truths for which they are used. This is why, for Nikulin (2010: 42–3), dialectic remains an art for Plato; specifically, as he aptly concludes, dialectic is "a discursive and argumentative *art* of reasoning that must be considered *the* art of finding and presenting logically provable, correct speeches about any subject." Its positive role is not to be found in the discovery of original truths, but in the intellectual work performed on the results of the arts that do aim to disclose truth about the material world. It remains crucially the case, though, in this account, that "dialectic stands apart from any particular philosophical discipline" and "is not an overarching universal method for the sciences." In just this way, dialectic forms the center of the classical liberal arts curriculum, organizing the engagement with disciplinary knowledge without ever being reducible to, or doing the work of, a discipline with its own single common denominator or deduced from a single method.

With this picture of dialectic in mind, we can articulate the answers to our biggest questions in part I. First, with respect to the "mathematics : dialectic :: prelude : song" analogy, we conclude that Plato holds mathematics to be important for, even integral to, cultivating a philosophical disposition, but that it does not in itself constitute or even contribute to the actual practice of philosophy. It is true that there are practices—for instance the method of hypothesis, the method of analysis, and the *logistikē* of proportions—that the Platonic practice of philosophy adopts (and adapts) from mathematical practice and that thus make up an important element of that practice.[9] But these practices are tools used for dialectic to proceed as an art, but *not* as a science. With Kahn (1996), we find Plato to be pursuing one unified project under the term presented (only partially and not always consistently) in the dialogues as dialectic[10] and as "legible" from the actual practice of dialectic in the Academy. This consolidation merits naming dialectic an art (*technē*) in that it is a set of logarithmic practices that has been provisionally systematized to achieve certain products or results. But it is not (yet) a science (*epistēmē*), in the

sense articulated by Aristotle; it is not a method by which we arrive at demonstrative, apodeictic knowledge.

Second, with respect to the question of how we would best understand "Plato's reception of Pythagorean wisdom," we say that the Pythagoreans, most of all Philolaus and Archytas, must be understood as predecessors who helped articulate the problems that would-be philosophers should try to cope with, but not as models for philosophical practice itself. Pythagorean harmonics, in Philolaus's articulation as received by Plato and presented in *Resp.* 9.587b–588a and *Tim.* 35b–36c, comes to light as disclosive of the whole of Pythagorean cosmology, because of the role of harmonics in integrating geometry and astronomy through the construction of small whole-number ratios in geometrical space, which are then analyzed with respect to motion. But this profound achievement in making the world of sense accessible to *logos* must be understood as always ultimately demonstrating the limits of this approach, and its fundamental incapacity to truly make the sensible intelligible. Put another way: Plato's considered view of the "mathematical ontology" he adopts and adapts from Philolaus and other Pythagoreans is that we should acquaint ourselves as well as possible with figures like his invented Timaeus, but if we want to be philosophers, we should understand our work as responding in an open-ended and dialectical fashion to such figures, rather than as trying to emulate them. Still more starkly: whatever the dialectical understanding of the intelligibility of the sensible world is, it is not the mathematical ontology that the most sophisticated Pythagorean can provide.[11]

In opening our discussion of Plato's view of the propaedeutic relationship between mathematics (as a prelude) and dialectic (as the song), we said that our basic claim could proceed equally well whether one works with a "therapeutic" or a "transcendental" reading of this analogy. The key difference between these readings is this: If we hold the former, then we believe the mathematical moment must be "altogether gotten over," while if we hold the latter, then we believe it must be "preserved within its transformation." Here, at last, we can see why we believe that the second of these two understandings of the relevant propaedeutic is correct. And this is so for the same reason that our work with respect to the reading of the *placement* of mathematics is meant to offer the "harmonization" of the interpretive principles diagnosed above as "dialectic-in-and-through-drama" and "dialectic-in-and-through-dogma." For, as Nikulin (2010: 22) notices, there is an inherent "polyvocality" in any given *logos* as presented in the dialogue form, both in the sense that even if only one character is speaking, the voices of the other interlocutors are implicated in what is said, and in the sense that both the author and the speaking character are

"speaking" as we read a dialogue. It is only against this feature of Plato's chosen form that our interpretive practices can clarify anything about both the drama and the dogma in any given written dialogue.

In this respect, happily, our view is entirely concordant with the considered opinion of Dillon (2003: 16), whose voice on Plato and the way he was understood by "the first Platonists" must be given credence, and who holds that "despite Plato's strong view on many subjects, it was not his purpose to leave to his successors a fixed body of doctrine which they were to defend against all comers," but rather to promote dialectic as a "method of inquiry" like that which he had himself received from Socrates. In our view, this is precisely right and entails identifying with Nikulin's (2010) understanding of the practice of dialectic as never (fully) separable from dialogue, and in this way understanding the technical insights from the mathematical arts as the prelude to dialectic's song precisely in the methodological conviction that the attention to the world of sense—however rigorous—cannot be the source of the rationalization of the sensible cosmos that can be accomplished only in and through dialectic. The crucial modification from the "mathematical moment" is that we hold such rationalization as accomplished not when one arrives at a complete, atemporal, independent *logistikē*, but rather in arriving in an incomplete, temporal, and mutually dependent dialectic.

This placement of the mathematical arts as integral to but incomplete without the progression to dialectic is at the heart of the development of liberal education in its Platonic articulation. Plato's liberal education is very much a liberal *arts* education, where the liberating element of the education was always intertwined with its embrace of *technical* problems (problems related to the arts [*technai*]). We have underscored this commitment, and attempted to demonstrate its intimate intertwinement with Plato's reception of Philolaus, in the service of our argument that these very same interdisciplinary problems in mathematics were integral to the design of the Parthenon. And that, for this reason, the Parthenon serves as a crucial vanishing mediator between the first articulations of these problems in the development of Greek theoretical mathematics as a response to Near-Eastern predecessors and the consolidation of a program of research in *logistikē* as a necessary but insufficient condition for becoming a liberally educated person. Having discussed the place of these problems in fifth-century Greek mathematics in the introduction, and in *Republic* and *Timaeus* in part I, we now turn to our detailed account of the Parthenon itself in part II.

Part II

Harmonia and *Symmetria* of the Parthenon

GEOFF LEHMAN

Chapter 4

The Parthenon and the Musical Scale

1. Introduction: The Discovery of the Irrational

It seems inevitable that a culture so focused on the being and the significance of numbers, and on their fit or misfit with magnitudes as such, as that of sixth- and fifth-century Greece, should eventually discover a category of magnitudes that cannot be expressed as a number of units. The existence of such magnitudes, described variously by one or more of three Greek substantives—*asummetron, alogon, arhēton* (where the first term must be rendered "[the] incommensurable," but the second and third both mean "[the] irrational")—until the canonization of the definitions of such magnitudes in Definitions 1–4 of Book 10 of Euclid's *Elements*, was first theorized in Greek mathematics of this period because of a concern with the relationship between numbers and geometric quantities. The mathematicians of the fifth-century Greek world encountered the irreducible difference between magnitude and multitude, but more importantly still, they not only thus discovered the irrational, but also engaged with it as an open-ended, or unsolvable, problem.[1]

The questions thus raised were not only mathematical, or even meta-mathematical, but ontological, metaphysical, and epistemological—that is, *philosophical*. As discussed in the introduction, we think it likely that, as the philologist Árpád Szabó has argued, these questions arose first and foremost in the context of music theory and musical practice, where the construction of small number ratios based on divisions of a given length of string raised the problem of the magnitude-multitude relationship in the most direct and pressing way.[2] However, as we will argue, such problems were also addressed in the realm of architecture, and for similar reasons.

In an architecture for which small number ratios and their relationships were important—that is, an architecture rooted in proportion, in *symmetria* (commensurability)—as was that of Doric temples, arithmetic (the study of number) and geometry (both plane and solid) are necessarily brought into close interaction and become deeply interdependent. They not only contribute together to addressing problems such as the aesthetics and the meaning of the Doric order, or the relationship of structure to meaning, although the *symmetria* of the Doric certainly does both. The very relationship of multitudes (the object of study in arithmetic) and magnitudes (the object of study in geometry) to each other also constitutes a problem, and an invitation to philosophical—at the time inseparable from religious—thought. And in the principal temple of fifth-century Athens, the Parthenon, that problem—the relationship between multitudes and magnitudes, and its meaning—is made self-reflexive, the object of explicit thought that also has a pedagogical function, in its invitation to the viewer, visitor, or worshiper to engage with the building, and think with it, whether rationally or intuitively. In discussing the Parthenon in these terms, and especially when considering the ways in which Doric architecture is deeply and consistently analogous to music, it will be helpful to look briefly at the problems raised by the practice and the theorization of music in the early to mid-fifth century—and especially at the construction of the scale.

In a seminal article from the 1940s, Kurt von Fritz reconstructs the methods by which, in his view, the ancient Greeks may have "discovered"[3] the irrational, probably toward the middle of the fifth century.[4] Firmly associated with the Pythagorean tradition, this *discovery* was just that: more than speculation, or a hypothesis, that such irrational quantities could exist. It was rather the deduction that they *must*, that is, the development of means to demonstrate with certainty that they do. Von Fritz's article is particularly compelling in its discussion of the pentagram. Through comparison of related and adjacent magnitudes in the figure of a pentagram that contains a recursive series of progressively smaller inscribed pentagrams within it, ad infinitum, one quickly discovers another sort of infinite regress: however far one carries this procedure, one never arrives at a unit common to any pair of magnitudes in the figure.[5] The relationship between any adjacent pair of these incommensurable magnitudes is what would come to be known as the "golden section."[6] More significant, though, is the method of comparison required to make this determination: *anthyphairesis* (reciprocal subtraction), the main subject of the second section of the introduction to this book, which in this context is relevant as a means for determining a common unit between any two magnitudes.

By subtracting the smaller magnitude from the larger one, either once or multiple times, a magnitude equal to or smaller than the smaller of the original pair is produced. This can be repeated as many times as necessary, until a magnitude is reached that "measures" each magnitude of the original pair, and thus serves as a unit—that is, that can divide each of the original magnitudes into an integer number of parts its own length (the unit's length), without a remainder. In the pentagram, as quickly becomes evident when applying this method, the procedure would necessarily continue ad infinitum, since each progressive *anthypharesis* only produces another proportionally smaller pair of magnitudes in the same relation to each other: the golden section.[7]

In the realm of *technē* (technical practices, i.e., the arts), the place where *anthyphairesis* was apparently of greatest use, and where its implications were probably first explored, was not the art of geometry but that of music. The period leading up to the time of the Parthenon, the later sixth and early to middle fifth centuries, was the one in which the ancient Greek musical scales—and in fact, the entire harmonic system of Greek music—were developed, and probably canonized, though the oldest surviving written sources apparently postdate the construction of the Parthenon by one or two generations.[8] Just as we will see in the analogous case of architecture (with the design of the Parthenon), the invention of a system of harmony, and of the musical scales on which to found it, was a thoroughly constructive process. And furthermore—and this is the key point—it was a constructive method by which theoretical questions were addressed in a specifically technical sense (not just in terms of *technē*, but more specifically of craft), viz., through the manipulation of physical, material reality. In music, that technical procedure was the division of a string, the *monochord*, stretched over a measuring device known as a *kanon*.[9] By allowing only parts of the string to vibrate—parts relating to the whole by various integer ratios—a range of pitches and the relationships among them could be produced. The crucial point for our discussion here is the following: this was not just a means of producing a specific set of musical scales and harmonies that could be used in performance, nor was it just a means of laying down the principles of Greek music theory, though it was that as well. Indeed, as Szabó has argued, it was, in addition, probably through experimentation with the *monochord* and the *kanon* that the most advanced, unsolved mathematical problems could first be addressed.[10]

In other words, the *technē* of music, as constructive procedure, laid the foundations for more fully abstracted approaches to mathematics: late archaic and early classical music theory was a kind of mathematical avant-garde.[11] As a philologist, Szabó traces the origins of Greek philosophical

terms as a means of understanding the origins of Greek philosophy. To give just one crucial example: in Pythagorean music theory, the part of the monochord kept from vibrating, thus creating a relationship between two pitches, was known as a *diastema*, but when referring to the two numbers themselves defining the lengths of string thus produced, the term *logos* was also used.[12] And here the status of this specific musical practice as philological root for the fully abstract and properly philosophical term for rationality in the Greek tradition is particularly revealing. What Szabó is claiming, and what the Parthenon corroborates (as we shall see), is the idea that Greek mathematical and meta-mathematical thought, and even philosophical thought, were born from the marriage of the technical and the theoretical—that is to say, in the realm of the procedural (what we could call "workshop practice") and, importantly, of the procedural as the manipulation of material reality, that is, as *craft*.

As may be evident from the above description, the specific method relevant to the construction of the Greek musical scale was *anthyphairesis*. Indeed, the basic, and certainly earliest,[13] harmonies in Greek music—the *diapason* (octave; a ratio of 2:1), *diapente* (fifth; 3:2), *diatessaron* (fourth; 4:3), and *tonos* (whole tone; 9:8)—can be generated, one from the other, on the *monochord* and *kanon* through repeated application of *anthyphairesis*. The *diatessaron* is produced when the *diapente* is subtracted from the *diapason*; the *tonos*, in turn, is the remainder when the *diatessaron* is subtracted from the *diapente*. It was the further division of the *diatessaron* by the *tonos* that raised the first problem; and indeed, this interval of the *diatessaron*, also known as the tetrachord, became the basic module that, when divided in various ways, engendered the entire range of Greek scales and genera.[14] Subtracting two whole tones (*tonoi*) from the *diatessaron*/tetrachord leaves a remainder of 256:243, no longer such a small number ratio, and furthermore not one that divides the *tonos*, or others among the principal intervals, into equal parts. In fact, the next step seems to have been to subtract this interval of 256:243, called the *leimma* by the Pythagoreans, from the *tonos*, leaving another interval as remainder: the *apotome*, at 2,187:2,048 a bit larger than the *leimma*. After subtracting another *leimma* from the *apotome*, the Pythagoreans arrived at the famous *comma*: 531,441:524,288. The evidence for these intervals goes back to the surviving fragments of the Pythagorean mathematician Philolaus, most importantly fragments 6 and 6A, dating probably from the mid-fifth century—texts, that is, that are more or less contemporaneous with the construction of the Parthenon.[15]

Without getting further into the specifics of fifth-century harmonics, which is beyond the scope of this project, it is crucial to note two points here. First, if the principal intervals down to the *tonos*, noted above,

predated Philolaus and the fifth-century Pythagoreans, for which there is some evidence,[16] one can see in the pursuit of further subdivisions outlined above, effectively, the desire to find a common unit to measure the scale, or, in other words, to subdivide the octave. The *comma*—which we arrived at just above by a different construction (the one recorded in Plato's *Timaeus,* probably following Philolaus[17])—is in fact also the remainder when six whole tones are subtracted from the *diapason* (octave). It is effectively the little bit left over that does not quite fit when the octave is divided into six whole tones. This gives the comma a particular significance, as the irreducible but relatively negligible remainder of an attempt to subdivide the octave into equal parts, which may help explain why no intervals still smaller than the *comma* were canonized. *Anthyphairesis* could have produced those smaller intervals, but perhaps the approximation of six tones to an octave, and the problematic remainder produced, represented the stage at which the presence of the irrational and its ontological significance began to emerge most clearly, at least to intuition, in the context of musical harmonics.

This leads to the second main point: it should be clear that the method used to construct scales—a repeated application of *anthyphairesis*—is precisely the one von Fritz describes as that applied to the pentagram in the discovery of the irrational. The difference, however, is that *anthyphairesis* in this musical context does not produce a recursive series that can be understood to continue ad infinitum and thus *prove* the existence of the irrational. Nevertheless, it clearly suggests the same ontological problem, inductively. And given that the analysis of the pentagram, the construction of the Pythagorean musical scale, and the development of *symmetria* and, more broadly and still more significantly, *harmonia* (harmony) in Doric architecture were all happening concurrently in the mid-fifth century Greek world, there must have been a sense that the demonstration of incommensurable magnitudes in the pentagram, the impossibility of dividing the octave perfectly into tones, or in fact into any number of equal intervals, and the irreducibility of actual Doric temples to perfect *symmetria*, specifically with respect to the elements at the corner, were all converging on the same problem: the relationship of ratio (or *logos*) to the irrational (the *alogon*).

The distilled essence of the "division of the octave" problem—the question of how to divide the octave into two equal parts, which is unsolvable by *anthyphairesis* for the same reason that its division into any number of equal parts is—is conceptually equivalent to the problem from plane geometry discussed in Plato's *Meno*,[18] and probably also current in fifth-century Athens: determination of the ratio between the side

and diagonal of a square. In modern terms, we would say the solution to both problems is the square root of two; and in the musical system of equal temperament, canonical since the seventeenth century, six semitones, or half the octave, is indeed precisely equal to the square root of two.[19] However, in the context of fifth-century Greek mathematics, in which numbers are by definition positive integers and a true ratio (a numerical ratio)[20] can only properly be a relationship between two such numbers, and for which the means for determining such relationships was *anthyphairesis*, the ratio of the side and diagonal of the square was the emblematic unsolvable problem, a meta-mathematical emblem that pointed toward a mysterious, perhaps unknowable condition of being, the *alogon*. To be sure, mathematical theory and religious, or metaphysical, speculations were never separate within the Pythagorean tradition. But more to the point here is the following: if these very questions were indeed the constitutive ones in the design of the Parthenon, as we will be discussing it below, they were certainly not addressed independently of religious or philosophical questions—that is, questions of being or of truth. One could hardly imagine that these mathematical issues would have been pursued at such length in the principal religious structure in fifth-century Athens, a temple dedicated to the city's patron goddess Athena, if they were not thought to have metaphysical, indeed sacred, import.[21] As a whole, the three chapters that constitute part II hope to show, among other things, that the connection of mathematical problems—centering on ratio and the irrational—to philosophical questions is not just one of coexistence within fifth-century Athenian culture, but of derivation. Indeed, it is the specific character of the engagement with such questions, of *logos* and the *alogon*, across "disciplines," or arts (*technike*)—arithmetic, geometry, harmonics—that gives rise to thought: thought that has a character we could call philosophical, and more specifically, *dialectical*.[22]

2. *Symmetria* and the Doric Order

The Parthenon (figures 4.1 and 4.2), built between 447 and 432 BCE, was the principal civic and religious monument of Periclean Athens. The temple was made of local Pentelic marble, and its design is attributed in surviving documents to two architects, Iktinos and Kallikrates.[23] Rebuilt after the sack of the Acropolis by the Persians in 480 BCE, but only after a period of more than thirty years during which the fragments of its predecessor, known now as the "Older Parthenon," remained *in situ*,[24] the Parthenon was not only an embodiment of the city's cult practices,

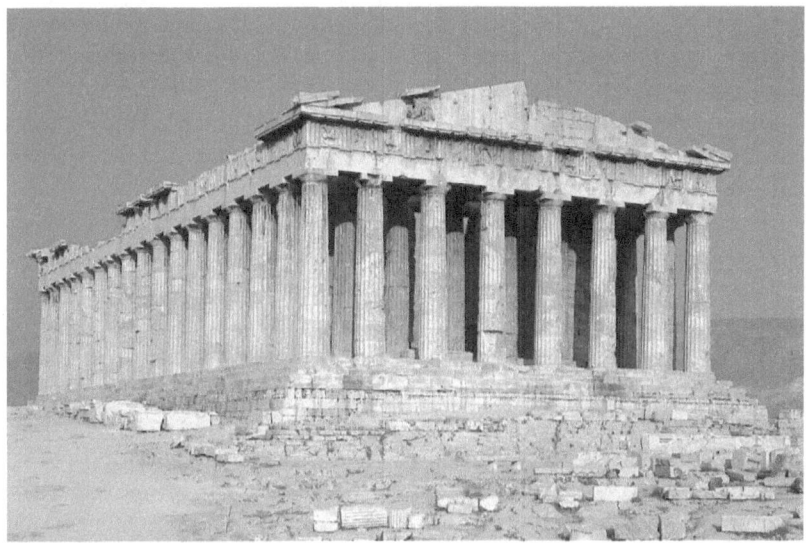

Figure 4.1. The Parthenon, Athens (447–432 BCE): view from the northwest. Source: StudyBlue.

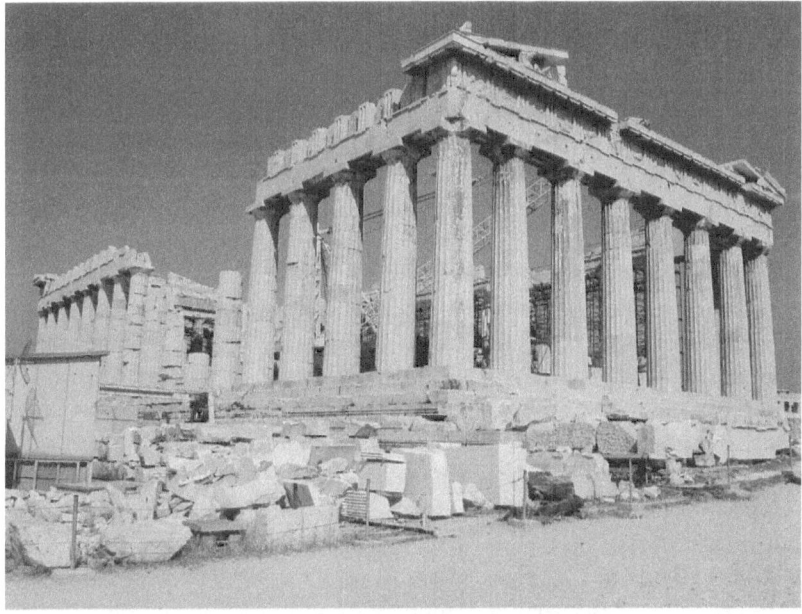

Figure 4.2. The Parthenon: view from the southeast. Photo by Peter van der Sluijs.

civic aspirations, and self-image; it also constituted a focal point for its creative and productive energy and, most relevant for the topic of this study, its intellectual culture.[25] The construction of a building of such ambition within the span of fifteen years indicates an extraordinary concentration of resources, thought, attention, and passion. Indeed, a large part of the population of Athens must have been involved in the design, construction, or decoration of the Parthenon, in some form or other: it was without doubt a collaborative project for the city and its citizens of a rather unique sort, whether those contributing were involved in cutting or carving stone, making tools, carrying materials, designing the structure, advising on the needs for cult practice, or any number of other functions.[26] The important point being that one very real foundation for the extraordinary, even organic, unity of the building must actually have been the breadth and diversity of participation in its design and construction, the daily collaboration of architects, mathematicians, sculptors, stonecutters, and numerous others. This historical framework, however schematically sketched, should also make clear that the notion of an intellectual collaboration between "disciplinary specialists" in architecture, mathematics, music, and sculpture is not only feasible, in the case of the Parthenon, but seems inevitable. Over the course of our discussion, this claim will be addressed through a close reading of the building itself, but it will be helpful always to keep its historical and civic context in mind.

As only one (albeit the most important) among a group of fifth-century temples on the Athenian Acropolis (figures 4.3 and 4.4), the specific character of the Parthenon's dedication and function is worth considering carefully, in relation to the aesthetic, intellectual, and (as we will see) even ontological character of the building itself. It was dedicated to Athena Parthenos,[27] and its sculptural iconography—from the enormous cult statue in the cella to the stories on the pediments and the Ionic frieze—is dominated by the figure of Athena, patron not only of the city of Athens but also of wisdom, craft, and warfare. Therefore, it should not be surprising if a temple devoted to a goddess who combines *sophia* (wisdom) and *technē* (art, or craft), and thus embodies practical forms of wisdom such as prudence, should be precisely the site where theoretical and practical questions are conceived and addressed together. Indeed, the notion that issues in theoretical mathematics regarding magnitude and multitude, *logos* and the *alogon*, were most thoroughly raised not in isolation but in and through the construction of an actual building seems entirely consonant with the religious meaning of a temple dedicated to Athena Parthenos, patron of practical wisdom. Furthermore, if in fact the building engages mathematical and musical problems in its design and construction

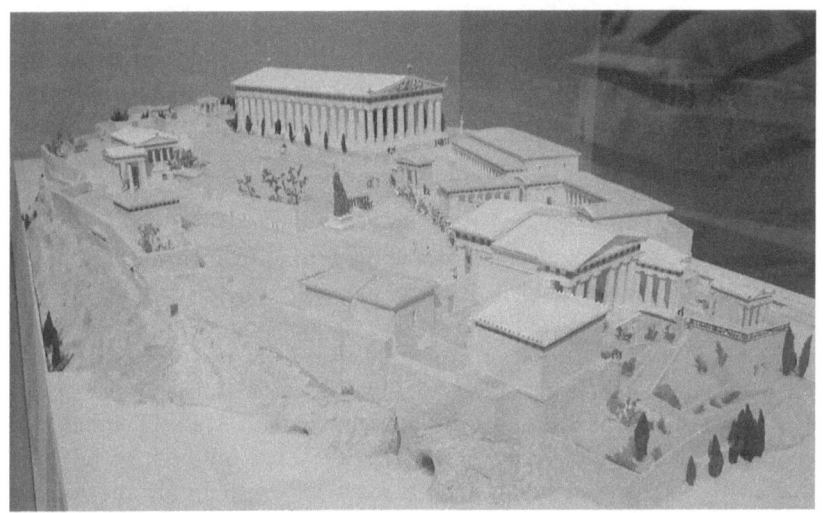

Figure 4.3. Model of the Acropolis as it looked around 400 BCE (Royal Ontario Museum, Toronto). Photo by InSapphoWeTrust.

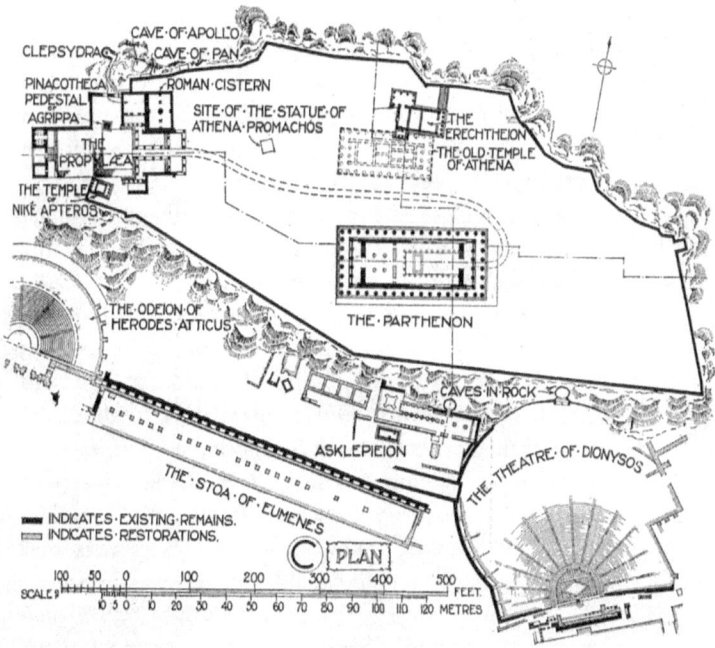

Figure 4.4. Ground plan of the Acropolis in the fifth century. Source: Penn State University Library.

(precisely analogous to the same process in the development of musical harmonics), methodologically deconstructing the very notion of a strict separation between theory and practice, it also does so self-reflexively. And this open-ended form of pedagogy is entirely appropriate to the *civic* function of the building, its ongoing dialogue with the citizens of Athens—a dialogue that is not only, but ultimately always, pedagogical, whatever else it may be.

The theoretical and practical question around which the Parthenon and its design are oriented is first and foremost that of harmonics. What we intend here, with the analogy to the construction of musical scales in mind, could be understood primarily in relation to two Greek theoretical terms that will be the focus of our discussion: *harmonia* (harmony) and *symmetria* (proportionality, or commensurability). We will address the etymology and uses of *harmonia* further below, but suffice it to say here that in its core meaning of "joining together"—specifically the joining together of things that are fundamentally different to make a whole, like the rim and the spokes of a wheel[28]—harmony is ultimately perhaps the most important idea to inform the spirit and meaning of the Parthenon. Indeed, the Parthenon not only relies on an impression of unity for its sense of coherence and beauty, it also integrates sculptural decoration into the architectural design in the most thorough way, and even joins elements and aesthetic principles from both the Doric and Ionic orders.[29] And furthermore, it actually combines design principles from both mainland Greece and the western colonies. Aesthetically and even thematically, harmony is clearly an overriding concern of the Parthenon, but also, and more significantly still (as we will see below), it is primarily through *harmonia* that the building's design engages philosophical and dialectical thought.

One can even see here an embodiment of a further trait of the virgin goddess Athena, namely her warlike character: indeed, the tensions, and conflicts, between opposites play out everywhere in the building. This occurs most strikingly perhaps in the joining of vertical column and horizontal lintel, with the characteristic Doric capital that mediates between the two, and in so doing articulates the tension that defines harmonics (figure 4.5). But it is also emblematized at the level of the frieze just above in the metopes, the great majority of which (from what we can see in their ruined state) depict pairs of opposing figures locked in battle (figure 4.6 on page 72). As we have seen in the introduction and earlier in this chapter, following on the discovery of incommensurability *harmonia* must surely have been among the most profound and even sacred of problems for the fifth-century Athenians, a problem concerning the nature of being and of truth. And the constructive and conceptual means by which the Parthenon approaches the problem of *harmonia* lie in the relationship of

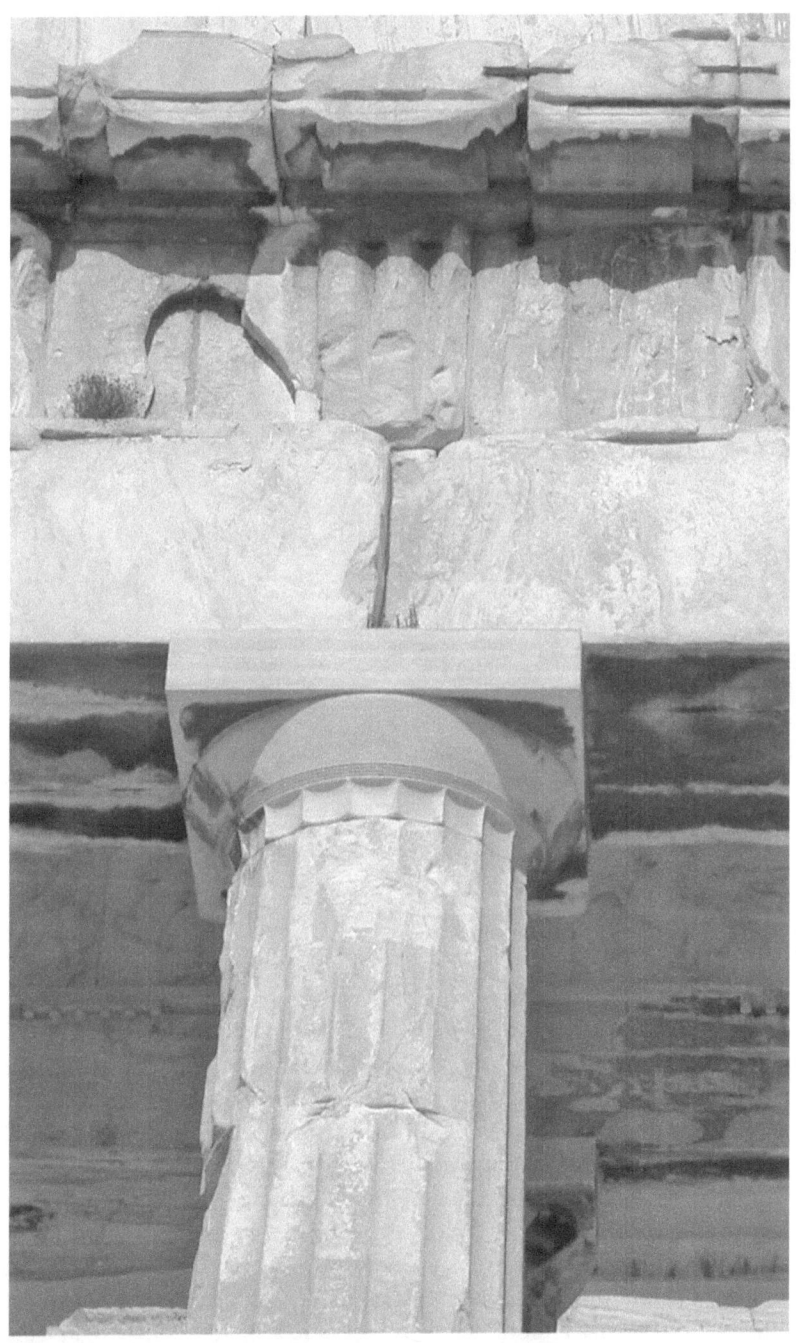

Figure 4.5. The Parthenon: column capital and entablature, west façade. Source: Creative Commons.

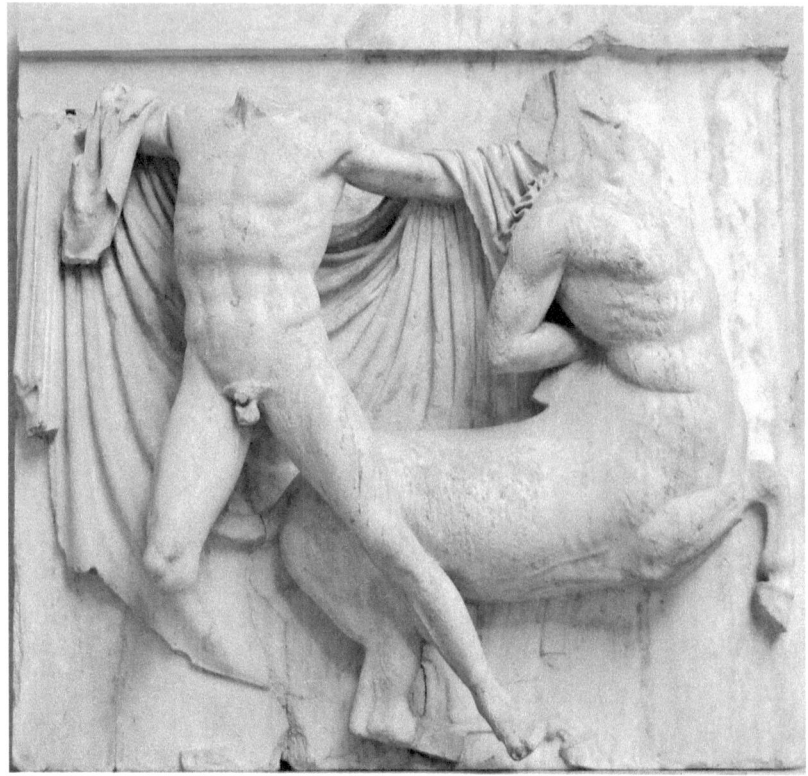

Figure 4.6. Battle of a Lapith and a Centaur: metope from the south flank of the Parthenon. Photo by Marie-Lan Nguyen.

proportional parts, in the numerical and also *musical* relations of architectural elements to each other: in other words, in *symmetria*. It is with the Parthenon's pervasive and extraordinary engagement with *symmetria*—intellectual, aesthetic, and artisanal—that we will begin our consideration of the building's harmonics. As we do so, it is of great importance to recall that the systematic concern for *symmetria* is not only a mathematical, musical, or technical field of engagement, but always also one with both sacred (ontological, metaphysical) and epistemological resonances.

The development and gradual canonization of the Doric order for the architecture of Greek temples is in many ways the development, in concrete and visible terms, of a system of *symmetria*. Doric is characterized by relationships between repeating sequences of similar elements at different scales—most prominently, the columns of the peristyle and the triglyphs of the frieze above—that lend Doric buildings a part of their

THE PARTHENON AND THE MUSICAL SCALE

"organic" quality: like the members of a body, the smaller elements relate to the larger ones both numerically and formally, all contributing to the being and to the beauty of the whole (figure 4.7; see also appendix C). While the Ionic is characterized by a decorative and graceful continuity (figures 4.8 and 4.9 on pages 74 and 75, the latter a capital from the Erechtheion), the Doric presents, by contrast, a coordination of separate,

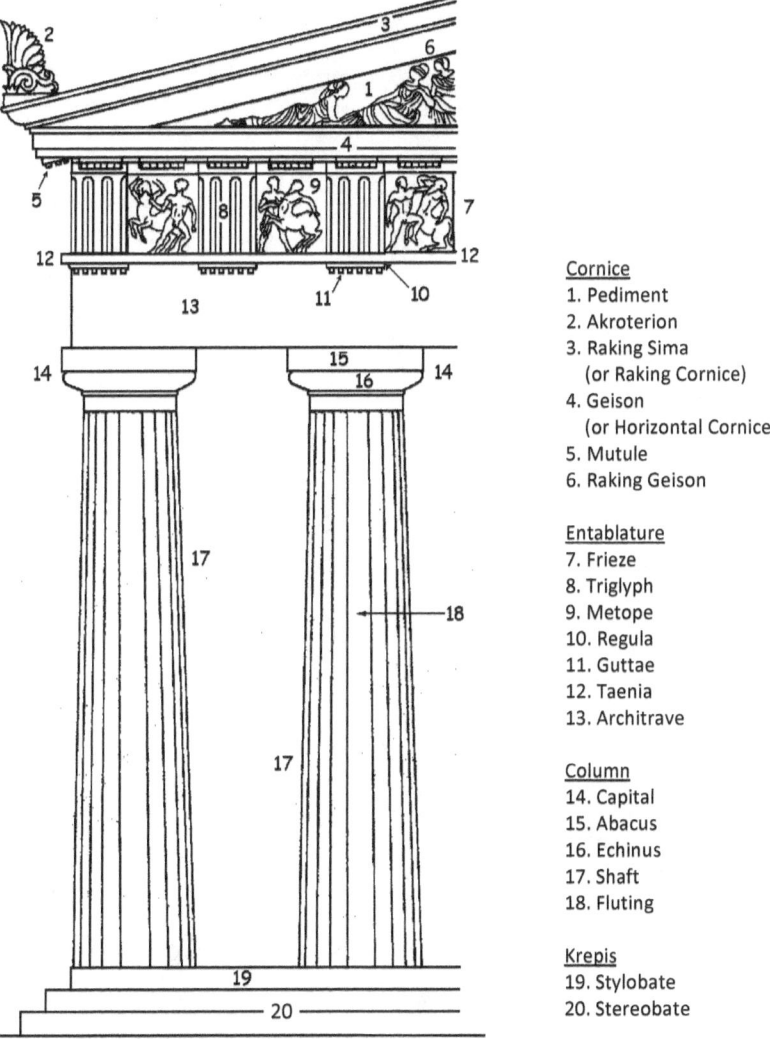

Cornice
1. Pediment
2. Akroterion
3. Raking Sima
 (or Raking Cornice)
4. Geison
 (or Horizontal Cornice)
5. Mutule
6. Raking Geison

Entablature
7. Frieze
8. Triglyph
9. Metope
10. Regula
11. Guttae
12. Taenia
13. Architrave

Column
14. Capital
15. Abacus
16. Echinus
17. Shaft
18. Fluting

Krepis
19. Stylobate
20. Stereobate

Figure 4.7. Diagram of the Doric order as it appears in the Parthenon. Drawing by Napoleon Vier.

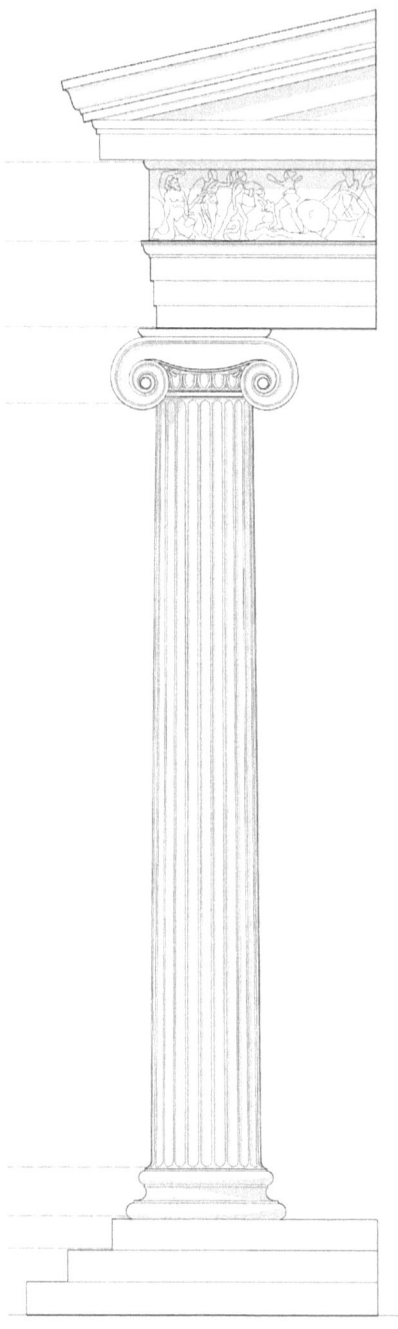

Figure 4.8. Diagram of the Ionic order. Source: Creative Commons.

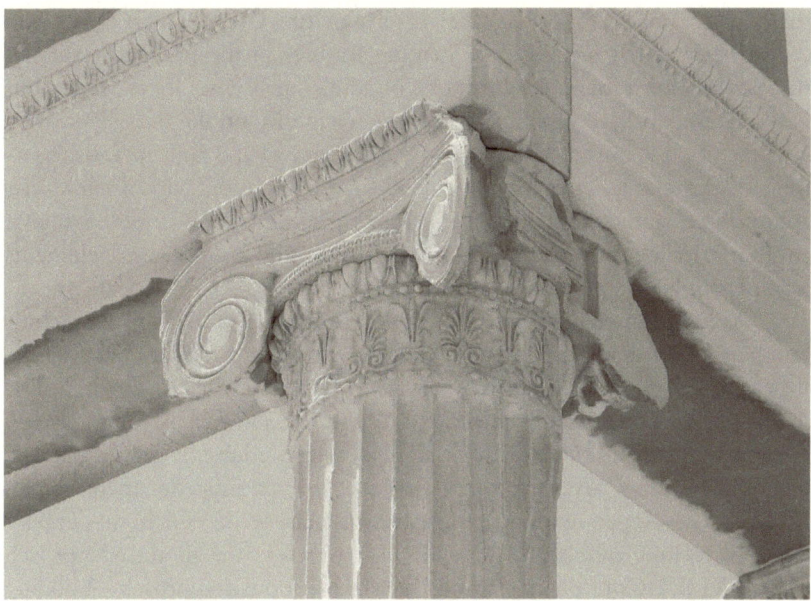

Figure 4.9. Erechtheion, Athens (421–406 BCE): Capital and architrave from the east façade. Photo by Guillaume Piolle.

well-defined elements; Doric architecture creates unity through disjunction and controlled juxtaposition among a countable number of discrete, formally precise parts.[30] In Greek art, and certainly in Greek art criticism, the notion of an aesthetics based on the proportional relationship among such discrete parts within an individual work of art—for which the Greek term is *symmetria*—is primarily associated with the sculptor Polykleitos, an exact contemporary of Pheidias, the chief sculptor of the Parthenon, and his workshop. And yet, as we will discuss in chapter 5, Polykleitos's (now mostly lost) theoretical discussion of *symmetria*—and, more importantly still, its embodiment in his sculptural works—may have been based on lost architectural treatises, and thus on principles of proportionality and of aesthetics that were modeled on the organic unity of the human body, but developed in architecture.[31] If so, it is not just Greek architecture generally that is relevant here, but, once again, the specific "harmonic"[32] character of the Doric order. We will not be able to do justice to the complexities of the historical processes and the range of contributing factors that led to the emergence of the characteristic forms of the Doric between the seventh and fifth centuries; Mark Wilson Jones has discussed

them in his recent book on the origins of the Greek orders.[33] We will only briefly touch on the most striking features in the proportionality of the Parthenon's crucial predecessors, building on Wilson Jones's assertions both of the formal significance of the elements of the Doric, as they converged on a canonical form toward the end of the archaic and beginning of the classical periods, and their firm association with a *constructive* approach to architecture, where the literal placing of one stone on top of another parallels the juxtaposition of discrete and proportional elements as a principle of aesthetics.[34]

As has been well discussed in recent scholarship on Doric architecture, building practices of the classical period (at least up until the end of the fifth century) were characterized by a modular approach to design.[35] The defining characteristics of the order, as discussed above, make immediately evident why the Doric lends itself so readily to modular design; or perhaps it would be more accurate to say that the characteristic design principles of Doric developed within an intellectual culture in which the importance of relating number to geometric form made the modular approach inevitable. J. J. Coulton has argued that the modular approach—building up an entire design, in terms of an overriding *symmetria*, based on a well-defined starting unit, or module—was specific to the archaic and classical periods, and that already by the fourth century, and even more so in the Hellenistic and Roman periods, there was a shift to the use of plan and elevation drawings. He also contends that both plan and (more rarely) elevation drawings were known and sometimes used much earlier, in Egypt and Mesopotamia.[36] Thus bracketed by its conceptual alternative, in which the entire building can be projected in relation to a more abstract scheme, and even a grid,[37] the modular approach of archaic and classical Greek temple design takes on even greater significance. For it indicates a consonance between developments in Greek mathematics and music theory and the evolution of the Doric order: they appear as parallel, and presumably even interdependent and collaborative, historical developments. To clarify: the chronological bracketing of the modular approach within the Greek tradition, as something specific to the sixth and fifth centuries in contradistinction to both the preceding and following periods, makes evident the contingency and intentionality of the choice for modularity as a design principle, appearing as it does at a time when alternative methods would have been well known. Indeed, to design an entire temple in relation to a basic module, or a group of them, brings to the fore the classical period's preoccupation with the magnitude-multitude problem, specifically its concern with measuring geometric quantities in terms of units, since the unit in mathematics is precisely analogous to (indeed, conceptually

identical to) the module in architecture. Some of the implications of the modular approach that are specific to the Parthenon will be discussed below.

As Dieter Mertens, among others, has pointed out, the more explicit resonances between mathematics and architecture—and specifically between the Pythagorean tradition and Doric temple design—seem to occur first in Sicily and South Italy, where a number of the most important Pythagoreans were based—most notably the Pythagorean school in Croton—between the end of the sixth and the beginning of the fifth centuries.[38] There has been significant scholarly discussion in recent decades about the role of Pythagorean musical and mathematical ideas in the design of the Temple of Athena at Paestum (figure 4.10), in particular, a building that dates to the last decades of the sixth century.[39] In Mertens's view, the Athena temple is the main predecessor for what he calls "*die rationale Baukunst*" (a rational art of building; or, rational architecture) of the fifth century, that is, the conception of the whole in terms of small number ratios, and thus of *symmetria*. Many of the principal dimensions of the temple are related to one another in terms of small number ratios: most notably, the stylobate is in a 7:3 proportion, while the façades have a width to height relation of 2:1. Furthermore, the temple has equal intercolumniations (façades and flanks), and the 7:3 ratio appears again as the height

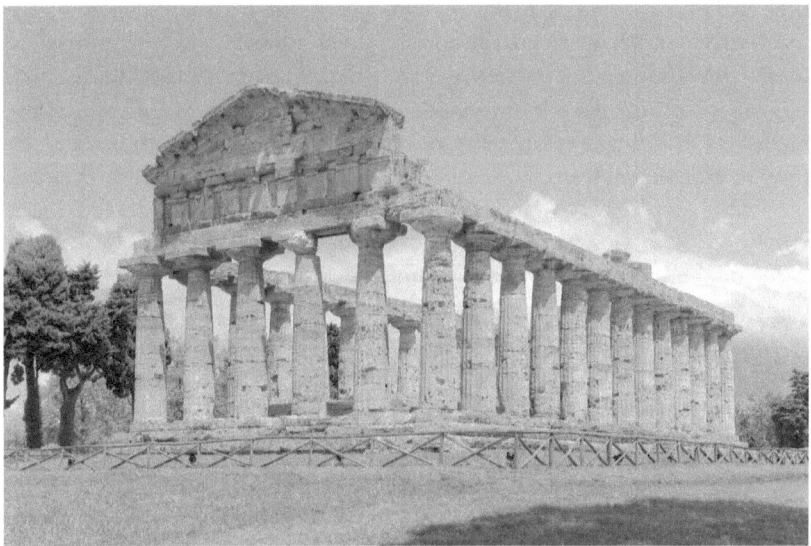

Figure 4.10. The Temple of Athena, Paestum (late sixth century BCE): view from the southwest. Photo by Berthold Werner.

of the peristyle columns in relation to the intercolumniations, while the triglyphs are proportioned by a 5:3 ratio of height to width.[40] The presence of particular numbers thought to have special importance in Pythagorean circles has struck some scholars as significant as well, particularly the idea that the building's stylobate is exactly 100 Doric feet in length, divided up by 8-foot intercolumniations, although such calculations rely on assumptions about the foot unit being used in the building.[41] In our view, the crucial point is not that the Athena Temple's design involved embedding specific symbolic numbers in the building's literal foot measurements (even if that was the case),[42] but rather the emergence of rational design techniques (again, Mertens's "*die rationale Baukunst*"): it is the *relations* between magnitudes that generate small number ratios, and thus reveal at least a partial *symmetria,* that are particularly significant here. If there was a dialogue between the Pythagoreans of Croton and the builders at Paestum, it is evident above all in the concern for ratios in the architecture, that is, for numerical relations between magnitudes, and thus for a relationship between multitude and magnitude—just as in music, where the ratios of string lengths, irrespective of the actual length of any given string, determine the harmonics of the musical scale.

The development of "rational design techniques"—of *symmetria* as a characteristic of Doric design—between the end of the sixth century and the middle of the fifth century establishes the tradition within which the Parthenon inscribes itself. We will not be able to consider here the individual temples in this tradition and their innovations with respect to proportional design;[43] however, a glance at the larger picture indicates the way in which the Parthenon draws together a number of different intersecting strands, manifest in temples both in the western colonies and on the Greek mainland. In Sicily, following the Temple of Athena at Paestum, the Temple of Victory at Himera (probably built shortly after 480 BCE) employed two ratios that would become important in later temples as well: a 5:2 dimension for the stylobate, and the crucial 3:2 ratio of metope to triglyph in the frieze.[44] Simultaneously, and in an inextricable relationship with the overall concern with *symmetria*, the approach to the famously problematic articulation of the corners in these temples (the "corner problem": the subject of chapter 5) began to involve more complex mutual adjustments.[45] Double corner contraction—the reduction of the intercolumniation measurement for the last two intercolumniations at each corner—was introduced at Himera and further developed, almost contemporaneously, in the Temple of Athena at Syracuse (dating also to the period immediately following the battle of Himera in 480 BCE), in conjunction with widening of both metopes and triglyphs at the corners. In the Athenaeon at Gela (ca. 470 BCE), the cubic dimensions of the building were projected as a

continuous proportion of 25:10:4, a crucial precedent for the Parthenon and its use of continuous proportion to define the building as a whole. The Temple of the Athenians at Delos provides an even more proximate precedent, with the prominent use throughout its design of the ratio 3:2 (the basis for the Parthenon's principal ratio of 9:4), including in its stylobate dimensions and the width-to-height ratio of its façades, giving the building a cubic volume in the continuous proportion 9:6:4.[46] And, as Mertens has argued, this increasing emphasis on *symmetria* in design would culminate in the fully realized proportionality of the classical temples of Akragas: the Temple of Hera Lacinia (figures 4.11 and 4.12) and the Temple of Concord

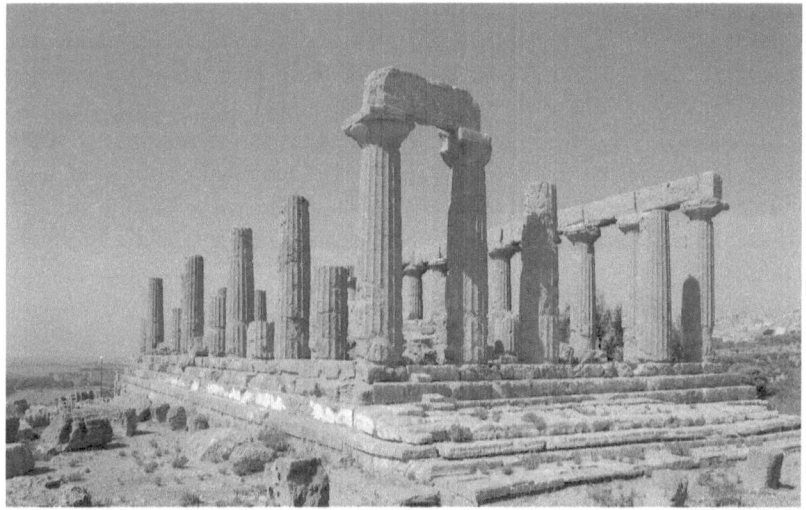

Figure 4.11. The Temple of Hera Lacinia, Akragas (begun ca. 460 BCE): view from the southeast. Photo by Berthold Werner.

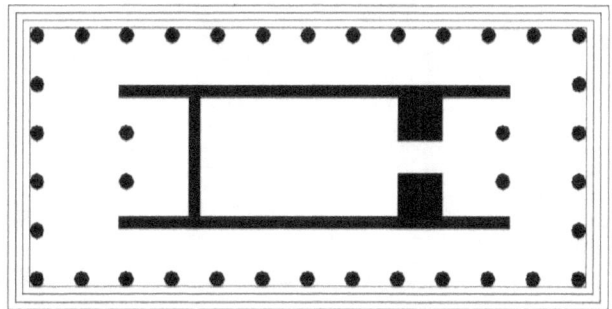

Figure 4.12. The Temple of Hera Lacinia, Akragas: ground plan. Drawing by Bernhard J. Scheuvens.

(figure 4.13), the former being the Parthenon's most immediate predecessor (begun around 460 BCE), the latter an almost exact contemporary. It is in the Temple of Hera Lacinia that we find not only the well-established metope to triglyph ratio of 3:2, but also the Parthenon's defining (also musical) ratio of 9:4, in the dimensions of the stylobate and in the spacing of the intercolumniations.[47]

On mainland Greece, the Parthenon's principal predecessor was the Temple of Zeus at Olympia, begun ca. 457–56 BCE (figures 4.14 and 4.15). There the entire building, both interior and exterior, is governed by the predominance of a single significant ratio, 2:1, for which a modular unit—the floor tile—functions as both a constructive (practical) and visible (rhetorical) module for the temple's continuous proportion of 16:8:4:2:1.[48] Here one sees the geographical diversity of the comingling strands that the Parthenon is "drawing together," the sense that this is an ongoing dialogue across the Greek world: the Parthenon develops the continuous proportionality of the proximate Temple of Zeus at Olympia, but with the incorporation of the 9:4 ratio prevalent in the intervening, but more geographically remote, Temple of Hera Lacinia at Akragas, all within the span of a couple of decades. At the same time, it builds on—whether through

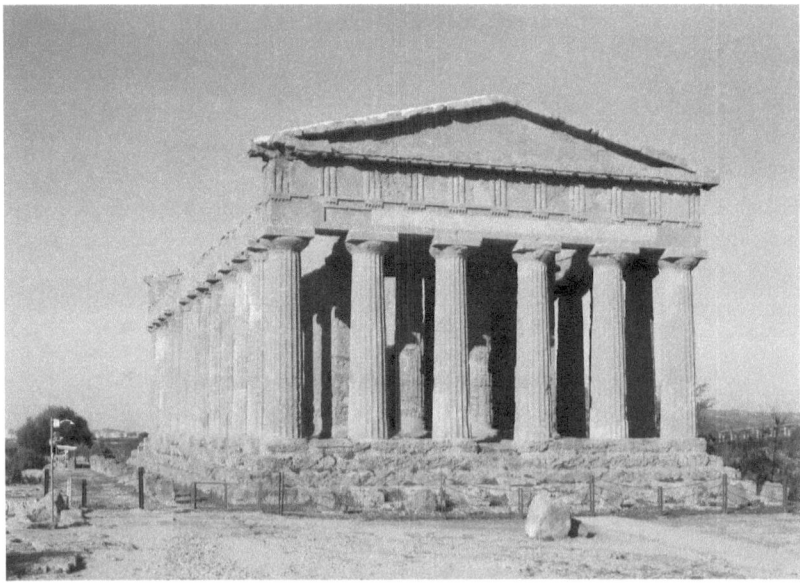

Figure 4.13. The Temple of Concord, Akragas (begun ca. 440 BCE): view from the southeast. Photo by José Luiz Bernardes Ribeiro.

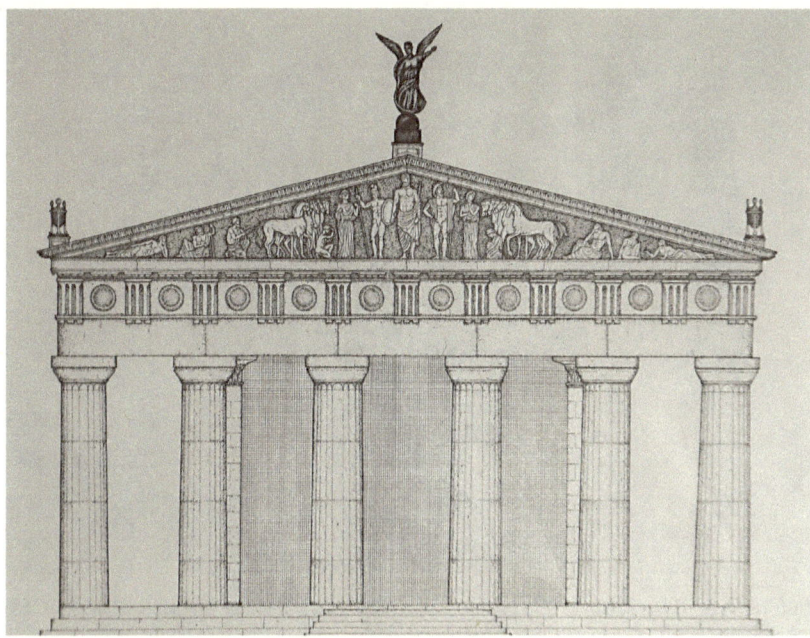

Figure 4.14. The Temple of Zeus, Olympia (begun ca. 457–56 BCE): east façade elevation. Drawing by Mauro Cateb.

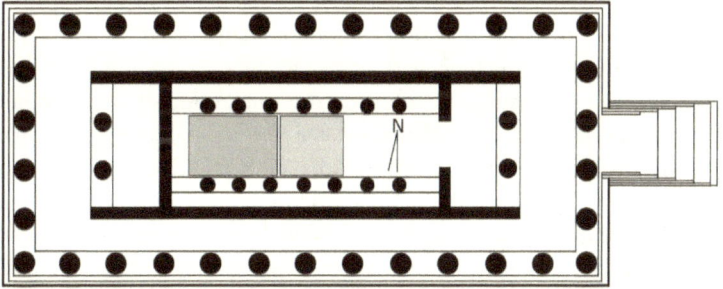

Figure 4.15. The Temple of Zeus, Olympia: ground plan. Drawing by Tusculum.

direct influence, or as a parallel development—the complex approach to the corner problem evident in the Temple of Hera II, or Poseidon (as it is more traditionally known), at Paestum, begun around 460 BCE (figure 4.16 on page 82), with its combination of double column contraction and a series of reciprocal adjustments to the metope and triglyph widths, that itself seems directly based on the approach to the corner problem in

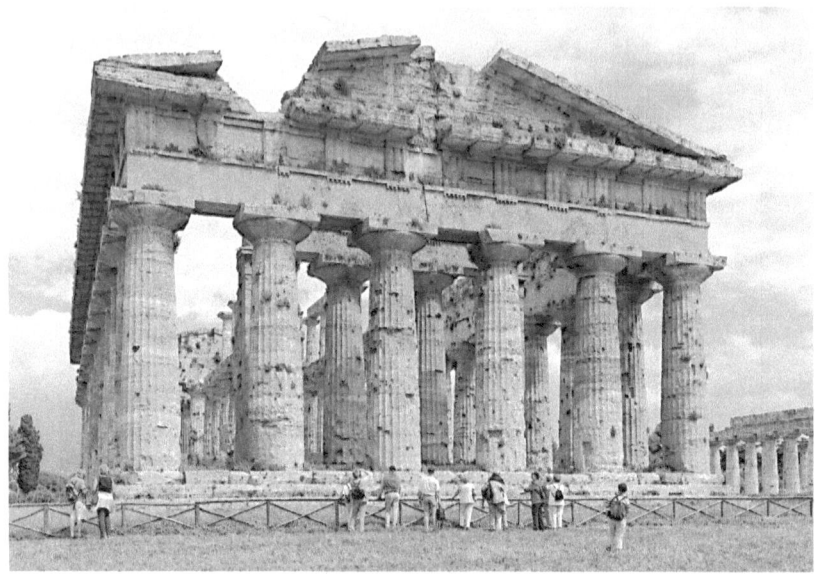

Figure 4.16. The Temple of Poseidon (or Hera II), Paestum (begun ca. 460 BCE): west façade. Photo by Berthold Werner.

the Temple of Zeus at Olympia (and going back to the development of these crucial innovations at Himera and Syracuse, as discussed above).[49] Likewise, many of the principal refinements that are so important to the Parthenon—the inclination of columns, the thickening of corner columns, and the curvature of the building[50]—have the local Temple of Aphaia at Aegina (figure 4.17), dating to around the 490s BCE, as a source. Indeed, it is in the Aegina Temple that the refinements, in conjunction, seem to have first appeared in a more or less fully realized form (see chapter 6, introduction). Yet almost contemporaneous with the Temple of Aphaia—most likely in the years immediately following its construction—the refinement of curvature is used at the Temple of Athena at Syracuse which, as mentioned above, is also a site where a more complex approach to the corner problem is developed, in conjunction with its participation in, and development of, the nascent tradition of a rational approach to design—that is, of an emphasis on *symmetria*—specific to the temples of the western colonies in the preceding decades.

In other words, the crucial point in trying to map out the larger dialogue in which the Parthenon participates is that dialogue's breadth and inclusiveness. To be sure, there is the remarkable *geographical* breadth of

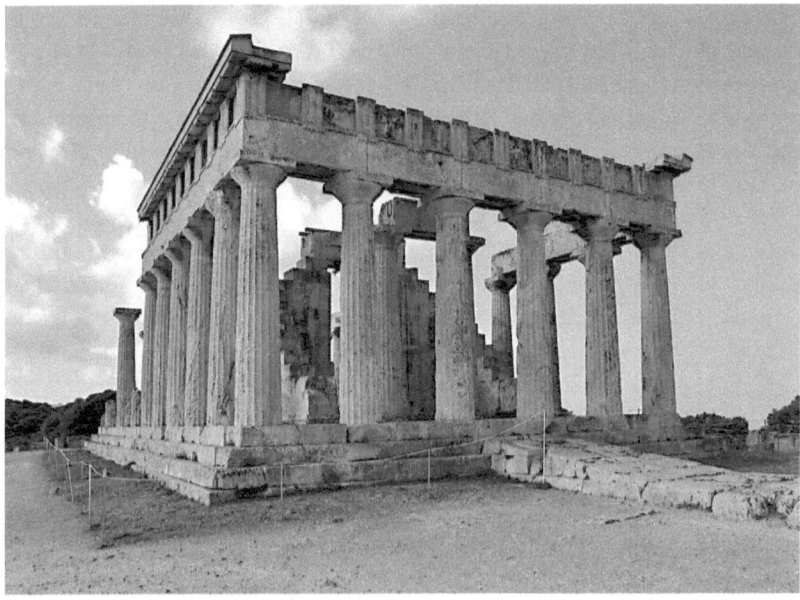

Figure 4.17. The Temple of Aphaia, Aegina (ca. 490s BCE): view from the southeast. Photo by Paweł "pbm" Szubert.

almost simultaneous developments across the Greek world, as well as the "interdisciplinary" breadth of a dialogue among Pythagorean mathematicians, architects, and others. Beyond this, though, we see that the fullest realization of Doric *symmetria* occurs in the integration of design problems as seemingly distinct as the proportionality of stylobate and intercolumniations, the negotiation of the corner problem, and the introduction of subtle refinements, most notably curvature: all these design problems were being worked out together rather than in isolation. The political context for this broad and diverse dialogue—or, one could say, colonial appropriation—was the Athenian empire, in which both the colonies in Sicily and the island of Aegina played an important part,[51] and its manifestation in stone was the fifth-century building program of the Acropolis. If one can see in the Parthenon a dialogue with, or appropriation of, approaches to *symmetria* in South Italy and Sicily as well as at Olympia, a fusion of approaches to the corner problem typical of both mainland Greece and the western colonies,[52] and also a taking up of the "Aegina strand" in its sophisticated use of refinements (most notably column inclination and curvature)—a strand itself also involving dialogue with the western colonies (e.g., Syracuse and Paestum)—one further source for the Parthenon must still

be emphasized here, the one forming its literal, physical foundations: the unused blocks of the planned but unfinished predecessor on the same site, now known as the Older Parthenon. Most important to note here is the physical module the Older Parthenon provided: the given dimensions of the already-carved marble blocks of the column drums. It is characteristic of the Parthenon, and of its integration of theory and practice, of abstract ideas and *technē*—right down to the physical cutting and measuring of individual blocks—that something as conceptual, and also geographically remote, as the Pythagorean-inspired *symmetria* of South Italian and Sicilian temples, and something as physically specific, and locally present, as the individual stones of the Older Parthenon, should both play equally important, and interdependent, roles in the building's design and its realization.

3. Continuous Proportion as Construction

When the rebuilding of the Parthenon finally began in 447 BCE, the actual physical remains of the Older Parthenon—the individual blocks and their proportions—were used as a starting point for the construction of the new building. This is true not only in a material sense but also in a metric one: in particular, a number of the carefully and precisely carved column drums that were to form the bases of the exterior columns, and that sit directly above the stylobate, still survived, and these drums of 1.905m in diameter[53] were used as the foundation of the Parthenon's complex series of interlocking ratios, its *symmetria*.[54] Simply put, the column drums were a kind of pre-existing module from which the proportions of the east and west façades could be determined, and from there, the proportions of the rest of the building.[55] It is worth noting here that the measurement of this module (1.905 m) is close enough to the scale of the human body to be significant—in particular, it more or less corresponds to the length of an average human being with arms extended—whether or not this correspondence was intentional or merely coincidental (cf. figure 4.18, a photograph of Le Corbusier on the Acropolis in 1911). Thus, with the scale of the human body as the module that would be the crucial point of departure for the building's proportions, the entire building can be understood to be built (in harmony with the famous preserved saying of Protagoras) to the measure of man.[56] This is an important point because, regardless of whether there was the explicit intention of scaling the column diameters to the human body (though there may well have been just such an intention), the Parthenon as a whole—as architecture, and as built environment—necessarily relates to its viewers, or worshipers, in

Figure 4.18. Photograph of Le Corbusier on the Acropolis, September 1911. Source: Santiago de Molina.

terms of the body, its scale, and its movements. Thus the building's mathematical proportions are inevitably experienced in a bodily sense, by an embodied, circumambulating viewer (figures 4.19 and 4.20 on pages 86 and 87).[57] As we shall see, the building's *symmetria* can also be understood abstractly, as an object for calculation and (more significantly still) for *thought*, but only in relation to the embodied experience of those same proportions in the physical building, as the architecture and the space it defines interact with a viewer approaching them, moving through them, or standing within them. This necessary connection between the building's properly *phenomenological* character (more than, though grounded in, its merely physical existence), on the one hand, and the abstractions of number and geometry, on the other, has broad ontological implications, which we will address much more fully later in this chapter. For now, it will be crucial simply to keep this connection of embodied experience, in the phenomenological sense, to rational calculation in mind throughout the following discussion.

The Parthenon fully embodies a *symmetria* of continuous proportionality, not only because so many of its measurements were determined by a technical procedure based on the application of identical or related small number ratios at different scales, but also because it presents itself as a

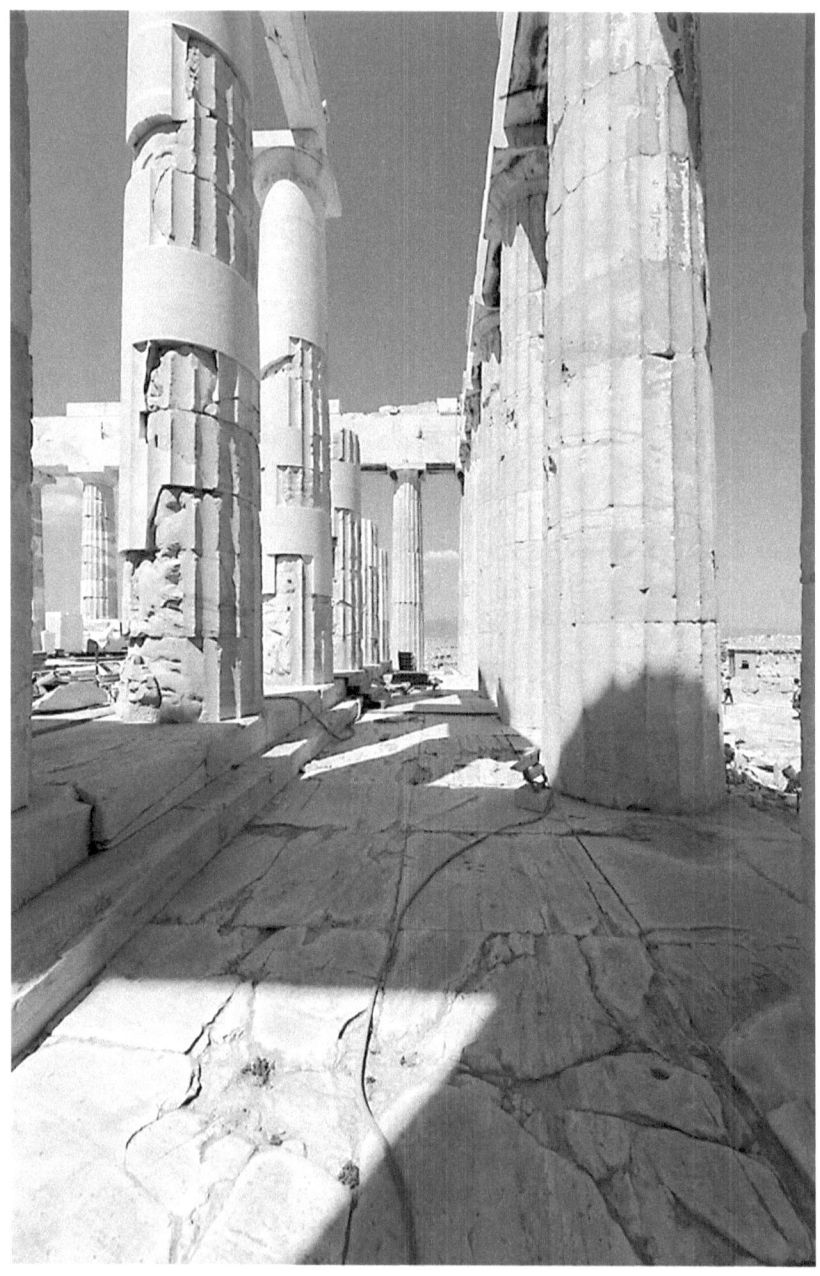

Figure 4.19. The Parthenon: interior of the south peristyle. Photo by Egisto Sani.

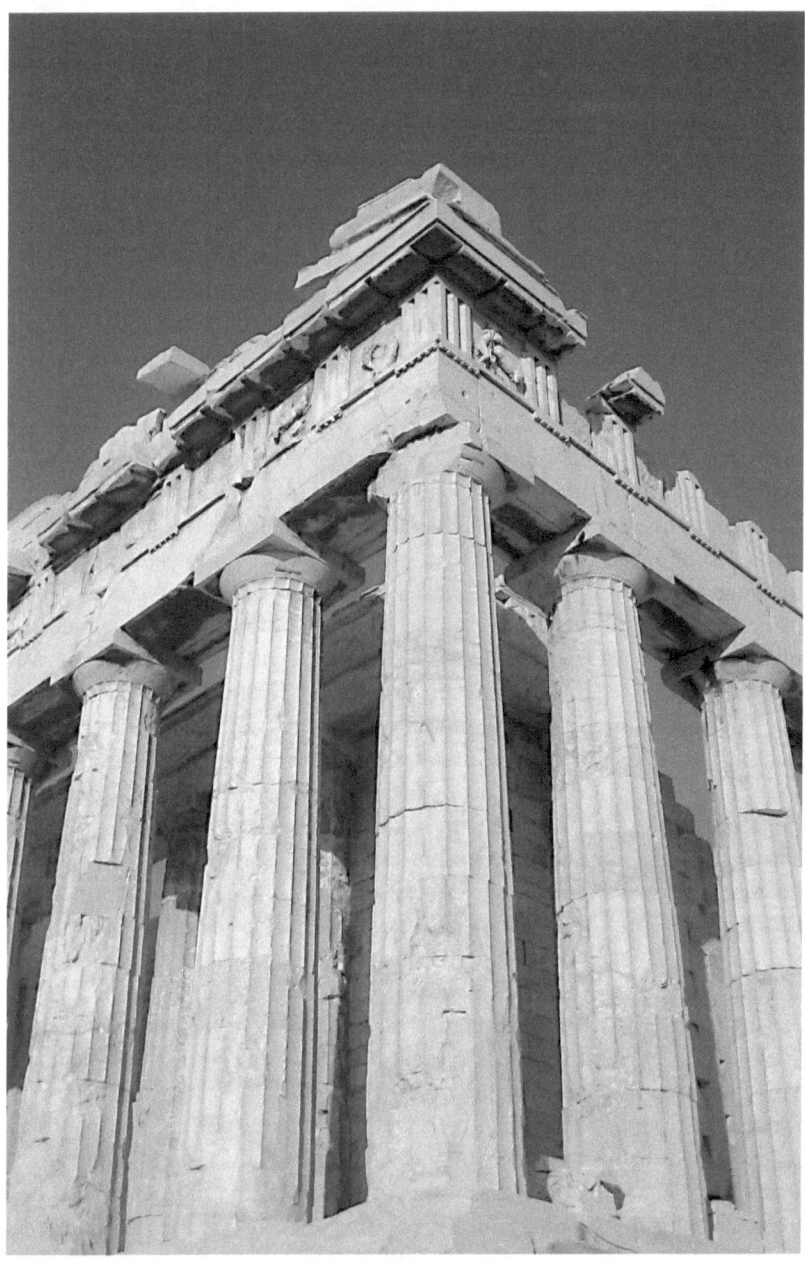

Figure 4.20. The Parthenon: view of the southwest corner. Source: Creative Commons.

thoroughly proportioned whole. It also makes visibly prominent a unit, or module—the triglyph width—that measures all the other magnitudes in the building. In other words, the continuous proportionality of the Parthenon can be understood simultaneously as a practical means of construction and as the demonstration, or manifestation, of a mathematical law (that governing continuous proportion), of the sort that would be fully theorized in writing by Euclid—specifically, in *Elements*, 8.2—a century (or more) later.[58] The crucial point here is that, as with contemporaneous developments in music theory and musical practice, the Parthenon engages mathematical problems through technical procedure (*technē*), problems that would only much later be committed to paper as fully worked out, rigorous mathematical theory. This issue, and what it implies for the teaching of mathematics in the intervening time, particularly in Plato's Academy, have been addressed in part I, but for the moment it is worth stressing, before presenting a hypothetical run-through of the way continuous proportionality may have been constructed in the Parthenon, that the process of determining the relationships among the various magnitudes (namely, the *symmetria*) in the building is always more than a working out of specific, practical problems of construction, though it is that, or even a modification and refinement of the elements of Doric style, with aesthetic goals in mind, though it is certainly that as well. It is also an engagement with (a process of working on) the unresolved mathematical problem of the relationship of small number ratios to the dimensions of a geometric object—of multitude to magnitude—specifically in light of the newly discovered existence of irrational quantities that work on the multitude-magnitude problem revealed (the latter point will be addressed more fully in chapter 5). The procedure for relating measurements in the Parthenon, however we hypothetically reconstruct it, can thus always be understood as a "working process" in both senses: in terms of specific constructive, design, or aesthetic problems, and in terms of mathematical, and even meta-mathematical, ones.

Once again, the Parthenon's construction seems to have begun with a literal, physical given: the column drums of 1.905 m in diameter. However, another equally important given, or at least a starting point, for the Parthenon's exterior design was the 3:2 ratio of metope width to triglyph width toward which the aesthetic modifications and adjustments made to the Doric order over the sixth and early fifth centuries had been converging. Once again, by the time of the Parthenon's immediate predecessors—the Temple of Zeus at Olympia, the Temple of Hera Lacinia at Akragas, and a few others—the 3:2 ratio seems to have become canonical.[59] With these two starting points in mind, one can imagine a design process for the flanks and façades (figure 4.21) in which an initial

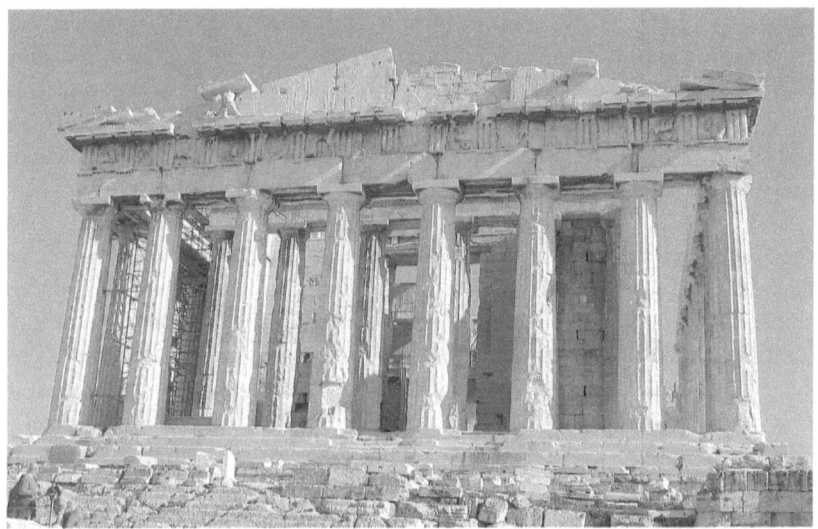

Figure 4.21. The Parthenon: west façade. Photo by Harrieta171.

continuous proportion is constructed to yield the building's governing ratio of 9:4. Beginning with the lower column diameter of 1.905 m, the average or "ideal" metope width is then established at 2/3 the column diameter (1.270 m). Then applying the recently canonized 3:2 ratio of metope to triglyph, the triglyph width becomes 0.8467 m (corresponding extremely closely to the actual standard triglyph width, based on the average of the triglyph widths of the east and west façades, of 0.845 m),[60] creating a continuous proportion of column diameter to metope to triglyph of 9:6:4, with the 9:4 ratio—so central to the Parthenon in all of its measurements—holding between the column widths and their visually analogous form at the level of the frieze, the triglyph. Moving in the other direction, and applying this newly constructed 9:4 ratio to the next larger principal visual element of the exterior (whether façade or flank), the intercolumniation, in its relation to the columns (the 1.905 m column drums), we obtain a standard intercolumniation of 4.296 m, that is, with a 9:4 ratio of intercolumniation to column diameter.[61] At this point, the further extension of the façade's continuous proportionality appears, yielding the proportion that, as we shall see, will ultimately define the cubic dimensions of the building as a whole: 81:36:16—here the ratio of intercolumniation to column diameter to triglyph. Thus, the design of the Parthenon's façades and flanks suggests the way these proportions are unfolded out of each other, and are in fact *constructed*, both in the literal

sense—in terms of the measuring and cutting of individual stones, the making of the building itself, that is, in terms of *technē* as craft—and in a musical or mathematical sense, viz., in a manner similar to the construction of a musical scale out of series of related small number ratios.

Because all of these elements are so prominently visible—indeed, they provide the principal visible horizontal articulation of the rectangular field (that is, the main divisions of its left-to-right extension)—they give the whole ensemble the character of a manifest demonstration of a simple mathematical law, the law of continuous proportionality. In addition, on a more profound if less explicit level, they collectively contribute to the ineffable aesthetic quality of harmony and of unity that so strongly characterizes the building as a whole. In other words, the pre-existing and recently canonized forms that defined the proportions of the Doric order[62] have been pressed into service to make visible, in geometric form, some of the same harmonic principles—specifically, the relationships among small integer ratios—by which the fifth-century Greek musical scale was constructed. Likewise, those ratios together produce an ineffable aesthetic effect analogous to the one produced by the same combinations of small integer ratios in music. This "aesthetic" experience, it is worth stressing once again, could be more fully described as an embodied one—again, analogous to that of music, with its effects on the body (most evident, for instance, in dance). Thus, the predominance of continuous proportions can be understood to engage the viewer in a bodily, as well as an intellectual, fashion. Approaching one of the façades, passing between columns, and circumambulating just outside or within the outer peristyle, one may experience, even if preconsciously, one's body, scaled to the column diameters, as a "4" in relation to the "9" of the intercolumniations, just as one is encouraged to feel one's body scaled as a "9" in relation to the "4" of the triglyphs, or a "3" in relation to the "2" of the metopes, when visually following the line of the columns to the entablature above.

The design of the stylobate (figure 4.22) presents more complex problems. Nevertheless, a similar approach that involves a meeting in the middle, or joining up, of two givens—one a physically pre-existing magnitude and the other an inherited rule of design—functions here as well, in a strikingly analogous fashion. In this case, the physical givens are the dimensions of the exterior elements enumerated above, most importantly here the intercolumniations and the triglyphs, with their 81:16 relationship. The design rule is that for determining the proportions of the stylobate based on the intercolumniation and/or column as a module. As Coulton has discussed at some length, in the middle of the fifth century there were effectively two rules for determining the dimensions of the stylobate, one

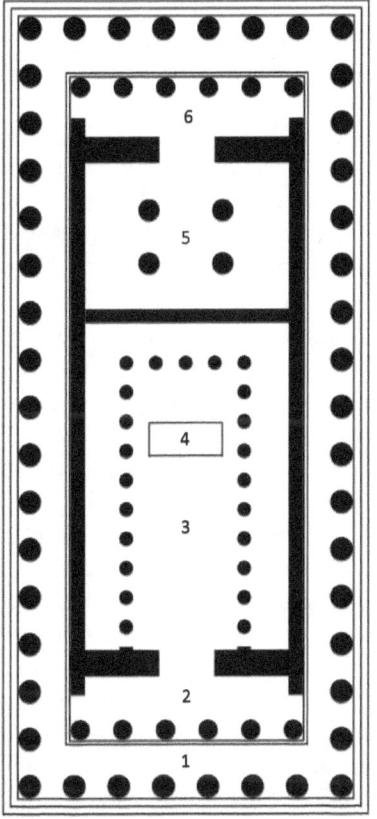

Figure 4.22. The Parthenon: ground plan. Source: Creative Commons.

based on the intercolumniation module, prevalent in mainland Greece, and another based on the number of columns in the peristyle, prevalent in the western colonies, particularly Sicily.[63] With its unusual design of an 8-column by 17-column peristyle—unprecedented in mainland Greece, where Doric temples invariably had 6 columns on the façades—the Parthenon, though based primarily on the "mainland" rule (where stylobate dimensions are determined by the intercolumniations, plus a small fraction—in this case 1/5), effectively harmonizes the two approaches by also conforming to the "Sicilian" rule (where an 8:17 peristyle yields an 8:[17 + 1], or 4:9, stylobate). Thus, along with harmonizing the two rules, this approach to

the design achieves a precise 9:4 ratio for the stylobate (measuring 69.503 m by 30.880 m).[64]

The real issue, however, seems not to lie so much in this particular "harmonizing" of two design rules, which may be something of a fortuitous side effect, as in the way the Parthenon's design accommodates the canonical mainland rule—with each stylobate dimension a multiple of the intercolumniation module, plus 1/5[65]—to the construction of dimensions for the exterior (façade and flank) elements, as discussed above, with their 81:36:16 proportionality. As Hermann Büsing has shown, the Parthenon's unusual 8 × 17 peristyle yields a stylobate, when following the mainland rule, of *precisely* a 9:4 proportion ([17 + 1/5]:[8 + 1/5] = 81:36 = 9:4). At the same time, this rule assumes a triglyph 1/5 the width of the intercolumniation, while in the Parthenon these two elements are instead in an 81:16 ratio. What the designers seem to have done to reconcile these two givens is to construct the stylobate *as if* the triglyph width were 1/5 that of the intercolumniation (0.858 m, a kind of "ideal" triglyph module[66]), but then account for the difference from the actual average triglyph width in the entablature, 16/81 of an intercolumniation (0.845 m), through the inclination of the columns, leaning inward from the stylobate to the slightly smaller entablature.[67] It is worth noting here that the refinements (adjustments, approximations) involved with fitting these two slightly different things together provide a crucial instance of the ascendancy of *harmonia* (as a "joining together" of things that are different) in the building's design, a point to which we will return.

The presence of 9:4 ratios in both the stylobate and the intercolumniations, alone, suggests a "harmonic" orientation (in the general sense), such that at the scale of both the stylobate as a whole, and at that of the principal unit of exterior articulation—the columns and the spacing between them—the same small integer ratio holds. This means that the rigorous, simple proportionality of the one is not sacrificed for the sake of the other, the full expression of a harmonic principle of construction, in both the literal and the figurative sense.[68] Furthermore, the height of the order, from the base of the columns to the top of the entablature, excluding the pediment (13.728 m), is chosen so that it too forms a ratio of 4:9 with the width of the stylobate,[69] involving a slight variation of the standard 3:1 ratio of order height to intercolumniation (in the Parthenon, the order height is increased slightly with respect to this standard),[70] giving the building as a whole a cubic volume in the proportion 81:36:16, the same continuous proportion that (as we have seen) defines the principal elements of the façades and flanks.[71]

The achievement of continuous proportion, both macrocosmically and microcosmically, on the exterior of the Parthenon seems to be an overriding concern of the building's designers, and makes a compelling case for the idea that the unusual octastyle façade was chosen to make these proportions possible and not, as has often been argued, for other reasons, such as to accommodate a larger cult statue in the cella.[72] In fact, the widening of the Parthenon's façades, from hexastyle to octastyle, effectively facilitates a *symmetria* of continuous proportion in two different directions. With reference to the common 5:2 stylobate proportion of many of the Parthenon's predecessors in the early to mid-fifth century, particularly in the western colonies,[73] it increases the width with respect to the length (a change in stylobate proportion from 10:4 to 9:4), and with respect to the precedent of a 2:1 proportion for the façades (the Temple of Hera Lacinia at Akragas; the Temple of Zeus at Olympia), it increases the width with respect to the height (changing the façade proportion from 8:4 to 9:4), in effect closing the gap between the two standard ratios to make them continuous. By comparison, while in the Temple of Hera Lacinia at Akragas the 9:4 ratio appears both in the principal dimensions of the stylobate and in the relation of intercolumniation to column diameter, suggesting a desire to harmonize these elements that is similar to the one at work in the Parthenon, other ratios seem to exist more in isolation. The intercolumniations vary slightly between façades and flanks in ways that could suggest discrete as well as coordinated adjustments, and on the whole, there is the sense that smaller-scale ratios—such as the 10:7 ratio of the standard intercolumniation to the height of the entablature that Mertens indicates[74]—often function discretely, rather than forming part of a fully integrated harmonic whole that defines the entire building, of the sort that the continued examination of different design elements of the Parthenon progressively reveals. Furthermore, the principal musical ratios of 9:4 and 2:1 in the Temple of Hera Lacinia, though they do together form a musically harmonic proportion (9:4:2), do not produce the same thoroughgoing *continuous* proportionality in the building's principal dimensions that the Parthenon achieves by "closing the gap" with its octastyle façades.

One consequence of the method used to determine the Parthenon's stylobate dimensions, combined with the unusual choice of octastyle façades—and indeed as a likely motivation for such—is that the building's overall proportion of 81:36:16 (length : width : height) *has as its modular unit the actual, visible triglyph* (see figure 4.1).[75] The "mainland" rule of design—five triglyphs per intercolumniation plus one additional triglyph

together defining the measure of each side of the stylobate—produces, for an 8 × 17 temple, a stylobate dimension of 36 × 81 triglyph widths. And with the height of the order (4/9 of the stylobate width) thus measuring 16 triglyph widths, the unit for the 81:36:16 cubic volume of the building becomes the basic formal unit of the entablature: the triglyph, so prominently visible at each of the building's corners, that articulates the horizontal extension of the building, in 2:3 rhythm with the metopes, at the level of the frieze. In effect, the Parthenon's design not only produces a rigorously commensurable building; it also foregrounds the unit of measure that defines it, seeming to invite the viewer to consider those very measurements reflectively, and thus to reflect on the whole problem of *symmetria* and its significance.

However, it is important to note here that there is only an approximate, and not exact, correspondence between the abstract unit that defines the Parthenon's *symmetria* and the physical object (the real triglyph) that, as a module, defines and articulates the rhythms of the visible building. Once again, the stylobate is based on an "ideal" triglyph module of 0.858 m, while the triglyphs in the slightly smaller entablature are 0.845 m in width. And indeed, with the column inclinations and curvature, the building itself is not a precisely rectilinear form at all, but only an approximate one. As we have briefly indicated in the introduction, the harmonics of the Parthenon in fact involve not only *symmetria* but also (at least as prominently) *harmonia*, viz., the joining of fundamentally different things, even those that cannot be fully reconciled, ontologically speaking. The various approximations noted briefly in this section are a first indication that *symmetria* alone will ultimately be inadequate for the fuller notion of harmonics at play in the Parthenon. This will be the principal subject of the next two chapters.

To return to the subject at hand, however: with respect to its predecessors, the Parthenon's realization of *symmetria* throughout the building is unprecedented. Indeed, the prevalence of musical ratios, the consistency of their use and their high degree of precision, has proven the object of continuous scholarly speculation, fascination, and even wonder, from the time of the first modern systematic measurement of the building by Francis Cranmer Penrose in the 1850s up to the present.[76] The ratio of 9:4, which gained a certain prominence in the Parthenon's immediate predecessor in Sicily, the Temple of Hera Lacinia, becomes in the Parthenon the basis for a thoroughgoing *symmetria* that penetrates and defines the building from the macrocosm of its principal dimensions to the microcosm of its smallest visible elements (and arguably at still smaller scales, as we will see in chapter 5[77]). While the Hera Lacinia Temple is built on a relationship

of discrete ratios, even if primarily musical—or at least Pythagorean—ones (i.e., based on relatively small integers), in the Parthenon the consistent and even rigorous use of 9:4 ratios at different scales produces a full *symmetria* based on continuous proportion: not a coordination of independent significant ratios, but the conception of the building in numerical/musical terms as an organic whole, in which all parts relate to all others in terms of a single, consistent proportional law. The nearest equivalent to this approach can be found, not surprisingly, in the building's other immediate predecessor, the Temple of Zeus at Olympia, with its consistent use of 2:1 ratios (as discussed above). However, the simplicity of the 2:1 ratio, although permitting one to interpret the proportions in the building as a continuous chain, does not really provide the same analogy to musical harmonics as the use of 9:4 in the Parthenon, since in the latter case a more complex but still entirely interdependent relationship of *different* ratios is produced. This is particularly striking given that the governing ratio of 9:4 is not only generated from a combination of two *diapentes* (fifths, in a ratio of 3:2), but also, in the cella, placed in relationship to the *tonos* (whole tone, 9:8), as we will see below, such that the harmony defined by 9:4, the *diapason* (octave, 2:1), the *tonos* (9:8), and the *diapente* (3:2) resonates throughout the building, effectively producing a construction analogous to the musical scale. By comparison, the continuous proportion of 2:1 in the Temple of Zeus at Olympia would be analogous to a simple sequence of octaves.

In the Parthenon, the analogy with music in the broadest and deepest sense, viz., in the sense that similar open-ended problems are being addressed—problems that, as with musical harmonics, involve a thinking through of the relationship between different fields of mathematical study: namely, arithmetic and geometry—becomes most fully evident in light of the prevalence of 9:4 and related musical ratios within the building, in its ground plan and in its interior sections, even where such ratios are not directly visible. What becomes clear is that the Parthenon's *symmetria* functions not only as a formal or aesthetic principle, but also an ontological one: the very being of the building, its holding together as one thing through the relationship of its parts, is defined throughout its structure (and not only in terms of *visible* relationships) by interlocking musical ratios. We will only touch on some of the most important ones here, though there are other studies that have analyzed these proportions much more fully.[78] For instance, the familiar 9:4 ratio defines not only visible interior dimensions such as the rectangular space described by the colonnade inside the eastern room of the cella, the naos proper[79] (26.67 m : 12.26 m; see figure 4.22, and also appendix D, as reference for the

architectural elements described in this section). Nor is its use limited to those only partially visible and requiring some circumambulation, such as the overall cella length to its width, including both interior rooms, excluding the antae (48.27 m : ~21.52 m). It also defines the ratio of the naos (eastern room) length to the length of the western room, or *parthenon* proper, adjacent to the opisthodomos (29.90 m : 13.37 m), a ratio that could only be established by careful measurement, or perhaps (with the embodied experience of the viewer always in mind) a pacing out of both spaces.

Furthermore, a consideration of the proportions built into the ground plan of the Parthenon, but again not directly available to vision, reveals further musical ratios beyond the 3:2 and 9:4 that govern the exterior.[80] *All* the principal dimensions of the cella exterior, taken together, relate to *all* the principal dimensions of the cella interior as 9:8, the musical *tonos*.[81] Or, to put it more clearly still: the exterior and interior dimensions of the Parthenon's cella, respectively, embody two distinct *symmetriai* that stand to each other in the crucial musical ratio of the *tonos*. The musicality of this construction could be understood in at least two ways. First, the prominent 9:8 ratio in the building suggests an alternative way to divide 9:4: into an octave, or *diapason* (2:1) and a whole tone, or *tonos* (9:8), as opposed to the pair of *diapentes* (3:2, 3:2) that produce 9:4 on the façades.[82] This method of alternative divisions of the musically pregnant 9:4 interval suggests a procedure analogous to the construction of musical scales in the Greek tradition, with its alternative divisions of the octave—or more properly, the tetrachord—to produce different but related harmonic systems, with their concomitant alternatives of mood and association.[83] Second, more broadly speaking, the sense that the *symmetria* of the building as a whole is made not just of the coordination of ratios, such as constitutes continuous proportion, but of the coordination of whole *symmetriai*, each subordinated to the harmonic system of the whole, suggests something of the aesthetics, and again the ontology, of music (as we have discussed it briefly in the introduction to this chapter), with its plurality or related scales, genera, and musical modes within a single overall harmonic system. Ultimately, however, as a geometric object, and even more so as an actual physical building, the being of the Parthenon is irreducible to perfect *symmetria*, and the more its designers submit the dimensions of the building on both the macrocosmic and the microcosmic levels to an apparently comprehensive *symmetria*, the more they also invite one to consider *symmetria*'s limitations in fully defining the reality of the building—a tension that will become most evident in the negotiation of the corner problem and in the introduction of subtle

refinements (the topics for the chapters that follow). And this above all is precisely analogous to the situation in musical harmonics, as theorized and practiced by the fifth-century Greeks, with its acknowledgement of the irrational and its Pythagorean *comma* as remainder.

If the construction of *symmetria* in the Parthenon can indeed be understood as analogous to the constructive methods, the aesthetics, and the ontology (the mathematical being) of the fifth-century Greek musical scale, one would expect the *symmetria* of the building's interior as a whole to relate to that of the exterior (the stylobate, flanks, and façades) in a significant way. And indeed it does: the overall ratio of principal exterior dimensions to principal cella dimensions is precisely 13:9 (for instance, comparing the stylobate length [69.503 m] to the cella length, excluding the ante [48.270 m]). This is a small integer ratio, though not an obviously musical one, and as such it raises interesting new questions. We discussed the crucial importance of *anthyphairesis* (reciprocal subtraction) in the introduction to this book, its importance not only for Greek mathematical developments of the mid-fifth century, but also specifically both for the construction of musical scales and for the discovery of the irrational.[84] Just as subtraction of the *diapason* (octave) from 9:4 yields the *tonos*, and just as, in the musical scale, subtraction of the *diapente* from the *diapason* produces the *diatessaron* (and the *leimma* is produced by subtracting two *tonoi* from the *diatessaron*, etc.), so also in the case of the 13:9 ratio, a single application of *anthyphairesis*, subtracting the smaller measure from the larger, produces a remainder of 4 and a new ratio of 4:9, the ratio of this remainder to the smaller of the original elements. One can imagine, and this is of course purely speculative, that the designers could have arrived at 13:9 as a desirable ratio quite easily, given the predominance of *anthyphairesis* as a working method in the Parthenon's construction, as well as the tendency to work from "both sides" of a problem—that is, not just to start from a given, but to start from dimensions that, through a known procedure, will arrive at a given (see, for instance, the discussion of the determination of stylobate dimensions above).

In addition, however, *anthyphairesis* not only has an arguably central importance (just as it does in the case of the musical scale) as a constructive method for the Parthenon, whose design does not merely "borrow" known musical ratios, but works with the methods of scale construction to produce ratios that are not on the surface literally musical ones, most notably 13:9. Its use also has a self-reflexive quality: the problems raised by *anthyphareisis*, qua problems, are made evident in various parts of the building, most notably in the treatment of the corner problem (which will be the focus of the next chapter), in ways that give the building a

pedagogical character. This appears, arguably, in its simplest form in the superimposed Doric orders of the naos interior (figure 4.23), where the lower order relates to the upper one in a ratio of 13:9 (7.680 m : 5.269 m). Certainly, there may have been aesthetic reasons for this particular choice of proportions, as well as structural ones (for instance, if it provided the appropriate reduction of mass of the upper order to avoid its being top-heavy, but still strong enough to hold up the roof). However, one cannot help but notice that precisely here in the building, one finds two visible elements that are proportionally and formally identical but at two different scales, inviting comparison: two unequal but analogous magnitudes, emphasizing a single dimension of extension, inviting the viewer to size one up against the other—that is, to perform a kind of intuitive *anthyphairesis* in thought, one that would then produce the 9:4 ratio as a result. Walking around the Parthenon interior, as one can still experience it today in the twentieth-century reproduction of the building—begun in the 1920s, based on Dinsmoor's specifications—in Nashville, Tennessee, one feels (preconsciously or otherwise) the simultaneous presence of the 9:4 proportions of the central space's ground plan and the 13:9 ratio of the two orders of Doric columns, along with the invitation to compare, and perhaps to calculate (figure 4.24).

The analogy between the architecture of the Parthenon and musical harmonics is based not only, or even primarily, on the simple presence of musically significant ratios throughout the building; rather, it is the coordination and, even more so, the *construction* of interdependent ratios to form the *symmetria* of the whole that gives the building its musical quality. We can properly speak of the *harmonics* of the building here. In terms of harmonics, however, what we are discussing in this chapter, *symmetria*, is really only a starting point for a much more complex engagement of

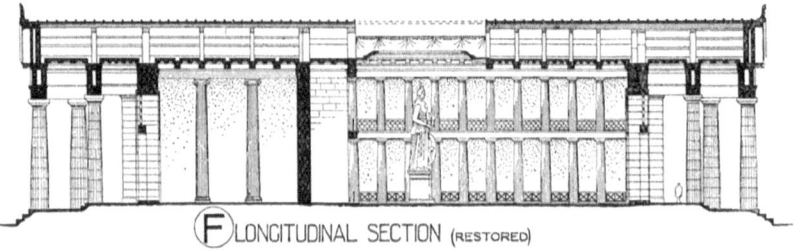

Figure 4.23. The Parthenon: section, showing the Doric and Ionic orders of the interior. Source: Penn State University Library.

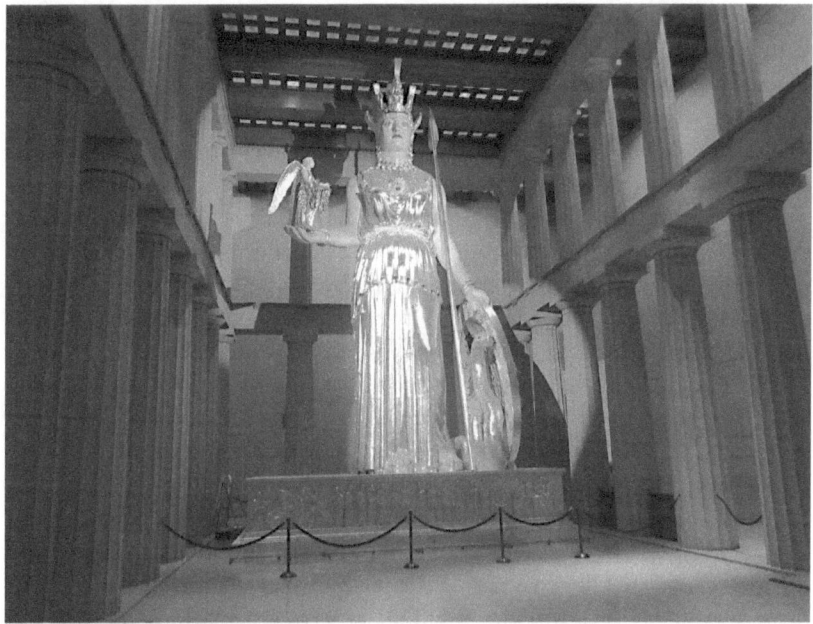

Figure 4.24. Parthenon replica, Nashville (begun 1920s): interior of the naos. Photo by Michael Rivera.

the problems raised by music theory and musical practice, including the necessary acknowledgement of the irrational, of magnitudes that cannot be reduced to multitudes. It is the notion of *harmonia*, in the fullest and most rigorous sense, that binds the irrational and the rational together—as well as joining ratios and *symmetriai*—to make a whole, and this will be the subject of the following chapters, central to understanding the Parthenon and its invitation to dialectic.[85] However, just as with the construction of the musical scale, the deepest engagement with these problems in harmonics begins with the attempt to construct *symmetria*—itself already more than just a series of proportions, or even continuous proportionality, but rather the resonance of each part with all the others and with the whole. Indeed, as Jerome Pollitt has observed, *symmetria* for the Greeks was not only a fundamental aesthetic concept, but arguably the predominant term of value in all of classical Greek and Roman aesthetics.[86] *Symmetria* not only forms the basis of the Parthenon's aesthetics, but, as we have begun to outline here, was the starting point of the inquiry into the nature of the building's *being* itself.

If we consider once again the actual relationship of the viewer/visitor/worshipper to the building, as a temporal, ambulatory, and, above all, embodied experience, it is worth stressing once again how this address of the viewer grounds the understanding of the building's formal properties, and especially its *symmetria*, in the phenomenological realm and, indeed, in the pedagogical realm as well. To consider one particularly crucial feature: the visible triglyph module, as a real physical object in the world, links the Parthenon, on the one hand, to the abstraction of measure—it seems to incarnate the unit by which the continuous proportionality of the building is measured—and, on the other hand, links the building to the scale and the spatio-temporal presence of the human body. (The analogy to music, with its dual relationship to mathematics and to bodily experience—for instance, in dance—can hardly be overstated at this point.) Just as we relate in a sensory and affective way to the specific presence and character of the building, and to its formal elements, so also we "measure" it in relation to ourselves—perhaps most obviously with the columns as starting points, but through the chain of proportions finally arriving at the visible triglyph module that in its turn, as a unit, measures the building as a (mathematical) object. It is with this sort of temporal engagement, regardless of whether one actually takes the trouble to calculate and measure rationally (which would be the exceptional case), that one encounters *symmetria* and, ultimately, harmonics, as a *problem*.[87] And it is there that the pedagogical aspect of the building's engagement of the viewer emerges.

4. On Beauty; or, Arithmetic and Geometry as Liberal Arts

Daniel Heller-Roazen, in *The Fifth Hammer*, shows in an incisive way how the question of harmonics in the Greek tradition, and in its afterlife in the medieval and Renaissance periods, centered on the complex relationship between magnitudes and multitudes.[88] As we have begun to show in this chapter, through a careful consideration of *symmetria* in the Parthenon, and as we will discuss much further in the following two chapters, expanding on the notion of *harmonia*, that relationship—a dialogue between arithmetic and geometry—raises profound ontological questions.[89] It is an ontology that ultimately centers on the recognition of a category of being that is irreducible to *logos*: the *alogon*. That such an ontology is always already an aesthetics as well, at least in the context

of art, may be harder to substantiate, though a defining quality of a work of art such as the Parthenon is the fact that any questions of meaning or of truth it raises are necessarily raised through an object present to the senses. Perhaps the word "aesthetics," often carrying a loaded sense associated with Kantian and post-Kantian critical philosophy, is not even the appropriate one: it would be better to say, rather, that the Parthenon engages, reflectively, with the related categories of being and the beautiful. One could take beauty in this context to mean a perfection of being, as presented to the senses, and one that in some mysterious way partakes of measure without being ultimately defined by it.[90]

The above could perhaps be a serviceable, though rough, definition of beauty in mid-fifth century Greece, or—at least one could say with more confidence—among the architects and sculptors of the Parthenon. Indeed, the most significant fragments of fifth-century Greek writing on art and beauty to survive, by the practicing sculptor Polykleitos, define perfection in sculpture as *almost* (or *except for a little bit*) arising from numbers, or measure.[91] As the course of the discussion in this chapter may have made evident already, a situation in which the object "partakes of measure without being ultimately defined by it" would also be a serviceable definition of the relationship between (measured) magnitudes and (measuring) multitudes, the (numerical, arithmetic) measuring of quantities in a geometric object that ultimately reveals the presence of the irrational—that is, of that which is beyond measure. Thus, in the Parthenon, the ontological issues arising from the relationship of two branches of mathematics to each other, on the one hand, and from the pursuit of beautiful forms, on the other, may really be two inseparable sides of the same problem. And it is the sense in which the two arts of arithmetic and geometry together raise philosophical questions, and provide the means not just to make architecture and sculpture but to strive toward, embody, and experience the beautiful in them, that arithmetic and geometry are no longer only arts in the technical sense, but are properly *liberal arts*.

Although the discussion of the Parthenon in this book focuses almost exclusively on architecture, its sculpture is so fully integrated in, and essential to, the building's architectural form that it may be worthwhile at this point to look, even if with painfully inadequate brevity, at one of the beautiful pediment sculptural groups of the Parthenon, among those preserved today in fragments in the British Museum and the Acropolis Museum.[92] Specifically, let us consider for a moment the group of three goddesses from the East Pediment that comprises figures K, L, and M

(figure 4.25).⁹³ Pollitt has argued that the sculptures of the Parthenon embody a perfect, harmonious balance between the two extremes of abstraction (the more dominant quality in sculpture from the preceding archaic period) and individuality (the quality that would shortly receive still greater emphasis, in the fourth century and even the last decades of the fifth).⁹⁴ This is a paradigm that resonates with a Vasarian model of art history, and is particularly close to an idea of classicism in the modern post-Vasarian tradition, for instance in Heinrich Wölfflin, whose analogous "classic moment" is that of the High Renaissance. However, the gently cascading forms of the reclining goddess usually identified as Aphrodite, with their complex and curvilinear grace (figure 4.26), not only ornamenting but also *articulating* the figure's *symmetria*—that is, actually serving to express the proportional relations among all the parts of the body—also suggest another kind of harmonization. It is a harmony of the discrete and the continuous analogous to the balancing of the Doric and Ionic orders in the Parthenon as a whole—the fusing of Doric's proportional articulation with Ionic's continuity and ornamental grace—although the two poles are even more fully fused here (the closest parallel in the Parthenon's architecture would perhaps be the slightly more Ionic proportions of the individual Doric columns). The "Doric" quality, evident in the proportional, numerical relationships that define the discrete parts of the body and hold them together in a unity expressive of ideal bodily beauty, and the "Ionic" quality of geometric continuity, graceful curvature, and the centrality (and not supplementarity) of ornamental forms, are so

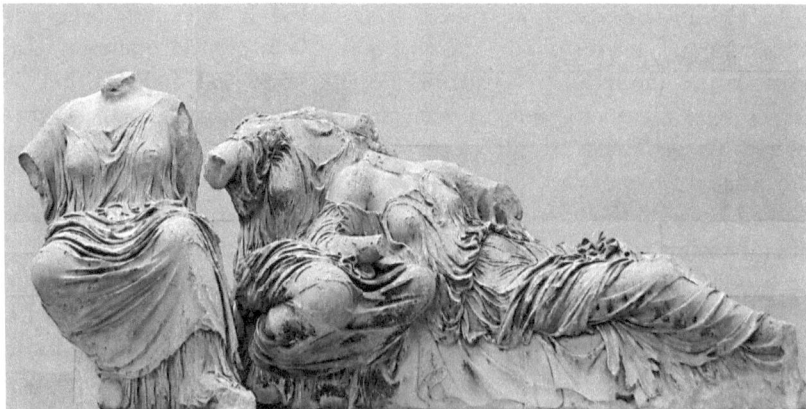

Figure 4.25. Figures K, L, and M from the Parthenon's east pediment. Photo by Marie-Lan Nguyen.

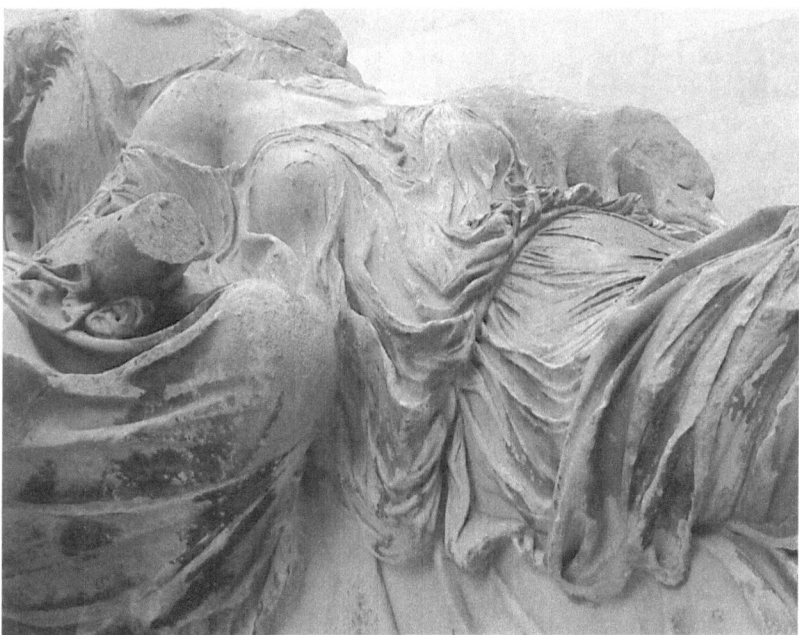

Figure 4.26. Figure M (Aphrodite?) from the Parthenon's east pediment, detail. Author's photo.

fully joined that one cannot conceive of the body's proportions or of its plasticity independently of the gracefully cascading drapery that defines them, with its series of complex interdependent curves.

The ideal of beauty here expressed—or rather, the feeling of beauty that a receptive viewer of this work experiences—is thus not only a *harmonia* (joining together) of abstraction and individuality, as Pollitt argues, but also of the discrete and the continuous, of the arithmetic and the geometric. Or, to put it in another, related fashion: there is in this figure a sense of *harmonia* that is founded on *symmetria* but that also transcends it, in that it necessarily includes that which exceeds numerical measure.[95] Far from being a mere ornament to the architecture, or functioning merely as the bearer of iconographic meaning, the best of the Pheidian works for the Parthenon, such as the reclining goddess on the East Pediment, distill in concentrated form the ontological and aesthetic problems of the building as whole, best described as a harmonics that embraces the *alogon*, even while grounded in *logos*. And to reinforce the point once again: these problems are simultaneously ontological *and* aesthetic, because beauty here (at least as we are attempting to define it) involves the fundamental Platonic

problem of the relation between being and appearances[96] (viz., the sensory experiences of the viewer), just as it does in the Parthenon's architecture (as we will have much more occasion to discuss in the coming chapters).

It is a defining characteristic of art objects, as opposed to ordinary objects of manufacture, not only to relate formal—and even material— qualities to the transcendent realm of thought and of meaning, but also to reflect on themselves, on their own conditions of being. This self-reflection, embedded within the work through a kind of dialogue between the artist and the artwork, becomes, in the afterlife of the work, a dialogue between artwork and viewer. The Parthenon creates such a dialogue, simultaneously in the way it engages the senses—and, indeed, the whole body—and in the way it engages thought. There is a sense in which the beautiful, in its representation of a perfection that cannot be perfectly described—that is, that contains a mysterious, irreducible remainder—both engages the viewer directly in the presentness of the object and leads her or him beyond it.[97] In this sense, there is a resonance between the Parthenon's pedagogical function—its invitation to thought and, to put it this way, to an education in the liberal arts—and its aesthetic function as a work of art: both involve an open-ended dialogue with the viewer or interlocutor, inviting him or her to engage with what is present in order also to go beyond it—affectively, interpretively, imaginatively, and intellectually. And naturally, as we have indicated above, both the pedagogical and the aesthetic modes resonate meaningfully with the Parthenon's principal, religious function, its call to worship and to piety. Furthermore, as we are suggesting in this closing section of the chapter, and will be substantiating in the coming two chapters, both the building's beauty—and by extension, its power as a work of art—and its pedagogical character arise, in some fundamental way, from the dialogue between arithmetic and geometry. In the Parthenon, these two mathematical arts are brought together with a third art, musical harmonics, and all are pressed into the service of trans-disciplinary questions and of aesthetic expression alike—that is, the three arts together work to engage a viewer in philosophical and value-oriented questions (the latter with respect to beauty)—and, in that sense, could more properly be described in this context as *liberal arts*.

Chapter 5

The Corner Problem

The Parthenon is built from a complex—and within the historical development of Doric architecture, unprecedented—coordination of continuous musical proportions. As we saw in the last chapter, the use of continuous proportions in the Parthenon, and even the constructive, technical procedure by which the design of the building was generated, suggests a sustained dialogue with music theory and musical practice. Specifically, the building's design engages with what was probably the most innovative mathematics of the mid-fifth century (innovative precisely through its relationship to music and architecture, and their experimental practices).[1] In the Parthenon, the building up of a proportional system from a flexible use of a modular approach, beginning from a physical given—specifically, the diameter (1.905 meters) of the column drums already carved for the Older Parthenon—also shares its methodological character, to a very high degree, with similar practices in music. This is especially true with regard to the construction of the scale as described by Philolaus in fragment 6A: both involve a combination of continuous proportion (series of the same ratio; in the Parthenon: 9:4, itself growing out of a 3:2 continuous proportion) with the interlocking of different ratios.[2] In the Parthenon, the principal ratios are 9:4, 3:2, 9:8, and 13:9, as well as 81:16; in music, they are the *diapason* (octave), the *diapente* (fifth), the *diatessaron* (fourth) and the *tonos* (whole tone). Again, summarizing some of the discussion in chapter 4, the close connection between fifth-century music and the Parthenon's architecture is not only one of method; the principal ratios out of which the building is constructed are among those most essential to Greek music: 3:2 (the *diapente*), 9:4 (two *diapentes*, or a *diapason* [octave] plus a *tonos*), and 9:8 (the *tonos*). However, the "interlocking of different ratios" in the Parthenon goes further: there is also an interlocking of different proportional systems altogether, different *symmetriai*—most notably, the coordination of the standard 5:1 (80:16) intercolumniation : triglyph

ratio, used as a rule to construct the stylobate, with the slightly different 81:16 intercolumniation : triglyph ratio given by the continuous proportion built on the 9:4 ratio that governs the building as a whole. It is clear that these two *symmetriai* do not fit perfectly together, given the slight discrepancy between 80:16 and 81:16, and thus interlocking them required adjustments, some of which have been discussed briefly in the preceding chapter. The work of joining these not entirely compatible *symmetriai* together to make a building that is a unified whole, that is, one that holds together as a single thing, is what we could call—borrowing the term in the sense normally used in other contexts than architecture—*harmonia*.

In Pollitt's *Ancient View of Greek Art*, with its review of the tradition of ancient art criticism, he notes the prevalence of the term *symmetria* in theoretical writing about art and architecture. At the same time, in his entry on the term *harmonia*, he notes its relative absence in classical Greek and Roman art theory; *harmonia* is much more prominent in theoretical discussions of music, but not so much in the visual arts, and Pollitt questions whether its relatively rare use indicates something substantially different from *symmetria*.[3] However (and as Pollitt also indicates), the term *harmonia* predates music criticism as well. As Petar Ilievski points out in an illuminating article, its literal sense could perhaps best be translated as "joining together," and since its earliest usage—most notably in Homer—it has conveyed something like the joining together of things that are fundamentally, or essentially, different.[4] According to Ilievski, its earliest known use in the literary sources is with respect to *technē* in the sense of craft, to processes of physical construction that involve fusing essentially different elements, like the joining of the spokes to the rim of a wheel—or like the putting together of opposing parts in the construction of a wooden ship, the context in which the term appears in Homer. Only later did *harmonia* develop and broaden semantically, to take on the sense it has in music theory, and ultimately—based on the more intangible connotations associated with music—in philosophy.[5]

Of course, music too is a *technē*, a kind of physical construction (the dividing of the monochord on the kanon), though one in which mathematical theory comes to the fore. The transition to the mathematical sense of *harmonia* suggests not just a literal joining of different physical things but a joining of different kinds of mathematical objects, namely, magnitudes and multitudes. And one could argue that it is in this context, when *harmonia* describes the joining together of the musical scale (or alternatively, the unity of a musical performance based on a particular scale and its concomitant mode) that its association with the joining of

magnitudes and multitudes—the two irreducibly different sorts of mathematical objects that must be brought together to divide a string according to numerical ratios—may have developed.[6] This kind of joining would have played the crucial role in the discovery of irrational magnitudes (as discussed in the introduction and chapter 4, section 1), and it is this kind of joining, or *harmonia*, irreducible to *symmetria* (since perfect *symmetria* in a geometric object implies the perfect compatibility of magnitude and multitude[7]), that plays the crucial role in the problems that the design of the Parthenon addresses. On an intuitive and an aesthetic level, as has often been recognized (and this will be addressed further below), the Parthenon seems to achieve an unparalleled effect of harmony, something that has been described variously as an ineffable liveliness, or a kind of "organic" unity (see figure 4.1).[8] What we will be discussing in this chapter, and the one that follows, is the way that organic unity, so evident in the building, emerges not from perfect *symmetria* (continuous proportions, the prevalence of musical ratios) alone, but from a more inclusive concept of *harmonia*, which acknowledges the irrational as a problem to be addressed. In so doing the Parthenon raises large ontological and epistemological questions and, perhaps, points toward a pedagogical mode, necessary to address them fully, that would come to be called "dialectic."

1. Remainders and Adjustments

Since the beginning of Doric's gradual canonization as an order during the archaic period, the need to place a triglyph at the corner, for aesthetic and expressive reasons, raised an unresolvable design problem that nevertheless needed to be addressed.[9] This well-known problem arises from the fact that the design and proportions of the Doric frieze rely on the centering of a triglyph over each of the columns in the peristyle below, something that creates an evident problem at the corners—given the difference in width between triglyph and column capital—if one wishes to place a triglyph at the corner rather than leave an unsystematic, that is, incommensurable, fraction of a metope as a remainder.[10] In sixth- and fifth-century Doric architecture, the placing of a triglyph at the corner was a fundamental principle, an inviolable component of the order's formal perfection, and an emblem of its structural solidity (figure 5.1 on page 108). Compare this—to choose just one example—with the approach taken in the neoclassical Brandenburg Gate, designed by Carl Gotthard Langhans and built between 1788 and 1791, with its fraction of a metope at the

108 THE PARTHENON AND LIBERAL EDUCATION

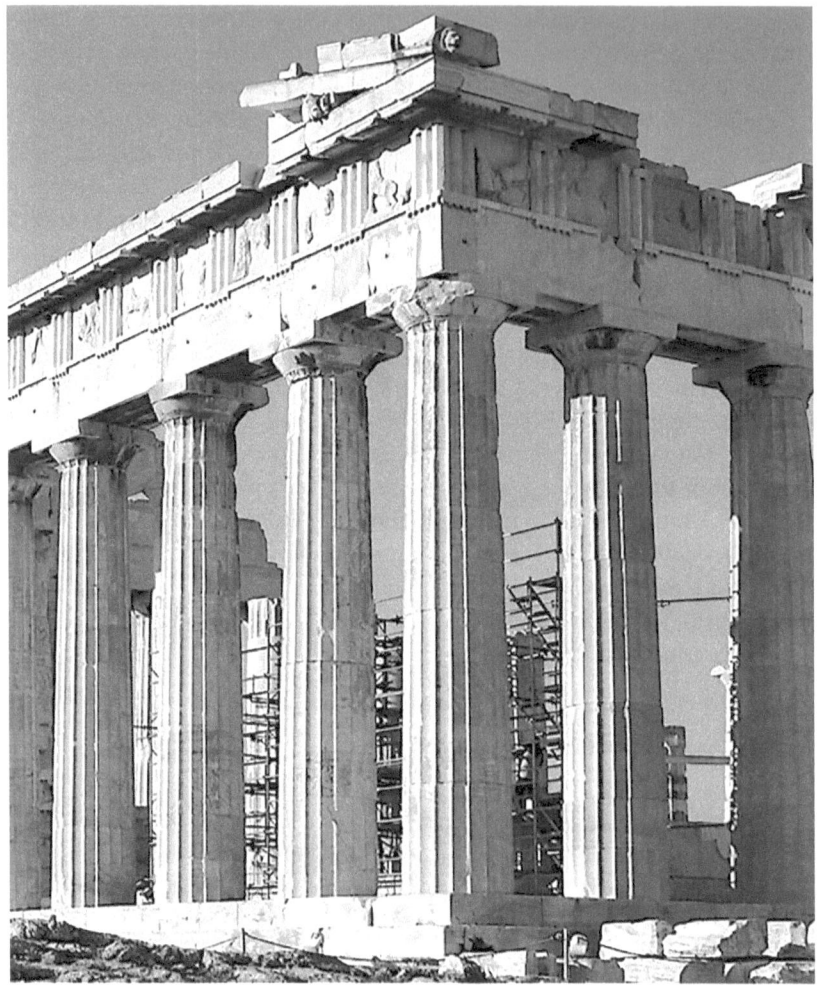

Figure 5.1. The Parthenon: northeast corner. Photo by George Rex.

corner (figures 5.2 and 5.3, showing the Parthenon and the Brandenburg Gate, respectively), typical of the Renaissance and post-Renaissance use of the Doric in architecture, and indeed a solution even recommended as early as Vitruvius (*De architectura*, IV.3.5). Over the course of the sixth and fifth centuries, a varying range of small adjustments[11] to the position and proportion of elements of the order was introduced to compensate for the irregularity—the small remainder left over—at the corner. On the whole, the tendency on mainland Greece in the sixth century was to

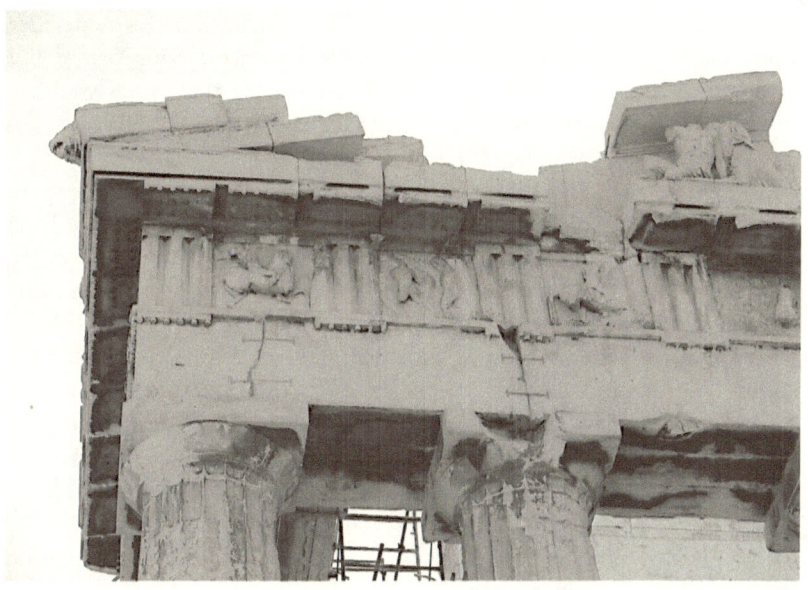

Figure 5.2. The Parthenon: entablature, northwest corner. Photo by Ken Russell Salvador.

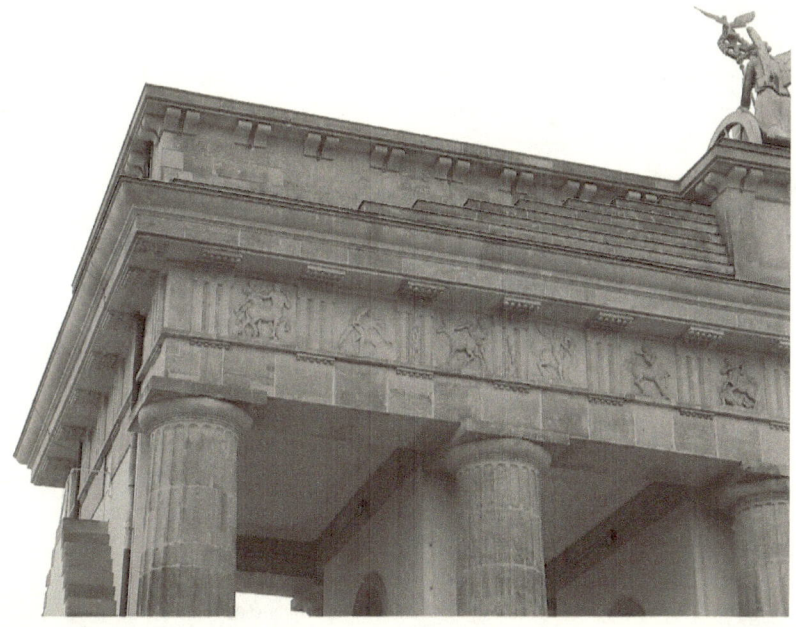

Figure 5.3. The Brandenburg Gate, Berlin (1788–1791): entablature, northwest corner. Author's photo.

contract the corner intercolumniations to compensate for this remainder, while the tendency in the western colonies during the same period was to slightly widen the corner metopes, and sometime the corner triglyphs as well.[12] This was far from a hard-and-fast rule, however, and there was plenty of dialogue between the two regions.[13]

The Parthenon's two most important predecessors, in terms of approaches to the corner problem, the Temple of Poseidon (or Hera II) at Paestum and the Temple of Hera Lacinia at Akragas, both from the western colonies, combined contraction of corner intercolumniations with widening of metopes. Specifically, the Temple of Poseidon combined corner column contraction with the progressive widening of a pair of metopes toward the corners (see figure 4.16), the culmination of a historical development in South Italian and Sicilian Doric in which more and more metopes, and sometimes triglyphs as well, were slightly widened to compensate for the remainder left over at the entablature corner. Furthermore, when column contraction was involved, this trend toward distribution of the discrepancy over a greater number of elements finds a parallel in the progression from single to double contraction, the latter being a feature unique to the Doric temples of the western colonies.[14] Mertens's recent major work on the architecture of the western colonies provides the most thorough account of this history, including the development of the combination of double contraction with widening of entablature elements in a number of key Sicilian or South Italian temples of the early to mid fifth century: in particular, the Temple of Victory at Himera, the Temple of Athena at Syracuse, and the Temples of Hera Lacinia and Concord at Akragas.[15] The most engaging and complex version of this solution to the corner problem among this group is that of the Temple of Hera Lacinia at Akragas, where the sincere desire to engage, or to "solve," the mathematically unsolvable corner problem is particularly evident in its complex series of reciprocal adjustments. The approach in the Hera Lacinia Temple is quite similar to that described above in the Temple of Poseidon at Paestum: a combination of adjustments to multiple metopes, triglyphs, and intercolumniations on each side.[16] This temple is also the most immediate predecessor for the Parthenon chronologically, either in the west or in mainland Greece, and, more significantly still, it is arguably the Parthenon's principal predecessor in terms of design principles.[17] Note also that the particular combination of adjustments to the entablature and to the peristyle intercolumniations in the Hera Lacinia Temple were then followed very closely in its successor at Akragas, the Temple of Concord, suggesting an awareness that a promising approach to the corner problem had been found, though (as Mertens describes it) the Temple of Concord then takes that approach

more in the direction of standardization, while the Parthenon goes in the direction of further experimentation.

Significantly, in both the Poseidon Temple and, slightly later, the Temple of Hera Lacinia, the triglyphs are no longer exactly centered over the columns, not only at the corners but within the façades as well (a result of the various adjustments), an important precedent for the Parthenon. Discussing the Poseidon Temple, Mertens refers to the effect of its relatively complex solution to the corner problem, combined with the slight curvature of the whole building, as giving an overall, if somewhat ineffable, impression of liveliness.[18] The implications of this observation are something to which we will return in chapter 6. Suffice it to say here that one of the implications of the complex and carefully calibrated irregularity found in these two buildings—a slight departure from perfect Doric *symmetria* in their decentering of triglyphs with respect to the columns below—could be an awareness of the discrepancy between *harmonia* and *symmetria* themselves. That is, the subtle adjustments incorporated within the design of these two temples may be understood to reflect the realization that a harmonic holding-together of the building as a three-dimensional object (*harmonia*) requires more than *symmetria* alone. This would follow directly, and necessarily, from an awareness and understanding of irrational magnitudes, that is, from the discovery that there are pairs of magnitudes that cannot be put into a whole number ratio, the same problem that must have arisen in musical harmonics, in a similar constructive context.[19] Certainly, an architect could choose to slightly detach the triglyph from the column axis, and thus introduce a small fractional ratio into the measurements of the design, for reasons other than the awareness of the irrational. But with this awareness, such irregularities might constitute not simply a reluctant compromise (and perhaps even an unexplainable toleration of avoidable imperfections) but an active engagement with an unsolvable problem, viz., with the need to incorporate the irrational— that which goes beyond perfect numerical ratios—into the harmonics of the building. The slight irregularities themselves would not account for the irrational itself, but may signify an attempt to approximate it with ever-finer adjustments, as happened in music with the convergence of ever-smaller tonal ratios on the Pythagorean *comma*. The larger problem of harmonics at stake here is one for which the rational discrepancies (e.g., the fractions of a metope left over at the ends of the frieze) associated with the corner problem would form a component part, in a broadly methodological if not a literal sense.

This suggests, furthermore, an engagement with specifically Pythagorean concerns. The question of the role Pythagorean thought played in the

design of Sicilian and South Italian temples, beginning with the Temple of Athena at Paestum in the later sixth century, has, once again, been addressed by a number of scholars, although inconclusively, given the lack of documentary evidence.[20] This question of the role of a Pythagorean musical and mathematical framework can, however, also be addressed (even if not "conclusively") through careful consideration of the design—and of the direct experience—of the Doric temple itself, and most prominently and significantly, of the Parthenon. This historical trajectory naturally suggests some kind of migration of Pythagorean thought from South Italy and Sicily to Athens around the time of the Parthenon. We are not attempting to make any specific historical claim of that nature, though it might be possible speculatively to reconstruct such a scenario, but rather to suggest that, given the sustained dialogue between the architecture of Athens and that of the western colonies in the middle of the fifth century, it can be inferred that there must have been a lively exchange of ideas, including those associated with Pythagorean mathematics and music, and that similar problems (technical, aesthetic, and philosophical) were being addressed through the design of temples in both regions.

The Parthenon deals with the corner problem, first and foremost, by combining corner column contraction with adjustments to the metopes (see figure 5.1), as with its immediate predecessors at Paestum and Akragas. However, unlike any previous Doric temple, the approach in the Parthenon results in the metopes being *narrower*, not wider, at the corners (figure 5.4). Furthermore, and more perplexingly, the apparent irregularity of metope widths across the entire extent of the Parthenon's frieze reflects

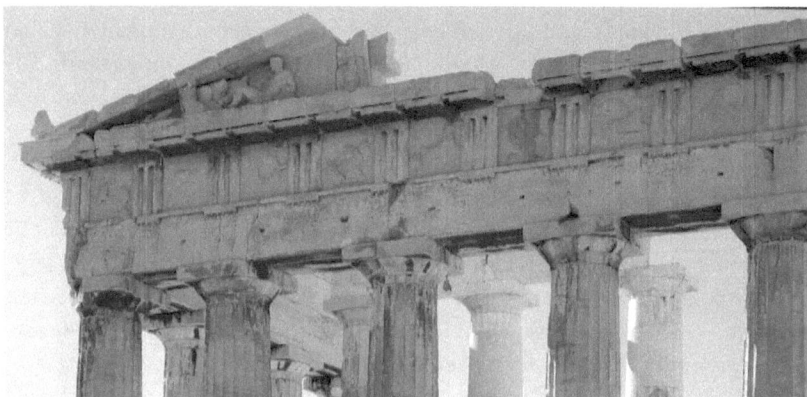

Figure 5.4. The Parthenon: east façade, south side of the entablature. Photo by Steven Zucker.

a much more thoroughgoing, and as yet still little understood and never systematically interpreted, series of adjustments. For instance, hardly any of the metopes across either the east or the west façades are precisely the same width, and a similar range of variations occurs along the two long flanks.[21] A number of scholars (Wesenberg, Korres, Barletta) have argued that variations in the sculptural subject matter can account for many of the irregularities, either because some blocks from the Older Parthenon were reused or because of the formal characteristics of the various metope reliefs and the width of the field required in each specific case.[22] However, as Penrose pointed out in his seminal early study of the Parthenon's architecture, the widths of the architrave blocks underneath the frieze already take into account the varying widths of the metopes with great precision, indicating that the planning of the variations reflected in the metope widths preceded the construction of the frieze itself (and presumably the carving of individual metopes). More recently, other scholars (Yeroulanou, Winter) have similarly argued that the variations in metope width must be for architectural rather than purely sculptural reasons.[23]

In the Parthenon, rather than refining the proportions of one or two metopes at either end, such as occurs in the Temple of Poseidon at Paestum and the Temple of Hera Lacinia at Akragas, the remainder at the corner is eliminated by effectively "distributing the difference" over all the metopes on a given façade or flank. Thus, although the overall effect is one of both intercolumniations *and* metope widths gradually contracting at the corners (in contrast to the Poseidon and Hera Lacinia temples, where the metope widths expand at the corners), the metope width variations are irregular, suggesting multiple, reciprocal small adjustments rather than a single rule or "algorithm." Coulton, discussing the larger historical trajectory of solutions to the corner problem, notes the intensity of engagement and the open-ended experimentation, over a significant period of time, which characterizes that trajectory. He attributes this to the fact that architects did not work everything out on paper beforehand (which would allow for a straightforward, equal geometric distribution of the difference), but rather worked, so to say, constructively.[24] We would add to this, however, that the specific character of this constructive approach to the problem suggests a negotiation of the tension between magnitude and multitude, a problem that was (as we have been arguing) of great concern across a range of technical and theoretical fields in the middle of the fifth century.

There are two principal implications of the remarkable solution to the corner problem in the Parthenon, both relating to the interaction between multitude and magnitude (or, to put it another way, between arithmetic and geometry). First, the design of the building seems to have relied on

anthyphairesis (reciprocal subtraction) as a construction method, parallel to the method used for constructing musical scales when confronting a similar problem of incommensurability—namely, the existence of the irrational.[25] Second, the adjustments to the intercolumniations and to the frieze were coordinated, in contrast to earlier buildings, in a way that suggests orientation toward a larger goal, that of *harmonia* in the corner articulation, and in the building as a whole. To begin with the first of these points: the range of subtle variations to metope width throughout the frieze suggests a process of continuous reciprocal adjustments that could be understood as the construction of proportional refinements through *anthyphairesis*. Early analyses of the building's refinements, specifically by Guido Hauck and William Goodyear, revealed minute adjustments not only to metope widths but to the guttae underneath the triglyphs and to the centering of the abaci over the columns in counterbalancing ways. For instance, considering the south side of the entablature on the Parthenon's east façade (see figure 5.4), if a triglyph is decentered to the left with respect to the intercolumniation beneath it (as is the case with the second triglyph from the south), the guttae underneath the triglyph are decentered a still smaller amount to the right to compensate, that is, to produce a slightly more centered overall ensemble. In addition, since the triglyph over the corner intercolumniation appears noticeably closer to one column than another, the triglyph over the adjacent intercolumniation is shifted off-center in the same direction, but by a smaller amount (and, correspondingly, the abaci of the columns to either side of this latter triglyph are shifted the opposite way to further, slightly, reinforce this decentering), in order to reduce the difference between the degrees of decentering in the two adjacent sections of the entablature.[26] Just as the use of a 13:9 proportion on the macrocosmic scale—the ratio of the exterior proportions to the interior proportions of the temple (see chapter 4, section 3)—invites one, in comparing them, to subtract the smaller from the larger and arrive at the normative 9:4 ratio (viz., the basic procedure of reciprocal subtraction), so too on this microcosmic scale the most subtle of the adjustments to the entablature proportions, involving progressively smaller shifts in opposing directions, indicates a constructive method reliant on *anthyphairesis*. Once again, although attempts have been made to account for the irregular widths of the metopes in terms of their sculptural subject matter, the variations in the metopes are also reflected in corresponding variations in architrave length, indicating planning for these refinements at an early stage, and at the level of the building's overall structure—that is, as part of the same process by which the stylobate dimensions, the cella dimensions, and the proportions between them were laid out.

The subtle, apparently reciprocal, adjustments to the entablature suggest a situation parallel to that of the construction of a musical scale as

Philolaus understood it, and as musicians practiced it.[27] As discussed in the introduction and in chapter 4, section 1, problems involving the tension between multitudes and magnitudes may have first been encountered and addressed in the construction of musical scales.[28] Once again, the account by Szabó indicates the degree to which work on the development of a technical procedure may have constituted the most serious engagement with the principal *theoretical* problems in the mathematics of the time, centered on the discovery of the irrational.[29] In this case (to review briefly the discussion in chapter 4, section 1), the dividing of the monochord (the stretched string on the kanon) into a series of smaller segments according to small integer ratios (the *diapason* [2:1], the *diapente* [3:2], the *diatessaron* [4:3], and the difference between the last two, the *tonos* [9:8]), and the subsequent measuring of the *diatessaron* by the *tonos*,[30] led to the production of progressively smaller increments of the string representing the ratios of progressively larger integers: namely the *diesis* or *leimma* (256:243; the difference between the *diatessaron* and two *tonoi*), the *apotome* (2,187:2,048; the difference between the *tonos* and the *leimma*) and the *comma* (531,441:524,288; the difference between the *apotome* and the *leimma*). The process of repeated *anthyphairesis* creates these ratios, and a further pursuit of this process would yield progressively smaller intervals ad infinitum; however, the unbounded nature of the procedure produces the sense, at least intuitively and inductively, of a convergence toward the recognition of the *alogon* (that which is irreducible to *logos*, the irrational).[31] Though this in itself would not constitute a proof of its existence, it is also possible, as von Fritz has argued and as we have indicated already in chapter 4, section 1, that the awareness of such a proof may have existed by the time of the Parthenon, that is, by the midfifth century, in Pythagorean mathematical circles, revealed by the repeated application of *anthyphairesis* to the pentagram.[32]

With this in mind, the repeated reciprocal adjustments evident in the Parthenon's design, producing what seems like a slight but unaccountable irregularity in the dimensions and positions of elements in the building's entablature may make more sense. It has the character of the analogous procedure by which progressively smaller intervals are produced in the construction of the musical scale, combined with the recognition that such a process can only be an incomplete solution, given the existence of irrational magnitudes, but that, nevertheless, such incompleteness is preferable to ignoring the problem altogether. Thus, the complex process of interrelated adjustments to the Parthenon's "ideal" proportions that seems to characterize the approach of the Parthenon's designers and builders to the corner problem—evidently an ongoing working out of an unsolved (or, rather, unsolvable) problem at the time the building was being constructed[33]—could be understood as parallel in method to the

building of a musical scale. In the scale, the component numerical ratios do not *perfectly* fit together, in the sense that they cannot measure (i.e., subdivide) each other, requiring progressively smaller ratios to fill the gaps (resulting, among other things, in the *leimma*, the *apotome*, and the *comma*), generated by a method of reciprocal subtraction that inevitably leaves a remainder. The reciprocal adjustments of the Parthenon suggest a similar procedure, and the "remainder" that has to be negotiated at the corner of the Doric frieze stands as an emblem for the broad ontological implications of the magnitude-multitude problem, and of the irreducible presence of the irrational that it reveals. (This also relates to the conceptual basis for the "refinements of refinements," the most subtle of the adjustments to perfect measure in the Parthenon, to be discussed in chapter 6.)

A simple geometric division of the entablature to account for the corner, though easy technically, would probably have been anathema to the designers of the Parthenon for the same reason that a simple geometric division of the scale, such as the division into twelve equal (irrational) semitones that characterizes modern equal temperament, would have been anathema to Greek musicians and music theorists, at least those in the Pythagorean vein. In either case, it would entail a renunciation of the relation of magnitude to multitude, of geometry to arithmetic. Moreover, it is clear in both cases (Aristoxenus's later geometric approach to the musical scale notwithstanding) that such a magnitude/multitude relation was essential to the fifth-century conception of the problem at hand.[34]

At this point it might be helpful to go through a purely hypothetical reconstruction of the design process for the calculation of metope widths, and in so doing to speculate on the different approaches to the "distribution of the difference" through *anthyphairesis* that are in evidence on the east and west façades of the Parthenon. In recent scholarship, two alternative chronologies for these changes in approach have been proposed. For Burkhardt Wesenberg, the iconography of the sculptural program as well as his hypotheses regarding which blocks were reused from the Older Parthenon recommend a chronological progression from west to east, while for Manolis Korres and for Marina Yeroulanou (following Korres) the construction would have begun at the east side moving west, which both argue based on architectural considerations, specifically the greater irregularity of the east side (i.e., the west façade would represent a more fully worked-out solution) and the fact that the stylobate block measurements with respect to the krepis seem to reflect later changes at the west side of the building.[35]

The chronology proposed by Korres and Yeroulanou seems preferable, given the architectural evidence they provide, as well as our overall sense that questions of architectural proportion rather than sculptural subject matter were primarily responsible for design decisions. Other rea-

sons, relating to the harmonics of the building, that may become clearer in the course of our reconstruction, also recommend the east-to-west chronology. Thus, assuming that the east façade predates the west, one can begin by observing two different approaches to the corner problem in evidence on the east façade alone (figure 5.5).[36] On the north side of the east façade (figure 5.6; see also figure 5.5), *anthyphairesis*—that is,

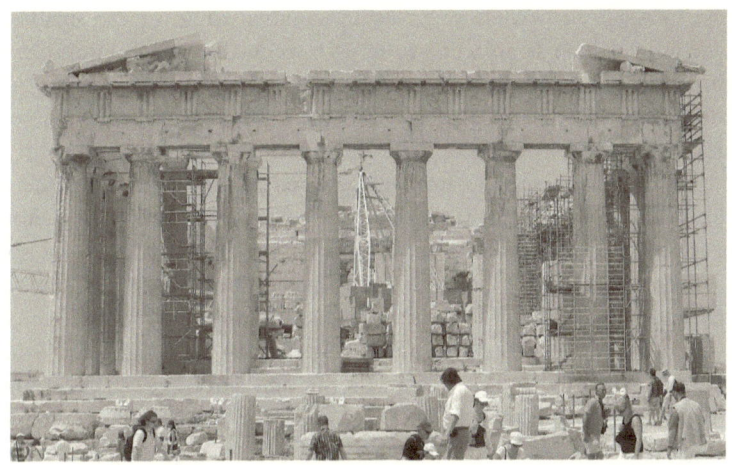

Figure 5.5. The Parthenon: east façade. Photo by Florestan.

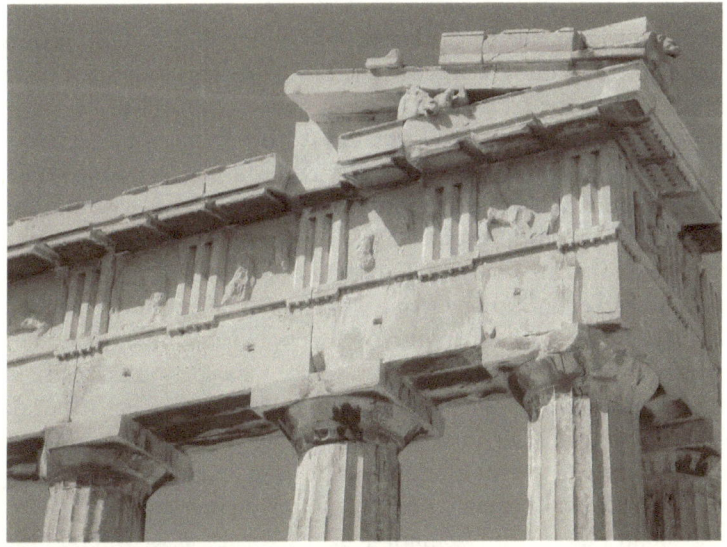

Figure 5.6. The Parthenon: east façade, north side of the entablature. Photo by Joanbanjo.

subtraction of the incommensurable remainder from the standard metope width, and then repeated comparison (reciprocal subtraction) of the different metope widths that result to produce a range of variations—could have been used to compensate for the discrepancy at the corner in the following way (again, speaking entirely hypothetically): first, the central metopes are made slightly larger than the four toward the corner, whose relative contraction is distributed over all four metopes, then the corner metope is made somewhat larger again, compensating for the smallest of the metopes, which is adjacent to it (the second from the end). On the south of the east façade (see figure 5.4), the approach seems to be to shift the difference more toward the center, with six relatively equal metopes, starting from the corner (still with irregularities, however, and with the fourth to the sixth metopes from the corner slightly larger than the first three), but then the seventh metope (one of the central pair of metopes) made noticeably larger. Thus, moving from the north side to the south side of the east façade, the progression is from a more uneven alteration of longer and shorter metopes (with a slight increase at the corner metope that counteracts the general trend of contraction) to a shift of the main contraction toward the center to make the difference between the corner and the rest less pronounced. Then, on the west façade (see figures 4.21 and 5.2),[37] as one could speculatively reconstruct it, the approach seems to be to shift that noticeable visual difference back to the corners, to reinforce and echo the column contraction below and the overall feeling of density at the corners (emphasized in the contraction of the corner intercolumniations and the thickening of the corner columns), increasing the metope size slightly across all but the two corner metopes on each side, and leaving the two at the corners noticeably smaller.

If this hypothetical reconstruction is correct, it would appear that a variety of refinements were tried out, but with an increasing tendency toward a harmonization of the corner intercolumniation with the corner of the frieze (i.e., on the west side of the building), with both being visibly contracted at the corner.[38] This progression toward greater harmony at the corners, culminating in the west façade, where the peristyle and the entablature refinements are most fully coordinated, and where the visible strengthening of the corners as a whole through contraction is most fully realized, seems consonant with the Parthenon's overall prioritizing of *harmonia* as a value. It is worth emphasizing the importance of corner definition for the impression of unity in the building as a whole, and both the harmonizing of elements and the greater density and strength at the corners contribute to this definition of the corner *qua* corner. However, a similar kind of experimental, working-out process could certainly be

reconstructed with an alternative chronology, going from west to east. What is important is not the specific reconstruction, but the sense of an experimentation through reciprocal adjustments to create the most satisfying solution to the corner problem, based on the interdependence of *all* elements in the design, and not only on the modification of an isolated few. It should also be noted that, although the building displays a range of solutions, all of them to some degree (and in contrast to all former approaches to the corner problem) display a general tendency to *contraction* of the entablature toward the corners, and that furthermore these adjustments are very subtle, such that the overall similarity in the three approaches is more striking than the relatively small (and virtually invisible), even if methodologically significant, differences between them.

The difference between this treatment of the corner and the approach taken in the Parthenon's most direct predecessors, the Temple of Poseidon and the Temple of Hera Lacinia, is crucial. In both of those earlier buildings, which also involve a complex range of adjustments, the entablature and peristyle *counteract* each other: the slight and progressive *increase* in the width of entablature elements toward the corner is joined to a slight and progressive *contraction* of intercolumniations toward the corner (see figure 4.16), as discussed above. The effect of this, as Mertens has argued with respect to the Hera Lacinia Temple, is the relative separation, visually and formally, of the entablature from the peristyle.[39] Along with this separation, according to Mertens, the entablature, with its clear *symmetria*, becomes ever more important for the overall appearance of the temple, effectively representing its own layer of design, relatively independent in its proportions. Concomitantly, the peristyle at the two façades, with their double contraction through which no pair of intercolumniations is equal to the others, likewise expresses its own independent concern: not so much a corner contraction as a widening of the center to emphasize the entrance to the temple.[40] Mertens describes this design as a not-yet-mature version of that of the Parthenon.[41] In a sense this is quite true, and yet in the Parthenon, even if a similar complex approach to adjustments is taken, and for similar reasons (response to the corner problem), the orientation is entirely different: the pairing of contraction in the peristyle with contraction in the entablature at the corners mobilizes the two levels of the elevation in conjunction to emphasize and strengthen, interdependently, the sense of the corners. In so doing, the Parthenon stresses the clear priority of a kind of *harmonia* that is irreducible to *symmetria* alone—a sense of the unity of the whole, built on the clear departure from perfect *symmetria* evident in the excessive corner column contractions, combined with the irregular entablature. And it does this both through the refusal

to uncouple the two principal parts of the building's exterior, entablature and peristyle/krepis, and through the affirmation of the corners that define the wholeness of the building (its holding together as *one thing*, as a geometric whole).

The Parthenon's design seems to insist on harmony as a "joining of different things to make a whole," true to the etymology of the word itself. It should already be evident that in the case of the Parthenon—considering the adjustments related to the problem of harmonizing 5:1 and 81:16 discussed above—the corner problem is not so much an exceptional, contingent problem, arising from an idiosyncrasy of the Doric order (as it is often understood),[42] but is integrally related to other key elements of proportionality and refinement throughout the building. Indeed, the corner problem is relevant to what we could call the "harmonics" of the building generally, within which the proportions and the refinements of the design operate together, with harmonics understood in the sense of musical harmonics, that is, as a condition in which magnitude and multitude are in a productive tension—in other words, from the point of view of a *harmonia* that includes but is not reducible to *symmetria*.[43]

2. The Kanon of Polykleitos

Among the key surviving texts—perhaps *the* key surviving text—for the modern understanding of the role *symmetria* played in ancient Greek art theory are four fragments attributed to Polykleitos, and most notably among the four is a particularly illuminating fragment that is preserved in Philo Mechanicus.[44] These fragments discuss the renowned "kanon of Polykleitos," thought to be derived from the principles Polykleitos used to achieve ideal proportions—and thus an ideal of beauty—in his actual sculptural practice, possibly evident today in the surviving copies of his *Doryphoros* (figure 5.7).[45] Since Polykleitos was the most prominent sculptor after Phidias in mainland Greece around the middle of the fifth century, exactly during the period of the Parthenon's construction, the relevance of this surviving fragment of his art theory to the interpretation of *symmetria* in the design of the Parthenon is evident. Andrew Stewart, in a seminal article on the subject, summarizes the principal characteristics of Polykleitos's kanon that can be deduced from the four surviving fragments attributable to him, which he divides into five points: (1) "The canon was composed of many numbers that '*para mikron*' [see below] led to beauty" (p. 126). (2) It aimed at a mean. (3) It was a system of proportions of the different parts to each other and to the whole (i.e., it is a

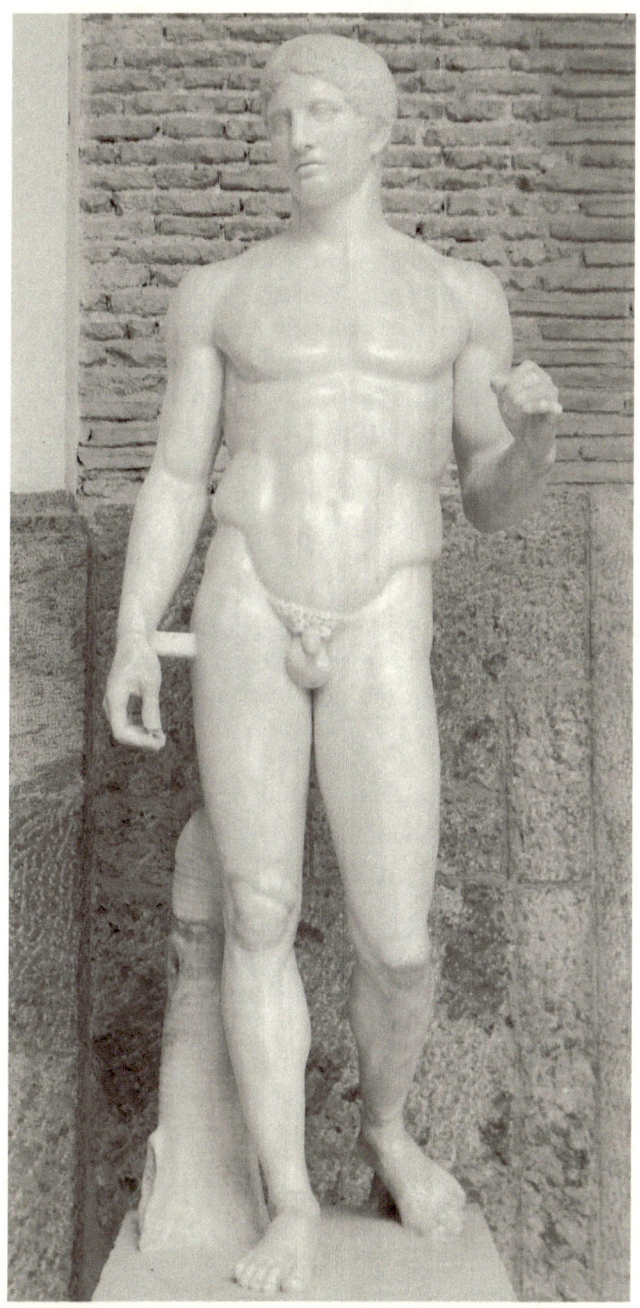

Figure 5.7. *Doryphoros*, ancient Roman copy in marble of a bronze original of ca. 450–440 BCE by Polykleitos. Photo by Marie-Lan Nguyen.

form of *symmetria*). (4) It became difficult to manage with respect to the precise modeling of the matrix. And (5) it was only through "coming to a *kairos*" (on *kairos*, see below) that beauty was obtained (p. 126), though this last point is based on a fifth, disputed, passage. Furthermore, Stewart argues, it can be inferred that the kanon was probably based on a series of mathematical progressions, and related to the three means: arithmetic, geometric, and harmonic.[46]

There is one crucial phrase, in particular, attributed to Polykleitos—as quoted in the passage from Philo Mechanicus—that has received notable scholarly attention because of its ambiguity of meaning: "beauty . . . comes about *para mikron* from many numbers."[47] Stewart summarizes the four alternative readings of *para mikron* prevalent among scholars as follows. In the context of the sentence in which it appears, "*para mikron*" could mean (1) "from minute calculation," (2) "little by little" (or, as Pollitt has it, "step by step"[48]), (3) "from a small unit (or module)," or (4) "except for a little, almost."[49] Without getting into the relative merits of the various readings on philological grounds (and both Stewart and Pollitt address this in their respective treatments of the problem),[50] it is clear that both the second and the fourth options are deeply relevant, in different but related ways, to exactly the kind of mathematical and musical problems we have been discussing as central to the development of Greek mathematics in the middle to late fifth century and, more specifically, to the design of the Parthenon.

Indeed, the idea of reaching beauty, or perfection (Pollitt's translation), in *symmetria* through a "step by step" process is clearly suggestive of *anthyphairesis* in the broadest sense, the sense of a recursive technical procedure that produces progressively finer adjustments. Once again, it was this sort of procedure by means of which the ratios of the musical scale were constructed and, as we are arguing here, by which the Parthenon may have negotiated the corner problem. The fourth reading, taking *para mikron* to mean "except for a little, almost" raises an even more important issue—one central to this chapter and its reading of the Parthenon—in its acknowledgement of an inevitable remainder created by the attempt to construct perfect proportions, a remainder that always necessarily escapes reduction to whole number ratios—that is, the *alogon* (irreducible to ratio, irrational). As we have seen, in the musical scale developed by Philolaus and the Pythagorean circle in the fifth century, this remainder was the *comma*, the result of a repeated application of *anthyphairesis* to build a scale by dividing it into tetrachords, *tonoi*, and still smaller intervals. The Pythagorean *comma* was the "except for a little" left over in that process: the difference between the *apotome* and the *leimma* (or *diesis*); or the dif-

ference between six *tonoi* and the *diapason*; or the difference between a sequence of twelve *diapentes* (fifths) and the sequence of seven *diapasons* (octaves) that it approximates, the same sequence that defines the "circle of fifths" in modern equal temperament; and so on.[51]

It is not essential that one settle on one of these readings of *para mikron*: the second, the fourth, or one of the others. It is likely that the ambiguity of the phrase includes more than one layer of meaning, perhaps two or more of the above options, especially since the preserved fragment may already reflect a conflation of earlier material from various sources, possibly architectural treatises (see below). And regardless: the sense of arriving at *symmetria* not through a joining of the simplest and most perfect ratios alone, but only through a more complex process that involves repeated or minute calculation, and/or small quantities (remainders, exceptions) that are irreducible to the principal ratios but nevertheless essential for beauty, or perfection, indicates clearly an awareness of a *symmetria* that partakes of the kind of process Philolaus articulates in terms of the musical scale.[52] That is, the proportionality of the Polykleiteon kanon seems to implicate the sort of procedure that leads to the discovery of the irrational. In other words, in the terms of this chapter, it seems to embody the kind of *symmetria*, absorbed within a broader concept of *harmonia*, that recognizes the necessity of accounting for the irrational—that is, for that which is irreducible to commensurability—within any procedure of measurement, and that includes the concomitant awareness of the ontological, as well as aesthetic, issues regarding the nature of magnitude and multitude, and their relationship, that this raises. Thus, Polykleitos's kanon, as an actual fifth-century sculptural workshop practice, was arguably much more like the Pythagorean musical kanon than it is generally understood to be: if later generations (and certainly modern scholars) took the Polykleiteon kanon to be a set of rules, a fixed set of proportions for sculptors to follow, its original sense may instead have been much closer to the kind of working-out process, in relation to the larger ontological and aesthetic problems of *harmonia*, that we see at work in the construction of musical scales and in the design of the Parthenon.[53]

In fact, Pollitt has argued that the fragment attributed to Polykleitos in Philo Mechanicus was probably based on a theoretical framework taken from a series of lost architectural treatises produced between the sixth and fifth centuries—and those treatises were, according to Pollitt, among the very first prose works in Greek[54]—raising further questions on the theoretical underpinnings of Greek architecture, even relatively early Greek architecture, of a sort recently taken up by Robert Hahn,[55] and relevant of course to the issues this book seeks to address. Among those

treatises would probably have been the one cited by Vitruvius as written by Iktinos and Karpion (a later corruption of the name Kallikrates?) focused on *symmetria*—that is, a theoretical treatise on architecture, focused on *symmetria*, by one or both of the architects of the Parthenon.[56] If this is true, it may be that similar problems were treated at greater length in Iktinos's treatise, or other writings on architecture in the mid to late fifth century. This, however, purely conjectural as it is, would only really serve as corroboration for the much more important evidence of the Parthenon itself, and the understanding of *symmetria* and *harmonia* evident in the specifics of its design and in its overall aesthetic character.

In his discussion of the Temple at Segesta, in Sicily (figure 5.8), dating to the 420s BCE, Mertens points out that, in contrast to the main tradition of Doric buildings in Sicily and South Italy from the early to mid-fifth century, the design of the Segesta temple is almost perfectly regular. That is, the adjustments to the frieze and intercolumniations at the corners, as well as all other aspects of the building's proportions, seem to be done in accordance with a precise set of rules, an emerging Doric canon drawing on a combination of typically Sicilian variations to metope

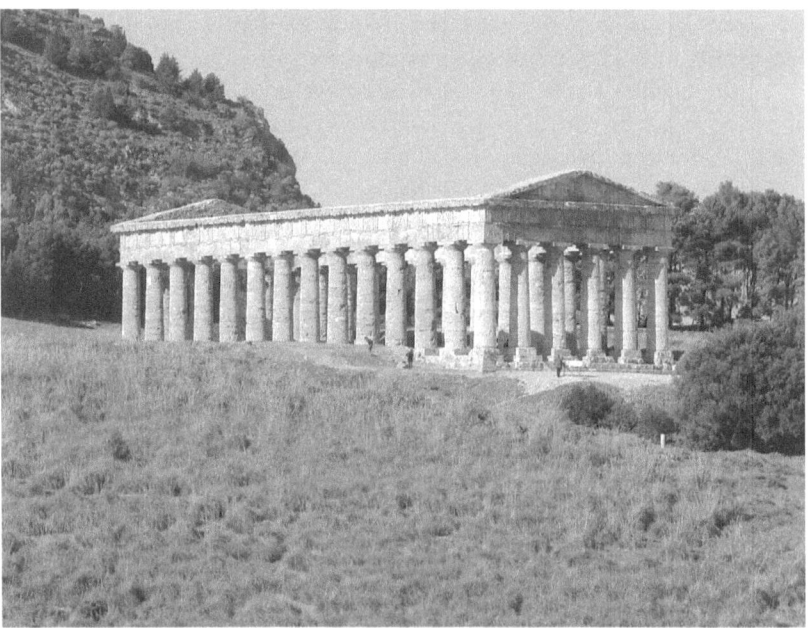

Figure 5.8. The Temple at Segesta (420s BCE): view from the southeast. Source: Creative Commons.

width and typically mainland Greek corner column contractions, as if a compromise had been reached with the corner problem that allowed for the acceptance of a standardized solution.[57] Mertens points out that the design in the Temple at Segesta indicates an awareness of the Parthenon, in its absorbing of mainland Greek influences, and yet no approach to the corner problem could be more different from that of the Parthenon. For whereas the approach in the Parthenon reveals an ongoing and self-reflexive coming-to-terms with the irreducible remainder at the corner, the incommensurable, as a necessary part of the building's harmonics, the Segesta Temple's "canonization" of rules for the Doric order is, as Mertens suggests, more an act of renunciation in the face of the unsolvable corner problem, and, furthermore, perhaps indicative of the gradual decline of Doric architecture itself, as interest in the design problems it raised began to wane. Mertens, however, attributes this systematization—and thus this end to experimentation—to an awareness of the existence of irrationality as discovered by the Pythagoreans.[58] Whereas what we are arguing here is that it was *that very awareness of the irrational* that had, in the Parthenon and its predecessors, sparked the deepest engagement with the problems of *symmetria*, problems raised by the formal characteristics of the Doric order and their relationship to *harmonia*—that is, to the being-as-one of the building as a whole. In any case, one could see the change of approach in the Segesta Temple and in other buildings shortly following the Parthenon as symptomatic of a rapid reinterpretation, and perhaps misunderstanding, in the field of temple architecture, of the problems of greatest concern to the generation of the Parthenon's designers, one that would lead to the misinterpretation of the refinements in general as optical rather than ontological in nature, an issue to be addressed in the next chapter.

It is worth noting here that the Temple at Segesta is also one of the (not so numerous) Sicilian buildings known for certain to include curvature, of the type practiced from the beginning of the fifth century (figure 5.9 on page 126). It seems that these refinements of curvature and those associated with the corner problem may have been increasingly thought about together, and thus together formed the basis for an increasingly canonical and standardized set of rules for the construction of Doric temples. Thus, even in a relatively straightforward and "untroubled" design, such as that at Segesta, curvature would be included as a now-canonical part of Doric temple construction. Lothar Haselberger has argued that during the same short time span in Athens, between Iktinos's design for the Parthenon and Mnesikles's design for the Propylaea (like Segesta, dating from the 420s BCE), the sense of the refinements, and especially the use of curvature, had shifted from what we would call an

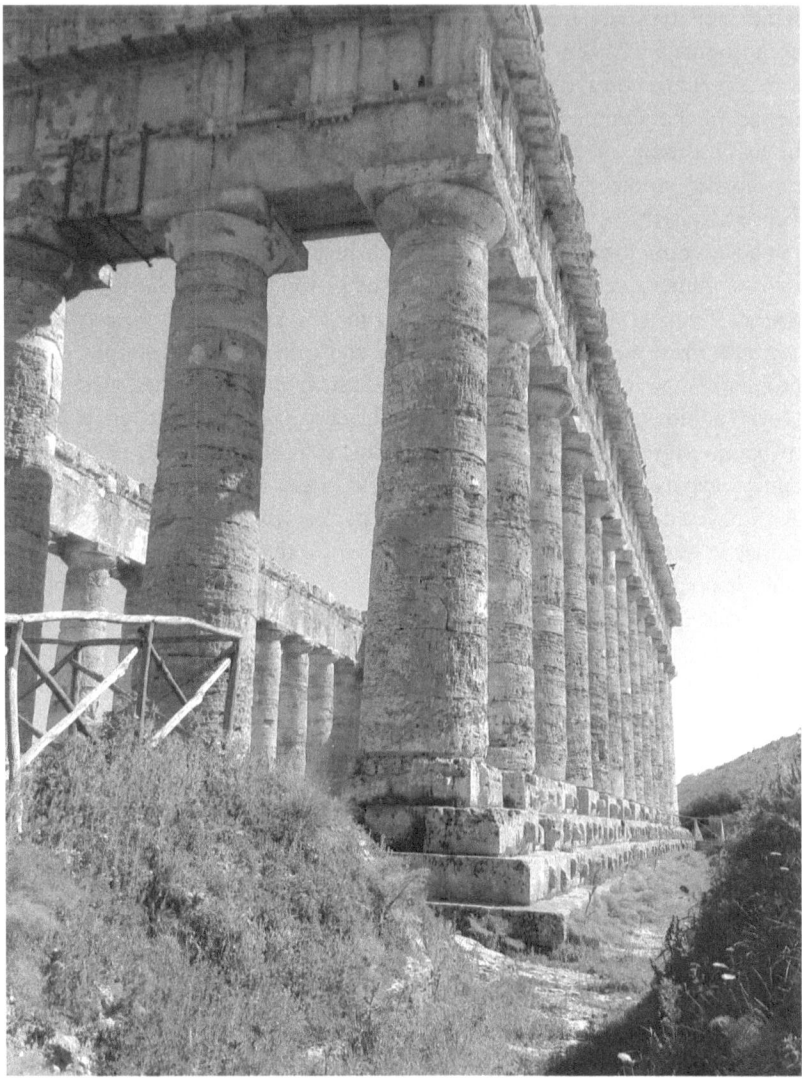

Figure 5.9. The Temple at Segesta: view from the southwest corner, showing curvature. Author's photo.

ontological sense (and what Haselberger describes as an interest in the nature and essence of the building itself) to an optical sense (a concern with visual effects), a point that will be taken up in chapter 6.[59] All this suggests, first, the degree to which, by the later fifth century, the adjust-

ments necessitated by the corner problem and the use of curvature were closely related. Beyond this, though, the case of Segesta, and (following Haselberger's argument) maybe that of the Propylaea as well, argue for a shift toward a "kanon of proportions" of the sort that would later be attributed—through misinterpretation of its original sense, as we have argued above—to Polykleitos, at this point joined to a "canonized" use of curvature, but that was already removed from the spirit of the Parthenon as well as from Polykleitos's own ideas, where the problem of *symmetria* was probably approached through technical experimentation very much like that used to address the question of harmonics in music.

Just as the kanon of Polykleitos has often been understood as a systematization of proportion—that is, as a set of rules for giving proportion to sculpture—so has the marked, even overwhelming, concern with numerical proportion in Doric architecture of the fifth century, including in the Parthenon, been understood by some scholars as an interest in specific, fixed (usually Pythagorean) numerical ratios.[60] Given the above, we would argue that what is made manifest in the design of the Parthenon is not primarily the expression of a fixed, or "canonized," system of proportions, in the sense usually attributed (probably wrongly) to Polykleitos, but is rather the expression of the ongoing working out of a literally unsolvable problem: the problem of harmonics, as first developed in the field of music through experimentation with the kanon (the device for measuring the string) and monochord (the string itself) by the early Pythagoreans. This problem could be stated, once again, as the tension between magnitude and multitude (that is, the problem of measuring and proportioning geometric objects with numbers) and the Parthenon's engagement with this problem may also reflect—or rather, may help us to understand better—the historical moment of the building's construction (447–432 BCE), when the recently discovered problem of the irrational was being actively worked on, before a rigorous mathematical proof had been achieved. If the evidence of the Segesta Temple, and even the Propylaea, indicates a significant shift in the meaning given to the refinements and their relationship to problems of commensurability, it means that by the 420s BCE that crucial historical moment may already have passed.

Chapter 6

Refinements and the Question of Dialectic

Like most of the Doric temples built on the Greek mainland in the fifth century, the Parthenon includes a range of subtle modifications to its design that have come to be known as the "refinements."[1] Beginning with the Temple of Aphaia at Aegina in the 490s BCE (see figure 4.17), and as further developed in both the Temple of Zeus at Olympia and in the Older Parthenon, the refinements became an integral part of Doric temple design, and fall into a number of broad categories, from which scholars today single out four in particular: *entasis*, corner column thickening, column inclination, and, most intriguingly and perhaps most importantly, curvature.[2] According to Haselberger, curvature of the principal horizontal elements of the building may have first appeared in the Temple of Apollo in Corinth, ca. 550 BCE, but it was first used systematically in the Temple of Aphaia at Aegina; furthermore, column inclination and corner column thickening also made their first appearance at Aegina.[3] Thus, it is at the Temple of Aphaia where these refinements were not only first developed, but were (right from their origins) being thought about together,[4] and for this reason that temple, located in what was by the mid-fifth century an Athenian colony, is clearly the most important precedent for the Parthenon with respect to the refinements.[5]

Given the preceding chapter, it should be clear already that what are normally defined as refinements proper—that is, the adjustments indicated in the four categories listed above—are far from an anomaly in relation to the design problems of the Doric order, since the corner problem necessarily demands various reciprocal adjustments with respect to "perfect" proportion, adjustments that are for all intents and purposes also "refinements." This in itself should signal that the refinements to be discussed in this chapter must have addressed conceptual and aesthetic

problems similar to those involved in the solution to the corner problem—especially in the case of the Parthenon, where that solution was so complex, multilayered, and subtle (cf. the subtlety of the refinements proper, discussed most notably by Korres[6])—and that consequently they should be understood as thoroughly integral to the design of the building and not as merely accidental or capricious. Indeed, the refinements are in fact an inseparable component of the building's unity as a single object or, in terms of our discussion, of its *harmonia*. Ironically, the refinement that seems the most capricious (in that it seems to be a luxury), or at least that involves the most effort (in terms of both design and physical construction) without apparently being necessary for the building's design, structural integrity, or function—namely, the curvature of all the principal lines of the building—may in fact be the one that is ultimately most essential for the building's ontological self-reflection and for its pedagogical function. This pedagogical aspect is the temple's invitation to a mode of thought that could best be described as dialectical, in precisely the sense that would later be developed in Plato's dialogues.

1. The Refinements: Optical or Ontological?

Since the time of Vitruvius, the refinements have primarily and overwhelmingly been referred to as "optical refinements," and understood as such. Given that Vitruvius's *De architectura* is the only treatise on architecture to survive from classical antiquity, its influence has naturally been immense, and its description of the refinements of Doric temples has had a decisive importance for later interpretations, providing their guiding framework and even their vocabulary.[7] In the section of *De architectura* on the foundations of temples (III.4), Vitruvius writes: "The stylobate must be so leveled that it increases towards the middle with unequal risers [*scamillos inpares*]; for if it is set out to a level it will seem to the eye to be hollowed."[8] Certainly this interpretation of the refinement of curvature as an "optical correction"—as done primarily to counteract an optical illusion—seems plausible, given that, at least on one level, these refinements, unlike the various adjustments with respect to the corner problem, are not necessary to the building's holding together proportionally. Instead, they seem at first glance to serve primarily expressive purposes, or rather, in the Vitruvian interpretation, corrective ones: the building is made curved in order to look straight.[9]

However, a consideration of the fundamental conceptual changes that both informed and emerged from changing practices of temple design

between the time of the Parthenon and Vitruvius's own, six centuries later, makes any reliance on Vitruvius as an interpreter of the refinements highly problematic. As Coulton has argued at some length, already by the Hellenistic period the procedure in building practice had shifted from one based on modular design (and/or of a conception of the temple building as a relationship of parts to a whole) to the use of a ground plan that determines a building's dimensions in relation to a pre-existing grid of measurement.[10] And Hans Junecke, in an article on the temple of Zeus at Olympia, points out that there is a discrepancy between the temple's actual measurements—based on a module determined by a sequence of geometric constructions and divisions derived from the stylobate dimensions—and the measurements one would get if using Vitruvius's approach to modular design (oriented more toward a "grid of measurement"), based on Hellenistic and post-Hellenistic practices.[11] What is at stake here is more than a change in building practices: it is an ontological shift, in that during and after the Hellenistic period the building is no longer understood as a harmony of conflicting but related parts joined to make a whole, but instead in relation to a pre-established overall framework for measurement, embodied by the ground plan. According to Coulton, this Hellenistic practice continued into the Roman period, which means effectively that Vitruvius would have perceived the Parthenon from a very different vantage point than that of a designer, viewer, or interpreter of the fifth century—that is, from a vantage point (Vitruvius's) in which the ontological problem of *harmonia*, as we have been discussing it, would have probably played little or no part.[12] Thus, the idea that refinements such as column inclination or curvature were introduced into the building as a way of engaging the problems raised by harmonics—that is, for ontological reasons—may not really have presented itself as a possibility to Vitruvius, and the idea of refinements as optical corrections would inevitably have seemed the most plausible explanation for these otherwise unexplainable phenomena. Furthermore, as other scholars have noted, the shift away from building practices oriented toward *harmonia* as an understanding of the nature—of the *being*—of the building itself also entailed a shift toward an emphasis on optical effects, perhaps (as Haselberger has suggested) already as early as the end of the fifth century.[13] Thus, the retrospective perception of the Parthenon's refinements as primarily serving optical effects may already have been well established by the time of Vitruvius and may in fact merely reflect the emphasis in both Hellenistic and Roman culture on the optical and on the subjective.[14]

The recognition that the refinements may be more ontological than optical in nature, *pace* Vitruvius, has been fairly widespread—even if it is still

not the prevailing view—since the modern rediscovery of the Parthenon's curvature.[15] It is telling that the resurgence of interest in an ontological interpretation of the Parthenon's refinements began with the rediscovery of the actual, visible curvature of the building's stylobate (figure 6.1; see also figure 4.19) during the excavations of the 1830s that followed Greece's independence from the Ottoman Empire. The experience of looking at and measuring the stylobate, its curvature now plainly visible since it had been excavated from the rubble of the Acropolis, encouraged Joseph Hoffer and

Figure 6.1. The Parthenon: view from the northeast corner, showing curvature. Photo by Allan T. Kohl.

other scholars of the period, no longer relying primarily on the textual authority of Vitruvius, to describe the curvature as an integral part of the building's "organic" quality, its mysterious presence and its impression of unity.[16] Since then, a number of the most prominent scholars of classical architecture, and of the refinements themselves, most notably Haselberger and Gottfried Gruben, have argued in a similar vein, drawing on more recent research to support these intuitions.[17] Haselberger has even argued for a shift, in the decades between Iktinos's design for the Parthenon and Mnesikles's design for the Propylaea, from (what we would call) a more ontological to a more optical approach to refinements—specifically, as Haselberger puts it, from an ideal of perfection in itself to a concern with appearances—based on subtle differences in the use and in the degree of specific refinements in the two buildings.[18] In addition, the fact that a number of the principal ratios that define the Parthenon's *symmetria* are not directly visible, for example, the 9:8 ratio of the exterior to the interior dimensions of the cella and the 13:9 ratio of cella to stylobate, as well as a number of the components of the building's 9:4 proportionality, further supports the idea that the objective wholeness of the building, its relationship to *alētheia* (truth) and not just *phantasia* (appearance), was being thought through in ways independent of purely optical effects.[19] And indeed, for a temple dedicated to the goddess of wisdom, a particular concern with truth and with true being, transcendent of the limitations of human perception, seems (to say the least) entirely fitting.

Of course, this raises the question of why the shift from an ontological and harmonic to an optical and subjective motivation for the refinements would have occurred, in Athens itself, so soon after the building of the Parthenon. What is at stake in this question is also the problem of the Parthenon's later reception and its status, with respect to Plato's dialogues and the liberal education of the Platonic Academy, as a mediator between the prehistory of Greek mathematics and the later philosophical tradition, specifically, the response we find in Plato and his followers to the theoretical problems associated with harmonics in the Parthenon (the irrational, the relationship of magnitude and multitude), and their pedagogical implications. If there is a continuous tradition, across "disciplines" (i.e., across fields of cultural production and aspects of intellectual culture), that involves a sustained engagement with these questions, why weren't the same questions pursued in the sacred architecture built in Athens immediately following the Parthenon, most notably in the Propylaea? Of course, any interpretation of this situation must be purely speculative. However, if we consider the regularization and standardization of the Temple of Segesta's design, begun only a decade or so after the completion of the Parthenon (see chapter 5, section 2 above), a standardization that also incorporates curvature and

other refinements, we can see the shift from an active engagement in such problems—in a Doric architecture that is developing and defining itself (in the Parthenon)—to a more reified definition of the order, as Mertens has argued.[20] In this more reified Doric order of the later fifth century we find an effectively standardized *symmetria* that includes refinements as a necessary and accepted component of that standardization, indicative of a shift away from the most intense engagement with Doric architecture (its forms, its *symmetria*, its harmonics) in a period when Ionic and other architectural forms were already coming into prominence and supplanting the Doric. This need not imply that the problems themselves that are addressed in the Parthenon also move out of focus; on the contrary, the whole point of the "interdisciplinarity" of these problems is that they are not specific to the design of Doric temples, any more than they are specific to the construction of the musical scale, and they can be engaged most adequately across disciplines, emerging for instance in more theoretical form in the dialogues of Plato at a time (the fourth century) when Doric architecture is less prominent as a cultural form.

To return to the question of curvature in the Parthenon: a further important point, addressed by Michael Duddy in an article on curvature in Doric temples, is that any account of the precisely calculated curvature of the Parthenon, or of other buildings with similar refinements, as being designed to produce specific optical effects inevitably assumes a fixed vantage point from which the curves would have a calculated effect within the visual field—specifically, with respect to the center or the edge of the retinal image, as determined by the distance and the position of the viewer with respect to the building.[21] Although that author's point is not, in fact, to challenge the optical interpretation of the refinements, the argument includes what is effectively a critique of Hauck's optically oriented discussion of the Parthenon's curvature in relation both to perspective theory and to the late-nineteenth-century physiology of vision developed by Helmholz and others, since it (Duddy's argument) problematizes any approach to the refinements based on a fixed point of view.[22] The situation in Doric buildings with curvature and other subtle refinements, like the Parthenon, is precisely the *opposite* of the one evident in early Renaissance architecture, particularly that of Brunelleschi, where the spatial geometry of the structure is conceived in relation to a series of genuinely fixed perspective views, and thus is necessarily based on perfectly proportional rectilinear, or circular/spherical, elements (undistorted circles and spheres being included as discrete forms, but subtle curvature of the kind found in the Doric refinements being inadmissible).[23]

Naturally, the principal experience of the viewer or worshiper visiting the Parthenon is not that of a restricted number of fixed vantage points,

from which its subtle curvature and columnar inclinations could have a calculated optical effect, but of a continuously moving one. Furthermore, if one chooses to interpret that experience as a continuous series of "fixed" vantage points, as one could in a building by Brunelleschi, each of those vantage points would require a slightly different set of curves—a clear impossibility—to produce the same corrective effect. Indeed, from this standpoint, the notion of curvature as a precisely calibrated corrective for the distortions of vision makes sense only for a fixed vantage point, and yet the entire orientation and situation of the Parthenon on the Acropolis seems consciously designed to encourage a moving experience, with a continuously changing vantage point. The building is seen from afar and from far below during the approach along the Panathenaic way, then nearer but still somewhat from below when seen through the Propylaea (see figure 4.3), then more and more head-on as one approaches it on the summit of the Acropolis. Furthermore, its principal façade and entrance lie at the far side with respect to the approach through the Propylaea, requiring the viewer to move around one side of the building, a journey that is also both encouraged—in terms of the visual momentum of the figures on the frieze—and literally depicted on the Panathenaic frieze directly above (figure 6.2). With the literal, embodied movement of a viewer or

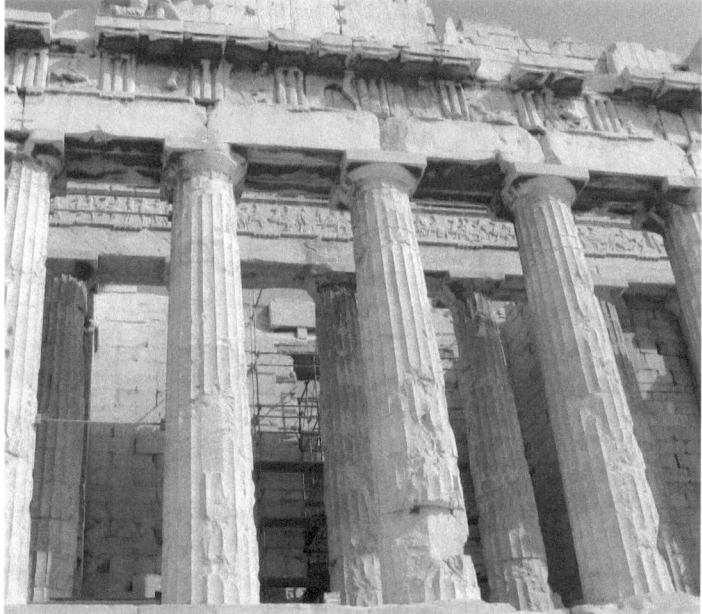

Figure 6.2. The Parthenon, west façade, Ionic frieze: beginning of the Panathenaic procession (?). Photo by Yair Haklai.

worshiper being so central to the experience of the building, and even thematized in its iconographic program, any reading of the Parthenon's curvature that privileges the experience of a fixed viewpoint is clearly problematic, a point to which we will return.

Perhaps a consideration of the Parthenon's engagement with musical harmonics, as practiced and theorized by Philolaus and the Pythagoreans of the mid-fifth century, might be one way to understand more fully the ontological problem addressed by the refinements, including that of curvature. From the point of view of harmonics, once again, the problem is that there is no way to make one building out of the various *symmetriai* at play in the Parthenon's design such that they *perfectly* fit together. Both Haselberger's understanding of the Parthenon's refinements as (to paraphrase) a way of expressing the truth of the building's existence, and in its own way, Pollitt's suggestion, to which we will return in section 3 below, that the building deliberately proposes a tension between *alētheia* (truth) and *phantasia* (appearance) acknowledge that something ontological is at stake in the Parthenon's refinements, in which the question of harmonics—that is, the question of what constitutes the building as a unified whole—may be implicated.[24] The most far-reaching and the most self-reflexive aspect of the tension Pollitt describes emerges with the Parthenon's use of the refinement of curvature. However, it may be helpful to begin with the integration of column inclination into the building's design, for it is there that the relationship between *harmonia* and *symmetria*—the defining problem of harmonics—shines forth most clearly.

2. Column Inclination: *Harmonia* over *Symmetria*

The inward inclination of the columns of the peristyle, as it was practiced from its appearance in the Temple of Aphaia at Aegina in the first decade of the fifth century down to the time of the Parthenon (figures 6.3 and 6.4; cf. figure 4.17),[25] added an additional half-triglyph width to each corner of the stylobate, that is, an extra triglyph width to each side, relative to the width of the entablature above, with the slightly inclining columns spanning the difference. However, as Büsing has shown in a concise but illuminating article, the approach taken at the Parthenon was slightly different. In Doric temples of more standard intercolumniations, such as 6 × 12, 6 × 13, or 6 × 15, the stylobate dimensions, with the half-triglyph addition to each corner, approximate relatively small number ratios (7:15, 3:7, or 7:19, respectively; or, to keep to the notation we have been using: 15:7, 7:3, and 19:7). In the case of the Parthenon, considering the stylobate *without* the half-triglyph additions (that is, taking

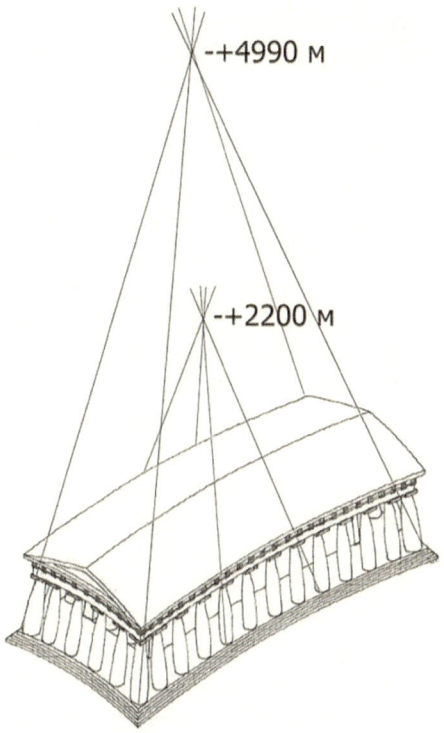

Figure 6.3. Diagram of the column inclinations of the Parthenon. Drawing by Erud.

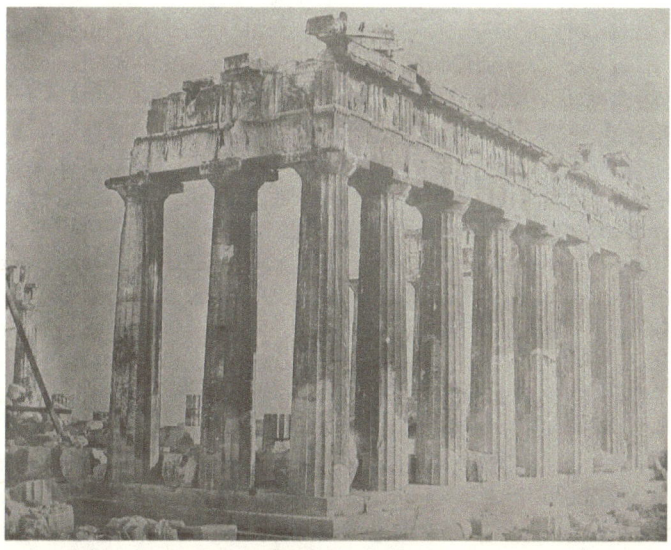

Figure 6.4. Joseph-Philibert Girault de Prangey, *Façade and North Colonnade of the Parthenon on the Acropolis, Athens*, daguerreotype, 1842. Source: Creative Commons.

the dimensions of the entablature for the dimensions of the stylobate) yields stylobate dimensions, like those of the entablature, that come out to *exactly* 9:4. Hence, he argues, the abnormally large contractions of the corner intercolumniations: the columns are brought in one half-triglyph more than the standard contraction to preserve the 9:4 proportions of the stylobate.[26]

Another way to describe this same process, though, which reveals how important Büsing's observations are for our discussion of the Parthenon, is the following: the stylobate proportions were kept as those of an "ideal" entablature of 81:36 "ideal" triglyph modules (0.858 m),[27] but the entablature was *compressed* by one triglyph width on each side (i.e., one half-triglyph width for each of two rows of inclined columns at the end), with a corresponding compression of the dimensions of the elements of the frieze, the triglyphs and metopes. If this is calculated based on the flanks, which are 81 ideal triglyph modules in length, the entablature when compressed by one triglyph module would be 80 ideal triglyph modules in length, and at the same time of course, 81 actual (now slightly compressed) triglyphs in length. And this in fact corresponds exactly to the 81:80 ratio of the ideal triglyph module—the one that determines the stylobate dimensions and the large-scale *symmetria* of the building[28]—to the actual average triglyph width of 0.845[29] (0.858:0.845 ≃ 81:80). Furthermore, this difference between the ideal module of the stylobate and the real triglyph width in the entablature precisely corresponds to, and counteracts, the difference between the 5:1 (= 80:16) ratio of intercolumniation to triglyph module—the standard method for determining the measurements of the stylobate and the principal unit of Doric modular design, as discussed in illuminating fashion by Gene Waddell and Mark Wilson Jones[30]—and the 81:16 ratio between actual intercolumniation and actual triglyph width with which the Parthenon was built, with its overriding concern for 3:2, 9:4, and 81:16 (81:36:16) continuous proportionality.[31]

What this means is that the column inclinations, a standard refinement in Attic Doric temples by the time of the Parthenon, together with the slight discrepancy they introduce between the dimensions of the stylobate and the dimensions of the entablature, were effectively used in the Parthenon as a mediation between two different and not entirely compatible principles of *symmetria*. These two *symmetriai* were the 5:1 intercolumniation-to-triglyph ratio used in the modular design of the Doric stylobate in the mid-fifth century and the 81:16 ratio between intercolumniation and triglyph (intercolumniation : column diameter : triglyph :: 81:36:16) on which the continuous proportions specific to

the Parthenon are based.[32] Thus, the refinement of column inclination was thoroughly integrated into the design of the building: as a mediating factor, it in effect "solved" the problem of the incompatibility of these two *symmetriai*, both so crucial to the temple's design. Or rather, since this "solution" also introduced approximations and adjustments that departed from perfect measure (for instance, the visible triglyph was now very close to, but not exactly, the width of the module used for the stylobate), it was clearly part of the larger working-out process in response to the irreducible tension between magnitude (the building's three-dimensional geometry) and multitude (its numerical, musical proportions). Thus, it was a crucial element in the process of joining the parts of the building as much as possible into a geometric whole defined by numerical ratios, that is, into a harmonic unity. As should be clear, this raises issues quite similar to those at stake in the Parthenon's approach to the corner problem, and in ways that make evident how the treatment of column inclination—with the adjustments it necessarily introduces into the entablature—is integrally bound up with the negotiation of the corner problem itself. This harmony shows, for instance, in the way the contraction of metopes at the corners, virtually unique to the Parthenon, relates both to the excessive corner column contractions (another unusual feature of the building) and to the now-standard refinement of thickening of the corner columns: all three now work together to create the impression of a strengthened corner (see figures 4.20, 5.1, and 6.4). And it is crucial to note that the emphasis on corners has the effect of reinforcing the unity and definition of the building as a three-dimensional object, that is, as a *harmonious whole*, since the corners are what articulate the most general contours of the building's three-dimensional geometric form.[33] Indeed, the method, discussed in this section, of joining slightly incompatible *symmetriai* and of integrating different but related problems (column inclinations, the corner problem) suggests an overriding concern with *harmonia*, even at the expense of perfect *symmetria*, a point to which we will return.[34]

It is worth pausing here to underscore again the difference between *harmonia* and *symmetria*, in the way that we are defining and using the two terms, given the fact that in most discussions of Doric architecture, and of the issues we are focusing on here, *harmonia* and *symmetria* are conflated, or at least the difference remains unexpressed. If *harmonia* is understood in its etymologically well-grounded sense of joining together things that are different, it implies something more paradoxical than the perfect fitting-together of *symmetria*, and in the context of our reading can also be understood as a way of thinking about how not only proportionality but also that which is irreducibly different, the irrational, can

be incorporated, in some sense or other, into the unity, based on joining together, of the object at hand (i.e., the physical building). In his overview of the antique tradition of art criticism, Pollitt remains skeptical about the difference between *harmonia* and *symmetria* in the rare cases when *harmonia* is used in reference to visual arts, given that *symmetria* is the normative term for addressing similar problems in art theory.[35] However, its association with music and also with physical construction, like ship building, seems to reinforce the idea that *harmonia* was a part of building practice that, although foundational for the aesthetics of Doric architecture, did not make its way into formalized, canonical art criticism. An additional possibility, in the purely speculative register, regards the term *eurhythmia*, which Pollitt defines as "a softened, more pleasing form of *symmetria* in which deviation from 'real' mathematical commensurability has been allowed" and also as "the quality of being well shaped or well formed."[36] Perhaps in *eurhythmia* one could recognize, though expressed in nonmathematical terms, an acknowledgement of some of the aesthetic—and by implication, ontological—problems inherent to what we have been defining as *harmonia*, though any substantiation of this would require further philological research of a kind we cannot attempt here.

To return to the Parthenon and its use of column inclination: to further clarify this as an actual building practice in which harmonics was addressed in an open-ended, problem-oriented way, we could summarize a hypothetical reconstruction of the integration of column inclinations into the building's design as follows, taking into account the constructive method based on continuous proportions that was the focus of chapter 4, especially section 3. The goal of achieving *symmetria* in the building through continuous proportions of 9:4 established a triglyph of average width 0.845 m, in a 4:9 relation to the existing column drums (1.905 m) and a 16:81 relation to the intercolumniations. At the same time, the usual rules for determining the dimensions of the Doric stylobate based on the intercolumniation width suggested an 8 × 17 peristyle as a way of producing a stylobate proportion of exactly 9:4, or 81:36 measured in triglyph units. However, as this latter calculation was based on a 5:1 (= 80:16) ratio of intercolumniation to triglyph, while construction through continuous proportion established an 81:16 ratio between them, the two forms of *symmetria* involved in the building's design thus far produced an 81:80 discrepancy, in terms of the intercolumniation measurement with respect to the triglyph. However, the column inclinations, also standardized by the mid-fifth century, that added one triglyph module to each side of the stylobate, given the dimensions of the Parthenon, would produce a precisely compensating 80:81 ratio of entablature to stylobate on the

flanks, if the entablature were conceived as compressed by one "ideal" triglyph module rather than the stylobate expanded (which would produce 81:82). The same degree of column inclination (and "compression") of the entablature) could then be used on the façades. Thus, with the real triglyph width (0.845 m), linked in a 4:9 ratio to the existing column drums, as a given, the "ideal" triglyph module for the stylobate (0.858 m), in a 1:5 ratio to the intercolumniations, would then be established in an 81:80 ratio to the actual triglyph, with the standard column inclinations snugly mediating between them.

This is, of course, just one way to reconstruct such a process. What is extraordinary is the way three different design principles—the continuous proportion of 9:4 specific to the Parthenon, the relation of the Doric stylobate dimensions to the triglyph module (standardized in the fifth century as based on a 5:1 intercolumniation : triglyph ratio), and the stylobate/entablature discrepancy introduced by column inclination—each with its own historical trajectory, and each addressing a different problem, are harmoniously joined to one another in the design of the Parthenon. One can only imagine the excitement the designers may have felt when they hit on the novel 8 × 17 peristyle and may have realized how it provoked the convergence of these three forms of *symmetria* toward the continuous proportionality of 9:4—that is, in recognizing how 81:36:16, 81:80, and 80:16 (5:1) could now work together to determine the proportions of the building as a whole. In addition, this convergence seems extraordinarily resonant with other aspects of the building's *harmonia* that involve the joining, or interplay, of different traditions at the most holistic level, most notably the coexistence of Doric and Ionic orders in the building's design, with respect to both the interior columns and the two friezes (figure 6.5 on page 142).[37] There is no space here to address the possible political implications of these alternative architectural modes, with their specific geographical associations, being fused in a monument to Athens's patron goddess at the very historical moment of the greatest extent of the city's hegemony through the Delian league. More to the point in terms of our discussion: the two orders embody two different systems of *symmetria* with two correspondingly different aesthetic characters, and the joining of the two in one building, in a way that involves active reciprocal adjustment (specifically, with respect to the slightly more Ionic proportions of the Doric peristyle), only reinforces the sense of *harmonia* as an overriding concern in the Parthenon, even at the meta-level of self-reflexivity with respect to architectural tradition.[38]

Once again, however, because the achievement of *harmonia* involved adjustments and approximations—most significantly, the slight discrepancy

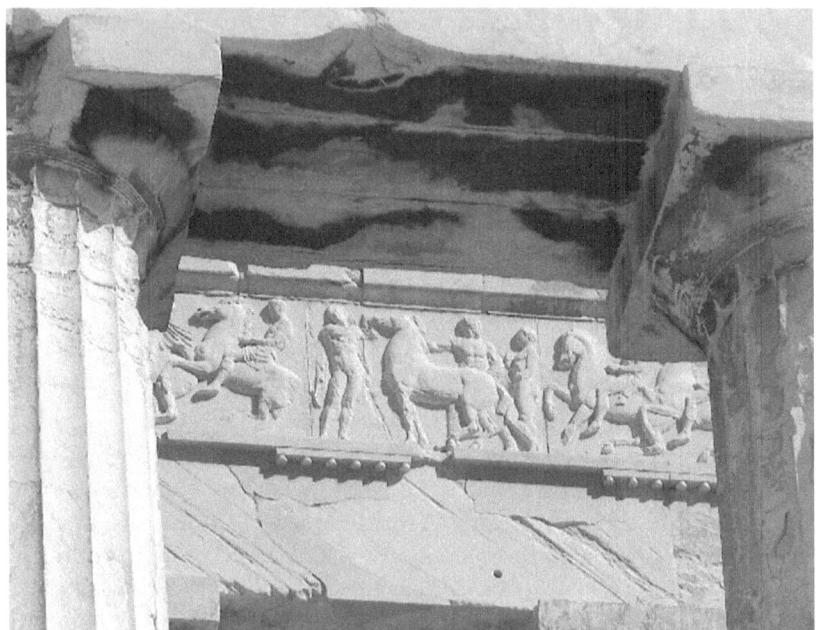

Figure 6.5. The Parthenon, west façade: detail showing Doric capitals and Ionic frieze with Doric guttae underneath. Photo by Athinaios.

between the real, visible triglyph and the ideal triglyph module—the situation is not one of simply merging all three of these rules for the proportioning of the building into a single system of *symmetria*, but rather implicates a more complex harmonics, a joining together to make one whole that also acknowledges the impossibility of the perfect realization of *symmetria* in the physical Parthenon—or, indeed, in the physical world itself, a world that includes both multitudes and magnitudes, discrete objects and continuous quantities. And it is the slight discrepancy between the visible (physical, real) and the ideal that, as we will see below, points toward dialectic, as discussed in *Resp.* 7, 531c–534a, and as it was also consciously and self-reflexively acknowledged in the Parthenon.[39]

The way in which adjustments are made to the entablature of the Parthenon to accommodate the inward inclination of columns on all sides indicates that the unity of the building as a whole, the joining together of its different parts—namely, its *harmonia*—takes precedence even over *symmetria*. This is manifest, first of all, in the adjustment of the triglyph with respect to the "ideal" triglyph module, a deviation from the pure *symmetria* of stylobate and entablature for the sake of balancing and adjusting

multiple elements to harmonize slightly different proportional systems, as well as to bring the corner into harmony with the rest of the building. Furthermore, it suggests that the holding-together, the very being, of the building, as *one thing*—what the refinements seem to address—takes precedence over proportion per se: the refinements are not just added on to pre-existing proportions, but instead engender adjustments to the building's *symmetria* as a whole—in fact, a reciprocal back-and-forth of adjustments. (Consider in this context Korres's and Haselberger's analysis of the concept of "refinements of refinements."[40]) In other words, proportion simply cannot be thought about, or understood, independently of refinements in the Parthenon.

One could look to the brief but challenging discussion of "the one" in *Resp.* 7 (probably a later theoretical reflection on a mid-fifth-century mathematical problem[41]), as an indication of the ontological depths of this problem of unity with respect to harmonics, and of what is at stake in the question of the unit, or module, in the Parthenon. Just as Socrates and Glaucon, in *Resp.* 7, 524d–526c, discuss "the one" as holding together as a unit despite the apparent divisibility of any specific "one" into innumerable parts, so the Parthenon is a building made up of carefully coordinated parts involving progressively smaller adjustments (suggesting the possibility of an *anthyphairesis* without limit) that also has a powerful presence as a single, harmonious whole. Creating unity out of disparate parts is, of course, a fundamental aesthetic value in many contexts and is even, one might argue, the defining value of aesthetics, from the point of view of the object (as opposed to that of the subject, i.e., of subjective judgment). However, the construction of a unified whole in the Parthenon engages a much more specific set of concerns, namely, the consideration of the relationship of *harmonia* (the wholeness, or oneness, of the object) to a constituent module, or unit, made visible in the triglyph that measures the building—and, in effect, that defines and anchors its corners at the level of the frieze. This is the problem (that of the unit), explored in greater detail in the introduction and in chapter 4, that underlies *anthyphairesis* and that is essential to the understanding of musical harmonics as a relationship of multitudes.

This is a theoretical issue, to be sure, and of a mathematical sort, but it is also, in the case of the Parthenon, a question of direct experience. A viewer or worshipper in the presence of the Parthenon experiences the building as an ontological and aesthetic whole, and at the same time is engaged, directly and intuitively, by an interplay of related parts (see figure 4.1) whose proportional relationships function as a kind of visual analogue to the effects of harmony in music, that is, to the relationships

among pitches built from some of the very same numerical ratios present in the Parthenon. The tension between wholeness and multiplicity remains a tension, as it does in the experience of music, precisely because the multiplicity of proportional parts is ultimately irreducible to the aesthetic/ontological whole, since that whole necessarily incorporates the irrational. It is this tension that one experiences as harmony, that underlies what various scholars have identified as the building's uniquely organic quality,[42] and that shapes the intuitive experience of the building.

At this point it should be clear that the subtle curvature to which all of the principal lines of the building are submitted—the most famous and most difficult to interpret of the building's refinements—cannot be thought of separately from the other refinements we have been discussing. Shortly after the Parthenon's curvature was first rediscovered in modern times, Penrose included a chapter in his *Investigation of the Principles of Athenian Architecture* that interpreted the curvature primarily in harmonic terms, arguing that individual curved elements were introduced to contribute to the harmony among various parts of the building (also in relation to the effects of other refinements, such as column inclination and *entasis*), and were thus essential to the beauty and perfection of the building as a whole.[43] And the idea of *harmonia* provides an important guide, even if in a speculative and open-ended way, for thinking about the interdependence of curvature—so central to the experience of the building's mysterious harmonic quality—with other refinements that address the relationship of multitude and magnitude, and by extension the ontological status of mathematical objects. If the Parthenon does indeed prioritize *harmonia*, then the curvature that touches and modifies every one of the building's visible features should be more than a mere sophisticated oddity inherited from its predecessors, or even a conscious modification of what would otherwise be a "perfect" straight building. Rather, it is an integral part of the joining together of related but irreducibly different forms, or systems of measure, that characterizes the harmonics of the Parthenon in a thoroughgoing way.

3. Curvature: Toward Dialectic

In his brief discussion of the curvature of the Parthenon in *Art and Experience in Classical Greece*, Pollitt suggests an alternative to the prevailing theory of optical corrections, as well as to its counterpart, the theory of exaggeration, that is, that the refinements are meant to exaggerate optical effects for expressive purposes.[44] The third option that Pollitt proposes is

that the discrepancy between the conception of the building as straight and its actual curvature is meant to produce a tension between *alētheia* and *phantasia*, between truth and appearances.[45] Broadly speaking, this third alternative brings one closer, in our view, to the real situation in the Parthenon, as it relates the optical effect of the curvature to epistemological and ontological questions: namely, how, and if, the building directs us toward truth, and what it reveals about its own being, respectively. For one thing, this interpretation of the building's curvature (what Pollitt calls the "tension theory") indicates the way a concern with the deceptive, or at least ambiguous, character of appearances directly relates to, and is in effect subsumed within, broader ontological concerns. What we have been arguing, in different ways, and what we would like to bring to bear on the problem of the Parthenon's curvature here, is that such tensions are central to the understanding of the building: to the *harmonia* that constitutes its being and its unity as an object; to its aesthetics and to the experience it creates for a viewer; and also, significantly, to its mode of intellectual engagement with the viewer, a mode that carries pedagogical value. With respect to the discrepancy between degrees of truth—between seeming and being (Plato's preferred expression of this problematic)—the direct experience, and the concomitant invitation to interpret such experience, created by the curvature of the Parthenon involves us in a tension that functions not as a simple contradiction, but as a multilayered series of contradictions or unresolvable ambiguities.

To clarify: the tension is not merely a simple one between appearance and reality; rather, the ambiguity begins already at the level of appearances. Any visitor to the Parthenon will note that in the process of approaching the building it can alternatively appear straight or curved, and often ambiguously both. From a distance, the Parthenon gives a fully rectilinear impression, but from a position close to one of the corners of the stylobate, the curvature becomes entirely evident (see figure 6.1, a view of the Parthenon from the northeast corner). From other vantage points, one is hard pressed to decide whether the building is straight or curved (see figure 6.4; see also figure 5.6, like figure 6.1 a view of the east façade of the building). And this latter experience, where the curvature lingers just at the threshold of conscious awareness, may contribute significantly to the intuition, shared by many scholars and critics of the Parthenon, that the building has an ineffable organic quality. And even while standing near one of the corners and clearly perceiving the curvature of the stylobate, one remains uncertain with respect to the curvature or straightness of the entablature above (compare figures 6.1 and 5.6). Thus, the initial tension could best be described as the tension

within a self-contradictory sensory experience, a tension that raises the question: Is the building curved or straight? This tension is reminiscent of Plato's discussion of the contradictions inherent in the perception of the three fingers in *Resp.* 523a–524e.[46] However, it is important to note that the experience of the Parthenon's curvature relates not so much to the example of contradictory sensations in a typical object, as described in Plato's dialogue, as it does to the *self-reflexive mode of the text itself*. The carefully considered introduction of curvature into the Parthenon does not just partake of the indeterminacy Plato attributes to all sensory perceptions with respect to qualities like magnitude, which would be relevant to any physical object; instead, through an incredibly labor-intensive process of designing curves, and cutting and joining individual stones that have to be fitted together to construct those curves, the Parthenon works to make an exceptional form of sense contradiction self-reflexively evident, in a way that demands reflection.[47]

The ambiguous sense experience that the Parthenon's curvature and other refinements (such as column inclination, or the small variations in metope width) produce exists, in turn, in a state of tension with the consistent curvature of the actual physical building, and with all its actual magnitudes in all their subtle variations, that can be clearly determined by measurement. In other words, there is a tension between the irreducible ambiguity of sense experience and the certainty of measurement. Furthermore, the discrepancy between the objectively curved building, with its various refinements and adjustments, and the mathematical idea of a perfectly rectilinear geometric object, governed by clear *symmetria*, would then constitute a third tension, building on the first two. In this sense, in addition to the tension within ambiguous sensory experience, one also experiences, first, a tension between subjective uncertainty and objective physical reality *and,* second, a tension between physical realization and mathematical idea—or, to put it another way, between physical being and mathematical being. The tension, or contradiction, between the subjective experience and the objective physical building may be primarily what Pollitt has in mind when describing the contradiction of *phantasia* and *alētheia*, while the tension between the physical building and the mathematical idea moves into more fully ontological territory, and toward the problem of harmonics that is the focus of this book: the relationship between objects of sensation and purely mathematical ones, and the way that, for the fifth-century Greeks, the former were never fully reducible to the latter.

It should also be clear, as suggested above, that these same tensions, between the subjective and the objective and between physical

and mathematical objects, that characterize the building's curvature and its effect on a viewer are the very ones at play, quite specifically, in the design of the Parthenon's entablature in response to the corner problem. Indeed, these different aspects of the temple's design—the adjustments to the entablature and the refinements proper—seem to be responses to the same set of concerns.[48] One could even argue that an *anthyphairesis*-oriented approach to determining dimensions, so important for the design of the Parthenon, is implied in Haselberger's observation about the relative degrees of curvature on the façades and the flanks of the building: the curvature is slightly greater on the flanks than the façades, but not by a ratio of 9:4; rather, the ratio is a median between absolute equality and proportional equality (where the flank curvature would be 9:4 that of the façades)—that is, a median that could be determined by comparing magnitudes (subtracting one from the other) and determining differences.[49] And, of course, it is worth re-emphasizing at this point that these are the same concerns at stake in musical harmonics. The latter tension, between the physical and the mathematical, is the principal problem of harmonics as encountered in the construction of the musical scale, made manifest in the tension between magnitude and multitude, between the physical string to be divided and the perfect numerical ratios that produce harmonious intervals. Likewise, the former (the relation of subjective experience to physical form) seems just as essential to understanding the aesthetics, the performance, and the reception of music—the experience of *mood*, tied as it is, in the Greek context, to the musical modes—as it is for the parallel situation in the visual arts.

To summarize what we have been discussing so far: an unresolvable ambiguity in perception leads to an awareness of the tension between subjective experience and objective physical being, which in turn leads to a consideration of the tension between physical being and mathematical being. If the ontological questions posed by the irreducibility of physical being to mathematical being, even as the two are in intimate and necessary relation to one another, in fact constitute a properly philosophical inquiry, it may be in this manner that the building offers its most powerful invitation to dialectical thought. Considering the epistemological and pedagogical questions posed in Books 6 and 7 of the *Republic,* as we have discussed them in chapter 3, one may recognize the way the pedagogical thought experiment of the divided line in *Resp.* 509d–511e effectively models the analogous relationships among levels of being, driven by tensions and contradictions, present in the Parthenon: from images/appearances (the straight/curved ambiguity presented to perception) to physical objects (the curved physical building) to ideas relying on hypotheses

(the mathematical idea of the building) to dialectical thought, free from hypotheses (the larger ontological, even metaphysical, questions the Parthenon raises).[50] Furthermore, just as the relationships (strictly speaking, in terms of the line itself, the ratios) that constitute the lower and upper parts of the divided line, respectively, are themselves analogous to each other, in the Parthenon the contradiction (straight/curved) at the level of appearances that encourages one to measure the physical building can be taken as analogous to the contradiction (arithmetic/geometry) at the level of the mathematical idea that invites one to explore ontological and metaphysical questions dialectically. More succinctly: the relationship of an inherently ambiguous sense experience to objective physical reality seems analogous, in its pedagogical function (viz., in motivating the pursuit of knowledge), to the relationship of the multitude/magnitude contradiction that defines the Parthenon's harmonics to a deeper ontological, or even metaphysical, reality.

Indeed, once one becomes fully engaged with the question of *harmonia*, and thus aware of the fact that a numerically based *symmetria* cannot ever be perfectly realized in geometric terms with an object as complex as the Parthenon (a problem brought to a head at the corners of the building), the question raised is no longer merely one regarding the proportions of the building per se, but rather the ontological one of the difference between magnitude and multitude (the different kinds of being they constitute) and, especially, of their relationship to each other. This is a questioning that is properly dialectical in nature, in the sense we have defined dialectic in part I, since it constitutes a focus on the problem itself that can continue independent of the "hypotheses" constituted by the building's specific proportions or formal characteristics.[51] In light of our discussion of dialectic in part I, and specifically of the way that thinking of the mathematical arts together leads to dialectical thought in *Resp.* 7,[52] one can argue that in bringing (at least four of) these arts (arithmetic, plane geometry, solid geometry, harmonics) into intimate dialogue, the Parthenon not only asks responsive viewers to consider the relationship of arithmetic (multitude) to geometry (magnitude), and the tension between them, as a problem of harmonics, and, with the corner problem, to consider in addition the relationship of plane geometry to solid geometry, the *symmetria* of the façade or flank to the unity and solidity of the three-dimensional building defined by its corners. And it not only asks viewers, furthermore, to think about the parallels between harmonics in architecture, in music, and in mathematical theory (which may have been a very lively discussion in precisely this time and place, mid-fifth-century Athens). It is also asking that this multivoiced dialogue

be engaged in ways that raise properly philosophical questions, of an open-ended nature—that is, of a kind that we would call dialectical.

At this point, it seems crucial to stress that the pedagogy proposed by the Parthenon, though discussed above in terms of epistemic "levels" ranging from the sensory to the dialectical, could be more properly understood as multiply directed and fluid rather than unitary and sequential. Indeed, there is no need to reconstruct a definite sequence of levels of awareness or response; in fact, such an approach, with its implicit teleology, would not do justice to the irreducible ambiguity, and to the polysemic and multivalent character, that define works of art such as the Parthenon and distinguish them from other sorts of objects in the world.[53] One could more adequately characterize an experience of deep engagement with the building as a recognition of the simultaneous modes in which it "speaks"—sensory, aesthetic, intellectual, religious, etc.—and of the multiple potential interpretations and experiences it offers at any given moment (though unfolding in time, even over a long time, according to the particular experience of the viewer or worshiper). Certainly, one could consider a process of measuring and calculating as a second stage of activity with respect to the more directly phenomenal encounter with the Parthenon, if one were prompted to study the building further in this way, just as philosophical reflection may follow upon careful consideration of the mathematical problems the Parthenon poses. However, the real experience of the building—aesthetic, phenomenological, and affective as well as intellectual—involves an ongoing interaction between thought, feeling, sense perception, bodily movement, and aesthetic judgment. Just as an ambulatory, embodied experience of the Parthenon's architectural proportions, or sustained visual attention and observation, may encourage abstract reflection, or a thoughtful conversation with a companion; likewise, a rigorous intellectual engagement may also reciprocally inform the interpretation of one's direct experience of the building and even guide one's movements, choices, foci of attention, and perceptions themselves—or simply prompt a renewal of vigor in one's visual engagement. It is the fluidity characteristic of the ongoing encounter of a viewer or worshiper with the Parthenon as a work of art and as a sacred site, the free movement between different modes of engagement, that embeds the philosophical problems posed by the building within its specific physical, phenomenological, and aesthetic character.

There must certainly be a very real historical connection between the Parthenon and Plato's dialogues, written in Athens some eighty years after the Parthenon's construction, just as there is a very real historical connection between the Parthenon's harmonics (its negotiation of the

alogon in the context of *symmetria*, its use of *anthyphairesis,* and its overriding interest in *harmonia*) and the work of Philolaus and his Greek and Near-Eastern historical predecessors.[54] And indeed, the Parthenon was the principal civic and religious monument in Athens at the time of Plato's birth, and throughout his life. However, the point is not that Plato necessarily had the Parthenon specifically in mind when writing the *Republic,* the *Timaeus*, or other dialogues. Rather, those dialogues indicate the sustained interest in, and increasing mathematical and philosophical theorization of, problems that had been worked on since at least the time of the Parthenon, and that were being engaged by an interdisciplinary field of activity that included music theory and performance, architecture, sculpture, and mathematics, the latter a field within which the Parthenon arguably played a decisive role. The presence of similar concerns in the *Republic* and the *Timaeus* provides historical corroboration of this, but the evidence of the active engagement with such problems is given by the "text" of the Parthenon itself. Certainly, the possible lost treatise by Iktinos and Karpion (Kallikrates?), mentioned in Vitruvius, had it survived, might have given us some further insight into the theoretical and technical problems with which the Parthenon was engaged.[55] And a comparison of such a text, if it existed, with the surviving fragments from Philolaus and from Polykleitos, as well as of course with Plato's dialogues and other texts indicative of the pedagogy of Plato's Academy, would be very useful. But the rediscovery of such a "lost treatise," or speculation about its contents, is not necessary. The Parthenon speaks for itself. And more than that: it "speaks" in ways that are necessarily irreducible to textual elaboration, in its character as a work of visual art. Even if any number of theoretical texts on the Parthenon and the questions it raises had survived, they could only be supplementary, and not definitive, to an understanding of the building itself, which speaks in its own (visual and plastic) terms.

But to whom was the Parthenon speaking, and in what ways? Since we are discussing the pedagogical aspects of the Parthenon, we must ask once again: given the complexity of the building itself and of the problems it engages, as well as their open-ended character, how many people in fifth-century Athens could have understood the intellectual implications of the Parthenon's design, and how much of it might they have understood? As we discussed near the beginning of this book (introduction, section 1), it is the Parthenon's character as a *work of art*, in the broadest sense, that determines the wide range of potential responses, interpretations, and experiences that the building encourages in any receptive viewer, visitor, or worshiper, responses that are also, necessarily, deeply interdependent. The encounter that the Parthenon creates with a viewer is, first and

foremost, a sensory and embodied one, relating an aesthetic awareness of the building's harmony with the bodily experience of walking around it, moving through its colonnades, or craning one's neck to examine the sculptures—in other words, an awareness of *symmetria* and *harmonia* in an intuitive, and also a phenomenological, sense. However, given its social and political context, a viewer/worshiper would naturally be inclined to relate those very experiences to the temple's religious and civic significance. More crucially still, for the questions we focus on in this book, any consideration of the Parthenon's mathematical proportions, any reflection on the relationship between arithmetic, geometry, and harmonics, or by extension, any dialectical engagement with the epistemological, ontological, and metaphysical questions raised by *harmonia* must inevitably grow out of those same sensory and embodied experiences of the physical building (as a seemingly regular and lawful, but actually also ineffable and open-ended, geometric object). Thus, returning to a point made in the introduction, some (perhaps many, or most) viewers may have experienced the building primarily in its aesthetic and phenomenological character, as embodied visitors, while others (probably also a large number) may have understood those experiences in harmony with the religious and civic meanings the building creates in its own, specifically artistic, terms. Still others (probably a relatively small number), building on the first, and probably also the second, of these categories of experience, may have reflected on *symmetria* and *harmonia*, on the being of the building (specifically, the questions about being raised by its mathematical character) and on its relationship to the divine (to beauty and truth in a metaphysical sense, perhaps) and thus been led toward dialectical thought. Certainly, we are making no precise claims as to the number of people in any of these categories, but given the breadth of engagement with the project of the Parthenon's construction, and its subsequent use as a sacred site, the experience of the building in the full range of aspects we have outlined above was available to a large number of people, and indeed was integral to the life, ritual practices, and civic self-definition of the *polis*. One could imagine a small group, perhaps even something like a philosophical "inner circle," discussing the harmonics of the Parthenon among each other, relatively isolated from the experiences and understanding of the rest of the citizens. However, it is our intuition, once again—especially when comparing the situation to other historical moments where art, religion, civic identity, and philosophical knowledge intersected, about which we know a bit more, such as Florence in the fifteenth century—that there may also have been somewhat more fluidity between the different modes of engagement (sensory/embodied, artisanal, intellectual, religious, etc.) than one is often inclined to imagine.

We should recall once more that the Parthenon was the principal religious monument of fifth-century Athens, and, quite significantly, was dedicated to a goddess associated with both wisdom—specifically, wisdom of a practical nature—and the arts. We have not really had adequate time to deal with this aspect of the building, but the relevance of Athena's patronage to a temple that involves such intensive engagement with the connections among the arts, and their relationship to larger philosophical questions, is striking. The cultural and political situation of the Parthenon, as well as its immense importance for the city and the fact that a large part of the population of Athens must have been involved in its design and construction between 447 and 432 BCE,[56] makes it the ideal and inevitable *locus* for the expression of, and experimentation with, the most avant-garde ideas in the principal fields of knowledge, epistemic and technical, central to Athenian intellectual culture, a culture that traced its roots (right from its name and founding myth) back to the patronage of the goddess of wisdom and of *technē*. And thus, as we have been stressing above, in this context it would make little sense to separate technical experimentation, philosophical speculation (as Plato would discuss it two generations later), and religious meaning from each other, since the three are so deeply interconnected—most prominently, and symbolically, in the very character of the goddess to whom the temple is dedicated.[57]

The sculptural program, with the incredible richness of its iconography, indicates a related interdependence: in its pedagogical aspects, it brings together a more traditional religious education, a self-reflexive commentary on the *polis* itself, its citizens, and its values, and reflections on *symmetria* and *harmonia* (in both its subject matter and its aesthetics) that resonate with the architecture. In the pediments and metopes, through a carefully harmonious arrangement of figures and scenes, the Parthenon educates in Homeric fashion, with its myths of the Olympian gods—beginning with the east and west pediments, depicting the birth of Athena and the contest between Athena and Poseidon for the founding of Athens, respectively (figures 6.6 [opposite] and 6.7 [on page 154]; these are 1674 drawings of the pediments by Jacques Carrey). Already, this Homeric pedagogy includes commentary on the city of Athens, but within the peristyle, in the Panathenaic frieze (whatever its precise subject matter), the sculptural program confronts Athenians directly with an image of the city itself and its values, through a representation of its citizens (figures 6.8 and 6.9 on page 155), asking them to reflect on themselves and their *polis*, to ask questions about who they are.[58] Here harmonics plays a striking role. In formal terms, the grouping of the figures on the Panathenaic frieze suggests *symmetria,* and specifically musical ratios, with its carefully balanced, proportional, but not equal arrangement along the north and south sides

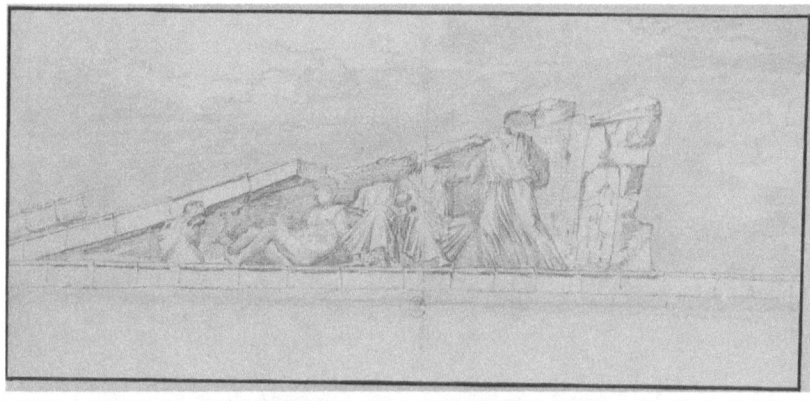

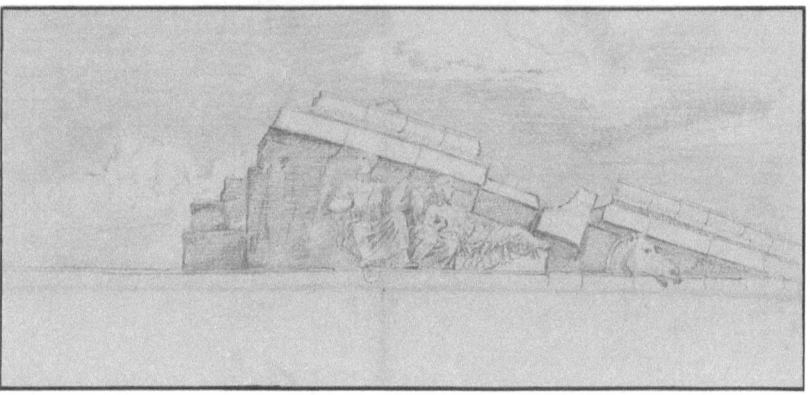

Figure 6.6a and 6.6b. Jacques Carrey, drawings of the south and north sides of the east pediment of the Parthenon, 1674 (Paris, Bibliothèque Nationale). Source: Creative Commons.

of the building: indeed, corresponding groups, in north/south dialogue, form ratios of 3:2, 4:3, and 9:8, with respect to the number of figures in each group.[59] And harmonics, specifically *harmonia*, is present even on the iconographic level, as the subject matter of the Panathenaic frieze is, at least in part, *harmonia* itself: the representation of the Athenians on the frieze brings together a diversity of figures, and groups of figures, to present an image of the city itself as a unified whole, joined together from its different parts, an image in which both music and religious ritual play a central role. If the Parthenon also constitutes an invitation to dialectical thought—an opening to a liberal education in and through the arts—in its thinking of the arts and of philosophical questions together within the metaphysical context of religious meaning, such an invitation would thus have been just one part, though perhaps the crowning one, of the broader educational program it offers.

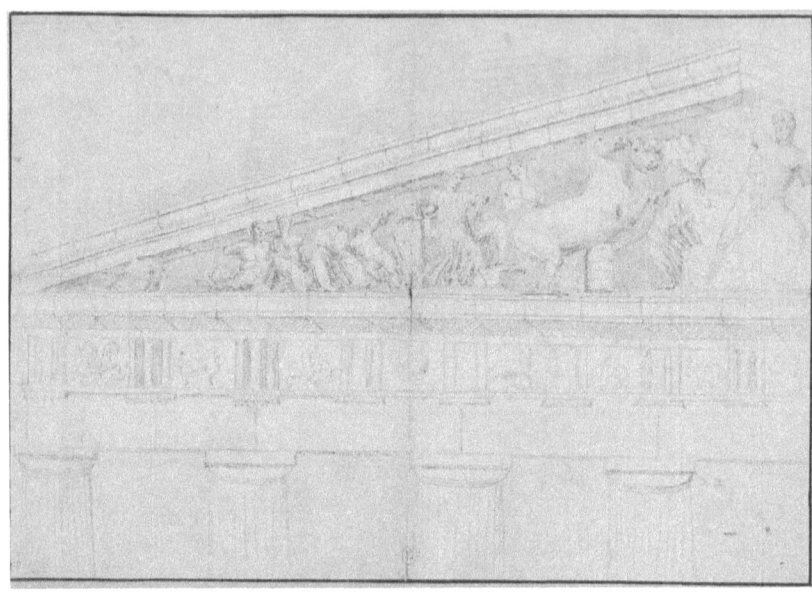

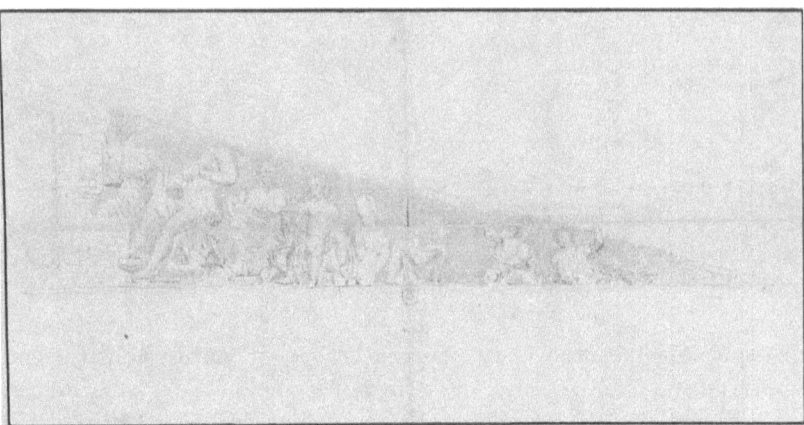

Figure 6.7a and 6.7b. Jacques Carrey, drawings of the north and south sides of the west pediment of the Parthenon, 1674 (Paris, Bibliothèque Nationale). Source: Creative Commons.

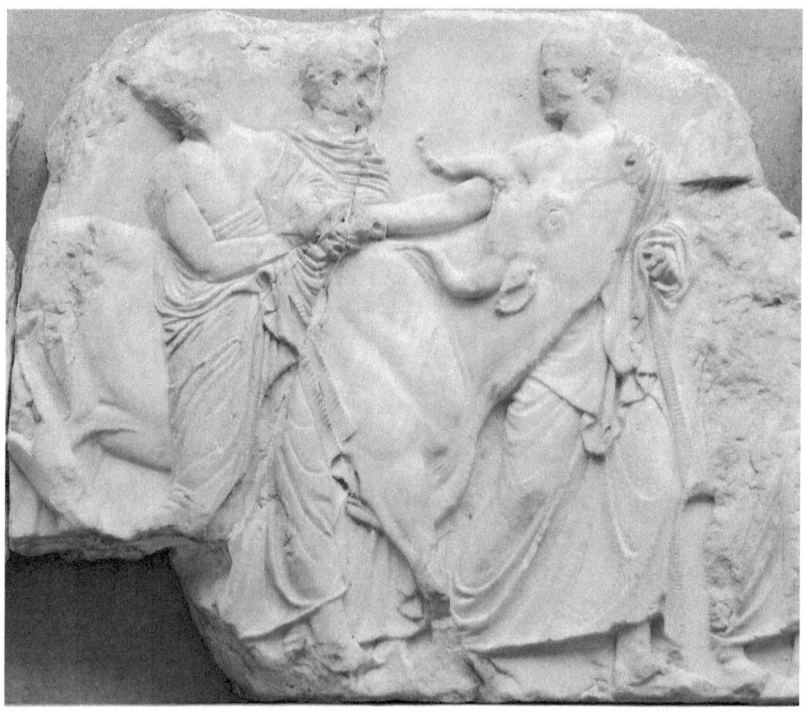

Figure 6.8. The Parthenon, Ionic frieze, depicting the Panathenaic procession (?): south side, bulls being led to sacrifice. Photo by Marie-Lan Nguyen.

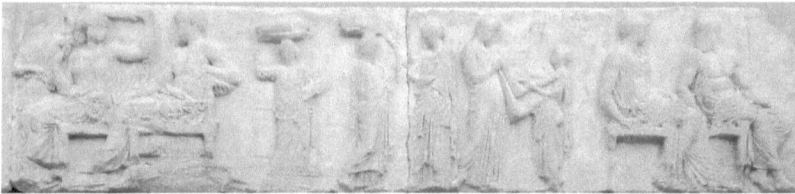

Figure 6.9. The Parthenon, Ionic frieze, depicting the Panathenaic procession (?): east side, central scene (ritual with the peplos of Athena, or sacrifice of the daughters of Erechtheus and Praxithea?). Author's photo.

Afterword

Geoff Lehman and Michael Weinman

How might a notion of "mathematics as a practice of humanist learning" meaningfully define the main object of consideration in this study: the Parthenon, mediating between the earliest theoretical advances in Greek mathematics, as received from Near-Eastern sources, and the articulation of the relationship between dialectic and the practical arts found in Plato's vision of a liberal arts education? Part of what was crucial for us with respect to the Parthenon was its status as a precursor in the development of dialectic, which in its Platonic elaboration is a set of procedures by which we might make clear the essential incapacity of the mathematical arts to solve the problems that can only be addressed, if not resolved, in an open-ended, dialectical fashion. This education—a liberal arts education that unites the problem-based knowledge procedures of mathematical *technai* with the theoretical reflection of philosophy—is what Plato offers as a preparation of the soul for ethical life. We argued that a close reading of the Parthenon itself shows that the open-ended approach to interdisciplinary problems in mathematics at work in the temple's "harmonic" design resonates with Plato's suggested liberal arts education. In this way, we have argued, the Parthenon can be thought to anticipate Plato's attention to harmony, in particular, as a phenomenon that is profitably subjected to rigorous mathematical analysis but ultimately exceeds the limits of that kind of intellectual activity and points to a more fundamental, dialectical need to pursue something higher and greater than intellectual mastery.

What is at stake in this dialogue between the Parthenon, early Greek mathematics, and Plato—the relationship between magnitude and multitude, and the way that relationship opens up a kind of questioning

that leads to dialectic—becomes most evident in comparison with another, analogous instantiation of "mathematics as a practice of humanist learning": the advent of mathematical perspective in the early Renaissance. The new epistemological, and even metaphysical, problems suggested by perspectival representation—grounded in perspective's projection of a physical world that is simultaneously commensurable and unbounded—were central to the intellectual culture of the fifteenth century, and provided a basis for theoretical and philosophical developments of the following centuries. For one thing, the homogeneous, isotropic, and infinite three-dimensional grid, projected from a precise, geometrically defined point of view, that is implied by Renaissance perspective would become the basis for Desargues's theoretically rigorous projective geometry in the seventeenth century; however, it had its origins in a centuries-long tradition of technical procedures developed in painters' workshops.[1] The range of problems that Renaissance painters addressed through the making of artworks structured by, and themselves articulating and developing, the paradigm of perspective did more than merely prepare the groundwork for projective geometry, however. In considering the representation of human, and often specifically Christian, subject matter within the new pictorial ontology of perspective representation, artists addressed what we can properly call philosophical (and not only religious or theological) questions arising from this new conception of space as fully measurable and potentially infinite. Already in the early fifteenth century, Masaccio's *Trinity* (fresco, ca. 1425), perhaps the first picture to use a fully consistent, and mathematically precise, perspective construction, raises the question of divine immanence within a rational space that is also (projectively) the bodily space of the viewer.[2] Jan Van Eyck, in the *Rolin Madonna* (oil on panel, ca. 1436) and other pictures, depicts vast landscapes where human vision (emblematized and redoubled by viewers within the picture), confronting an unbounded but measurable physical space, is also confronted with a new paradigm of knowledge, of a sort that would come to inform the modern scientific method. Here the parallel to the Parthenon and to the conditions and context of its construction, where philosophical questions emerged directly from workshop practice, becomes evident.

In the Parthenon, as we have seen, the grounding of theory in workshop practice—that is, in the *technai*—is reflected in the character of the inquiry: the posing of a problem that the work of art engages, both in its finished state and through the creative process that produces it, without ultimately resolving the (necessarily unresolvable) questions that the initial problem raises. In other words, as we have seen in our analysis of the Parthenon, the most important intellectual problems of the time

were addressed there in a way that was simultaneously technical—based on craft, on construction, and on procedural expertise—and self-reflexive, unresolved, and philosophically open. Still more significantly, the viewer, visitor, or worshiper was, and still is, invited to engage dialectically with the open, trans-disciplinary questions embedded within the work's specific formal and structural character. In this fashion, we can see how a work of art, functioning suggestively and self-reflexively in its relationship to the viewer, lays the groundwork for the more rigorous theoretical articulations of the problems it poses in the centuries that would follow.[3] As we have tried to indicate briefly in the discussion above, a remarkably similar situation emerged in the Renaissance period, where an equally close relationship between philosophical and technical (artistic, scientific) approaches to knowledge held sway.[4]

However, the differences between the two periods are even more striking, and may shed some light on the specificity of the problems raised by the Parthenon and developed in the Platonic corpus and the Academy. Perspective is a thoroughly *geometric* system of measurement, completely independent of arithmetic in the Greek sense, and thus, as the dominant mathematical paradigm of the Renaissance, effectively elides the problems that the consideration of number—that is, of multitudes, in their relation to magnitudes—might raise within its geometric world picture. Furthermore, the units of perspective's emblematic grid do not correspond to any actual physical objects within the fiction of the representation. They are ciphers, as Heller-Roazen defines them,[5] and what they depict is an abstraction, or rationalization, of space in its relationship to a geometricized and geometricizing vision.[6] As Leon Battista Alberti's discussion in *Della pittura* (1435–36) demonstrates, and as pictures by artists such as Masaccio and Piero della Francesca make self-reflexively explicit, it is the relationship of the position of the "ideal" viewing eye (the point of projection) to the picture plane that determines the geometry of the perspective construction, *not* the architectural forms or other objects inserted into the perspective matrix.[7] The grid of perspective—with its theoretical implications of an infinite and homogeneous space—is thus quite different from the discrete grid used for ground plans in the Hellenistic period,[8] let alone the modular approach of earlier Doric construction that is based on actual physical units, since perspective does not involve the division of a discrete, finite structure according to a regular, abstract grid, but, arguably, the representation of space as such.[9]

What is, in fact, at stake, we may again ask, in the emergence of a geometry freed from its relation to objects in the physical world, freed from the grounding in visible and countable things that had been so

important for Greek *arithmetikē*, as manifested in the symbolic centrality of the Parthenon's visible triglyph module? In the Renaissance, as Heller-Roazen has shown, the dissonance of the legendary "fifth hammer" of Pythagoras—the one that produced a sound incommensurable with the other four hammers (6, 8, 9, and 12: the musical scale), through which (according to the classical account) Pythagoras "discovered" the *alogon*—has been effectively elided.[10] Geometry, in Renaissance perspective, proposes to make the infinite, and the irrational, commensurable. Thus, the irreducible tension between magnitude and multitude that defined the problem of harmonics for the Parthenon—and in ancient Greek mathematics and intellectual culture more broadly—slips out of view: now geometry will be understood as fully representable and measurable, if not numerically, at least (by the seventeenth century) algebraically. Perhaps, one could argue, the tension between a physical world conceived as infinite, on the one hand, and understood as a measurable, observable phenomenon, on the other, generated another kind of productive tension, grounded in mathematics, that was specific to the Renaissance. Just as the legendary "fifth hammer"—the irrational—raised a seemingly irresolvable problem in classical Greece, so the invention of *costruzione legittima* (mathematical perspective), arising from over a century of workshop practice and experimentation, raised the mathematical and, more importantly, *philosophical* problem of the knowledge, and even measurement, of the infinite. At the same time, however, one also senses, in the loss of attention to the problems so important to the Pythagoreans, to the Parthenon, and to Plato's dialogues, another possible loss as well, in a diminishing engagement with the particular philosophical, and open-ended, questions that the tension between magnitude and multitude had raised.

In the conclusion to part I, we noted that, through Aristotle and later through Hellenistic and Neoplatonic philosophers, Plato's understanding of the dynamic between the theoretical (dialectical) and practical/productive (technical) elements of an education for the whole soul grew into the trivium and quadrivium that define the "liberal arts" as classically understood. Crucially, the quadrivium, the residue of the mathematical arts canonized by Plato, were divided between the two that dealt with magnitudes and the two that dealt with pure quantities. The view, given its definitive articulation by Proclus,[11] was that for each of these two kinds there were two arts; for magnitudes, there were geometry (study of magnitudes at rest) and astronomy (study of magnitudes in motion); for pure quantities (numbers), there were arithmetic (study of numbers in themselves) and harmony (study of relations between numbers). As Renaissance perspective painting approaches the problem of the tension

between commensurability and infinity, it does so in the light of this tradition of humanist learning, but also in contest with it, specifically with the notion that mathematical objects divide neatly between magnitude and multitude. Indeed, through its engagement with and disturbance of the classical conception of the distinction between kinds of mathematical objects, Renaissance intellectual culture challenges far more than Euclidean metamathematics. The integration of infinity and the dissolution of the kinds of mathematical objects and of ways of knowing through recursive procedures that belong to them raise, as well, new questions about the relationship between *technē* and *dialektikē*—a much larger issue, and an open-ended one, that we only wish to signal here.

In both periods that we are considering in this afterword, the mathematical and philosophical problems raised by the treatment of mathematics as liberal arts are embedded within a broader field of cultural concerns, the field that in the Renaissance period would come to be defined as humanism. The Parthenon, in its aesthetic aspect, as a harmonious, integrated work of art, and in its religious and civic aspect, as a temple dedicated to the patron of the city, integrates the theoretical and technical problems of its construction with the religious, cultural, and civic concerns of Periclean Athens. In other words, its significance remains embedded within a broader cultural, and also *pedagogical,* sphere, the sort of context that in the Renaissance period would be constituted by humanism.

In the Renaissance, too, technical, or workshop, practice, and humanist intellectual culture go hand in hand, as interdependent aspects of the liberal arts, broadly conceived.[12] Indeed, the peculiarly Renaissance problem of rational measure's relationship to physical infinity would take on its deepest resonances at the point of intersection between technical practices—in painting, primarily those of perspective—and humanistic study. It is this point of intersection that gives rise to questions regarding the place of human (cultural, religious) meaning within the realm of a physical nature now conceived as infinite, a quality that previously had only been attributable to God.[13] In a Renaissance painting such as Piero della Francesca's *Flagellation* (oil on wood panel, ca. 1459–60), the depicted architecture situates Christ at the center, but the vanishing point (the emblem of spatial infinity) is displaced from that position (somewhat to the right of and below Christ), centering instead the viewer's gaze and coordinated with the surface geometry of the panel itself. The acknowledgement of a discrepancy between those two centers—the theological and the subjective/spatial/mathematical—appears perhaps in a still more subtle form in Leonardo da Vinci's *Last Supper* (mural [oil], ca. 1495–97), where the two centers are conflated, and the double function of the vanishing

point becomes potentially unstable: the vanishing point coincides with Christ's right temple (the mind of God) while at the same time governing the mathematics of a centerless and unbounded physical space.[14] The implications of perspective's purely mathematical aspect would be most fully realized in the seventeenth century with the scientific method, in ways that would ultimately subvert the Renaissance harmonizing of *technē* with humanist culture.[15] In Renaissance pictures, the unstable coexistence of the new geometric world picture and the realm of Christian humanist values still provisionally prevails, but that fragile harmony could not hold.

In attending to the different ways in which the problem of rational measure manifests itself in Renaissance perspective painting and in Doric temple construction, we have learned that for Plato, dialectic as a "method of inquiry" is never (fully) separable from dialogue and the open-ended pursuit of questions concerning the condition of the soul, and thus that the problem-based pursuit of mathematical solutions for the rationalization of the sensible cosmos is doomed to fail. That is, we have argued, for Plato, the "mathematical moment" is never self-sufficient because *logistikē* (mathematical calculation) must issue in *dialektikē*. And that, in contrast, for Renaissance perspective painting, the reconciliation of infinity with commensurability holds out the possibility of, or at least hope for, a fully mathematized view of nature (the one implicit in the modern scientific world view), but that this is potentially subversive of the Christian and humanist culture within which it emerged—even as that culture sought to bring perspective into harmony with its own humanistic concerns.

In contrast with the separation between "the two cultures" (classically expressed as that of the trivium and quadrivium, but equally well captured as humanities and exact sciences) that one finds already well advanced by the time projective geometry receives its systematic theorization in the work of Desargues and Descartes, we can see in the place of projective geometry in Renaissance perspective painting something much closer to the deep intimacy between the humanist and the technical in the Parthenon and subsequently in Plato's response to the interdisciplinary pursuit of mathematical problems. It is true that, already in the perspective paintings of Piero della Francesca or Leonardo da Vinci, there is evidence of the inherent impossibility of Renaissance humanism's attempt to incorporate the constructive methods of perspective, and the mathematical and epistemological innovations they bring with them, within their embrace of Christian metaphysics, which itself is to be somehow harmonized with classical learning (the latter a core goal of the Renaissance humanist project). For instance, even as the technique of perspectival representation mobilizes infinity in the service of the iconographic representation of divine infinitude and transcendence, we can see how its methods are

always directed toward the infinitely expanding and infinitely divisible empty and centerless space of the Cartesian grid. Nevertheless, the spirit of works like the *Flagellation* or the *Last Supper* is clearly directed toward preserving the integrity of the technical methods and the humanist program. It is this wholeness that seems utterly missing today and without which, we would argue, an education in the humanities—as currently defined—will remain in an incurably defensive position.

On the other hand, in the case of the Parthenon—as in the Renaissance pictures we have briefly touched on in this afterword—the building's harmonic unity as a work of art, its processes of creation and construction (self-reflexively indicated within the work itself), and its multivalent and open-ended engagement with the viewer, visitor, or worshipper, together make thoroughly evident the deep interdependence of artistic practice, technical (i.e., mathematical) knowledge, and philosophical questioning—and, by extension, what would in the Renaissance context be called "humanistic culture." The building's ongoing dialogue with its viewers constitutes the integrated, liberal education that the Parthenon, with its distinctive blend of sensory/bodily, technical, imaginative, and dialectical engagement, all part and parcel of the building's creation of religious and civic meaning, offered to the Athenians of the fifth century, and that it continues to offer today.

Appendix A

Pythagorean Musical Ratios

Interval	Ratio	English name	Derivation using *anthyphairesis*
Diapason	2:1	octave	
Diapente	3:2	fifth	
Diatessaron	4:3	fourth	*diapason* minus *diapente*
Tonos	9:8	whole tone	*diapente* minus *diatessaron*
Leimma	256:243		*diatessaron* minus two *tonoi*
Apotome	2,187:2,048		*tonos* minus *leimma*
Comma	531,441:524,288		*apotome* minus *leimma*[1]

1. The Pythagorean comma also represents the difference between a whole tone and two *leimmata*, between an octave and six whole tones, or between seven octaves and twelve fifths. The closing of the gap represented by the *comma* (i.e., elimination of the remainder through adjustment of intervals) in the latter case produced the "circle of fifths," and the concomitant unification of the twelve keys, in the modern system of equal temperament.

Appendix B

Principal Measurements of the Parthenon[1]

Exterior
Stylobate length	69.503 m
Stylobate width	30.880 m
Height to the top of the entablature	13.728 m
Column height, peristyle	10.433 m
Height of the entablature	3.295 m
Height of the pediment, including cornice	4.30 m
Height of the pediment, excluding cornice (west façade)	3.428 m
Column lower diameter, peristyle (average)	1.905 m
Intercolumniation, peristyle, excluding corners (average)	4.296 m
Average metope width, east façade	1.274 m*
Average metope width, west façade	1.275 m*
Average triglyph width, east façade	0.8445 m
Average triglyph width, west façade	0.8446 m

Interior
Cella[2] length, excluding the antae	48.270 m
Cella width	~21.52 m
Naos (eastern room) length, inside the walls	29.90 m
Naos width, inside the walls	19.065 m
Naos interior height	13.09 m
Western room (parthenon proper) length, inside the walls	13.37 m

Naos central space length, including colonnade	26.67 m
Naos central space width, including colonnade	12.26 m
Naos interior colonnade, lower order height	7.680 m
Naos interior colonnade, upper order height	5.269 m

1. Source: Orlandos (1976–78: 100, 101, 147, 262–63, 349, 353, 362, 379, 404, 680; taf. XXVI, XXVII, XXVIII), except *Yeroulanou (1998: 410, 413).

2. For the sake of clarity, we refer to the entire Parthenon interior (both rooms) as the cella, and the eastern room alone as the naos.

Appendix C

Elements of the Doric Order

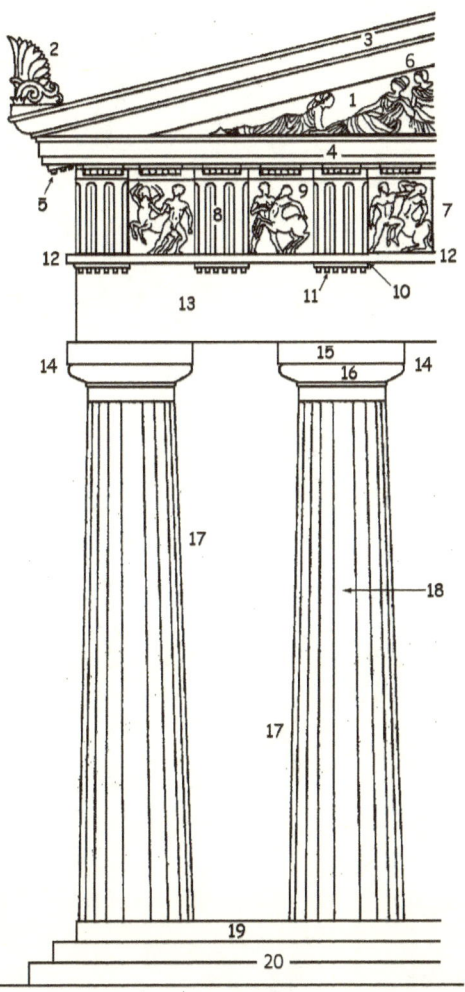

Cornice
1. Pediment
2. Akroterion
3. Raking Sima
 (or Raking Cornice)
4. Geison
 (or Horizontal Cornice)
5. Mutule
6. Raking Geison

Entablature
7. Frieze
8. Triglyph
9. Metope
10. Regula
11. Guttae
12. Taenia
13. Architrave

Column
14. Capital
15. Abacus
16. Echinus
17. Shaft
18. Fluting

Krepis
19. Stylobate
20. Stereobate

Appendix D

Ground Plan of the Parthenon

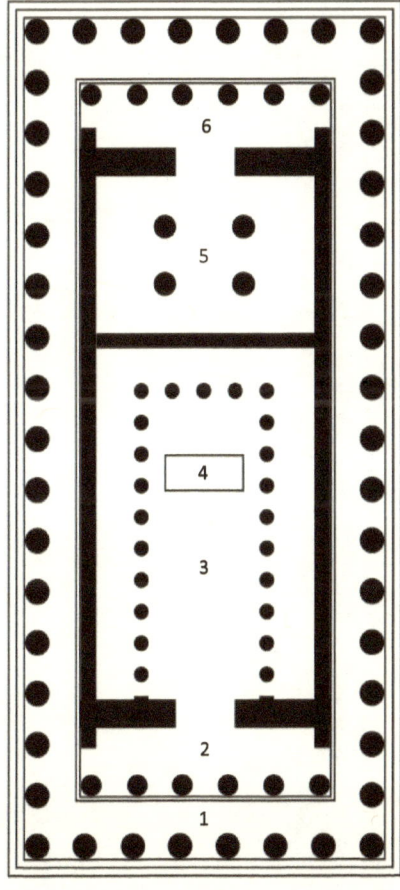

1. Peristyle

2. Pronaos

3. Naos (Greek)
 or
 Cella (Latin)
 or
 Hekatempedos
 (in the Parthenon)

4. Cult statue of Athena Parthenos

5. Parthenon

6. Opisthodomos

Appendix E

Glossary of Technical Terms

For additional musical terms not included in this glossary, see appendix A. For additional architectural terms not included in this glossary, see appendices C and D.

anthyphairesis: reciprocal subtraction or repeated subtraction. The procedure by which two magnitudes—which may, but need not, be thought of as numbers—are repeatedly subtracted one from the other, until eventually the remainder does or does not share a unit with the original two magnitudes. If it does, then the procedure is "closed" and thus "finite." If it does not, then the procedure is "open" and thus "infinite." The procedure of "infinite *anthyphairesis*" developed with the theoretical understanding of incommensurability, and is thus of crucial importance for many arguments presented here.

arithmetic mean: the result of dividing the sum of a series of numbers by the number of members in the series. To take a result relevant for the small number ratios involved in the Parthenon, and one crucial for defining the Pythagorean musical scale (12:9:8:6), the arithmetic mean of 6 and 12 is 9 (6 + 12 = 18/2 = 9).

commensurability: see *symmetria*.

continuous (or continued) proportion: a relation between terms in which each term in a series bears to the next term the same ratio as the term previous to it bears to it. For example, 1:2:4:8:16:32 (1:2::2:4::4:8::8:16::16:32), and so on. Or, to take a result relevant to the Parthenon, 81:36:16. See also *proportion* and other cognate terms defined herein.

Doric: see *order*.

entasis: the vertical curvature of columns, resulting in a top that is narrower than the base and a gentle swelling toward the center. See also *refinements*.

geometric mean: in modern terms, this is the nth root, usually the positive nth root, of a product of n factors. In the context of the mathematics around the time of the Parthenon's construction, this is the mean proportional—the base of the square that is the product (or the square root of the product) of the sides of the rectangle. To take a result relevant to the Parthenon, 6 is the geometric mean of 4 and 9, because the square on (or of) 6 is equal to the product of 4 and 9 (i.e., $6 \star 6 = 36 = 9 \star 4$). See also *proportion* and other cognate terms defined herein.

harmonia (harmony): like *symmetria*, a technical term in music theory and in the plastic arts that initially indicates, in quite literal fashion, the joining together of physical things that are fundamentally different to make a whole, like the rim and the spokes of a wheel. Over time, in the context of music and the visual arts, and notably in the Parthenon, this literal meaning is extended to a more metaphorical sense of "joining together," like the *harmonia* binding different musical pitches into an aesthetic whole, or the one between arithmetic and geometry that is evident in the Parthenon—or, by extension, among a collection of figures, among different social or political classes, among the spheres of the cosmos, etc.

harmonic mean: also called the *subcontrary*, this is the relation that obtains when, in a series of numbers, by whatever part of itself the first term exceeds the second, the middle term exceeds the third by the same part of the third. To take an instance relevant for the small number ratios involved in the Parthenon, and one crucial for defining the Pythagorean musical scale (12:9:8:6), the harmonic mean of 6 and 12 is 8 (because 12 exceeds 8 by the same part of itself as the part of 6 by which 8 exceeds 6, or $12 - 8/12 = 4/12 = 8 - 6/6 = 2/6$, because 4/12 and 2/6 both reduce to 1/3). See also *proportion* and other cognate terms defined herein.

incommensurability: the condition where two magnitudes cannot be counted as so many applications of the same unit. This embraces but is not reducible to the condition of irrational numbers, where (for instance) the base of the square of eight units cannot be defined in terms of a whole number of units, however much smaller we make the unit in search of a "rational base." See also *symmetria*.

Ionic: see *order*.

irrational (*alogon*): see *incommensurability*.

kanon **(canon)**: 1. (music): the measuring device over which a string, known as a monochord, is stretched, and on which the string can be divided to produce different pitches. The term then comes to carry the metaphorical meaning of a defined system of musical proportions, a meaning then carried over into the visual arts. See also *monochord*. 2. (visual arts): the system of proportions defining beauty, specifically in sculpture and with respect to the human figure, associated with the sculptor Polykleitos. See chapter 5, section 2, for more on this second definition.

logistikē: the practices of calculation, and the theoretical reflection on those processes; becomes canonized as a branch of study in the early Academy. See Fowler (1999), introduction, section 2, and chapter 3 for more on this term.

monochord: in early Greek musical practice, a string stretched over a measuring device known as a *kanon*, which can then be divided in various ratios to produce different musical pitches. See also *kanon*.

order: a system of formal and aesthetic principles, and gradually standardized practices, that govern the design and structure of ancient Greek temples. A particular *symmetria*—specifically, the proportional relationships holding among all the constituent parts—is the guiding principle of the design of an order and the defining characteristic of its aesthetics. The two principal orders by the time of the fifth century BCE, each with its characteristic formal features and *symmetria*, are the Doric and the Ionic. A third, the Corinthian, was introduced sometime in the fifth century (possibly in the Parthenon). By the time of Vitruvius, there are five recognized orders: Tuscan, Doric, Ionic, Corinthian, and Composite.

proportion (***analogia***): a proportion is a special relation in which the same ratio (*logos*) that holds between one magnitude and another also holds between either: (1) one of those magnitudes and a third magnitude—this is a proportion in three terms, or (2) two other magnitudes, where the third magnitude holds to the fourth the same ratio that the first holds to the second. A proportion in three terms is the basis of a "continuous proportion," defined above. One such proportion of great importance for the Parthenon is 9:6:4, which in expanded form (taken in square) is 81:36:16. A series of related proportions in four terms of great importance for the

Parthenon can be derived from comparing pairs of the terms involved in the continuous proportion, for instance: 9:4::36:16. See also *symmetria*.

ratio (*logos*): the relation between two numbers. In terms of geometry, the classical definition from Book 5 of Euclid's *Elements* (Book 5, Definition 3) describes a ratio as "a sort of relation in respect of size between two magnitudes of the same kind." Definition 4 goes on to say that "magnitudes are said to have a ratio to one another which can, when multiplied, exceed one another."

refinements: modifications to the strict proportionality (i.e., *symmetria*) and precise geometric form of an ancient Greek temple, including adjustments to magnitudes (e.g., corner column thickening) and orientation (e.g., inclination of columns), as well as the introduction of curvature to ordinarily straight elements. Modern scholars generally specify four categories of refinements: *entasis*, corner column thickening, column inclination, and curvature.

symmetria **(proportionality or commensurability)**: *Symmetria* is the root of our word *symmetry* and its cognates; it refers directly to the manner in which, taken together (*sum*), two or more magnitudes share a measure (*metron*). In a related but extended sense, *symmetria* refers to the proportionality that obtains among magnitudes arising from their being symmetrical in the first sense (for instance, the proportionality among magnitudes that form part of a temple, or any work of art—*symmetria* being one of the most prevalent terms in ancient Greek art criticism).

technē: a term meaning "art" that includes within its scope (1) the arts in our modern sense (i.e., the "fine arts": painting, sculpture, architecture), (2) the crafts (fields of artisanal specialization), and (3) the mathematical arts, or "sciences" in our modern sense (fields of mathematical and/or technical knowledge).

tetrachord: in early Greek (Pythagorean) music theory, the interval of the *diatessaron* (see appendix A), defined by the ratio 4:3, that can be divided into different sequences of smaller pitches, or ratios (two *tonoi* and a *leimma*, for example) to produce the various scales and genera of Greek music.

Notes

Introduction

1. A "vanishing mediator" is a concept, a term, or an object that serves as a bridge between an earlier form and a later form, but whose appearance is obscured when viewed from within present discourse. The existence and significance of such "mediators" has been theorized (with an underlying Hegelian similarity, but also with characteristic differences) by Badiou, Jameson, and Zizek. For an exemplification of the concept in practice, see Schrift (2006).

2. The "trivium" (of grammar, logic, and rhetoric) is distinguished from the "quadrivium" (of arithmetic (or number); geometry; astronomy; and harmonics), in the canonical presentation of Proclus.

3. For historical and historiographical details, see (especially) the work of Leonid Zhmud (2006, 2012, 2013 inter alia) and Horky (2013).

4. "Well, then, if there is nothing in public, it is told that Homer, while he was himself alive, was in private a leader in education [ἡγεμὼν παιδείας] for certain men who cherished him . . . just as Pythagoras himself was particularly cherished for this reason, and his successors even now still give Pythagoras' name to a way of life that makes them seem somehow outstanding among men" (*Resp.*, 10.600a4–b3).

5. For more the comparison of Homer and Pythagoras as educators, see Horky (2013). For Aristotle's discussion of "liberal education," see Books 7 and 8 of *Politics*.

6. See Waddell (2002: 2–3) on the development of the 5:1 intercolumniation : triglyph ratio as standard practice in Doric architecture, and Busing (1988) for further analysis of its use in the Parthenon, and the adjustments made there to accommodate a continuous proportion of 81:36:16.

7. The details of this and other aspects of the constructive procedures alluded to here, as well as their broader implications, will be discussed more fully in chapter 4, section 3, and chapter 6, section 2 below.

8. As these are presented in *Republic*, 7.522–532 and represented in a pedagogic context by Proclus.

9. This point is developed in section 2 below; the relevant literature includes Zhmud (2006, 2013a,b), Horky (2013), Fowler (1999), Knorr (1975), and Szabó (1978 [1969]).

10. Vitruvius, *De architectura*, VII, praef., 12 (Granger, tr. [1962, II: 72–73]). "Karpion" may be a corrupted form of "Kallikrates," the other architect associated with the Parthenon, though this is disputed.

11. For definitions of these technical terms and others that follow, please see the glossary of technical terms in appendix E.

12. For instance, the crucial question of who among the designers of the Parthenon had received what kind of education, at whose expense, and for what purpose. To answer this, we must bring together recent work on forms of education and civic life in fifth-century Athens, such as Taylor and Baird (2011) and Too (2000), with work on the nature of "liberal arts education" in (especially but not exclusively) Hellenistic and Roman Egypt, such as Morgan (1998), Booth (1979), Marrou (1982 [1956]). This is done on the hypothesis that there exist features of "liberal arts education" in Hellenistic Egypt that are generalizable and thus probably derive from an Athenian origin of such education, through a continuous process of adoption and adaptation. Serafina Cuomo is currently testing this hypothesis in her forthcoming work on ancient numeracy; our thanks to her for assistance in developing this approach and for bibliographical assistance.

13. For more on this debate about Plato and the Academy, and also the claim about the stability of the dating of the rise of theoretical mathematics, see Zhmud (2006).

14. See Berggren (1984) and, especially, Bowen (1984).

15. Bowen (1984) is particularly unconvinced by the *dunamis* argument. To the best of our knowledge, though, this matter has not received sufficient scholarly attention to be deemed "decided."

16. Here, the Stranger tells young Socrates that he and Theaetetus ought to divide the animals between them, since they are interested in geometry, and answers the question "How should we do that?" with the response "By the diameter, of course, and again by the diameter of the square of the diameter [ἡ διάμετρος ἡ δυνάμει δίπους]." The pun then follows when the Stranger relates this to humans being two-footed (δίπους): "Is the nature which our human race possesses related to walking in any other way than as the diameter which is the square root of two feet?"

17. See Szabó (1978: 76, nn. 57–59) for full bibliographical detail on this matter. For the Greek of the Scholium in question, see Szabó (1978: 76n59).

18. The details of the discussion are not crucial for the present analysis. Suffice it to say, what is at stake here is that, as Theaetetus reports (147d), Theodorus has just shown "that squares containing three square feet and five square feet are not commensurable in length with the unit of the foot, and so, selecting each one in its turn up to the square containing seventeen square feet and at that he stopped," meaning that Theodorus could show that all the prime numbers up to

17 had irrational roots, but he needed to show each one individually. Theaetetus, along with young Socrates, has noticed that "since the number of roots appeared to be infinite," it would be good "to try to collect them under one name." The fact that it is still shown individually for the respective squares shows the nascent state of demonstrative mathematical knowledge at the dramatic date of the dialogue, which is generally taken to be at the very end of the fifth century (ca. 400 BCE), just before the death of Socrates.

19. Further corroboration of at least this element of Szabó's picture—which is really the most crucial for us here—can be found in Barbera (1991), Barker (1984, 1989), Barker (2007), and Zhmud (2006).

20. It is notable here that even though—to the best of our knowledge—this debate proceeded and was received as a debate in the history of mathematics, a careful consideration of Knorr's argument—see especially nn. 71, 74—shows that, again, the decision comes down to how one interprets Plato's work, and not historical knowledge of independent sources. Thus, if one finds Szabó's reading of Plato more convincing than Knorr's, then there is no reason yet given *not* to adopt Szabó's historical hypothesis.

21. See especially Fowler (1999: 289–302). But as Fowler (1999: vii) notes, reading all of chapter 10 (356–401) will serve our reader well in trying to determine what his work has to teach as a corrective to the "standard story."

22. See Fowler (1999: 15–20), but also chapter 10.1.

23. See Fowler (1999: 204–17), but also chapter 10.4.

24. Also of special relevance for this question would be (chronologically): Mahoney (1968), Berggren (1984), Bowen (1984), Cuomo (2001), and Acerbi (2010a, 2010b).

25. As pointed out to us by Jeanette Fricke and Lis Brack-Bernsen, one possible point of direct influence that has not yet been thoroughly checked would be an analysis of the "Works and Days" section of *Works and Days* with column 6 of the "Astronomical Diary Text" known as BM47762/BM49107. The general point that there was some direct influence by at least the sixth and fifth centuries, and perhaps as early as the eighth and seventh centuries, has been accepted since Neugebauer (1969). For more on this see Hoyrup (2010) and Rowe (2013).

26. More on this in Evans (1998). We are grateful to Alexander Jones for the reference.

27. We are grateful to Michalis Sialaros and Dmitri Nikulin for independently calling our attention to this piece of "possible corroboration."

28. We are indebted to Jens Hoyrup and Alexander Jones for help with articulating this.

29. Friburg (2007: vii). The argument is developed in chapter 1 as a whole.

30. For (what little) information (there is) on Philolaus's life, including his dates, see Huffman (1993: 5–6).

31. An attractiveness that was clear to Plato, who chooses to make the number crucial for the central problem of *Republic*—and show that the life of

the just is better than the life of the unjust—by having Socrates claim that the life of the just man is 729 times more pleasant than that of an unjust man, and expressly citing Philolaus's great year in the process (*Resp.* 9, 587b–588a).

32. See for instance: Brack-Bernsen (1999, 2014), Britton (2002), Huber and Britton (2007), Huber and Steele (2007), Hunger and Pingree (1999), Steele (2007), and Steele and Imhausen (2002).

33. Our account here would not have been possible without the assistance of Lis Brack-Bernsen. We alone are responsible for what errors remain despite her patient guidance and assistance.

34. Which will be the focus of part I of the current work, especially chapter 1. For more on this see (among much else) Barbera 1981, Benson 2011, and Burnyeat 1987, 2001.

35. The "master complaint" at 510c–d, while Socrates is discussing the "divided line" that famously ends Book 6, is that the mathematicians "treat as known the things like the odd and the even, the figures, the three forms of angles," and other things like that and taking these things "as hypotheses and don't think it worthwhile to give any further account of them to themselves or others, as though they were clear to all." In Book 7, this is specified with respect to the individual mathematical arts. At 528b–d, Socrates applies this critique to the difficulty in canonizing solid geometry (which looks at three-dimensional figures at rest) as the field that mediates between plane geometry (which looks at two-dimensional figures at rest) and astronomy (which looks at three-dimensional figures in motion). At 529b–c, he chastises the astronomers whom Socrates "would deny ever learn" anything of value, since they "look upward" to the heavens and not toward what "concerns what is and is invisible," then suggesting how "a man who is really an astronomer" would rather use "the decoration of the heaven" as "patterns for the sake of learning" about what always is (529e–530b). Finally, at 531b–c, the lesson concerning the astronomers is applied to the problems of harmonics, where Socrates concludes that his objection to those who pursue harmonics in the wrong way—by whom he means the Pythagoreans and not "those who harass the strings and put them to torture"—is that they "seek the numbers in the heard accords and don't rise to problems, to the consideration of which numbers are concordant and which not, and why in each case." Throughout these passages, the issue keeps returning to the place of the sensible world and the relationship between mathematics and dialectic where mathematical inquiry would help bring dialectic out of the world of sense, rather than (as Socrates claims is the case in the dramatic "now" of the dialogue) keep it within that limitation.

36. Specifically, Aristotle cites a proof that demonstrates proposition 2 of Book X of Euclid's *Elements*, with reference to a way of showing "same ratios" (proportions) using *anthyphairesis*, which Aristotle here calls *antanairesis*: "it is not easily proved, for instance, that the line parallel to the side and cutting the plane figure divides similarly the base and the area. But once the definition is stated, the said becomes immediately clear. For the areas and the base have the same *antanaireisis*; such is the definition of the same ratio," as quoted in Knorr (1975: 257).

37. See part II, especially chapter 5, for more on the features captioned here.

Chapter 1

1. See n. 1 in the introduction above for a discussion of this term.
2. *Resp.* 9.587b–588a.
3. A demonstration of just how unresolved these questions are would be the mutually exclusive but also individually unimpeachable arguments by Zhmud (2006: 82–118), to the effect that the mathematical acumen and importance of Plato and his followers was quite minimal, and Hösle (2012 [2004]: 161–82), to the effect that Plato (or, the Academy under Plato) offered nothing less than the basis for the development of the Euclidean *Elements*, a proposition that Zhmud (2006: 100–1) contests but cannot definitively dismiss. Other instances would not be hard to provide. Suffice it to say, the resolution of this debate is not likely to be just around the corner.
4. For instance: "And when Socrates, disregarding the physical universe and confining his study to moral questions, sought in this sphere for the universal and was the first to concentrate upon definition, Plato followed him and assumed that the problem of definition is concerned not with any sensible thing but with entities of another kind; for the reason that there can be no general definition of sensible things which are always changing. These entities he called 'Ideas,' and held that all sensible things are named after them and in virtue of their relation to them; for the plurality of things which bear the same name as the Forms exist by participation in them. (With regard to the 'participation,' it was only the term that he changed; for whereas the Pythagoreans say that things exist by imitation of numbers, Plato says that they exist by participation.)" (A.6.988b1–12). Or again in the famous contest against Speussipus and the other Academics of Aristotle's time: "And as for that which we can see to be the cause in the sciences, and through which all mind and all nature works—this cause which we hold to be one of the first principles—the Forms have not the slightest bearing upon it either. Philosophy has become mathematics for modern thinkers, although they profess that mathematics is only to be studied as a means to some other end." (A.9. 992a25–29).
5. We ask for the moment, as a postulate, that "lives a life 729 times more pleasant" or "lives 729 more happily" be considered equivalent. At the proper time, we will try to think more carefully about why the comparison here is about pleasure in particular and in what way this is telling for the manner in which the core argument of Book 9 actually satisfies the demand that it is meant to address.
6. Just in the last generation or so, this moment has received careful attention from Baracchi (1999), Benardete (1989), Clay (2000), Ferrari (2005, 2007), Griswold (2002 [1988]), Kraut (1992, 1997), and Reeve (2013).
7. Without cessation since at least the debate between Cornford (1966 [1937]) and Taylor (1928), and right through Broadie (2011), Derrida (1995),

Gregory (2000), Johansen (2003, 2004, 2012), and Sallis (1999). Close engagement with these works follows in chapter 2.

8. On "dialogue and dialectic," see especially Ferrari (2005, 2007), Frede (1992), Gadamer (1980), Gonzalez (1998), Griswold (2002 [1988]), Kahn (1996, 2005), Nikulin (2010), Reeve (2013), Roochnik (1986, 2003), Sayre (1995), and Szelak (1999, 2004). On "Plato and mathematics," see especially: Anton (1980), Burnyeat (1987, 2001), Hösle (2012 [2004]), Horky (2013), Kahn (2001), Nikulin (2002, 2012a), Stenzel (1933, 1940), and Zhmud (2006). More will be said concerning both of these sites of scholarly debate later in this chapter and in the following chapters.

9. The "co-presence" of 512 with 729 is clear from the treatment of the relevant number series as analyzed in *Timaeus*. In our detailed discussion of the "729-times-more-pleasant" passage below, we will discuss this.

10. That is, the "Pythagorean" theory of which our earliest record (if genuine) is the famous fragment (6, or 6 and 6A according to Huffman [1993]) of Philolaus.

11. In reading this way, we acknowledge the influence of McNeill (2010), who focuses on the "image of the soul in speech" passage (588b f.), which immediately follows the "729 times more pleasantly" argument. See also Kahn (1996), Nikulin (2010), Roochnik (2003), and Sallis (1999) on this point.

12. In this sense, while adopting the Kantian language of "transcendental" here, there is more than the whiff of a Hegelian sublation in our sense of the relationship between dialectic and mathematics.

13. For a definitive treatment of harmonics as the *highest* of the arts and the nearest to the work of dialectic, see Miller (2007: 327f.).

14. For a definitive introduction and defense of this approach, see Nikulin (2010) and Nikulin (2012a), chapter 2.

15. For a classic instance of this tradition, see Annas (1997 [1981]); notable recent exemplars (among many others) include Benson (2011) and Denyer (2007).

16. Those seeking a further "big picture" defense of this way of reading "the importance of leaving things out for Plato's dialectic" would do well to consult above all, the Appendix of Roochnik (2003) and Miller (2007).

17. See chapter 3, section 1 for a further discussion of these passages and their relation to the theme of dialectic's relation to mathematics in Plato's thought overall, and with respect to Timaeus in particular.

18. Presented by Adeimantus: "Don't only show by the argument that justice is stronger than injustice, but show what each in itself does to the man who has it—whether it is noticed by gods and human beings or not—that makes the one good and the other bad" (*Resp.*, 2.367e). That and how the argument concluding at *Resp.* 9.588a is the answer to the problem posed here by Adeimantus is clearly shown by Kraut (1992).

19. As Recco (2010: 2–7) also neatly summarizes these debates in the opening discussion of the "method" by which one can best read *Republic*.

20. See Ferrari (2007: xvi–xx, xxv–vi) for both a historical account of the development of these divergent traditions and his and his fellow authors' attempt to reconcile them in creating a unified "companion" for readers of *Republic*.

21. In a review, Johanssen (2012) neatly summarizes her position: "Cosmology may be a *muthos* about gods but it is emphatically, for Broadie, a scientific one."

22. As Socrates says (*Resp.*, 9.577a3–b1) we must do in order to see the tyrant as he is truly is: "What if I were to suppose that all of us must hear that man who is able to judge and has lived together with the tyrant in the same place and was witness to his actions at home and saw how he is with each of his own, among whom he could most be seen stripped of his tragic gear; and again has seen him in public dangers; and since he has seen all that, we were to bid him to report how the tyrant stands in relation to others in happiness and wretchedness?"

23. In his account of the conflicting interpretive traditions with respect to Timaeus (and his role in *Timaeus*), particularly in the debate between Taylor (1928) and Cornford (1966 [1937]). Had Taylor "won" that debate (in the English-speaking world), the whole interpretive approach to Plato and the dialogue form in twentieth-century English-language philosophy might well have gone otherwise.

24. So marked in honor of Cornford (1966 [1937]) making this the title of his influential reading of *Timaeus*.

25. While we suggest here that there is recent historical trajectory to the bridging of a dogmatic/dramatic divide in the interpretation of Plato, we also accept Phil Horky's critique (shared with us in private correspondence) of the whole category of "Platonic dogma," as the dogmata can only be reliably assigned to the first generations of Platonists and not to Plato himself: "Dogmatism develops in the Platonic tradition at the earliest in the writings of Hermodorus of Syracuse, who wrote a book 'On Plato' (F 8 Isnardi Parente = Simpl. In Arist. Phys. p. 256.31ff. Diels), and of course in the writings of his critics, such as Aristotle and Aristoxenus. Perhaps nothing is 'dogmatic' in Plato's dialogues, and more importantly, there is no way that we could go about developing a methodology which would be sufficient for identifying the dogmata; for, the 'unwritten dialogues' are wholly unreliable on this front, and in my opinion represent attempts by later scholars to appropriate Platonic thought to their own projects."

26. For more on this, see Huffman (1993), McKirahan (2011), Horky (2013), Cornelli (2013), and Zhmud (2012, 2013).

27. This fragment is quoted nearly in its entirety in our detailed discussion of the number 729 and its salience for Plato below. For the text of the fragment see Huffman (1993: 123–24).

28. Here we join the project of reconciliation offered by Griswold (2002 [1988]) and Ferrari (2007).

29. *Resp.* 9.588a2.

30. "Socrates has had to make two rather fast moves. First, he illegitimately capitalizes on the Greek manner of counting series in order to count the oligarch twice, once as the last term in his first series (tyrant, democrat, oligarch) and again as the first term in his second series (oligarch, timocrat, king). Second, he multiplies the number of times the tyrant is removed from the oligarch by the number of times the oligarch is removed from the king, when he should have

added them. In fact, the tyrant is only five times removed from the king, and so lives only 125 times less pleasantly!"

31. Adeimantus asks Socrates, at the moment that sets off the whole string of images that culminated in the allegory of the cave: "How can it be good to say that the cities will have no rest from evils before the philosophers, whom we agree to be useless to the cities, rule in them?"

32. Where Socrates suggests that there "are likely to be as many types of soul as there are types of regimes possessing distinct forms," and goes on to say that just as there is "one form for virtue and an unlimited number for vice, but some of four among them worth mentioning," so too there is "one type of regime" that possesses virtue—namely, "the one we've described"—but it can be named either a kingship or an aristocracy. Already we see there's something strange about this analysis: there is one virtuous regime and it can be either kingship or aristocracy, which don't differ essentially. But the account is left incomplete because Socrates is arrested again and forced to discuss the common possession of women, which "the many" listening to the conversation insist be discussed before continuing with the analysis of regimes.

33. The core of what is picked up from Book 4 being described by Glaucon as the assertion that "there are four forms it is worthwhile having an account of, and whose mistakes are worth seeing, and similarly with the men who are like these regimes."

34. It is no accident that wrestling, an integral part of education in *gymnastic*, is going to decide this question. Note that the final defense of justice as a wrestling match was already introduced by Glaucon (544b3) when he poses his request for Socrates to go back over the five types of regimes (which, as Glaucon notes [544b1] were actually not named in Book 4) thus: "Well then, like a wrestler, give me the same hold again . . ."

35. The argument to this effect opens Book 9 (571b–572b), stipulating that while we know from Book 8 that there are both necessary pleasures and unnecessary pleasures (and desires that accord to them), a further qualification is needed. For "of the unnecessary pleasures and desires" there are also two relevant kinds: one kind that is "hostile to law (παράνομοι)" (571b3) but can be checked by laws and by better desires, and "others" that are "stronger and more numerous," which bring a soul to "dare to do everything as though it were released from, and rid of, all shame and prudence" (571c3–4).

36. For this reason, while owing much to what Kraut (1992: 325ff.) says about the work of the form of the good in the just person's soul being at the heart of Plato's defense of justice, we must dissent from his claim (312–14) that pleasure—specifically what Adam (1902) calls the "hedonistic calculus" of 587–88—is not integral to how the just person holds the form of the good in his soul.

37. And note that separating out the one, the two, and the three is exactly what we need to do in carrying out the 729-times calculation.

38. Cornford (1945), Shorey (2003 [1937]), and Reeve (2004), to cite a few relevant instances, all express profound doubts about the seriousness of the

729 passage. Shorey (2003: 394–5) cites approvingly Temple's (1916) observation that: "Finally the whole thing is a satire on the humbug of mystical number, but I need not add that the German commentators are serious exercised." This is also an exemplar of the interpretive rift discussed earlier, and the tendency to associate interpretative attitudes with nationality.

39. As Cornford (1945: 315n1) recommends in basically eliminating all of Socrates's attempts to make the quantitative comparison salient at all; his translation practice (now in disrepute but widely endorsed in English-speaking philosophy throughout much of the interwar and postwar period) has been discussed above. What is remarkable here, though, is that he does note the possibility that the passage is intentionally obscure. This implies that we might want to make an attempt to understand why there is deliberate obscurity here, which is precisely what we attempt to do in recovering what we call the positive absence of harmonics in this passage. For Cornford, though, rather than engage in this act of interpretive justice, the task is to "simplify the text"—perhaps, one imagines, to be able to read it at face value.

40. An idea expressly presented and defended in the conclusion of the *Protagoras*, and explored in detail in the *Philebus*. See Benardete (1993) for more on this.

41. "Plato finds the natural vehicle of his thoughts in a progression of numbers; *this arithmetical formula he draws out with the utmost seriousness*, and both here and in the number of generation seems to find an additional proof of the truth of his speculation in forming the number into a geometrical figure; just as persons in our own day are apt to fancy that a statement is verified when it has been only thrown into an abstract form" (emphasis mine). Jowett may himself be skeptical that the quantification adds much to the argument, but acknowledges that Plato himself was not so skeptical.

42. Burnyeat (2001: 48–50) provides a nice account of how and why Plato has Socrates (528b–e) rush past solid geometry to speak about astronomy, only to correct himself and include work done by Archytas that actually was not known at the time that Glaucon and Socrates were putatively speaking with another (perhaps 411 BCE, but surely before Archytas would have published his results [390 BCE? 380 BCE?]). The details of this work in Pythagorean Harmonics, and Plato's reception thereof, will be discussed further in the following sections. We gratefully acknowledge the help of Bill Pastille in helping to articulate this point; he is surely blameless for any remaining obscurity here.

43. Cornford (1945: 315n2), like Reeve (2004), claims that "[i]t is not explained why 9 is to be raised to the third power, 729." But I believe this is the moment that clarifies the procedure. It also helps us to understand why we have 3 times 3 in the first place; it is rather remarkable, given the justified fame of *Plato's Cosmology*, that Cornford is unconcerned here to see how 9 is first constructed as the square of 3, and then taken in cube.

44. On this see Adam (1902) and all those who follow in his wake. Burkert (1972) is another touchstone.

45. Adam believes so; we know of no later elaboration, or rejection, of the suggestion.

46. Leonid Zhmud (private correspondence) suggests that Philolaus's Great Year follows Oenopides's Great Year, which contained 730 synodic months, but Philaus subtracted a month, probably for numerological considerations, thus making the Great Year $9^3 = 729$ months. Of course, one can get the same number via many different ways. See Huffman (1993) for more on this.

47. The famous "first founding" of the cosmos passage, the focus of chapter 2.

48. Here we follow Heller-Roazen (2011). See the treatment of "Pythagorean Harmonics" in chapter 4 for a fuller account of this.

49. That is, between ca. 420 BCE and 385 BCE, which is to say, during Plato's intellectual formation. Barbera (1991) shows that the debate as to whether sounds are magnitudes or multitudes propelled the theoretical investigation of the musical canon; Heller-Roazen (2011: 36 and 147n15) wonders if Philolaus really did bisect the *comma* as Boethius suggests, noting that if so, this would be a violation of the theorem (Archytas) of the indivisibility of the tone. More on this in the treatment "Pythagorean Harmonics" in chapter 4, and in our discussion of *Timaeus* following.

50. Mueller (1980: 118) also insists on the fact that mathematical problem-solving can only ever offer *approximate* solutions, and that this is crucial for understanding the relationship between mathematics and dialectic.

51. We owe the formulation and the reference to Stevens to David Hayes.

Chapter 2

1. Which reads, in Kalkavage's translation: "And so let us now declare that our account of the all at last has its end; for by having acquired animals mortal as well as immortal and having been all filled up, this cosmos has thus come to be—a visible animal embracing visible animals, a likeness of the intelligible, a sensed god; greatest and best, most beautiful and most perfect—this one heaven, being alone of its kind!"

2. Nikulin (2012a: 27f.) further contextualizes this opening of *Tim*. with respect to Plato's "mathematical ontology."

3. See chapter 1, section 1, for a discussion of this passage.

4. Burnyeat (2011: 67) offers a related, but contrasting reading of the "positive absence" of so much of what is most valuable in *Resp*., holding that this shows that (unlike the philosopher-kings being educated in *Resp*.) Timaeus doesn't need all the preparatory work that goes into the dialogue with Glaucon, because Timaeus already has considerable political expertise. But this, to our view, comes to the same as what Kalkavage argues, and still implies that we must not hold that Timaeus's understanding of the relationship between mathematics and the cosmos is the truth, or even the approximate truth, for Plato.

5. Against the identification of Timaeus with one of the most famous Pythagoreans, Zhmud (2013: 1n3) notes that "The birthplace of Timaeus calls to mind rather the well-known doctor Philistion of Locri. The physiology and medicine of the *Timaeus* owe much to Philistion."

6. As will be clear, our reading of this section owes much to Sallis (1999: 65–77); for a concise and complete introduction to the technical details of this passage, see Kalkavage (2001: 148–52).

7. This leftover (256:243) is, more or less, the semitone, save for the "Pythagorean *comma*." The reader interested in the technical details can find them discussed in chapter 3. Kalkavage (2001: 150–51) presents the scale construction in greater detail and with a musical score in modern notation.

8. See Heller-Roazen (2011) and Barker (2007). This matter also arises in the discussion of Pythagorean music theory in chapter 4.

9. Kalkavage (2001: 152).

10. Including Miller (1999, 2003, 2004, 2007). Especially relevant for our concern here is Miller (2007: 327–42).

11. Kalkavage (2001: 152). On the construction of the regular solids in relation to the political frame of *Tim.*, see also Sallis (1999: 125–45).

12. In chapter 3, we will have occasion to test our view against this last interpretive tradition.

Chapter 3

1. Chiefly Burnyeat (2001), Mendell (2008), Miller (2003, 2007), Mueller (1980, 1991, 1992), and Nikulin (2012b).

2. In speaking this way, we do not intend to insist that there is, was, or will be a fixed set of Platonic *dogmata*. We are persuaded that there is no set of fixed opinions out there belonging to "Plato the Pythagorean" (or to "Plato the Socratic," or to "Plato the Anaxagorean, the Democritean, or even the Protagorean." In this sense we are happy to think of the Plato with the commitments attributed to him in what follows as a Pythagorean in potential, who coexisted with other Platos with other commitments that weren't always consistent. (We thank Phil Horky for his objection and suggestion on this point.)

3. See Kraut (1992: 325f) for what we mean by this term here.

4. This will be discussed in greater length in the closing section of this chapter, with respect to Proclus's account of the debate between the constructivists and the realists in the early Academy. The account here is the minimum needed to understand how the sensible/intelligible distinction is at work in the articulation of geometry as the second of the mathematical arts in the educational program of the philosopher-kings.

5. If indeed this Menaechmus is identical with Eudoxus's student. For reasons to doubt this see Zhmud (2006: 208f).

6. For more about this little-documented but possibly quite important figure, see Bodnar (2007).

7. Leonid Zhmud reports that we have reasons not to be too sure about such time in Athens.

8. In clear and obvious contrast with Descartes in the *Rules* and the *Discourse on the Method*, as Nikulin (2002) is at pains to show with respect to mathematical ontology in particular.

9. We are grateful to Richard Kraut for insisting on this point and helping us clarify our view of the relationship between mathematical procedures and dialectic as constitutive of philosophy as a practice.

10. Kahn (1996: chapter 10) provides (1) a helpful catalogue of the dialogues that are relevant for trying to develop this picture, specifically a group that calls into question the project of assigning a chronological order of composition, and surely the "developmental" interpretation thereof. His reading embraces dialogues as diverse as *Gorgias*, *Hippias Minor*, *Meno*, *Parmenides*, *Phaedo*, *Republic*, *Euthydemus*, and *Cratylus*. On this basis, he further offers (2) an attempt to characterize an intertextual understanding of the meaning of dialectic across this corpus.

11. For more on the status of Pythagoreanism in the early Academy, particularly with response to inner-Academic debates about mathematical ontology, see Dillon (2003), especially chapter 2.

Chapter 4

1. See the introduction, section 2, where this issue is discussed at length. See also Heller-Roazen (2011), esp. chapters 1–3.

2. Szabó (1978), part 2, and also the discussion in the introduction, section 2.

3. Or perhaps it is better to say "re-discovered," or "first theorized." On the controversies concerning knowledge of the incommensurable in (much) earlier Near-Eastern and Egyptian mathematics, see the introduction.

4. Von Fritz (1945). Hahn (2017) argues that the relevant fact about triangles and incommensurability was known already to Thales one hundred years earlier.

5. Von Fritz (1945: 256–60). In the pentagram, the relation between one side of the arms of the star to a side of the pentagon at its center is the golden section. It can then be shown, through *anthyphairesis* (reciprocal subtraction), that the relation between the side of the pentagon and the arm of a star inscribed within it, is also the golden section, and so on, ad infinitum, for a series of recursively inscribed nested pentagrams, without limit.

6. The golden section would have been understood by the ancient Greeks as a purely geometrical relation, but it can be expressed algebraically as $(\sqrt{5} + 1) / 2$.

7. "Proportionally smaller pair of magnitudes" or "magnitudes in the same ratio" (see Euclid, *Elements*, Book 5, Definitions 5 and 6), although, of course, an irrational relation like the golden section, as indicated by the very name (Greek:

a-logon, indicating a pair of magnitudes that cannot be brought into whole number relation), cannot be a numerical ratio in the proper sense.

8. See especially Barker (1984, 1989, 2007) and Barbera (1991). On Philolaus's contribution to this see Huffman (1993). See also the contributions of Graham, Schofield, and Barker in Huffman, ed. (2014).

9. See our account of Szabó (1978) on this in the introduction, section 2; see also Barbera (1991).

10. Szabó (1978: 28–29); see also his full elaboration of this idea in part 2 of the book.

11. For a discussion of similar issues in the Renaissance context, see Drake (1970) and Peterson (2011).

12. Szabó (1978: 104–08).

13. See Franklin (2002).

14. For a comprehensive account of these considerations of harmonics as both a theoretical and practical art, and, especially, on the tetrachord, see Barker (2007). For the construction of the scale and the emergence of the *leimma* and the *apotome*, see Kalkavage (2001: 150–51). On the division of the diatonic tetrachord, the genus that is being described in this section, see Franklin (2002), Heller-Roazen (2011), chapter 3, and Winnington-Ingram (1932).

15. For fragments 6 and 6A of Philolaus, with commentary, see Huffman (1993: 123–65). Philolaus is also the focus of chapter 2, section 2. For a summary of the intervals of the Pythagorean musical scale discussed above, see appendix A.

16. Franklin (2002). Barker (2007) weighs in on this debate in his introduction.

17. Plato, *Timaeus*, 35b–36c. See chapter 2.

18. Plato, *Meno*, 84c. This passage is at the heart of the debate between Szabò (1978 [1969]) and Knorr (1975). Hahn (2017) argues that this problem was well known already two generations earlier than Szabò argues, and more than a century before Knorr thinks likely.

19. Cf. Heller-Roazen (2011), chapter 6, on equal temperament.

20. The relation between two magnitudes could still be called a "ratio" and treated as such, but if the relationship between the two magnitudes was irrational, it would no longer be a *numerical* ratio, and for fifth-century Greek mathematics this is a profoundly important distinction. In Euclid's *Elements*, ratios are introduced in Book 5, and Book 6 is full of ratios involving geometrical figures; however, numbers are introduced only in Book 7, and then everything is proved all over again for numbers.

21. Wilson Jones (2014) and Connelly (2014), two of the most recent major works on ancient Greek architecture, both emphasize the importance of the Greek temple's religious function and meaning in defining every aspect of these buildings. Wilson Jones also stresses the specific character of Greek temples as gifts, or offerings, to the gods.

22. A consideration of the dialogue between music, visual arts, and the broader intellectual culture of a specific time and place—in this case, fifteenth-

century Florence—that is somewhat parallel to the approach we are taking here can be found in Baxandall (1988), especially section 10 of chapter II (pp. 94–102), where he discusses the Renaissance approach to Pythagorean harmonics not only in relation to the music theorist Francesco Gaffurio, but also in relation to, and within a larger discussion of, painter's perspective and the more general cultural relevance of the mathematical problems it engages. See also Baxandall (1980) for a related discussion of the dialogue between music and visual arts in the context of southern Germany in the Renaissance.

23. The specific roles each of these two architects played in the design of the building is uncertain. That Iktinos, also known from the Temple of Apollo at Bassae, may have been the principal architect, with Kallikrates either as a predecessor or successor, an assistant architect, or an engineer, is the prevailing view among scholars (see, for instance, Pollitt [1972:71]). For a good recent overview of the problem, see Barletta in Neils, ed. (2005: 88–95). For a more thorough discussion, see Carpenter (1970) and Wesenberg (1982). For a suggestion that the chief sculptor Pheidias played the leading role in designing the building, see Bundgaard (1976: 69–70).

The mention by Vitruvius (*De architectura*, VII, praef., 12) of a lost architectural treatise on the Parthenon by Iktinos and "Carpion" further complicates the issue, as Carpion is generally either identified as a corruption of Kallikrates or as referring to a different person altogether. Here is Frank Granger's translation of the relevant passage, in vol. 2 of the Loeb edition of Vitruvius (1934: 71–73): "Subsequently Silenus published a work upon Doric proportions; Rhoecus and Theodorus on the Ionic temple of Juno which is at Samos; Chersiphron and Metagenes on the Ionic temple of Diana which is at Ephesus; Pythius on the temple of Minerva in the Ionic style which is at Priene; Ictinus and Carpion on the Doric temple of Minerva which is on the Acropolis at Athens. . . ."

24. On the Older Parthenon, see Barletta in Neils, ed. (2005: 68–72), Gruben (2001: 170–72), and Hill (1912). For an alternate chronology with respect to the construction of the Older Parthenon, see Bundgaard (1976: 61–63).

25. For a good introduction to the Parthenon in its historical context, see Connelly (2014: 76–125) and Bruno in Bruno, ed. (1974: 57–97). On Athens at the time of the Parthenon, see Kallet in Neils, ed. (2005: 35–65). On the Parthenon's physical context, see Stevens (1940).

26. See Connelly (2014: 86–87). In addition to payment records from the time of the Parthenon's construction, the principal ancient source on public participation in the Parthenon project (though written several centuries later) is Plutarch's *Life of Pericles*, XII–XIII (Plutarch [1958]: 34–47). References to the relevant passages in Plutarch and to surviving documents from the fifth century can be found in Connelly (2014: 76–125) and Kallet in Neils, ed. (2005: 35–65).

27. Connelly (2014: 229–35) has recently argued that the name Parthenon refers to "virgins" in the plural, and may be a reference not only to Athena but also to the three sacrificed daughters of Erechtheus and Praxithea (the legendary king and high priestess of Athens, respectively). She further argues that the cult

of the three daughters may have been located in the Parthenon's west room, the *parthenon* proper, which, furthermore, would probably have been intended to mark their burial place.

28. See Ilievski (1993), on the etymology of *harmonia*, its origins, and the historical development of its significance in the Greek tradition. See also Lippman (1963).

29. See Korres in Tournikiotis, ed. (1994: 84–88) and Pollitt (1972: 78–79).

30. Cf. Wilson Jones (2014), chapter 3, and also Hellmann (2002: 123–30). Wilson Jones's analysis of the development of the Doric order in relation to constructive problems and methods illuminates the historical basis, in terms of a chronology of specific building practices, for understanding the formal character of the Doric, that is, its modularity and its reliance on the juxtaposition of discrete proportional elements.

31. See chapter 5, section 2, for a discussion of this topic, and for the relevant bibliography.

32. Using the term in the broadest sense here that includes both *harmonia* and *symmetria* in the more rigorous sense—what we refer to elsewhere as "harmonics."

33. Wilson Jones (2014), chapter 3. See also Hellmann (2002), chapter 7.

34. See Wilson Jones (2014: 76–81), on the relationship between formal (aesthetic) and tectonic, or constructive, considerations in Doric architecture. The fuller significance of the "constructive" will be the focus of the following section.

35. See Coulton (1977), chapter 3. See also Wilson Jones (2001) and Waddell (2002), on the importance of modular design in fifth-century architecture. In Waddell's reconstruction of Doric building practices, the design begins with the dimensions of the krepis, from which the triglyph module is subsequently determined, while for Wilson Jones the starting point of the design is the triglyph module.

36. Coulton (1977: 51–53, 68–73). See also Mertens (2006: 415–16) on the more ornamental treatment of the frieze and the spatial, rather than plastic, emphasis in the positioning of the columns in the Temple at Segesta, implying that a shift away from the modular approach of the classical period may be in evidence here already by the end of the fifth century. For a thorough treatment of the Segesta temple, see Mertens (1984), esp. part 1.

37. A grid in the limited sense of a system of regular geometric divisions of a finite object, in contrast to the infinite grid of Renaissance perspective space (see the afterword).

38. Mertens (2006: 258, 267, 381–86).

39. See the sections on the Paestum Temple of Athena in Gruben (2001: 269–74, esp. 270–71) and Mertens (2006: 222–27). See also Pollitt (1995: 22–23), Nabers and Wiltshire (1980), Ross Holloway (1966), and Lauenstein (1998: 75–105).

40. Mertens (2006: 223–24).

41. See Nabers and Wiltshire (1980: 208–11).

42. Nabers and Wiltshire (1980) and Lauenstein (1998: 75–105) both take this approach, focusing more on the presence of specific numbers or ratios in the

building than on the methodological questions of modular design or harmonics, as we have been discussing them, and thus differ fundamentally in their interpretation of the significance of Pythagorean influence on architectural practice from the one we are taking in this book. Bell (1980) discusses the Olympeion at Akragas in a similar vein, arguing in particular for a stylobate perimeter of 1,000 Doric feet, and the significance of that number for the Pythagoreans.

Schneider Berrenberg (1988) takes a parallel approach in his interpretation of the musical ratios in the Parthenon, relying on the assumption of a Doric foot measurement of 0.322m to develop his argument.

43. For discussions of the major temples of this period in chronological sequence, see Gruben (2001) and Dinsmoor (1950), for both mainland Greek and western colonial buildings, and Mertens (2006) for temples in the western colonies.

44. On the canonization of the 3:2 metope to triglyph ratio within the Doric order, see Waddell (2002: 2–3) and Mertens (2006: 270–71, 389).

45. For a full discussion of the corner problem, including the significance of such terms as "double contraction," see chapter 5, section 1.

46. See Mertens (2006: 385, 402, 406, 413) and Mertens (1984: 220–28) on the Temple of the Athenians at Delos, with the prominence of the 3:2 ratio in its design (see esp. Mertens [2006]: fig. 653) as an important source for Periclean architecture.

47. See the sections on the Temple of Hera Lacinia in Mertens (2006: 386–91) and Mertens (1984: 98–108), and especially the diagrams showing the proportions of the east façade (Mertens [2006]: fig. 658). Although both the stylobate dimensions and the intercolumniation to column diameter ratio are 9:4, the dimensions of the façades are 2:1; in this way, and others, the building's continuous proportionality based on 9:4 is less thoroughgoing than that of the Parthenon, which appears, with respect to its Sicilian predecessor, to be a modification with the goal of developing much further the use of 9:4 as the basis of a harmonious design. See the fuller discussion of the relationship between the Temple of Hera Lacinia and the Parthenon in section 3 below.

48. Dinsmoor (1950: 152). According to Dinsmoor, 16:8:4:2:1 is the continuous proportion connecting column height, intercolumniation, axial spacing of the triglyphs, axial spacing of the mutules and lion heads, and individual tile width. Dinsmoor further argues that this *symmetria* was constructed from integer numbers of actual Doric feet (32:16:8:4:2, in feet), with the floor tile module as 2 Doric feet, and then states: "it seems clear that Libon [the architect] was attempting to work out some ideal system of proportions." Cf. similar practices in the design of Sicilian buildings such as the Temple of Athena at Syracuse (see Mertens [2006: 269–74]).

Junecke (1982: 60–69) proposes another form of modular design for the Temple of Zeus at Olympia, one that involves purely geometric construction (irrespective of multitudes) as well as equal divisions of magnitudes and small number ratios, that is, a combination of different approaches. For Junecke, the relevant module of 0.3193 m, used for the construction of the peristyle column

diameters, was determined as one-tenth the length of the cella, which itself had been constructed geometrically from the dimensions of the stylobate. See also Gruben (2001: 56–62).

49. Mertens (2006: 266–74), on the treatment of the corners in the Temple of Poseidon at Paestum and its similarity to the approach taken in the Temple of Zeus at Olympia.

50. The refinements will be discussed at length in chapter 6, where they are the principal subject.

51. See Kallet in Neils, ed. (2005: 35–65), and the relevant bibliography on the Athenian empire following the Persian wars cited there. Cf. Plutarch, *Life of Pericles*, XII.1–4 (Plutarch [1958]: 34–7), on the financial aspect of this colonial appropriation.

52. See chapter 5, section 1.

53. Here and throughout, we will be using the measurements from Orlandos (1976–78), unless otherwise specified. For a summary of the principal measurements of the Parthenon discussed in this and the following chapters, see appendix B.

Given the continuing debates regarding the exact dimensions of the foot unit used in the Parthenon, we will be giving measurements in meters throughout. On the foot unit, see Wesenberg (1995), and specifically on the Doric foot possibly used in the Parthenon, Dinsmoor (1950: 161n1).

54. For a still-reliable and comprehensive early documentation of the measurements of the Parthenon, see Penrose (1888 [1851]: 9–21). For the most important recent publication of the building's measurements, see Orlandos (1976–78). See also Berger in Berger, ed. (1984: 377–404), and Berger (1980). Appendix B also summarizes the measurements of the principal dimensions of the building, based on those given by Orlandos.

55. See the bibliography in n. 24 above, especially Bundgaard (1976: 61–63), and his argument that the Older Parthenon most likely was partially built and then taken apart again so that the stones could be reused: the important point here being that it was not the overall dimensions of the older building but the measurements of the individual column drums that were influential in the design of the new building on the same site.

56. For a version of Protagoras's position and an attempted refutation, see Plato, *Theaetetus*, 160e–172c.

57. Note, by way of comparison, the use of the *braccio* as a modular unit for Leon Battista Alberti in the fifteenth century and, given this, the irony of readings of perspective (quite common in the current theoretical discourse) that see Renaissance perspective as appealing to an entirely disembodied vision. See Alberti, *Della pittura* (1435, 1436), I, 19 (Spencer, tr. [1966: 56]).

58. Cf. Fowler (1999) and Szabò (1978), part 2.

59. See n. 44 above.

60. Berger (1980: 75) gives the average triglyph width as 0.846 m, while in Orlandos (1976–78), whose measurements we are using throughout, it is 0.845 m (see appendix B).

61. See Waddell (2002: 15–16). According to Waddell (p. 16), the new krepis blocks were cut to make the interaxials 1 percent less than those of the Older Parthenon, in order to maintain this commensurability of 9:4, indicating the effort the builders of the Parthenon were willing to expend for the sake of precision in the building's *symmetria*, even at the large scale of the stylobate dimensions. See also Korres in Tournikiotis, ed. (1994: 65–66) on the precision of measurement in the Parthenon.

62. See Wilson Jones (2014: 81–86) and Hellmann (2002: 130–45) on the historical emergence of canonical Doric elements. See also Waddell (2002: 2–3), on the standardization of the 3:2 metope-to-triglyph ratio, as well as the 5:1 intercolumniation to triglyph ratio, from the Temple of Aphaia at Aegina onward.

63. Coulton (1974). Coulton further suggests that the combination of mainland and Sicilian approaches to the proportioning of the stylobate may be the main reason for the Parthenon's excessive angle contractions. Winter (1980: 409–10), following Coulton, points out that the excessive corner contraction of the Parthenon allows the flank and façade intercolumniations, with the exception of the corners, to be equal at the same time as making it possible for the stylobate's dimensions to conform to both the mainland and Sicilian rules. This last point is important in that it reinforces the sense that design decisions were made with the goal of *symmetria* throughout the building (here, in the equal intercolumniations) firmly in mind.

As both Coulton and Winter describe them, the "Sicilian rule" is based on the number of columns, yielding stylobate dimensions of façade columns : flank columns + 1, while the "mainland rule" bases the stylobate dimensions on the intercolumniations, plus a small fraction (e.g., 1/3 or 1/5) on both façades and flanks for the corner triglyph. The Parthenon, which conforms to the mainland rule (using an additional fraction of 1/5), conforms of course to the Sicilian rule as well (with an 8 × 17 peristyle: 8: [17 + 1] = 4:9).

64. Coulton (1974: 76).

65. One of a number of different small fractions that could be added to the measurement based on intercolumniations, as Coulton (1974: 76, 83–84) points out.

66. See Berger (1980: 75–79), who refers to this magnitude as the "cubic module" (Kubus-Modul), the basic module for the cubic volume of the building, related to the triglyph width (effectively, as an "ideal triglyph module" of the sort we have been discussing above).

67. See Büsing (1988). The emphasis of Büsing's argument, however, is less on the reconciliation of 1:5 (16:80) and 16:81 (the focus of our discussion above) and more on an explanation of the Parthenon's excessive column contractions as a means to produce the 9:4 proportion of the stylobate.

For a full discussion of this problem, and its implications for the meaning of harmonics in the Parthenon, see chapter 6, section 2.

68. Cf. Waddell (2002; 14–19) on the use of 9:4 ratios at various scales in the building. The 9:4 ratio was probably chosen for the Parthenon, he argues, because "no other ratio had lent itself so well to achieving commensurability for a wider range of elements" (p. 14).

69. It is worth noting that this approach reflects that of the Parthenon's immediate predecessors, the Temple of Hera Lacinia and the Temple of Zeus at Olympia, which both use a small number ratio to define the dimensions of the façades. The Parthenon, however, substitutes 9:4 for the 2:1 ratio used in those two temples.

70. See Wadell (2002: 17).

71. That the stylobate formed a 9:4 rectangle to a high degree of precision in measurement (69.503 m by 30.880 m) was first rediscovered by Stuart and Revett in the second half of the eighteenth century (2008, II [1787]: 8). Penrose (1888 [1851]: 118), in his systematic measurement of the building first published in 1851, confirmed that the height of the order was also, and equally precisely, in a ratio of 4 to 9 with the stylobate width. Lloyd (1863: 113) then pointed out that the ratio of the intercolumniations to the lower column diameters of the peristyle formed another series of 9:4 ratios. See Wadell (2002: 15).

72. Winter (1980: 408–9) argues that the 8 × 17 peristyle must have been chosen primarily for reasons of harmony (specifically, in the service of a *symmetria* grounded in the 9:4 ratio), since it makes the 9:4 dimensions of the façades possible. For an argument that the width of the cult statue was the primary reason for the increase in width of the Parthenon (from hexastyle to octastyle), along with a case for Pheidias rather than Iktinos or Kallikrates as the principal designer of the building, see Bundgaard (1976: 69–70).

73. The 5:2 proportion of the stylobate occurs in the Temple of Victory at Himera, the Temple of Athena at Syracuse, the Athenaion at Gela, the Temple of Poseidon at Paestum, and Temple A at Selinus. See Mertens (2006: 267, 270, 275, 284–86, 401).

74. See Mertens (2006), fig. 658.

75. Cf. Berger (1980: 75–79), and his reading of the building's cubic volume as 81:36:16 cubic modules (i.e., ideal triglyph modules; see n. 66 above) of 0.858 cm. Berger also discusses (1980: 88–90) a cella module (Naos-Moul) in a ratio of 9:13 to the triglyph module, based on the overall 9:13 ratio of cella to stylobate, relevant to our discussion of the cella below.

See Wilson Jones (2001: 680–81) on the difference in connotation between proportional design and modular design, the latter defined by the use of a module that is not only a given magnitude (i.e., a mathematical object) but also a real, physical object. It is also in these pages that Wilson Jones proposes the triglyph as the principal module used in the design of fifth-century Doric temples, a claim of central importance for our argument above.

76. Two recent considerations of the musical ratios in the Parthenon's architecture and their significance are Bulckens (PhD diss., 2001) and Kappraff and McClain (2005).

77. Chapter 5, section 1. Goodyear (1912: 200–2) has even discussed minute 9:4 relations with respect to the refinements (see chapter 5, n. 26 below).

78. A number of sources compile lists of the 9:4 ratios in the Parthenon, but those of Berger (1980) and Winter (1980: 409–10) are particularly complete. See also Lloyd (1863: 111–16) for discussion of still further 9:4 ratios among the building's elements.

79. For the sake of clarity, following Pollitt (1972), we will be referring to the entire Parthenon interior, including both eastern and western rooms, as the cella, and to the eastern room alone as the naos. The eastern room of the Parthenon was also known as the *hekatompedon* (100-foot temple), a name that may have been inherited from the Older Parthenon (see Waddell [2002: 17–19 and n31], Winter [1980: 408], and Hill [1912: 555–57]).

80. For the principal measurements of the Parthenon's ground plan, see appendix B.

81. Cf. Winter (1980: 410) on the harmony between interior and exterior proportions of the Parthenon.

82. One could even argue that this musical construction of octave (2:1) plus additional whole tone (9:8) resonates with the Parthenon's 8 × 17 peristyle, not a musical proportion in itself but suggestive of the procedure of "doubling plus one" (i.e., the octave as double, plus the additional "one" of the whole tone). On the increasing canonicity of this "doubling plus one" principle for temple peristyles in the mid-fifth century, see Barletta in Neils, ed. (2005: 74) and Pollitt (1972: 72).

83. Furthermore, broadly speaking and with respect to the alternatives of mood, the shift from a predominantly Doric exterior to a mixed Doric and Ionic interior, given the different associations of the two orders, may be relevant here. The significance of the building's harmonization of Doric and Ionic will be discussed further in chapter 6.

On the association of musical modes with moods, and even with modes of life, see Plato, *Resp.*, 3.398e–399c.

84. See the relevant sections in the introduction to the book and the introduction to this chapter.

85. Cf. Philolaus, fragment 6 (Huffman [1993: 123–24]), perhaps the most crucial fifth-century textual source for the ontological—indeed, philosophical—notion of *harmonia* we are considering here. In this fragment, Philolaus claims that the being of things is made up of both "limiting things" and "unlimited things" (effectively—and especially given the discussion in fragment 6A that follows—number [ratio, *symmetria*] and the irrational, respectively), categories that are unlike, even unrelated, and yet joined together by *harmonia*.

86. Pollitt (1964: 14–23, 256–58).

87. For the philosophical foundations of the idea of the "problem" as we have been defining it throughout this chapter, see Plato, *Resp.*, 6.509d–511e and 7.521d–531d, and the discussion of this in chapter 2, section 2, and chapter 3, section 1, with further elaboration on the definition of "problem" in the sense we are using it here, and in the book as a whole. We will return to this point at the end of chapter 6.

88. Heller-Roazen (2011).

89. It is worth noting, however, that, at least in our reading of his text, Heller-Roazen's interpretation of the magnitude/multitude problem goes somewhat more in an epistemological than an ontological direction (see, for instance Heller-Roazen [2011: 16]), although the difference is only one of emphasis, since (in our view) these two aspects of the problem are very closely related.

90. Cf. Plato, *Philebus*, 64c–66c. See also Pollitt (1964: 16–17).

Note that in this section we will maintain a dialogue with Platonic texts in the notes, with part I's focus on the *Republic* and the *Timaeus* in mind.

91. See chapter 5, section 2, which is focused on the interpretation of these fragments and of the significance of Polykleitos's "kanon" of proportions.

92. On the sculpture of the Parthenon see Brommer (1963), Brommer (1967), and Brommer (1977).

93. On the iconography of the Parthenon's east pediment, including the possible identities of Figures K, L, and M, discussed above, see Harrison (1967).

94. Pollitt (1972: 79–97, esp. 95–97).

95. The concept of *eurhythmia* may also be relevant here: see Pollitt (1964: 169–81), and the discussion of *eurhythmia* in chapter 6, section 2, below.

96. Cf. Plato, *Resp.*, 5.475e–476d.

97. Cf. Plato, *Symposium*, 209e–212a. In Diotima's ladder of love, however, the individual beautiful body is definitively left behind for the sake of a transcendent beauty, while in the Parthenon, as we are interpreting it, the individuality and presentness of the beautiful physical object remain important throughout.

Although one could, following Nussbaum (2001 [1986]: 165–99) and others, note that the presence of Alcibiades as a disturbance to Socrates's speech on behalf of Diotima and her ladder deeply troubles the story being told about leaving the physical, the present, and the individual behind. In that case, the *Symposium* would be offering an account very much like the reading of the Parthenon, and the beauty it embodies, that we adduce here.

Chapter 5

1. See the introduction, section 2, where this topic is the focus of the discussion.
2. Philolaus fragment 6A is cited and translated in Huffman (1993: 145–47).
3. Pollitt (1964: 151–54, esp. 153).
4. Ilievski (1993: 19–21).
5. Ibid., 21–27.
6. See Heller-Roazen (2011), chapters 1–3.
7. That is to say: if a three-dimensional geometric object, such as a building or a sculpture, is understood to be *perfectly* proportional, this means that all its geometric magnitudes (its dimensions and the dimensions of its parts) could be put into numerical ratios with each other—that is, that they could be measured by numbers (what we would call integers), based on a given, shared unit. Magnitudes and multitudes would then fully correspond. The discovery of irrational magnitudes is the recognition that this is not always the case (see chapter 4, section 1).
8. See the discussion of this aspect of the building's reception, with the relevant sources, in chapter 6, section 1 below.
9. Robertson (1964: 106–12) provides a relatively concise but good overview of the corner problem (what he calls Doric's "insoluble problem"), including a discussion of the range of solutions in the various temples of the archaic and

classical periods. See also Gruben (2001: 42–43), Korres in Tournikiotis, ed. (1994: 83–84), Mertens (1984:153–56), and Coulton (1977: 60–64).

10. On the relationship of this formal concern to historical problems of temple construction, see Wilson Jones (2014: 68–75).

11. We will be using the term *adjustments* for these slight modifications throughout this section, to distinguish them from the four categories of "refinements," as first defined by Goodyear (1912) and as they are normatively categorized in scholarship on classical architecture. Note, however, that in character and method, they are essentially identical to the refinements proper, an issue that will be dealt with at some length in chapter 6.

12. See Coulton (1977: 60–62).

13. It is worth emphasizing that the regional difference is not a sharp one, first and foremost because, as has often been noted, there is a continuous, sustained dialogue between the two regions over the entire relevant time period, as is evident in the architecture itself. See Mertens (2006: 283–95, esp. 294–95) on the close connection between the Temple of Poseidon at Paestum and the Temple of Zeus at Olympia, most notably in terms of the approach to the corner problem.

Furthermore, one could point to the temple site of Akragas, where it seems that particularly intensive work was done on the corner problem between the late sixth and late fifth centuries, and where a range of solutions that includes both corner contraction and adjustments to the entablature was tried (contraction in the Temple of Hercules; widening of metopes in the Olympeion; and then a combination of the two in both the Hera Lacinia Temple and the Concord Temple). Cf. Robertson (1964: 111), who lists the Temple of Hercules among a group of three temples that were perhaps the first (with the exception of one uncertain previous case: the Heraeum at Olympia) to employ column contraction.

14. See Dinsmoor (1950: 108): he argues that double corner column contraction, characteristic of the Doric temples of Sicily and South Italy, was conceived at Syracuse, after 480, for the Temple of Athena, and then spread, though not to mainland Greece.

15. Mertens (2006: 266–74, 386–96).

16. For more details regarding these adjustments, for measurements, and for the ratios between the various elements of the façades, see Mertens (2006: 387–90) and Mertens (1984: 98–108). See also the sections on the Poseidon Temple and the Hera Lacinia Temple in Gruben (2001: 274–80, 332–34).

17. See the discussion of the prevalence of the 9:4 and 3:2 ratios in the Temple of Hera Lacinia in chapter 4, section 2.

18. Mertens (2006: 287–91, esp. 291).

19. See the relevant section in chapter 4, section 1.

20. Cf. Mertens (2006: 381–86), who summarizes the situation in the architects' workshops in Akragas as one in which observational science on the one hand and Pythagoreanism on the other played an important role, producing a "mathematical geometry" that led to the emphasis on small number ratios in architecture parallel to those used in musical harmonics. He also points out in this context that there is evidence Empedocles was active in Akragas during the

period of construction of some of these temples. See also chapter 4, section 2, esp. the relevant bibliography in nn. 39 and 42.

21. See Yeroulanou (1998) and Wesenberg (1983) for measurements of all the Parthenon's surviving metopes.

22. For the most thorough discussion of this, see Wesenberg (1983). See also Barletta in Neils, ed. (2005: 75–78) and Korres (1994: 72), and Korres in Tournikiotis (1994: 95n29). On the dating and subject matter of the Parthenon metopes, see Schwab in Neils, ed. (2005: 159–97).

23. Penrose (1888 [1851]: 17–18); Yeroulanou (1998), who argues that it was architectural considerations that determined the variations in metope width in both the Parthenon and the Hephaestion, with the Hephaestion as the more normative Doric building and the Parthenon as the more experimental and innovative (hence its greater irregularity); and Winter (1980: 404), who makes a case against the idea that metopes from the Older Parthenon were reused, based on the lack of consistency in the variations found in the metopes of the Parthenon. On the Hephaestion, see Gruben (2001: 223–29) and Dinsmoor (1950: 179–81).

24. Coulton (1977: 64).

25. See section 2 of the introduction, where this knowledge procedure is the central concern.

26. Hauck (1879: 130–33) and Goodyear (1912: 200–2). Also, according to Goodyear, the minute decenterings of the first three abaci on the south side of the east façade (extremely subtle shifts to the left in the range of 1–5 mm, in each case) are in the ratio of 4:9:13. The presence of the Parthenon's principal numerical ratios in the relations among even these most subtle of refinements is quite suggestive, though with such small quantities this correspondence could also be entirely coincidental.

27. Philolaus, fragments F6 and F6a, in Huffman (1993: 123–45). Cf. Heller-Roazen (2011), chapter 2 and discussion of this fragment in both the introduction, section 2, and chapter 4, section 1 above.

28. The introduction and chapter 4, section 1, both discuss these problems in much more detail, the latter specifically with respect to the construction of the ancient Greek musical scale and its relationship to Pythagorean music theory.

29. Szabó (1978), part 2.

30. See chapter 4, n. 14, above for relevant bibliography on the division of the tetrachord.

31. Cf. Szabó (1978), part 1, on the discovery of irrationality in the mid-fifth century. See, again, chapter 4, section 1, for a fuller discussion of the construction of the Greek musical scale, and the (ontological) issues at stake in terms of the relationship of multitude to magnitude.

Note also that Szabó (1978), in part 2 (as mentioned already in chapter 4, above), also addresses the significance of the relevant terms that emerged from this procedure of scale construction (kanon, monochord, *oroi, diastema* [=*logos*], etc.), terms that then took on more abstract meanings within the framework of mathematics and philosophy.

32. Von Fritz (1945: 256–60).

33. Cf. Yeroulanou (1998: 414–16), on the evidence for modifications to the building's design during the course of construction, based on the variations of metope widths on the west and east façades.

34. On arithmetic versus geometric tuning in the fifth century, see Barbera (1977). For the surviving fragments from Aristoxenus, see Marquard (1868).

35. Wesenberg (1983: 60–62), Korres (1994: 115), and Yeroulanou (1998: 423). Goodyear (1912: 191–92) also presents an argument that the east façade is older than the west, based on changes to the column capitals.

36. Here are the measurements for the metopes of the Parthenon's east façade, as given by Yeroulanou (1998: 413), moving from south to north: 1.251 m, 1.255 m, 1.245 m, 1.287 m, 1.272 m, 1.270 m, 1.330 m, 1.317 m, 1.300 m, 1.318 m, 1.243 m, 1.238 m, 1.237 m, 1.275 m.

37. Here are the measurements for the metopes of the Parthenon's west façade, as given by Yeroulanou (1998: 410), moving from north to south: 1.178 m, 1.212 m, 1.314 m, 1.318 m, 1.305 m, 1.310 m, 1.325 m, 1.312 m, 1.305 m, 1.321 m, ?, 1.294 m, 1.201 m, 1.184 m.

38. On corner column contraction in the Parthenon, see Coulton (1974: 66, 76), Bundgaard (1976: 63–64), and Wesenberg (1982).

39. Mertens (1984: 106). See also Mertens (2006: 389).

40. See Mertens (1984: 101), on the design of the façades in the Temple of Hera Lacinia: "Nicht die Eckjoche sollten kontrahiert, sondern die mittleren in rhythmischer Staffelung weiter geöffnet werden."

41. Mertens (1984: 106).

42. Cf. Robertson (1964: 112): "[the corner problem] was the worm in the Doric bud: but in fifth-century architecture it lay almost concealed, and it need trouble us no further in our contemplation of that glorious blossoming." Why this dismissal is problematic, in terms of our reading, should be clear in light of this chapter and the following one.

43. Cf. Mertens (2006: 385–86): "Das Ende der Bindekraft der geschlossenen rationalen Proprtionen ging zeitlich einher mit der Verbreitung des Bewusstseins von der Existenz irrationaler Zahlen—und damit der Auflösung einer der Grundlagen des Denkens und des Wertsystems der weitverbreiteten pythagoräischen Lehre." What we are arguing in this book, of course (and will be developing further in the following chapter), is that the discovery of irrational magnitudes was an *integral part* of the rational approach to Doric design, and of its Pythagorean connotations—that is, that *symmetria* was bound up with a broader conception of *harmonia*—and *not* that awareness of the irrational invalidated or eroded a commitment to rational, proportional design on the part of fifth-century architects.

44. Philo Mechanicus, *Syntaxis*, iv, I.49, 20, translated in Stewart (1978: 124n19) as follows: "Many, though, have begun the construction of weapons of the same size, have made use of the same system of rules, the same type of wood and the same amounts of iron, and have kept to the same weight; yet of these some have made machines that throw their missiles far and with great force, while those made by others have lagged behind their specifications. When

asked why this happened, the latter have not been able to give an answer. So, it is appropriate to warn the prospective engineer of the saying of Polykleitos the sculptor: beauty, he said, comes about *para mikron* through many numbers. And in the same way, as far as concerns our science, it happens that in many of the items that go to make up the machine a tiny deviation is made each time, resulting in a large cumulative error."

See just below for the different possible meanings of *para mikron*. For the passage in its original Greek, as well as both the Greek original and English translation of the other classical texts that refer to Polykleitos's kanon, see Stewart (1978: 124–26).

45. On the principal proportions of the Doryphoros, see the diagrams in Von Steuben (1973: fig. 10).

46. Stewart (1978). In this article, Stewart summarizes the surviving evidence for Polykleitos's kanon as comprising the monumental evidence (surviving sculpture, but specifically the Doryphoros, see figure 5.7) and the textual evidence, which consists of five fragments from Polkleitos's lost *Kanon* text, preserved in the works of various authors: Philo Mechanicus, Plutarch (two passages), and Galen (two passages), although one of the Plutarch passages is disputed.

For further discussion of the kanon of Polykleitos, see also Pollitt (1995), Beck and Bol, ed. (1993), Beck, Bol, and Bückling, ed. (1990), and Von Steuben (1973).

47. Stewart (1978: 124n19). The full passage from Philo Mechanicus, in Stewart's English translation, is quoted in n. 44 above.

48. Pollitt (1995: 21).

49. Stewart (1978: 126). See also nn. 26–29 on the same page for relevant bibliography on the various interpretations of *para mikron*.

50. Stewart (1978: 126) and Pollitt (1995: 21–22). For Stewart, the first and second options are probably closer to Philo's meaning; for Pollitt, all four are possible readings.

51. Cf. Stewart (1978: 126–27) and his discussion of the term *kairos*, most notably the following points: the *kairos* as something beyond the kanon (beyond measure); the definition of *kairos* as "the right moment"; also, the term's association with the Pythagoreans (p. 127). Stewart argues against the idea that Polykleitos was explicitly a Pythagorean (given that there is no documentation for such an assertion), but suggests that he may have had a Pythagorean source.

52. Philolaus, fragment 6A, in Huffmann (1993: 145–47).

53. On the relationship of Polykleitos's kanon specifically to the architecture of the Parthenon, see Haselberger in Neils, ed. (2005: 105–8).

Pollitt (1995: 22–23), in his article on the Polykleitean canon, discusses the connection of the Pythagorean school in Southern Italy to the developments in architecture at Paestum—specifically in the Temple of Athena, the first Greek temple to exhibit a system of proportion in all or most of its parts (see the relevant sections in chapter 4, section 2 above)—and claims that Pythagorean ideas first reached the visual arts in the context of architecture, and then were passed on to sculpture. For further bibliography on the possible Pythagorean influence on the architecture of the western colonies, see chapter 4, nn. 39 and 42 above.

54. Pollitt (1995: 20), where he not only mentions the lost treatise on the Parthenon (by Iktinos and Karpion) cited in Vitruvius, but continues: "Vitruvius uses the word *symmetriae* to describe the content of the treatises by Philon, by Arkesios, and by a certain Silenos, date uncertain, who wrote a book about the Doric order."

55. Hahn (2010).

56. Vitruvius, *De architectura*, VII, Praef., 12. For our view concerning the verification that the existence of this treatise can or cannot reasonably expect, and why this ultimately is not telling for or against our reading of the Parthenon, see the closing discussion of section 1 of the introduction above.

57. Mertens (2006: 410–11). He further points out that the perfectly regular entablature of the Temple at Segesta, deriving from the rationality of its design, effectively produces a complete detachment of the peristyle from the entablature, the frieze becoming something more like an ornamental band. See also Mertens (1984: 106), and the discussion of this in section 1 above, on a precedent for this in the Temple of Hera Lacinia. Mertens stresses, in the case of the Temple at Segesta, the way interest in the corner problem wanes as standardization sets in, via the proliferation of something like an "international Doric" style. Cf. Junecke (1982: 65–66) and his discussion of Vitruvius's interpretation of Doric design principles, in relation to intervening Hellenistic "mechanization."

58. Mertens (2006: 385–86). See n. 43 above, for the passage in question.

59. Haselberger, in Neils, ed. (2005: 108–11, 133–42), and also Haselberger in Haselberger, ed. (1999: 60–67).

60. See, in particular, Schneider Berrenberg (1988), his argument for a foot unit of 0.328 m in the Parthenon, and his discussion of the musically significant numbers in its design based on the use of that foot unit. On the importance of numbers or geometric figures with particular Pythagorean significance in Sicilian temples, see Nabers and Wiltshire (1980) on Pythagorean triangles in the Athena Temple at Paestum, and Bell (1980: esp. 368–72) on the use of significant Pythagorean numbers in the Olympeion at Akragas, especially the 1,000-foot perimeter of the stylobate and the 13:27 dimensions of the stylobate (deriving Pythagorean numbers as follows: $13 = 256 - 243$, $27 = 243 - 216$).

Regarding the Doric foot: Wesenberg (1995) addresses the question of foot and dactyl measurements with technical precision, and Dinsmoor (1950: 161n1) also discusses this issue. However, in our reading, the problem with a too-thorough emphasis on the specific measurement of the foot unit in relation to interpretive questions lies in the fact that it emphasizes something more like a "fixed" canon (in this case, a canon of numbers with special significance for the Pythagoreans) rather than the ongoing working-out of a problem.

Chapter 6

1. The volume on the refinement of curvature, the proceedings of a 1993 conference, edited by Haselberger, ed. (1999), is the most important recent source for discussion of the topic.

In Haselberger's contribution to that volume, he defines a refinement as follows: (1) it is a small addition or subtraction to a magnitude; (2) that magnitude is understood as already defined before the refinement is applied. Haselberger's article also provides a list of twenty-three ancient Greek buildings where systematic curvature is well established. Haselberger in Neils, ed. (2005: 101–57), his more recent discussion of refinements, focuses on the Parthenon and updates and amends a number of the points from his earlier article.

2. One of the most recent significant discussions of the refinement of curvature is Wilson Jones (2009). For more on the refinements in the Parthenon, especially curvature, see Rocco (2003), Zambas (2002), Hellmann (2002: 185–91), Gruben (2001: 186–88), Höcker (2000), Korres, Panetsos, and Seki, eds. (1996), Wycherley (1978), Coulton (1977), Orlandos (1976–78), Dinsmoor (1950: 164–69), Goodyear (1912), Hauck (1879: 91–147), and Penrose (1888 [1851]: 22–44, 103–9). It was Goodyear who first coined the modern term "refinements" itself. See also Koch (1963) on the Parthenon stylobate's curvature, Marvikios (1965) on aesthetic questions relating to the Parthenon's curvature, and Heyman (2010) for a recent interpretation of technical problems relating to curvature.

3. Haselberger in Neils, ed. (2005: 119, 122, 124) and Haselberger in Haselberger, ed. (1999: 16, 32). In both texts, these observations are part of a broader discussion of the four categories of refinements (Haselberger in Neils, ed. [2005: 117–27] and Haselberger in Haselberger, ed. [1999: 3–36]).

4. See Haselberger in Haselberger, ed. (1999: 66), specifically on the significance of the coordination of the two refinements relating to curvature (curvature of the building as a whole and *entasis* of the columns) at the Aphaia Temple in Aegina.

5. For a good general discussion of the Temple of Aphaia at Aegina, see Gruben (2001: 121–27) and Dinsmoor (1950: 105–7).

6. See Korres in Haselberger, ed. (1999: 79–104), on "refinements of refinements"; see also Korres in Tournikiotis, ed. (1994: 65–66), on the case for precision of measurement in analyzing the Parthenon.

Note that the question regarding how subtle a deviation from perfect measure can be counted as a refinement, as opposed to an error in measurement, is a crucial issue for interpreting the refinements of the Parthenon (especially what Korres has dubbed "refinements of refinements"), since different scholars admit different degrees of subtlety as actual refinements.

7. The most relevant passages from Vitruvius, *De architectura*, are: III.3.13 (Granger, trans., Loeb ed., vol. 1 [1931: 178–81]), on the *entasis* of columns; IV.3–4 (Granger, trans., Loeb ed., vol. 1 [1931: 218–31]), on the design and construction of Doric temples, specifically in relation to proportion; and VI.2–3 (Granger, trans., Loeb ed., vol. 2 [1934: 20–33]), on optical effects, and the necessary adjustments to architectural proportions, in relation to the building's physical site.

The opening paragraph of the passage on optical effects cited above is particularly important for our discussion; here is Granger's translation (1934: 23): "The architect's greatest care must be that his buildings should have their design determined by the proportions of a fixed unit. When therefore account has been

taken of the symmetries of the design and the dimensions have been worked out by calculation, it is then the business of his skill to have regard to the nature of the site, either for use or beauty, to produce a proper balance by adjustment, adding or subtracting from the symmetry of the design, so that it may seem to be rightly planned and the elevation may lack nothing."

8. Vitruvius, *De architectura* III.4.5 (Granger, tr., Loeb ed., vol. 1 [1931: 184–85]). For a discussion of the possible significance of the *scamillos inpares*, see various entries in Haselberger, ed. (1999), but especially the relevant section in Haselberger's contribution (Haselberger, ed. [1999: 36–56]), and also Heyman (2010).

Haselberger also discusses other ancient theorists who refer to refinements, directly or indirectly, including a passage on *skenographia*, attributed to "Damianos," that also mentions *alexemata* (counter-devices, i.e., refinements) and discusses the difference between the appearance of harmony (what he claims architecture should strive for) and actual harmony, and Philo Mechanicus (referred to here as Philon of Byzantion), who discusses additions and subtractions as a generally accepted practice in architecture, in the same text that includes the reference to Polykleitos's kanon discussed in chapter 5, section 2 (see esp. chapter 5, n. 44). For these and further references, see Haselberger, ed. (1999: 56–67, esp. 58–60 and nn. 219 [for Damianos] and 222–23 [for Philon]). Haselberger further argues (pp. 59–60) that what is new by Philon's time (the third century) is the idea that there are theoretical (presumably textual) justifications for these refinements, refinements that had long been part of architectural practice already.

9. On the refinements as optical: Pollitt (1972: 74–78), though Pollitt discusses a range of interpretations that include ontological as well as optical considerations, Dinsmoor (1950: 164–69), Panofsky (1997 [1927]: 34–35 and n12 [pp. 87–92]), Hauck (1879: 91–147), and, of course, Vitruvius (*De architectura*, III.4.5 and VI.2–3), as well as the various writers influenced by his famous interpretation of the curvature of Greek buildings as an optical correction. On refinements in relation both to perspective and to psychology (also with respect to optical effects): Michelis (1955).

The alternative to this view, emphasizing what we have been calling the ontological reading, can be found in: Haselberger in Neils, ed. (2005: 101–57), Haselberger in Haselberger, ed. (1999: 1–68), Gruben (2001: 186–88), Goodyear (1912: 83–103), and Hoffer (1838). Penrose (1888 [1851]: 103–9) discusses the refinements in both optical and ontological/aesthetic terms, suggesting possible optical origins for the refinements, though also arguing that they ultimately served ends of beauty, perfection, and harmony.

10. Coulton (1977: 68–73). Specifically, he traces the origins of the grid-oriented approach to architectural design back to fourth-century Ionia.

See also Wilson Jones (2001), on the importance of modular design in the fifth century, and on the relationship of modular design to proportional design.

11. Junecke (1982: 60–69).

12. Cf. Coulton (1977: 68).

13. Haselberger, in Neils, ed. (2005: 108–11, 133–42) and Haselberger in Haselberger, ed. (1999: 60–67). Haselberger connects the changing conception of

the refinements (more connected to appearances, defined in opposition to reality) to Plato's and to Aristotle's concern with artistic deceptiveness ([2005: 114–15] and [1999: 60–1]), and also to architects' increasing reservations about Doric form altogether, including a loss of interest in the corner problem. Cf. Mertens (2006: 410–16) and his analysis of the Temple at Segesta, with respect to the standardization of design in Doric temples from the later fifth century onward. For more on Haselberger's reading, see the discussion of the Parthenon's refinements in relation to those of the Propylaea below.

14. Cf. Riegl (2000 [1901]), on the "late Roman art industry" and the dialectic between objective and subjective aesthetic principles (manifest, among other things, in a related dialectic between the haptic and the optical)—and more specifically, on the ever-increasing importance of the subjective pole—as the principal force driving the historical development of classical Greco-Roman art.

15. See Korres in Haselberger, ed. (1999: 83–85) on the discovery of curvature and the effect it had on the interpretation of the Parthenon.

16. See Hoffer (1838), for instance the passage on p. 370 that describes the beauty and organic quality of curved lines, and their connection to nature (cited in Goodyear [1912: 83]). On other scholars following in this tradition, as well as Goodyear's own similar views, see Goodyear (1912: 81–103). Goodyear also devotes an entire chapter to the refutation of the post-Vitruvian view that the refinements are corrections for an optical illusion (Goodyear [1912: 33–80]).

Cf. also the following passage from Valéry's *Eupalinos* (1967 [1923]: 62): "Pareil à ces orateurs et à ces poètes auxquels tu pensais tout à l'heure, il [the architect] connaissait, ô Socrate, la vertu mystérieuse des imperceptibles modulations. Nul ne s'apercevait, devant une masse délicatement allégée, et d'apparence si simple, d'être conduit à une sorte de bonheur par des courbures insensibles, par des inflexions infimes et toutes-puissantes; et par ces profondes combinaisons du régulier et de l'irrégulier qu'il avait introduites et cachées, et rendues aussi impérieuses qu'elle était indéfinissables."

17. See Gruben (2001: 187–88) on the curvature as an expression of the life of the temple, and Haselberger in Neils, ed. (2005: 105): "[the Parthenon] as a whole had to be shaped and sculpted so that its inner coherence became a tangible reality," leading him to argue that neither technical nor optical reasons could ever fully explain the refinements, but rather that they reflect the desire for an animated perfection in the whole. Cf. also Pollitt (1972: 74–78).

18. Haselberger in Neils, ed. (2005: 108–11, 133–42). It is the latter approach, the one that, according to Haselberger, makes its appearance as early as the design of the Propylaea, that is inherited from the fourth century by later building practice, right down to Vitruvius.

19. Cf. Winter (1980: 409), who makes the point that many of the 9:4 and related ratios are actually invisible in the finished temple. See also chapter 4, section 3.

Note also that a similar emphasis on formal perfection beyond the visible is evident in the fact that the sculptures of the pediments were carved in the round even though the rear sides would never be seen once they were placed on the building.

20. See chapter 5, n. 57, above.

21. Duddy (2008). See also Thompson, Papadopoulou, and Vassiliou (2007), an attempt to refute Vitruvius based on neuroscientific and psychological research; the authors' aesthetic interpretation, however, diverges substantially from our own.

22. Cf. Hauck (1879: 91–147). Note that Hauck is also probably the principal inspiration for Panofsky's interpretation of the Parthenon's refinements in *Perspective as Symbolic Form* (1997 [1927]: 34–35 and n. 12 [pp. 87–92]).

23. See Wittkower (1953). It is interesting to note, and quite telling with respect to the difference between optically oriented Renaissance architecture and fifth-century Doric, that Alberti, when treating Doric architecture in *De re aedificatoria*, entirely omits the refinements from his discussion (this omission of Alberti's was discussed by Jeffrey Hoover in a paper presented at the conference "Pythagorean Harmonics from Philolaus to Leibniz" at Bard College Berlin in October 2013).

24. Haselberger in Neils, ed. (2005: 105) and Pollitt (1972: 74–78).

25. Cf. the diagram in Korres in Tournikiotis, ed. (1994: fig. 13).

26. Büsing (1988). Compare his reading with that of Bundgaard (1976: 63–64), who argues that the excessive contractions are based on changes to the design along the way, starting from the intercolumniations inherited from the Older Parthenon.

27. On the building's *symmetria* in terms of this ideal triglyph module, see Berger (1980: 75–79).

28. See the relevant section in chapter 4, section 3.

29. See chapter 4, n. 60 above.

30. See Waddell (2002), whose reconstruction of Doric design methods suggests that first the krepis and stylobate dimensions were determined in this fashion, and from there the dimensions of the module (the triglyph) were derived, and Wilson Jones (2001), who proposes a somewhat different, but related, procedure for the determination of the proportions in Doric temples, emphasizing a modular design that begins not with the overall krepis dimensions but with the physical module, i.e., the triglyph. For his more recent work on mathematical problems relating to Doric design, see Wilson Jones (2006).

See also Coulton (1974), on the genealogy of these methods, specifically on three alternative constructive methods prevalent in Doric architecture, their variations, and their combinations.

Note also that the intercolumniation "module" used in the Parthenon, like the triglyph module, is based on a 9:4 ratio to the existing physical "module," the Older Parthenon column drums. See chapter 4, section 3, for a fuller discussion of this.

31. Cf. Mertens (2006: 389) and Mertens (1984: 107–8). Mertens points out that in the Temple of Hera Lacinia the 3:2 metope : triglyph ratio and the 5:1 intercolumniation : triglyph ratio had now become standard (along with a number of other small number ratios on the façades), a bringing together in the Parthenon's immediate predecessor of the two ratios that the Parthenon's designers tasked themselves with harmonizing.

32. Cf. Coulton (1974: 76) and his argument about a further mediation in the Parthenon, between the Sicilian approach and the mainland approach to the design of the stylobate, with respect to the competing methods mentioned in chapter 4, n. 63 above.

33. Cf. Waddell (2002: 21), who, in discussing the layout of intercolumniations as a fusion of the 8 × 17 peristyle with the 9:4 stylobate dimensions, refers to the Parthenon's "unparalleled harmony," emphasized even at the cost of visual unity, since the excessive column contraction makes the corners stand out as noticeably different. This is true, but the difference of the corners from the rest of the peristyle, we would argue, in fact reinforces the unity of the building, since the strong corners help define the Parthenon as a three-dimensional object.

34. On the importance of harmony—or at least *symmetria* as harmony (to differentiate the general concept from *harmonia* more precisely, as we are defining it)—in Doric architecture, see Mertens (2006), Waddell (2002: 14–15, 20–22), and Wilson Jones (2001: 698–99). See also Mertens (1984: 158): "Es müssen demnach alle Einzelverhältnisse am ganzen Bau als Ganzes zusammengesehen werden, wobei jede einzelne Dimensionierungsentscheidung alle anderen mit beeinflusst. Dabei zu immer harmonischerem Ausgleich aller widerstrebenden Tendenzen und einer lebendigen, spannungsvollen Geschlossenheit ze gelangen, ist das zentrale Anliegen der klassischen Zeit."

Also, with respect to the Parthenon in particular: Gruben (2001: 185–86) claims that, considering the continuous proportion of 9:4 in its architecture, "ist hier doch erstmals ein Bauwerk synthetisch in allen seinen Seiten durch *eine* Proportion erfasst, ist durch mathematische Bindungen auf einen harmonischen Akkord gestimmt." See also Winter (1980: 410), who likewise stresses the harmonic unity of the entire building, inside and out, arguing that Iktinos may have increased the intercolumniations slightly, once the stylobate had been determined, with the aim of "bringing the proportions of the interior structure into harmony with the exterior."

35. Pollitt (1964: 153).

36. Ibid., 175, 177. Cf. also the discussion of the Parthenon's sculpture in chapter 4, section 4.

37. For bibliography on the harmony between Doric and Ionic in the Parthenon, see chapter 4, n. 29 above.

38. It is worth noting a similar argument about *symmetria* functioning at the "meta-level" in Mertens (2006: 399), regarding the temples at Akragas: four of these temples include identical dimensions—two with the same width, and two with the same length—and the Dioscuri Temple is exactly 1/6 smaller than three of them, with the Athena Temple as a proportional mean between them. The main idea of these observations is that the temples were planned to be commensurable with each other.

39. Cf. Hahn (2010), on the relationship of Greek architecture, and the visual arts more broadly, to the development of Greek philosophy.

40. On refinements of refinements, see Korres in Haselberger, ed. (1999: 79–104), and also Haselberger in Neils, ed. (2005: 127–33, 142–46). Wycherley (1978) apparently coined the phrase "refinements of refinements."

41. See the discussion of *Republic* 7 in chapter 3.
42. See nn. 16 and 17 above.
43. Penrose (1888 [1851]: 103–9).
44. See Pollitt (1972: 75–76). See also Goodyear (1912) for ancient sources on the various theories regarding the Parthenon's curvature, including the "exaggeration" theory.
45. Pollitt (1972: 78).
46. See our discussion of this in chapter 3, section 1.
47. On the labor-intensive character of this process, see Korres in Tournikiotis, ed. (1994: 65–66), and also Pollitt (1972: 75).
48. Cf. Haselberger in Haselberger, ed. (1999: 66), on the coordination of the different refinements in the Temple of Aphaia at Aegina (a precedent for the temples that follow in the fifth century), and also Haselberger in Neils, ed. (2005: 130–33), arguing that the proportions of the refinements in the *entasis* and in the curvature of the temple are analogous in the Parthenon; that is, they are coordinated in a way indicative of an overriding concern with harmony.
49. Haselberger in Neils, ed. (2005: 129–30).
50. See our reading of this aspect of the divided line in chapter 3, section 1, especially in the discussion of the sensible and the intelligible.
51. See all of part I, but especially chapter 1, section 1, and chapter 3, section 2.
52. Cf. esp. *Resp.* 7.530c–532b.
53. Cf. Steinberg (1981: 46n4).
54. As we have tried to show in the introduction. Especially relevant to the most profound philosophical issues raised by the Parthenon's harmonics is Philolaus, fragment 6 (Huffman [1993: 123–24]), with its discussion of the "limiting things" and the "unlimited things" as fundamentally different categories of being that are joined by *harmonia*.
55. Vitruvius, *De architectura*, VII, Praef., 12. See the closing discussion of section 1 of the introduction, above, for our view on the report of such a treatise and its relevance for our argument here.
56. See chapter 4, n. 26 above.
57. Cf. in particular Hahn (2010).

Cf. also Wilson Jones (2014) and his discussion of the classical temples as gifts to the gods. This form of relationship to the divine seems particularly relevant to the Parthenon's apparent intensive concern with questions of an ontological and even metaphysical nature, its emphatic form of striving after truth and after a perfection acknowledged as not entirely attainable—in short, its striving, in every aspect of the building (and not only its iconography), toward divine things and the divine realm.

58. For a provocative and well-supported recent reinterpretation of the Ionic frieze's subject, see Connelly (2014). She argues that the subject in the center of the frieze's east side, over the main entrance, is not in fact the handing

over of the peplos for the cult image of Athena in the Erechtheion, as scholarly consensus has generally interpreted it, but in fact represents the three daughters of Erechtheus and Praxithea, with their parents, preparing to be sacrificed, a story that was the subject of a lost play by Euripides. For Connelly, this story and its depiction on the Parthenon's Ionic frieze were crucial in the Athenians' self-definition of their democracy as a community, bound together by individual sacrifice for the good of the whole—an idea relevant to the emphasis on (civic) harmony in the subject matter and aesthetic character of the frieze as a whole that we discuss above.

Other publications on the iconography of the Panathenaic frieze's sculptural program include Neils in Neils, ed. (2005: 199–223), Brommer (1977), and Fehl (1961).

59. To give a few prominent examples: 18 elders on the south frieze balance 16 elders on the north frieze (9:8), 16 maidens on the south side of the east frieze balance 12 maidens on its north side (4:3), and 6 founders (of the city of Athens) to the south of the east frieze's central scene balance 4 founders to its north (3:2)—in each case invoking a musical ratio. The central scene on the east frieze also divides into two relatively self-contained groups, one of 3 figures and the other of 2 (thus also invoking a musical ratio in their juxtaposition).

Certainly, these correspondences could be coincidental, but given the importance of musical harmonics in the Parthenon's architecture, such arrangements in the sculptural groupings at least deserve careful consideration, as does, perhaps even more so (although it is outside the scope of this book), the role of Polykleitian (or in this case Pheidian) *symmetria* and *harmonia* in the proportioning of the individual sculpted figures themselves (cf. the discussion in chapter 4, section 4).

Afterword

1. See Panofsky (1997 [1927]), section III, and also White (1987).

2. Cf. Arasse (1999), chapter 1, esp. pp. 27–39.

3. In the case of the mathematics of the fifth century in Athens, that later rigorous theorization was of course Euclid's *Elements*, as discussed in the introduction; in the case of Renaissance perspective, it would be Desargues's projective geometry and, by extension, the mathematics and philosophy of Descartes.

4. See Peterson (2011), who has recently argued that the approach to mathematics taken by painters, poets, and musicians of the late Middle Ages and the Renaissance was far more innovative than that of the professional mathematicians of their time. See also Drake (1970).

5. Heller-Roazen (2011), chapter 5.

6. Two of the most important works published on the history and theory of perspective could be said to exemplify the alternative emphases on space and on vision, respectively: in Panofsky (1997 [1927]) the discussion focuses primarily

on the representation of *rational space* (though point of view has greater priority in the last section of the essay), while Belting (2011) focuses on perspective as a representation of the *gaze*.

7. Alberti, *Della pittura* (1435, 1436), I, 12, 19–20 (Spencer, tr. [1966: 51–2, 56–8]) and II, 33–5 (Spencer, tr. [1966: 70–2]).

Masaccio's *Florentine Nativity Scene*, a *desco da parto* (birth tray) in Berlin (tempera on wood panel, 1427–28) and Piero della Francesca's *Annunciation* from the Polyptych of Saint Anthony (oil and tempera on wood panel, ca. 1470) are two early Renaissance pictures, among many, where the perspective construction and the geometry of the architecture are oriented around subtly but deliberately different centers, making the dependence of perspectival geometry on the gaze itself, rather than on the structure of the architecture, evident in ways that, in themselves, constitute a commentary on the problem at hand.

8. See chapter 4, section 2. See also Coulton (1977: 68–73).

9. Furthermore, in *Perspective as Symbolic Form*, Panofsky (not without ongoing controversy) draws the philosophical implications of this: that perspective depicts the relationship of the viewing eye to a homogeneous and infinite space, which objects merely inhabit, and *not* its relationship to the objects themselves. See Panofsky (1997 [1927]: 28–31, 63–66).

An alternative view, arguing, first, that there were multiple perspective constructions in the Renaissance rather than a single one, and second, and more significantly still, that perspective served primarily for the depiction of objects rather than of space itself, has been presented with particular thoughtfulness and eloquence by Elkins (1994).

10. See Heller-Roazen (2011), chapters 1 and 5.

11. Proclus (1992: 29–30) writes: "The Pythagoreans considered all mathematical science to be divided into four parts: one half they marked off as concerned with quantity, the other half with magnitude; and each of these they posited as twofold. A quantity can be considered in regard to its character by itself or in its relation to another quantity, magnitudes as either stationary or in motion. Arithmetic, then, studies quantities as such, music the relations between quantities, geometry magnitude at rest, spherics [astronomy] magnitude inherently moving."

12. Cf. Alberti's discussion of the painter's education in *Della pittura*, III, 51–5 (Spencer, tr. [1966: 89–92]). On the Renaissance inclusion of painting among the liberal arts, see Rosand (2000).

13. Cf. Koyré (1958: 16–19).

14. Cf. Brachert (1971), whose discussion of the musical harmonies built into the structure of Leonardo's *Last Supper*—specifically, in the depicted architecture and its relationship to the division of the picture's surface—addresses this coexistence of the theological (Christian metaphysics) and the perspectival (the mathematics of centerless, unbounded space) in a different, related way, and one deeply relevant to the subject matter of this book, given Brachert's focus on musical harmonics and its meaning.

15. Cf. Panofsky (1962 [1953]).

Works Cited

Acerbi, F. 2010a. "Homeomeric Lines in Greek Mathematics." *Science in Context* 23: 1–37 (doi: 10.1017/S0269889709990226).
———. 2010b. "Two Approaches to Foundations in Greek Mathematics: Apollonius and Geminus." *Science in Context* 23: 151–86 (doi:10.1017/S0269889710000037).
Adam, J. 1902. *Plato: Republic.* Cambridge: Cambridge University Press.
Alberti, L. B. 1966 [1435, 1436]. *On Painting.* Translated by J. R. Spencer. New Haven: Yale University Press.
Annas, J. 1997. "Understanding and the Good: Sun, Line and Cave." In Kraut, 1997, pp. 143–68.
Anton, J. P., ed. 1980. *Science and the Sciences in Plato.* Albany, NY: SUNY Press.
Arasse, D. 1999. *L'annonciation italienne: une histoire de perspective.* Paris: Hazan.
Barbera, A. 1981. "Republic 530C–531C: Another Look at Plato and the Pythagoreans." *The American Journal of Philology* 102, no. 4: 395–410.
———. 1984, 1989. *Greek Musical Writings.* 2 vols. Cambridge, UK: Cambridge University Press.
———. 1991. *The Euclidian Division of the Canon: Greek and Latin Sources.* Lincoln: University of Nebraska Press.
———. 2007. *The Science of Harmonics in Classical Greece.* Cambridge, UK: Cambridge University Press.
Baxandall, M. 1980. *The Limewood Sculptors of Renaissance Germany.* New Haven, CT: Yale University Press.
———. 1988 [1972]. *Painting and Experience in Fifteenth Century Italy: A Primer in the Social History of Pictorial Style.* Oxford, UK: Oxford University Press.
Beck, H., P. C. Bol, and M. Bückling, eds. 1990. *Polyklet: Der Bildhauer der griechischen Klassik.* Mainz am Rhein, Germany: Verlag Philipp von Zabern.
Beck, H., and P. C. Bol, ed. 1993. *Polykletforschungen.* Berlin: Gebr. Mann Verlag.
Bell, M. 1980. "Stylobate and Roof in the Olympeion at Akragas." *American Journal of Archeology* 84: 359–72.
Belting, H. 2011 [2008]. Translated by Deborah Lucas Schneider. *Florence and Baghdad: Renaissance Art and Arab Science.* Cambridge, MA: Harvard University Press.

Benardete, S. 1989. *Socrates' Second Sailing: On Plato's* Republic. Chicago: University of Chicago Press.
———. 1993. *The Tragedy and Comedy of Life: Plato's* Philebus. Chicago: University of Chicago Press.
Benson, H. H. 2011. "Dialectic in the *Republic*: The Divided Line 510b–511d." In *Plato's Republic: A Critical Guide*, edited by Mark McPherran. Cambridge, UK: Cambridge University Press.
———. 2011. "The Problem Is Not Mathematics, but Mathematicians: Plato and the Mathematicians Again," *Philosophia Mathematica*; doi: 10.1093/philmat/nkq029.
Berger, E. 1980. "Das Basler Parthenon-Modell. Bemerkungen zur Architektur des Tempels." *Antike Kunst* 23: 66–100.
———, ed. 1984. *Parthenon-Kongress Basel. Referate und Berichte 4. bis 8. April 1982.* 2 vols. Mainz, Germany: Philipp von Zabern.
Berggren, J. L. 1984. "History of Greek Mathematics: A Survey of Recent Research." *Historia Mathematica* 11: 394–410.
Bodnar, I. 2007. "Oenopides of Chius: A Survey of the Modern Literature with a Collection of the Ancient Testimonia." Berlin: Max Planck Institute Preprint Series, No. 327.
Böhme, G. 1976. "Platons Theorie der exakten Wissenschaften." *Antike und Abendland* 22: 40–53.
Bonazzi, M., C. Lévy, and C. Steel, eds. 2007. *A Platonic Pythagoras: Platonism and Pythagoreanism in the Imperial Age.* Turnhout, Belgium: Brepols.
Bowen, A. C. 1984. "Review of Szabó, *Origins of Greek Mathematics*." *Historia Mathematica* 11: 335–45.
Brachert, T. 1971. "A Musical Canon of Proportions in Leonardo da Vinci's *Last Supper*." *Art Bulletin* 53, no. 4: 461–66.
Brack-Bernsen, L. 1999. "Goal-Year Tablets: Lunar Data and Predictions." In Swerdlow, ed., pp. 149–77.
———. 2014. "The Lunar Four in Connection with Concepts and Methods in Early Babylonian Astronomy" (ms. on file with author).
Brann, E. 2004. *The Music of the Republic: Essays on Socrates' Conversations and Plato's Writings.* Philadelphia: Paul Dry Books.
Britton, J. P. 2002. "Treatments of Annual Phenomena in Cuneiform Sources." In Steele and Imhausen, eds., pp. 21–78.
Broadie, S. 2011. *Nature and Divinity in Plato's* Timaeus. Cambridge, UK: Cambridge University Press.
Brommer, F. 1963. *Die Skulpturen der Parthenon-Giebel.* 2 vols. Mainz, Germany: Philipp von Zabern.
———. 1967. *Die Metopen des Parthenon.* 2 vols. Mainz, Germany: Philipp von Zabern.
———. 1977. *Das Parthenonfries.* 2 vols. Mainz, Germany: Philipp von Zabern.
Bruchmüller, U., ed. 2012. *Platons Hermeneutik und Pinzipiendenken im Licht der Dialoge und der Antike Tradition.* Hildesheim, Germany: Olms Verlag.

Brumbaugh, R. 1954. *Plato's Mathematical Imagination*. Bloomington: Indiana University Press.
Bruno, V. J., ed. 1974. *The Parthenon*. Norton Critical Studies in Art History. New York: W. W. Norton and Co.
Bulckens, A. 2001. "The Parthenon's Main Design Proportion and its Meaning." PhD diss., Deakin School of Architecture, Geelong, Australia.
Bulmer-Thomas, I. 1983. "Plato's Theory of Numbers." *Classical Quarterly* 33: 375–84.
———. 1984. "Plato's Astronomy." *Classical Quarterly* 34: 107–12.
Bundgaard, J. A. 1976. *The Parthenon and the Mycenaean City on the Heights*. Copenhagen: The National Museum of Denmark.
Büsing, H. 1988. "Einheitjoch und Triglyphon am Parthenon." In M. Schmidt, ed., *Kanon, Festschrift Ernst Berger*, edited by M. Schmidt. Basel, Switzerland: Vereinigung der Freunde Antiker Kunst, pp. 2–3.
Burnyeat, M. 1987. "Platonism and Mathematics." In Graeser, ed., pp. 213–40.
———. 2001. "Plato on Why Mathematics Is Good for the Soul." In *Proceedings of the British Academy* 103, pp. 1–81.
Carpenter, R. 1970. *The Architects of the Parthenon*. Harmondsworth, UK: Penguin.
Cherniss, H. 1951. "Plato as Mathematician," *Review of Metaphysics* 4, no. 1: 395–425.
Christianidis, J., ed. 2004. *Classics in the History of Greek Mathematics*. Dordrecht, the Netherlands: Kluwer Academic Publishers.
Clay, D. 2000. *Platonic Questions: Dialogues with the Silent Philosopher*. College Park: Pennsylvania State University Press.
Collobert, C., et al., eds. 2012. *Plato and Myth: Studies on the Use and Status of Platonic Myths* (Mnemosyne Supplements, 337). Leiden, the Netherlands: Brill.
Connelly, J. B. 2014. *The Parthenon Enigma*. New York: Alfred A. Knopf.
Cornelli, D., R. McKirahan, and C. Macris, eds. 2013. *On Pythagoreanism*. Berlin: DeGruyter. Cornelli, G. 2013. *In Search of Pythagoreanism*. Berlin: DeGruyter.
Cornford, F. M. 1939. *Plato and Parmenides: Parmenides' "Way of Truth" and Plato's Parmenides*. London: Kegan Paul.
———, trans. 1945 [1941]. *The Republic of Plato*. London: Oxford University Press.
———. 1966 [1937]. *Plato's Cosmology*. London: Routledge Kegan & Paul.
Coulton, J. J. 1974. "Towards Understanding Doric Design: The Stylobate and the Intercolumniations." *Annual of the British School in Athens* 69: 61–86.
———. 1977. *Ancient Greek Architects at Work: Problems of Structure and Design*. Ithaca, NY: Cornell University Press.
Cuomo, S. 2001. *Ancient Mathematics*. London: Routledge.
De Vogel, C. J. 1966. *Pythagoras and Early Pythagoreanism. An Interpretation of Neglected Evidence on the Philosopher Pythagoras*. Assen, the Netherlands: Van Gorcum.
Denyer, N. 2007. "Sun and Line: The Role of the Good." In G. R. F. Ferrari, ed., 284–309.
Derrida, J. 1995. *On the Name*. Edited by T. Dutoit. Translated by D. Wood, J. Leavey, Jr., and I. McLeod. Palo Alto, CA: Stanford University Press.
Detlefsen, M. 2005. "Formalism." In Shapiro, ed., pp. 236–317.

de Vogel, C. 1966. *Pythagoras and Early Pythagoreanism*. Assen, the Netherlands: Van Gorcum.

———. 1986. *Rethinking Plato and Platonism*. Leiden, the Netherlands: Brill.

Dillon, J. M. 2003. *The Heirs of Plato: A Study of the Old Academy (347–274 BC)*. Oxford, UK: Oxford University Press.

Dinsmoor, W. B. 1950 [1902]. *The Architecture of Ancient Greece: An Account of Its Historic Development*. 3rd ed. New York: W. W. Norton.

Drake, S. 1970. "Renaissance Music and Experimental Science." *Journal of the History of Ideas* 31, no. 4: 483–500.

Duddy, M. 2008. "Roaming Point Perspective: A Dynamic Interpretation of the Visual Refinements of the Greek Doric Temple." *Nexus Network Journal* 10, no. 2: 291–306.

Elkins, J. 1994. *The Poetics of Perspective*. Ithaca, NY: Cornell University Press.

Euclid. 1956. *The Thirteen Books of the Elements*. 2nd ed. Translated by Sir Thomas Heath. 3 vols. Cambridge: Dover reprint, by arrangement with Cambridge University Press.

Evans, J. 1998. *The History and Practice of Ancient Astronomy*. Oxford, UK: Oxford University Press.

Fehl, P. 1961. "The Rocks on the Parthenon Frieze." *Journal of the Warburg and Courtauld Institutes* 24: 1–44.

Ferrari, G. R. F., ed. 2000. *Plato: Republic*. Translated by T. Griffith. Cambridge, UK: Cambridge University Press.

———. 2005 [2003]. *City and Soul in Plato's Republic*. Chicago: University of Chicago Press.

———, ed. 2007. *The Cambridge Companion to Plato's* Republic. Cambridge, UK: Cambridge University Press.

Flannery, D. 2005. *The Square Root of Two*. Berlin: Springer-Verlag.

Follesdal, D., and J. Woods, eds. 2008. *Logos and Language: Essays in Honour of Julius Moravcsik*. London: College Publications.

Fowler, D. 1999. *The Mathematics of Plato's Academy*. Oxford, UK: Oxford University Press.

Frank, E. 1923. *Platon und die sogenannten Pythagoreer*. Halle, Germany: Max Niemeyer.

Franklin, J. C. 2002. "Diatonic Music in Greece: A Reassessment of Its Antiquity." *Mnemosyne* 56, no. 1: 669–702.

Frede, M. 1992. "Plato's Arguments and the Dialogue Form." In Klagge and Smith, eds., pp. 201–19.

Friburg, J. 2007. *Amazing Traces of a Babylonian Origin in Greek Mathematics*. Singapore: World Academic Publishing.

Fussi, A. 2013. "Literary Form and Philosophical Discourse: The Problem of Myth in the Platonic Dialogues." *The International Journal of the Platonic Tradition* 7: 221–28.

Fuyarchuk, A. 2010. *Gadamer's Path to Plato: A Response to Heidegger and a Rejoinder by Stanley Rosen*. Eugene, OR: Wipf & Stock.

Gadamer, H.-G. 1980. *Dialogue and Dialectic: Eight Hermeneutical Studies on Plato*. Translated by P. C. Smith. New Haven, CT: Yale University Press.

———. 1986. *The Idea of the Good in Platonic-Aristotelian Philosophy.* Translated by P. C. Smith. New Haven, CT: Yale University Press.
———. 1991. *Plato's Dialectical Ethics: Phenomenological Interpretations Related to the Philebus.* Translated by R. M. Wallace. New Haven, CT: Yale University Press.
Gerson, L. P. 2005. *Aristotle and Other Platonists.* Ithaca, NY: Cornell University Press.
Gonzalez, F. J. 1998. *Dialectic and Dialogue: Plato's Practice of Philosophical Inquiry.* Evanston, IL: Northwestern University Press.
Goodyear, W. H. 1912. *Greek Refinements: Studies in Temperamental Architecture.* New Haven, CT: Yale University Press.
Graeser, A., ed., 1987. *Mathematics and Metaphysics in Aristotle.* Bern, Switzerland: Haupt.
Graham, D. W. 2013. *Science Before Socrates: Parmenides, Anaxagoras, and the New Astronomy.* Oxford, UK: Oxford University Press.
Gregory, A. 2000. *Plato's Philosophy of Science.* London: Duckworth.
———. 2011. "Mathematics and Cosmology in Plato." (Ms. on file with authors.)
Griswold, C. 1981. "Gadamer and the Interpretation of Plato." *Ancient Philosophy* 1: 171–8.
———. 2002 [1988]. *Platonic Writings/Platonic Readings.* College Park: Pennsylvania State University Press.
Gruben, G. 2001. *Griechische Tempel und Heiligtümer.* Munich: Hirmer Verlag.
Hahn, R. 2010. *Archaeology and the Origins of Philosophy.* Albany, NY: SUNY Press.
———. 2017. *The Metaphysics of the Pythagorean Theorem.* Albany, NY: SUNY Press.
Harrison, E. B. 1967. "Athena and Athens in the East Pediment of the Parthenon." *American Journal of Archaeology* 71: 27–58.
Haselberger, L., ed. 1999. *Appearance and Essence. Refinements of Classical Architecture: Curvature. Proceedings of the Second Williams Symposium on Classical Architecture,* held at the University of Pennsylvania, Philadelphia, April 2–4, 1993. Philadelphia: The University of Pennsylvania Museum.
Hauck, G. 1879. *Die subjektive Perspektive und die horizontalen Curvaturen des dorischen Styls: eine perspektivisch-äesthetische Studie.* Stuttgart, Germany: Konrad Wittwer.
Heller-Roazen, D. 2011. *The Fifth Hammer: Pythagoras and the Disharmony of the World.* New York: Zone Books.
Hellmann, M.-C. 2002. *L'architecture grec, 1: Les principes de la construction.* Paris: Picard.
Heyman, J. 2010. "The Curvature of the Stylobate." In *Auguste Choisy (1841–1909): L'architecture et l'art de bâtir,* eds. J. Girón and S. Huerta. Madrid: Instituto Juan de Herrera, 277–88.
Hill, B. H. 1912. "The Older Parthenon." *American Journal of Archaeology* 16: 535–58.
Höcker, C. 2000. "Optical Refinements." *Der neue Pauly* 8: 1,270.
Hoffer, J. 1838. "Das Parthenon zu Athen, in seinen Hauptteilen neu gemessen." *Allgemeine Bauzeitung* 3: 249–51, 371–75, 379–83, and 387–91.
Horky, P. S. 2013. *Plato and Pythagoreanism.* Oxford, UK: Oxford University Press.
Hösle, V. 2006. *Der philosophische Dialog. Eine Poetik und Hermeneutik.* Munich: C. H. Beck.
———. 2012 [2004 (1982)]. "Plato's Foundation of the Euclidean Character of Geometry." In *The Other Plato,* ed. D. Nikulin, pp. 161–82.

Howland, J. 2004. *The Republic: The Odyssey of Philosophy.* Philadelphia: Paul Dry Books.
Hoyrup, J. 2010. "Old Babylonian 'Algebra,' and What It Teaches Us about Possible Kinds of Mathematics." *Ganita Bharati* 32: 87–110.
Huber, P. J., and J. Britton. 2007. "A Lunar Six Text from 591 BC." *Wiener Zeitschrift fuer die Kunde des Morgenslandes* 97: 213–18.
Huber, P. J., and J. M. Steele. 2007. "Babylonian Lunar Six Tablets." *SCIAMVS* 8: 8–36.
Hübner, W. 1980. "Die geometrische Theologie des Philolaus," *Philologus* 124: 18–32.
Huffman, C. 1993. *Philolaus of Croton: Pythagorean and Presocratic.* Cambridge, UK: Cambridge University Press.
———. 2005. *Archytas of Tarentum: Pythagorean, Philosopher and Mathematician King.* Cambridge, UK: Cambridge University Press.
———, ed. 2014. *A History of Pythagoreanism.* Cambridge, UK: Cambridge University Press.
Hunger, H., and D. Pingree. 1999. *Astral Sciences in Mesopotamia.* Leiden, the Netherlands: Brill.
Hyland, D. 1968. "Why Plato Wrote Dialogues." *Philosophy and Rhetoric* 1: 38–50.
Ilievski, P. 1993. "The Origin and Semantic Development of the Term *Harmony*." *Illinois Classical Studies* 18: 19–29.
Johansen, T. K. 2003. "Review of [Gregory 2000, *Plato's Philosophy of Science*]." *The British Journal for the Philosophy of Science* 54, no. 4, pp. 617–21.
———. 2004. *Plato's Natural Philosophy: A Study of the Timaeus-Critias.* Cambridge, UK: Cambridge University Press.
———. 2012 (accessed 4.3.2013): http://ndpr.nd.edu/news/32759-nature-and-divinity-in-plato-s-timaeus/.
Jolissaint, J. G. 2007. "Sacred Doorways: Tracing the Body in Plato's *Timaeus*." *Epoché* 11, no. 2: 333–52.
Jowett, B., translator. 1894. *Plato's* Republic. Oxford, UK: Oxford University Press.
Junecke, H. 1982. *Die wohlbemessene Ordnung. Pythagoreische Proportionen in der historischen Architektur.* Berlin: Verlag der Beeken.
Kahn, C. 1970. "On Early Greek Astronomy," *The Journal of Hellenic Studies* 90: 99–116.
———. 1996. *Plato and the Socratic Dialogue.* Cambridge, UK: Cambridge University Press.
———. 2001. *Pythagoras and the Pythagoreans: A Brief History.* Indianapolis: Hackett.
———. 2005. "The Philosophical Importance of the Dialogue Form in Plato." *Graduate Faculty Philosophy Journal* 26: 13–28.
Kalkavage, P. 2001. *Plato's* Timaeus: *Translation and Commentary.* Newburyport, MA: Focus Philosophical Library.
Kappraff, J., and E. McClain. 2005. "The System of Proportions of the Parthenon: A Work of Musically Inspired Architecture." *Music in Art* 30, nos. 1–2: 5–16.
Klagge, J. C., and N. D. Smith, eds. 1992. *Oxford Studies in Ancient Philosophy, Supplementary Volume: Methods of Interpreting Plato and His Dialogues.* Oxford, UK: Oxford University Press.

Klein, J. 1968. *Greek Mathematical Thought and the Origins of Algebra.* Translated by E. Brann. Cambridge, MA: MIT Press.

Knorr, W. R. 1975. *Evolution of the Euclidean Elements.* Dordrecht, the Netherlands: D. Reidel.

Koch, M. 1963. "La Courbure du stylobate du Parthenon." *Annales archéologique* 34: 231.

Korres, M. 1994. "Der Plan des Parthenon." *Mitteilungen des Deutschen Archäologischen Instituts, Athenische Abteilung* 109: 53–120

Korres, M., G. Panetsos, and T. Seki, eds. 1996. *The Parthenon: Architecture and Conservation.* Athens: Foundation for Hellenic Culture, Committee for the Conservation of the Acropolis Monuments.

Koyré, A. 1958. *From the Closed World to the Infinite Universe.* New York: Modern Library.

Kraut, R. 1992. "The Defense of Justice in Plato's *Republic.*" In *The Cambridge Companion to Plato,* ed. R. Kraut, pp. 311–37.

———, ed. 1992. *The Cambridge Companion to Plato.* Cambridge, UK: Cambridge University Press.

———, ed. 1997. *Plato's* Republic: *Critical Essays.* Lanham, MD: Rowman and Littlefield.

Lachterman, D. 1989. *The Ethics of Geometry.* New York: Routledge.

Lauenstein, H. 1998. *Arithmetik und Geometrie in Raffaels Schule von Athen.* Frankfurt am Main, Germany: Peter Lang.

Lear, J. 2011. *A Case for Irony.* Cambridge, MA: Harvard University Press.

Ledger, G. R. 1989. *Recounting Plato.* Oxford, UK: Oxford University Press.

Lippman, E. 1963. "Hellenic Conceptions of Harmony." *Journal of the American Musicological Society* 16, no. 1: 3–35.

Lloyd, W. W. 1863. *On the General Theory of Proportions in Architectural Design and Its Exemplification in Detail in the Parthenon.* In F. C. Penrose, 1888 [1851], *An Investigation of the Principles of Athenian Architecture.* Rev. ed. London: Macmillan and Co., pp. 111–16.

Mahoney, M. 1968. "Another Look at Greek Geometrical Analysis." *Archive for History of Exact Sciences* 5 (1968): 318–48.

Mansfeld, J. 1990. *Studies in the Historiography of Greek Philosophy.* Assen/Maastricht, the Netherlands: Van Gorcum.

Marquard, P., ed. 1868. *Die Harmonischen Fragmente des Aristoxenos.* Berlin.

Marvikios, A. 1965. "Aesthetic Analysis Concerning the Curvature of the Parthenon." *American Journal of Archaeology* 69: 264–68.

McClain, E. G. 1978. *The Pythagorean Plato: The Prelude to the Song Itself.* York Beach, ME: Nicolas-Hays.

McKirahan, R. 1995. *Readings in Ancient Greek Philosophy.* Indianapolis: Hackett.

———. 1996. *A PreSocratics Reader.* Indianapolis: Hackett.

———. 2011 (1994). *Philosophy Before Socrates.* 2nd ed. Indianapolis: Hackett.

McNeill, D. 2010. *An Image of the Soul in Speech.* College Park, PA: Penn State University Press.

Mendell, H. 2008. "Plato by the Numbers." In Follesdal and Woods, eds., pp. 125–60.

Mertens, D. 1984. *Der Tempel von Segesta und die dorische Tempelbaukunst des griechischen Westens in klassicher Zeit*. Mainz: Philipp von Zabern.
———. 2006. *Städte und Bauten der Westgriechen*. Munich: Hirmer Verlag.
Michelis, P. A. 1955. "Refinements in Architecture." *The Journal of Aesthetics and Art Criticism* 14, no. 1: 19–43.
Miller, M. 1999. "Dialectical Education and 'Unwritten Teachings' in Plato's *Statesman*." In Van Ophuijsen, ed., pp. 218–41.
———. 2003. "The Timaeus and the 'Longer Way': Godly Method and the Constitution of Elements and Animals." In Reydams-Schils, ed., pp. 17–59.
———. 2007. "Beginning the 'Longer Way.'" In G. R. F. Ferrari, ed., 310–44.
Mohr, R. D. 1981. "The Number Theory in Plato's *Republic* VII and *Philebus*." *Isis* 72: 620–27.
Mountford, J. F. 1923. "The Musical Scales of Plato's *Republic*." *Classical Quarterly* 17: 125–36.
Mourelatos, A. P. D. 1980. "Plato's 'Real Astronomy': *Republic* 527d–531d," in Anton (1980): 33–73.
Moutsopoulos, E. 1959. *La musique dans l'oeuvre de Platon*. Paris: PUF.
———. 1963. "Dialectique musicale et dialectique philosophique chez Platon." *Annales de la Faculté des Lettres et Sciences humaines d'Aix* 37: 159–63.
Mueller, I. 1980. "Ascending to Problems: Astronomy and Harmonics in *Republic* VII." In Anton, ed., pp. 103–21.
———. 1991. "Mathematics and Education: Some Notes on the Platonist Programme." *Apeiron* 24: 85–104.
———. 1992. "Mathematical Method and Philosophical Truth." In *The Cambridge Companion to Plato*, ed. R. Kraut, pp. 170–99.
Nabers, N., and S. F. Wilshire. 1980. "The Athena Temple at Paestum and Pythagorean Theory." *Greek, Roman, and Byzantine Studies* 21: 207–15.
Negrepontis, S. 2012. "Plato's Theory of Knowledge of Forms by Division and Collection in the Sophistes Is a Philosophic Analogue of Periodic Anthyphairesis." (Ms. on file with author.)
Neils, J., ed. 2005. *The Parthenon: From Antiquity to the Present*. Cambridge, UK: Cambridge University Press.
Neugebauer, O. 1969. *The Exact Sciences in Antiquity*. 2nd rev. ed. New York: Dover.
Netz, R. 2002. "Counter Culture: Towards a History of Greek Numeracy." *History of Science* 40: 321–52.
———. 2014. "The Problem of Pythagorean Mathematics." In Huffman, ed., pp. 167–84.
Nikulin, D. 2002. *Matter, Imagination and Geometry: Ontology, Natural Philosophy and Mathematics in Proclus, Plotinus and Descartes*. Aldershot, UK: Ashgate.
———. 2008. "Imagination and Mathematics in Proclus." *Ancient Philosophy* 28: 153–72.
———. 2010. *Dialectic and Dialogue*. Stanford, CA: Stanford University Press.
———, ed. 2012a. *The Other Plato: The Tübingen Interpretation of Plato's Inner-Academic Teaching*. Albany: State University of New York Press.

———. 2012b. "Indivisible Lines and Plato's Mathematical Ontology." In Bruchmüller, ed., pp. 291–326.
Nussbaum, M. C. 2001 (1986). *The Fragility of Goodness: Luck and Ethics in Greek Tragedy and Philosophy*. Cambridge, UK: Cambridge University Press.
Orlandos, A. K. 1976–78. *Hē architektonikē tou Parthenōnos*. 3 vols. Athens: Archaiologikē Hetaireia.
Parry, R. D. 2007. "The Unhappy Tyrant and the Craft of Inner Rule." In G. R. F. Ferrari (ed.), *Cambridge Companion*, 386–413.
Panofsky, E. 1962 [1953]. "Artist, Scientist, Genius: Notes on the Renaissance Dämmerung." In W. K. Ferguson et al., *The Renaissance: Six Essays*, New York: Harper & Row, pp. 121–82.
———.1997 [1927]. *Perspective as Symbolic Form*. Translated by C. Wood. New York: Zone Books.
Penrose, F. C. 1888 [1851]. *An Investigation of the Principles of Athenian Architecture*. Rev. ed. London: Macmillan and Co.
Peterson, M. 2011. *Galileo's Muse: Renaissance Mathematics and the Arts*. Cambridge, MA: Harvard University Press.
Plutarch 1958 [1916]. *Plutarch's Lives, III: Pericles and Fabius Maximus, Nicias and Crassus*. Loeb ed. Translated by B. Perrin. Cambridge, MA: Harvard University Press.
Pollitt, J. J. 1964. *Ancient View of Greek Art: Criticism, History, and Terminology*. New Haven, CT: Yale University Press.
———. 1972. *Art and Experience in Classical Greece*. Cambridge, UK: Cambridge University Press.
———. 1995. "The Canon of Polykleitos and Other Canons." In W. G. Moon, ed., *Polykleitos, the Doryphoros, and Tradition*, Madison: University of Wisconsin Press, pp. 19–24.
Proclus. 1970. *A Commentary on Euclid's Elements*. Translated by G. Morrow. Princeton, NJ: Princeton University Press.
Recco, G. 2010. *Athens Victorious: Democracy in Plato's Republic*. Lanham, MD: Lexington Books.
Reeve, C. D. C., translator. 2004. *Plato: Republic*. Indianapolis: Hackett.
———. 2006 (1988). *Philosopher-Kings*. Indianapolis: Hackett.
———. 2013. *Blindness and Reorientation: Problems in Plato's* Republic. Oxford, UK: Oxford University Press.
Reydams-Schils, G. 2003. *Plato's* Timaeus *as Cultural* Icon. Notre Dame, IN: University of Notre Dame Press.
Riegl, A. 2000 [1901]. *Spätrömische Kunstindustrie*. Berlin: Gebr. Mann Verlag.
Robertson, D. S. 1964. *A Handbook of Greek and Roman Architecture*. 2nd ed. Cambridge, UK: Cambridge University Press.
Rocco, G. 2003. *Guida alla lettura degli ordini architettonici antichi*. Vol. II: *Lo ionico*. Naples, Italy: Ligouri Editore.
Roochnik, D. 1986. "The Impossibility of a Philosophical Dialogue." *Philosophy and Rhetoric* 19: 147–65.

———. 2003. *Beautiful City: The Dialectical Character of Plato's Republic.* Ithaca, NY: Cornell University Press.

Rosand, D. 2000. "Raphael's School of Athens and the Artist of the Modern Manner." In S. Fletcher and C. Shaw, eds. *The World of Savonarola: Italian Elites and Perceptions of Crisis*, Aldershot, UK: Ashgate Press, pp. 212–32.

Rosen, S. 2005. *Plato's Republic: A Study.* New Haven, CT: Yale University Press.

Ross Holloway, R. 1966. "Architettura sacra e mattematica pitagorica a Paestum." *La parola del passato* 106: 60–64.

Rowe, D. 2013. "Otto Neugebauer's Vision for Rewriting the History of Ancient Mathematics." (Ms. on file with author.)

Russon, J. E., and J. Sallis, eds. *Retracing the Platonic Text.* pp. 57–69. Evanston, IL: Northwestern Press.

Sallis, J. 1999. *Chorology: On Beginning in Plato's Timaeus.* Bloomington: Indiana University Press.

———. 2000. "Traces of the Chora." In J. E. Russon and J. Sallis (eds.), pp. 57–69.

Sayre, K. M. 1995. *Plato's Literary Garden: How to Read a Platonic Dialogue.* Chicago: University of Chicago Press.

Schibli, H. S. 1996. "On the One in Philolaus, fragment 7," *Classical Quarterly* 46: 114–30.

Schneider Berrenberg, R. 1988. *Sie Bauten ein Abbild der Seele. Anmerkungen zur Metrik und Harmonik der St. Elisabethkirche in Marburg und des Parthenon-Tempels in Athen.* Munich: Schneider Berrenberg.

Schrift, A. 2006. *Twentieth-Century French Philosophy: Key Themes and Thinkers.* Oxford, UK: Blackwell.

Sedley, D. 2007. "Philosophy, the Forms, and the Art of Ruling." In G. R. F. Ferrari (ed.), 256–83.

Shapiro, S., ed. 2005. *The Oxford Handbook of Philosophy of Mathematics and Logic*, Oxford, UK: Oxford University Press.

Shorey, P. 2003 [1937]. *Plato: The Republic.* Cambridge, MA: Harvard University Press.

Smiley, T., ed. 2001. *Mathematics and Necessity.* Oxford, UK: Oxford University Press.

Steele, J. M. 2007. *Calendars and Years: Astronomy and Time in the Ancient Near East.* Oxford, UK: Oxbow Books.

Steele, J. M., and A. Imhausen, eds. 2002. *Under One Sky: Astronomy and Mathematics in the Ancient Near East.* Muenster, Germany: Ugarit-Verlag.

Stenzel, J. 1933. *Zahl und Gestalt bei Platon und Aristoteles.* Leipzig, Germany: Teubner.

———. 1940. *Plato's Method of Dialectic.* Translated by D. J. Allan. Oxford, UK: Clarendon Press.

Stevens, G. P. 1940. "The Setting of the Periclean Parthenon." *Hesperia: Journal of the American School of Classical Studies.* Supplement 3: 1–88.

Stewart, A. 1978. "The Kanon of Polykleitos: A Question of Evidence." *Journal of Hellenic Studies* 98: 122–31.

Stewart, J. A. 1905. *Myths of Plato.* London: Macmillan and Company.

Stuart, J., and N. Revett. 2008 [1762, 1787, 1794]. *The Antiquities of Athens: Measured and Delineated by James Stuart and Nicholas Revett.* 3 vols. Reprint. New York: Princeton Architectural Press.

Swerdlow, N. M., ed. 1999. *Ancient Astronomy and Celestial Divination*. Cambridge, MA: MIT Press.
Szabó, Á. 1978 [1969]. *The Beginnings of Greek Mathematics*. Translated by A. M. Ungarr. Hingham, MA: D. Reidel.
Szelak, T. A. 1999. *Reading Plato*. Translated by Graham Zanker. London: Routledge.
———. 2004. *Das Bild des Dialektikers in Platons spaten Dialogen. Plato und die Schriftlichkeit der Philosophie, Teil II*. Berlin: Walter de Gruyter.
Tarrant, H. A. 2012a. "Plato's *Republics*." *Plato: The Internet Journal of the International Plato Society* 1: 1–12. (http://gramata.univ-paris1.fr/Plato/article118.html, accessed 19 February 2015).
———. 2012b. "The Origins and Shape of Plato's Six-Book Republic." *Antichthon* 46: 52–78. (doi:10.1017/S0066477400000149).
Tarrant, H. A., E. E. Benitez, and T. Roberts. 2011. "The Mythical Voice in the Timaeus-Critias Stylometric Indicators." *Ancient Philosophy* 31: 95–120.
Taylor, A. E. 1928. *Commentary on Plato's Timaeus*. Oxford, UK: Oxford University Press.
Temple, W. 1916. *Plato and Christianity*. London: Macmillan and Company.
Thompson, P., G. Papadopoulou, and E. Vassiliou. 2007. "The Origins of Entasis: Illusion, Aesthetics or Engineering?" *Spatial Illusion* 20, no. 6: 531–43.
Tournikiotis, P., ed. 1994. *The Parthenon and Its Impact in Modern Times*. Athens: Melissa Publishing House.
Valéry, P. 1967 [1923]. *Eupalinos and L'Ame et la danse*. Edited by V. J. Daniel. Oxford, UK: Oxford University Press.
Van Ophuijsen, J. M. 1999. *Plato and Platonism*. Washington, DC: Catholic University of America Press.
Vitruvius. 1931, 1934. *On Architecture*. Loeb ed. 2 vols. Translated by F. Granger. Cambridge, MA: Harvard University Press.
von Fritz, K. 1945. "The Discovery of Incommensurability by Hippasus of Metapontum," *Annals of Mathematics* 46, no. 2: 242–64.
———. 1973. "Philolaus," in Pauly-Wissowa (1973) *Realencyclopaedie* supplement 13: 453–84.
von Steuben, H. 1973. *Der Kanon des Polyklet*. Tübingen, Germany: Verlag Ernst Wasmuth.
Waddell, G. 2002. "The Principal Design Methods for Greek Doric Temples and Their Modification for the Parthenon." *Architectural History* 45: 1–31.
Weber, M. 2004. *The Vocation Lectures*. Edited by D. Owen and T. Strong. Translated by R. Livingstone. Indianapolis, IN: Hackett Publishing.
Weiss, R. 2012. *Philosophers in the Republic: Plato's Two Paradigms*. Ithaca, NY: Cornell University Press.
Wesenberg, B. 1982. "Wer erbaute den Parthenon?" *Mitteilungen des Deutschen Archäologischen Instituts, Athenische Abteilung* 97: 99–125.
———. 1983. "Parthenongebälk und Südmetopenproblem." *Jahrbuch des Deutschen Archäologischen Instituts* 98: 57–86.
———. 1995. "Die Metrologie der griechischen Architektur: Probleme interdiziplinärer Forschung." In *Ordo et mensura III: 3. Internationaler Interdisziplinärer*

Kongress für Historische Metrologie, edited by D. Ahrens and R. Rottländer. St. Katharinen: Scripta Mercaturae Verlag, pp. 199–222.

White, J. 1987 [1957]. *The Birth and Rebirth of Pictorial Space*. 3rd ed., Cambridge, MA: Belknap Press of Harvard University Press.

Wilson Jones, M. 2001. "Doric Measure and Architectural Design 2: A Modular Reading of the Classical Temples." *American Journal of Archaeology* 105: 675–713.

———. 2006. "Ancient Architecture and Mathematics: Methodology and the Doric Temple." In *Nexus VI: Architecture and Mathematics*, edited by S. Duvernoy and O. Pedemonte. Turin, Italy: Kim Williams Books, pp. 1–20.

———. 2009. "Ancient Greek and Roman Architects' Approach to Curvature—the Corinthian Capital, Entasis and Amphitheaters." In *Creating Shapes in Civil and Naval Architecture: A Cross-Disciplinary Comparison*, edited by H. Nowacki and W. Lefèvre. Leiden, the Netherlands: Koninklijke Brill NV, pp. 93–116.

———. 2014. *The Origins of Classical Architecture: Temples, Orders and Gifts to the Gods in Ancient Greece*. New Haven, CT: Yale University Press.

Winnington-Ingram, R. P. 1932. "Aristoxenus and the Intervals of Greek Music." *The Classical Quarterly* 26, nos. 3 and 4: 195–208.

Winter, F. E. 1980. "Tradition and Innovation in Doric Design III: The Work of Iktinos." *American Journal of Archaeology* 84: 399–416.

Wittkower, R. 1953. "Brunelleschi and 'Proportion in Perspective.'" *Journal of the Warburg and Courtauld Institutes* 16, nos. 3 and 4: 275–91.

Wright, M. R. 2000. *Reason and Necessity: Essays on Plato's* Timaeus. London: Duckworth.

Wycherley, R. E. 1978. *The Stones of Athens*. Princeton, NJ: Princeton University Press.

Yeroulanou, M. 1998. "Metopes and Architecture: The Hepaisteion and the Parthenon." *Annual of the British School at Athens* 93: 401–25.

Zambas, K. 2002. *Oi ekleptunseis ton kionon tou Parthenonos*. Athens: The Acropolis Restoration Service (YSMA).

Zhmud, L. 2006. *The Origin of the History of Science in Classical Antiquity*. Berlin: De Gruyter.

———. 2012. *Pythagoras and the Early Pythagoreans*. New York: Oxford University Press.

———. 2013a. "Pythagorean Number Theory in the Academy." (Ms. on file with authors.)

———. 2013b. *Pythagoreanismsus*. (Ms. on file with authors.)

Index

abstraction, xviii, xxvii, 42–44, 63–64, 84–85, 100–103, 149, 159
Academy, of Plato, xiii–iv, xxxi–iii, 36–39, 45–46, 52–55, 88, 133, 150, 159
Acerbi, Fabio, 179n24
Acropolis, 66, 68–69, 83–85, 101, 132, 135–37
 Erechtheion, 75, 209n58
 Older Parthenon, 66, 84, 105, 113, 116, 129, 190n24, 193n55, 194n61, 196n79, 199n23, 206n26, 206n30
 Parthenon. *See* Parthenon
 Propylaea, 125, 127, 133–35, 205n13, 205n18
Adam, James, 15–16, 184n36, 185n44, 186n45
adjustments, 78, 81, 88, 92–93, 106–16, 119–26, 129–30, 139–43, 147, 177n6, 198n11, 198n13, 198n16, 203n7. *See also* refinements
aesthetics, 62, 75–76, 96–101, 140, 143–47, 152
Aegina, 82–83, 129
 Temple of Aphaia, 82, 129, 136–37, 194n62, 203n4, 203n5, 208n48
Akagras, 79–80, 112, 192n42, 198n13, 198n20, 202n60, 207n38
 Temple of Concord, 79, 110
 Temple of Hera Lacinia, 80, 88, 93, 110, 113

alētheia, 133, 136, 145–46. *See also* truth
Alberti, Leon Battista, 159, 193n57, 206n23, 210n7, 210n10
Alcibiades, 197n97
ambiguity, 122–23, 145–47, 149
analysis, mathematical method of, xix, xxx, 17–18, 37, 39–41, 45, 55, 65, 157–58
Annas, Julia, 182n15
anthyphairesis, xx, xxii, xxv–vii, xxxii, 14, 62–66, 97–98, 114–17, 122, 143, 147, 150, 173, 180n36, 188n5
Aphrodite, 102–103
apotome, 32, 64, 115–16, 122, 165, 189n14
approximation, xxxi, 4, 20, 65, 92, 94, 139, 141
architect, 66–68, 83–85, 101, 110–12, 159–61
 Plato as "architect of sciences," 45–46
Archytas, xxi–iii, xxv, xxviii, 19, 32, 37, 45, 56, 185n42, 186n49
Aristotle, xv, xxxii, 3, 17, 25, 46, 54, 56, 160, 177n5, 180n30, 181n4, 183n25, 205n13
Aristoxenus, 32, 116, 183n25, 200n34
arithmetic, xv–xvii, xxii, xxiv, xxxii, 4, 30–31, 41–43, 62, 66, 95, 100–104, 113, 116, 122, 148, 151, 159–60, 163, 173, 177n2, 185n41, 200n34, 210n11. *See also* number

art (*technē*), xvi–ii, 4, 10, 17–18, 23, 26, 31, 39, 49–51, 55, 57, 63, 66, 75–77, 84, 88, 90, 101–106, 140, 144, 149–51, 158–61, 176, 189n14
astronomy, xiii, xvi, xxv–vi, xxix–xxx, 4, 13, 17, 20, 31, 41–45, 48, 56, 170, 177n2, 179n25, 180n35, 185n42, 210n11
Athena, 66, 68, 77–78, 82, 152, 155, 190n27, 198n14, 201n53, 202n60, 207n, 209n58
Athena Parthenos, 68, 70
Athenaeon (at Gela), 79, 195n73
Athens, xxvii, xxxi, xxxiii, 62, 65–70, 112, 125, 133, 148–52, 161, 178n12, 188n7, 190n25, 190n27, 209n3
audible, 47–48. See also music

Babylon, xxvii–xxxi. See also mathematics, of the ancient Near East
Badiou, Alain, 177n1
balance, 102, 152, 204n7, 209n59. See also harmony
Baracchi, Claudia, 181n6
Barbera, Andre, 179n19, 180n34, 186n39, 189n8, 189n9, 200n34
Barker, Andrew, 179n19, 187n8, 189n8, 189n14, 189n16
Barletta, Barbara, 113, 190n23, 190n24, 196n82, 199n22
beauty, xvii, 26, 28, 33–35, 49, 70, 73, 100–104, 120–23, 144, 151, 197n97, 201n44, 204n7, 204n9, 205n16
Benardete, Seth, 181n6, 185n40
Benson, Hugh, 180n34, 182n15
Berger, Ernest, 193n54, 193n60, 194n66, 195n75, 195n78, 206n27
Berggren, J. L., 178n14, 179n24
body, 20, 42, 57, 73, 75, 84–85, 90, 100, 102–104, 197n97
Boethius, 32, 186n49
Bowen, Alan, xxvii, 178n14, 178n15, 179n24

Brack-Bernsen, Lis, 179n25, 180n32, 180n33
Broadie, Sarah, 8, 29, 181n7, 183n21
Brunelleschi, Filippo, 134–35
Bundgaard, Jens Andreas, 190n23, 190n24, 193n55, 195n72, 200n38, 206n26
Burkert, Walter, 36, 185n44
Burnyeat, Miles, 20, 34, 41, 47, 51–52, 180n34, 182n8, 185n42, 186n4, 187n1
Büsing, Hermann, 92, 136, 138, 177n6, 194n67, 206n26

canon. See *kanon*
Carrey, Jacques, 152–54
cave, Plato's "allegory," of 6, 34–35, 51–52, 184n31. See also divided line
cella, 68, 93, 95–97, 114, 133, 167, 193n48, 195n75, 196n79
Christianidis, Jean, xx, xxvi
citizenship, xiv, xvi–xix, 68, 70
 civic function of Parthenon, xxi, 66–68, 70, 150–52, 161–63, 178n12, 209n58
Clay, Diskin, 9, 181n6
colonies, of Athens, xxxiii, 70, 78, 82, 129
 appropriation of Doric order by, 83, 91, 93, 110, 192n43, 193n51, 201n53
columns, 72, 78, 89–92, 98, 100, 102, 107, 111, 191n36, 194n63, 203n4
 entasis, 129, 144, 174, 203n4, 203n7, 208n48
 intercolumniation, xv, xxxii, 77–80, 83, 89–93, 105–106, 110, 113–14, 118–19, 124, 136, 138–41, 177n6, 192n47, 192n48, 194n62, 194n63, 194n65, 195n71, 206n26, 206n30, 206n31, 207n33, 207n34
 inclination of, 82, 83, 92, 94, 129, 131, 135–42, 144, 146
 thickening of (at the corners), 83, 118, 129, 139. See also refinements

Connelly, Joan Breton, 189n21, 190n25, 190n26, 190n25, 208n58
construction, xxx, 106, 113–15, 120, 158–59
 of Parthenon, xiii, xv–xvii, xxvi, 63–64, 68, 70, 76, 80, 88–92, 95–99, 111, 140, 143, 151–52, 162–63
 and mathematical analysis, xxi–ii, xxxi–iii, 10, 16, 21, 24, 29, 33, 35, 40, 46–47, 51, 61–62, 65, 131, 147
constructivism, xxxi–iii, 1, 45, 52–53, 187n4. *See also* realism, Le Corbusier
Cornford, F. M., 8, 29, 32, 181n7, 183n23, 183n24, 185n39, 185n43
Cornelli, Gabriele, 36, 183n26
cosmos, 18, 24–25, 28–29, 32, 34, 37, 57, 162, 186n47, 186n1, 186n4
cosmology, xxix, 9, 24–29, 34–35, 56, 183n21, 185n43. *See also* astronomy
Coulton, J. J., 76, 90, 113, 131, 191n35, 191n36, 194n63, 194n64, 194n65, 198n9, 198n12, 199n24, 200n38, 203n2, 204n10, 204n12, 206n30, 207n32, 210n8
Croton, 77–78. *See also* Philolaus, Pythagoreanism
cult practices, 66–68, 93, 190n27, 195n72, 209n58. *See also* religion
Cuomo, Serafina, xx, 178n12, 179n24
curvature, 82–83, 94, 102, 111, 125–36, 144–47, 202n1, 203n2, 203n4, 204n9, 205n15, 205n17, 208n44, 208n48. *See also* refinements

De Architectura, xix, 108, 130, 178n10, 190n23, 202n56, 203n7, 204n8, 204n9, 208n55
Delos, 79, 141, 192n46
demonstration, xviii–xxi, xxvii, 53, 56, 65, 88, 90, 179n18, 181n3. *See also* knowledge

Derrida, Jacques, 181n7
Detlefsen, M., 52–53
dialogue, xiv–xv, xxiii–iv, 2–4, 6–9, 36–39, 49, 53–57, 100, 104–105, 110, 130–33, 146, 148–50, 162–63, 178n18, 180n35, 182n8, 183n23, 189n22
dialectic (*dialektikē*), xix–xxiv, 2–6, 21–25, 32–35, 39–41, 45–57, 66, 70, 99, 107, 129–30, 142–63, 180n35, 182n8, 182n12, 182n16, 182n17, 186n50, 188n9, 188n10, 205n14
Dillon, John, 57, 188n11
Diotima, 197n97
Dinsmoor, William Bell, 98, 192n43, 192n48, 193n53, 198n14, 199n23, 202n60, 203n3, 203n5, 204n9
divided line, Plato's image of, xxxiii, 6, 49, 147–48, 180n35, 208n50. *See also* proportion
Doric, xv, xxxii, 62, 65–66, 70, 72–73, 75–78, 82–83, 88, 90–91, 98, 102, 105–12, 116, 120, 124–27, 136–41, 159, 162, 169, 177n6, 190n23, 191n30, 191n34, 191n35, 192n42, 192n44, 194n62, 196n83, 199n23, 202n54, 202n57, 202n60, 205n13, 206n23, 206n30, 207n34, 207n37. *See also* order
Drake, Stillman, 189n11, 209n4
Duddy, Michael, 134, 206n21

education, xiv–xix, 5, 17, 23, 34–36, 39–41, 45–47, 50–52, 55–57, 62, 104, 133, 152–53, 157, 160, 163, 177n4, 178n12, 184n34, 187n4. *See also* Academy, *Republic*
Elements (attributed to Euclid), xix, xxi–iii, xxv–vii, 42, 61, 88, 176, 180n36, 181n3, 188n7, 189n20, 209n3
entablature, 90, 92–94, 109–12, 114–20, 136, 138–42, 145, 147, 198n13, 202n57

entasis. See columns
epistemology, xv, xxxi, 7, 35, 41, 47, 49, 52, 61, 72, 107, 145, 147, 149–52, 158, 196n89
Erechtheion. *See* Acropolis
esotericism, 7–8, 37
ethics, 17, 46. *See also* harmony
Euclid, xix–xxii, xxvii, xxx, 46, 88, 161, 181n3
eurhythmia, 140, 197n95
Eudoxus, xxi, xxiv–vii, 45, 52, 187n5
Evans, James, xxx, 179n26
experience, xv–xviii, 14, 21, 52, 85, 90, 96–98, 101–104, 110, 112, 132, 134–36, 143–51

façades, xv, 77, 79, 84, 88–93, 96–97, 111, 113, 116, 141, 147, 192n47, 194n63, 195n69, 195n72, 198n16, 200n33, 200n40, 206n31
Ferrari, G. R. F., 9, 12, 34, 181n6, 182n8, 182n20, 183n28
figures, 36, 43, 46, 70, 101, 152–53, 180n35, 189n20, 197n93, 202n60, 209n59
 pentagram, 62–63, 65, 115, 188n5. *See also* geometry
forms, xv, xxxi, 14, 16, 21, 26, 29, 35, 41, 43, 46–48, 53, 55, 68, 75, 90, 92, 99, 101–102, 134, 140–44, 159, 178n12, 180n35, 181n4, 184n32, 184n33
Fowler, David, xx, xxv–vi, xxxii, 178n9, 179n21, 179n22, 179n23, 179n24, 193n58
fraction, xxv, 91, 107, 111, 194n63, 194n65. *See also* number, ratio
Frede, Michael, 182n8
freedom, 39, 148–49. *See also* citizenship
Florence, 151, 190n22
foundations
 of knowledge, xix, xxiv–vi, 1, 49, 63, 196n87
 of the Parthenon, 84, 130, 140
Friburg, Jöran, xxvii–viii, 179n29

Fricke, Jeanette, 179n25
frieze, 68, 70, 72, 78, 89, 94, 107, 111–14, 116, 118, 124, 135, 138, 141–43, 152–53, 191n36, 202n57, 208n58, 209n59

Gadamer, Hans-Georg, 23, 182n8
geometry, xv–xvii, xxi–xxv, xxvii, 4, 13, 15–16, 31, 41, 43–46, 56, 62–66, 85, 95, 100–104, 113, 116, 134, 139, 141, 148, 158–62, 177n2, 17816, 180n34, 185n42, 187n4, 198n20, 209n3, 210n7, 210n11
golden section, 62–63, 188n5, 188n6, 188n7. *See also* irrational
good (the form of, in Plato), 6–7, 12, 19–21, 24, 33–37, 39–41, 45–52, 179n18, 182n18, 184n31, 184n36, 209n58
Goodyear, William, 114, 195n77, 198n11, 199n26, 200n35, 203n2, 204n9, 205n16, 208n44
Gonzalez, Francisco, 182n8
Graham, Daniel, 44, 189n8
Gregory, Andrew, 44, 182n7
Great Year, xxviii–xxx, 10, 17, 48, 180n31, 186n46. *See also* Philolaus
Griswold, Charles, xxiii, 9, 181n6, 182n8, 183n28
Gruben, Gottfried, 133, 190n24, 191n39, 192n43, 193n48, 198n9, 198n16, 199n23, 203n2, 203n5, 204n9, 205n17, 207n34
guardian, 18, 41, 44. *See also* philosopher-king

Hahn, Robert, 188n4, 189n18, 202n55, 207n39, 208n57
harmony (*harmonia*), xiii, xvi–iii, xxxii, 4, 10, 18, 20–21, 23, 28, 33, 48, 63, 65, 70, 84, 90, 95, 102, 107, 118, 120, 131, 139, 143–44, 151, 157, 160, 162, 174, 195n72, 196n81, 204n8, 204n9, 207n33,

207n34, 207n36, 207n37, 208n48, 209n58
harmonic mean, xx, 31, 174. *See also* musical scale
Haselberger, Lothar, 125–27, 129, 131, 133, 136, 143, 147, 201n53, 202n59, 202n1, 203n3, 203n4, 203n6, 204n8, 204n9, 204n13, 204n15, 205n17, 205n18, 206n24, 208n48, 208n49
Hauck, Guido, 114, 134, 199n26, 203n2, 204n9, 206n22
hegemony. *See* leadership
Hellenistic
 architecture, 76, 131, 159, 202n57
 philosophy, 54, 160, 178n12
Heller-Roazen, Daniel, 32, 100, 159–60, 186n48, 186n49, 188n1, 189n14, 189n19, 196n88, 196n89, 198n6, 199n27, 209n5
Hellman, M. C., 191n30, 191n33, 194n62, 203n2
hermeneutics, xxiii, 8, 10. *See also* Gadamer
Hesiod, xxvi, 179n25
Himera, 78, 82
 Temple of Victory, 78, 110, 195n73
Hippocrates, xxi, xxiii–v, xxviii
Hoffer, Joseph, 132, 204n9, 205n16
Hösle, Vittorio, xv, 181n3, 182n8
Homer, xv, 106, 152, 177n4, 177n5
Horky, Phillip, 9, 36–37, 177n5, 178n9, 182n8, 183n25, 183n26, 187n2
Hoyrup, Jens, 179n25, 179n28
Huffman, Carl, xxviii–xxix, 37, 179n30, 182n10, 183n26, 183n27, 186n46, 189n8, 189n15, 196n85, 197n2, 199n27, 201n52, 208n54
human
 being/nature/essence, of 13, 20–21, 133, 158, 178n16, 182n18
 as embodied, 25, 28–29, 75, 84, 100
humanism, xiv, xviii, 40, 157–58, 161–63

Hypsicles, xxx

iconography, 68, 103, 116, 136, 152–53, 162, 197n93, 208n57, 209n58
ideas (of Plato), 54, 77, 147, 152, 181n4. *See also* forms
Iktinos, xix, 66, 124–25, 133, 150, 190n23, 195n72, 202n54, 207n34
Ilievski, Petar, 106, 191n28, 197n4
image
 Plato's use of, 3, 6, 20, 25–26, 34–35, 42, 48–49, 51–52, 182n11, 184n31
 and viewing the Parthenon, 68, 134, 147, 152–53, 209n58
imagination, 43, 48, 53
imitation, 26, 181n4. *See also* forms, images
incommensurable, xx–xxv, 20, 54, 61–62, 65, 70, 107, 114, 118, 160, 174, 188n3, 188n4
induction, 65, 115. *See also* knowledge
integers, xxiv, 33, 63, 66, 90, 92, 95, 97, 115, 192n48, 197n7. *See also* unit
intellection (*noēsis*), 43, 47–49, 54. *See also* knowledge
intelligible, 33, 42–49, 53, 56, 186n1, 187n4, 208n50
interdisciplinarity, xiii, xix, 24, 39, 41, 53–54, 57, 83, 134, 150, 157, 162
interval, xxx, 19, 21, 30–33, 64–65, 96, 115, 120, 122, 147, 165, 189n15. *See also* musical scale
Ionic, 68, 70, 73–74, 98, 102, 134, 141–42, 155, 175, 190n23, 196n83, 207n37, 208n58. *See also* order
irrational, xxiii, xxv, xxviii, 4–5, 18–21, 33, 36, 41, 47, 61–63, 65–66, 88, 97, 99, 101, 107, 111, 114–16, 121–25, 127, 133, 139, 144, 160, 175, 179n18, 188n7, 189n20, 196n85, 197n7, 199n31, 200n43. *See also* incommensurable

Jameson, Frederic, 177n1
Johansen, Thomas Kjeller, 29, 182n7
Jones, Alexander, 179n26, 179n28
Jowett, Benjamin, 16, 21, 185n41
justice, 2–3, 13, 23, 34, 75, 149, 182n18, 184n34, 184n36, 185n39. See also ethics, good
Junecke, Hans, 131, 192n48, 202n57, 204n11

Kahn, Charles, 9, 12, 54–55, 182n8, 182n11, 188n10
Kalkavage, Peter, 9, 24, 26–29, 33, 35, 186n1, 186n4, 187n6, 187n7, 187n9, 187n11, 187n14
Kallikrates, 66, 124, 150, 178n10, 190n23, 195n72
Kallipolis (the city-in-speech in Plato's *Republic*), 16, 26, 49, 52
kairos, 122, 201n51
kanon, xv–xvi, 16, 53, 63–64, 106, 115, 120–27, 175, 197n91, 199n31, 201n44, 201n46, 201n51, 201n53, 204n8
Kant, Immanuel, 101, 182n12
Korres, Manolis, 113, 116, 130, 143, 191n29, 194n61, 198n9, 199n22, 200n35, 203n3, 203n6, 205n15, 206n25207n40, 208n47
Knorr, Wilbur, xx–xxv, xxvii, xxxii, 178n9, 179n20, 180n36, 189n18
knowledge
 procedures of, xiv, xvii–ix, xxv–vii, xxx–xxxiii, 40, 64, 157–59, 199n25
 theory of, 9, 27, 50, 55–56, 148, 151–52, 159–60, 163
 See also mathematics
Kraut, Richard, 13, 181n6, 182n18, 184n36, 187n3, 188n9
krepis, 116, 120, 191n35, 194n61, 206n30

leadership (*hēgemôn*), xv, 27, 141, 177n4. See also Homer, philosopher-king

Le Corbusier (Charles-Édouard Jeanneret-Gris), 84–85
leimma, 31–32, 64, 97, 115–16, 122, 165
liberal arts, xiv–xvi, xviii, 5, 39, 50, 54–57, 101–104, 157, 160–61, 178n12, 210n12. See also education
Lloyd, W. W., 195n71, 195n78
logistikē, xx, 55, 57, 162, 175. See also arithmetic
logos, 4, 14, 19, 56, 64–66, 68, 100, 103, 115, 176, 199n31. See also ratio

magnitude, xxv, xxxii, 15, 18, 30–32, 47, 61–63, 65, 68, 76, 78, 88, 90, 98–101, 106–107, 111, 113, 115–16, 120–21, 127, 133, 139, 142–48, 157, 159–61, 186n49, 188n7, 189n20, 192n48, 194n66, 195n75, 196n89, 197n7, 199n31, 200n43, 203n1, 210n11. See also number
Masaccio, 158–59, 210n7
McKirahan, Richard, 183n26
McNeill, David, 7, 182n11
mathematics, in Archaic and Classical Greece, xiii–xiv, xix–xxvi, 61–63, 66, 88, 112, 115, 157
 and Doric Temple design, 68, 76–77, 100, 122, 150
 influence of ancient Near East on, xxvii–xxxiii
 and Platonic dialectic, 5, 18–21, 24, 26–27, 33–34, 37–39, 41–43, 45–48, 50–55, 57, 133
 Renaissance reception and transformation of, 161–62
 See also *Republic, Timaeus*
matrix, 122, 159
median, 147
mean, xvii, xix–xxiv, xxvi, xxviii, xxx, 5, 28, 31, 48, 61, 101, 120, 122, 173, 174, 207n38. See also proportion

INDEX

measure, xvii, 12, 15–16, 65, 84, 94, 97, 100–103, 116, 139, 144, 148, 162, 176, 201n51, 203n6. *See also* incommensurable
measurements, of the Parthenon, 78, 85, 88–89, 94, 111, 116, 131, 138, 167, 193n53, 193n54, 193n60, 196n80, 199n21, 200n36, 202n60
Menaechmus, 45, 53, 187n5
Meno (dialogue of Plato), 65, 188n10, 189n18
Mertens, Dieter, 77, 79, 93, 110–11, 119, 124–25, 134, 191n36, 191n38, 191n39, 191n40, 192n43, 192n46, 192n47, 192n48, 193n49, 195n73, 195n74, 198n9, 198n13, 198n15, 198n16, 198n18, 198n20, 200n39, 200n40, 200n41, 200n43, 202n57, 202n58, 205n13, 206n31, 207n34, 207n38
Mesopotamia, xxvii–xxix, 76. *See also* mathematics
metaphysics, 7, 162, 210n14
Metaphysics (of Aristotle), 3, 25, 46
method, xix–xx, xxix–xxxi, 7, 12, 24, 28, 45–46, 50, 53–57, 62–65, 70, 76, 95–97, 105, 111, 114–16, 138–40, 158, 162–63, 182n19, 183n25, 188n8, 191n30, 192n42, 206n30, 207n32
Meton, xxvi
metope, 70, 72, 78, 80–81, 88–90, 94, 97, 110–14, 116, 118, 124, 138–39, 146, 152, 192n44, 194n62, 198n13, 199n21, 199n22, 199n23, 200n33, 200n36, 200n37, 206n31 *see also* frieze
Miller, Mitchell, 7, 34, 43, 46–47, 51, 182n13, 182n16, 187n10, 187n1
mimesis. *See* imitation
mode, 50, 55, 106–107, 130, 145–46
model, xv, 5, 36, 56, 75, 102, 122, 147
module, xvii, xxxii, 64, 76–77, 80, 84, 88, 90–94, 100, 105, 122, 131, 138–43, 159–60, 191n30, 191n35, 191n36, 192n42, 192n48, 193n57, 194n66, 195n75, 204n10, 205n16, 206n27, 206n30
monochord, xxi, 63–64, 106, 115, 127, 175, 199n31
Mnesikles, 125, 133
Mourelatos, Alexander, 33
Mueller, Ian, 44–46, 49–50, 186n50, 187n1
multitude, xxxii, 32, 61–62, 68, 76, 78, 88, 99–101, 106–107, 113, 115–16, 120, 123, 127, 133, 139, 142–48, 157, 159–61, 186n49, 192n48, 196n89, 197n7, 199n31. *See also* number
music, xvii, xxi–xxv, xxxii, 4–5, 10, 18, 61–62, 187n8, 189n22, 190n22, 199n28, 210n11
musical scale, 23–24, 31–33, 35–36, 40–41, 48, 63–64, 70, 78, 90, 95–97, 99, 106, 114–16, 122–23, 134, 147, 160, 189n15, 199n28, 199n31. *See also* Pythagorean
myth, 35, 152

naos, 95–96, 98–99
Neils, Jenifer, 190n23, 190n24, 190n26, 193n51, 196n82, 199n22, 201n53, 202n59, 203n1, 208n58
Neoplatonism, 54, 160
Neugebauer, Otto, 179n25
Nicomachean Ethics (of Aristotle), 17
Nikulin, Dmitri, xxiii, xxxii, 25–27, 35, 43, 51, 54–57, 179n27, 182n8, 182n11, 182n14, 186n2, 187n1, 188n8
nomos, 14, 28–29
number, xix–xxv, xxviii–xxxii, 4, 10–21, 24–25, 30–33, 35, 41–43, 47–48, 52–53, 56, 61–66, 68, 75–78, 84–85, 88, 91, 101, 110–13, 120, 122, 127, 129, 133–34, 136, 150–53, 159–63, 177n2,

number *(continued)*
 178n18, 179n31, 180n35, 181n4, 182n9, 183n27, 183n30, 184n32, 185n38, 185n41, 186n46, 189n7, 189n20, 191n42, 192n48, 194n63, 195n69, 196n85, 197n7, 198n20, 201n44, 202n60, 206n31. *See also* arithmetic
Nussbaum, Martha Craven, 197n97

octave, 10–20, 31–33, 64–66, 95–97, 105, 123, 165, 196n82. *See also* musical scale
Oenopides, xxvii–viii, 53, 186n46
Older Parthenon. *See also* Acropolis
Olympia 152
 Temple of Zeus 80–83, 88, 93, 95, 129, 131, 192n48, 193n49, 195n69, 198n13
ontology, xxvi, xxxi–ii, 4, 11, 19, 23, 25, 30, 36, 39–43, 46–50, 52–56, 61, 65, 68, 72, 85, 94–97, 100–103, 107, 116, 123, 130–33, 136, 140, 143–48, 151, 158, 186n2, 188n8, 188n11, 196n85, 196n89, 199n31, 204n9, 208n57. *See also* metaphysics
opinion, 26–29, 33, 36, 183n25, 187n2
order, 10, 24–26, 28–35, 40–43, 50, 62, 66, 70, 72–76, 88, 90, 92, 94, 98, 102, 107–108, 141, 175, 196n83
orientation, 19, 28, 50, 92, 114, 119, 135
Orlandos, A. K., 193n53, 193n54, 193n60, 203n2

Paestum, 77, 83
 Temple of Athena, 78, 112, 191n39, 201n53, 202n60
 Temple of Poseidon (or Hera II), 81, 110, 113, 193n49, 195n73, 198n13
Panathenaia, 135, 152–55, 209n58

Panofsky, Erwin, 204n9, 206n22, 209n1, 209n6
Parthenon
 dimensions of xv, xxxii, 25, 77–80, 88–97, 114–15, 131, 136, 138, 140–41, 148, 191n35, 192n47, 193n48, 193n53, 193n55, 194n61, 194n63, 195n69, 195n72, 197n7, 202n60, 204n7, 206n30, 207n33, 207n38
 harmonia in (*see* harmony)
 organic quality of, 73, 133, 144–45, 205n16
 precedents of, 79, 93, 111, 129, 202n57, 208n48
 refinements of (*see* refinements)
 religious character of, xvii, xix, 62, 66–68, 104, 150–53, 161–63, 189n21
 sculptural program of, 116, 152–53, 209n58
 symmetria in (see *symmetria*)
 See also Older Parthenon
pattern (*paradeigma*), xix, xxx, 20, 28, 33, 102, 158–59, 180n35
pedagogy, 7, 12, 41, 50, 54, 62, 70, 98, 100, 104, 130, 133, 145, 147–50, 152, 161, 177n8. *See also* education
Penrose, Francis, 193n54, 195n71, 199n23, 203n2, 204n9, 208n43
Pericles, 190n26, 193n53
peristyle, 72, 78, 86, 90–92, 107, 110, 118–19, 136, 140–41, 152, 192n48, 194n63, 195n71, 195n72, 196n82, 202n57, 207n33
Persia, 66, 193n51. *See also* Older Parthenon
perspective, xv, 134, 158–62, 193n57, 204n9, 206n22, 209n3, 209n6, 210n7, 210n9
Pheidias, 75, 190n23, 195n72
Phenomenology, 85, 100, 149, 151. *See also* experience
Philebus (dialogue of Plato), xxxii, 17, 185n40, 197n90

INDEX

Philo Mechanicus, 120, 122–23, 200n44, 201n46, 201n47, 204n8
Philolaus, xiii–iv, xxi, xxviii–xxx, 5, 10–13, 17–20, 23–24, 29–33, 35–41, 56–57, 64–65, 105, 114, 122–23, 136, 150, 179n30, 180n31, 182n10, 186n46, 186n49, 189n8, 189n15, 196n85, 197n2, 199n27, 201n52, 206n23, 208n54
philosopher-king, 5, 18, 26, 34, 36, 40–41, 45–55, 186n4, 187n4
Plato, 179n20, 179n31, 181n3, 181n4
 as author of dialogues, 3–6, 11, 18–21, 183n23
 as educator, xv, xviii, xxiii, xxxi–iii, 50, 54–57, 157, 160–62
 and mathematical Pythagoreanism, 24–25, 29–31, 35–38, 45–46, 133–34, 178n13, 182n8, 183n25, 185n41, 185n42, 187n2
 and the Parthenon, 146, 150–52
 See also *Meno, Philebus, Republic, Theaetetus, Timaeus*
Platonism. *See* realism; *see also* Academy, of Plato
pleasure, 14–17, 181n5, 184n36
Plutarch, 46, 190n26, 193n51, 201n46
politics, art of, 7, 10, 13, 28, 33–34, 39, 41, 46, 141, 151–52, 177n5, 186n4, 187n11
polis, 151–52. *See also* Athens, citizenship
Pollitt, Jerome, 99, 102–103, 106, 122–23, 136, 140, 144–46, 190n23, 191n29, 191n39, 196n79, 196n82, 196n86, 197n90, 197n94, 197n95, 197n3, 201n46, 201n48, 201n50, 201n53, 202n54, 204n9, 205n17, 206n25, 207n35, 208n44, 208n45, 208n47
Polykleitos, 75, 101, 120–27, 150, 197n91, 201n44, 201n46, 201n51, 201n53, 204n8, 209n59
practical wisdom (*phronēsis*), 68. *See also* wisdom (*sophia*)

problem, xvi–xix, xxii–vii, xxx–xxxiii, 4–5, 14, 19, 24–25, 32–35, 44–48, 51–53, 56–57, 61–66, 68, 70, 76, 78, 81–83, 88, 90, 94–97, 99–104, 107, 131–36, 139–50, 157–62, 180n35, 181n4, 182n18, 186n50, 190n22, 192n45, 194n67, 196n87, 196n89, 199n28, 205n13, 210n7
"corner problem" in Doric temple design, 105–27 *passim*
Proclus, xvii, xxxi, 1, 10, 39, 52–53, 160, 177n2, 177n8, 187n4, 210n11
Propylaea, 125, 127, 133, 135, 205n13, 205n18. *See also* Acropolis
proportion, xv–xxvi, xxvii, 31, 33–34, 53, 55, 62–63, 70, 72, 75–76, 78–80, 83, 93, 102, 107, 114, 120, 124, 127, 133–34, 138, 151–52, 175, 180n36, 188n7, 190n23, 191n30, 192n47, 194n63, 194n67, 195n73, 195n75, 196n82, 197n91, 201n53, 207n3, 204n10, 206n30, 209n59
 continuous proportionality (in Parthenon), 84–85, 88–93, 95–96, 98–100, 105, 119–20, 138–44, 173, 177n6, 192n48, 196n81, 207n34, 207n38
 See also *kanon,* measure, *symmetria*
Protagoras, 84, 187n2, 193n56
Protagoras (dialogue of Plato), 17, 185n40
Pythagoras, xv, xxv, 9, 160, 177n4, 177n5
Pythagorean, 180n35, 181n4, 201n51, 210n11
 comma, 19, 31, 35, 97, 111, 122, 165, 187n7
 harmonics, 4, 7, 9, 12, 19, 31–32, 35, 56, 64–67, 77, 186n48, 186n49, 187n8, 189n15, 190n22, 199n28
 theorem, xxiii, xxv, 182n10, 185n42

Pythagoreanism, xxii, xxiv, xxviii–ix, 9–11, 24, 27, 31–38 *passim*, 54, 56, 83–84, 112, 115–16, 125, 127, 136, 160, 188n11, 192n42, 198n20, 201n53, 202n60

quadrivium, xiv–xv, 54, 160, 162, 177n2

ratio, xv–xvi, xxxii, 4, 19–20, 31, 65–66, 92–98, 138–41, 176, 180n36, 188n7, 189n20. *See also* irrationality
realism, xxxi, 1, 29, 52–53, 187n4. *See also* Academy
Recco, Gregory, 39, 182n19
Reeve, C. D. C., 9, 11, 15, 181n6, 182n8, 184n38, 185n43
refinements, xv, xviii, xxxii, 19, 88, 92, 97, 114, 116, 118, 120, 127, 129–55 *passim*, 176, 193n50, 195n77, 198n11, 199n26, 203n6, 207n40
 column inclination (*see* columns)
 corner column thickening (*see* columns)
 curvature, 82–83, 125, 144–55 *passim*, 202n1, 203n3, 203n4, 204n9, 205n15, 205n17, 208n44, 208n48
 entasis (*see* columns)
 optical or ontological in nature, 125, 130–36, 204n9, 205n16, 205n17, 206n23
 See also corner problem
regularization, 133
religion, 66–68, 104, 149–53, 161–63, 189n21
remainder, 19–20, 30–32, 63–65, 97, 104, 107–10, 113, 116, 118, 122–25, 173. *See also* measure
Renaissance, xiv–v, 36, 100, 102, 108, 134, 158–63, 189n11, 190n22, 191n37, 193n57, 206n23, 209n3, 209n4, 210n7, 210n9, 210n12. *See also* Neoplatonism

Republic (dialogue of Plato), xv, xviii, xxxi, 2–5, 11–12, 20, 27, 34–38, 40–44, 52, 54, 57, 146–48, 150, 177n8, 179n31, 182n19, 188n10, 197n90
Roman art and architecture, 76, 99, 106, 131, 178n12, 205n14
Roochnik, David, 7, 182n8, 182n11, 182n16
Rowe, David, 179n25
rule, 14, 33, 49, 54, 113, 123–25, 127, 140–42, 194n63. See also *kanon*, measure

Sallis, John, 25, 182n7, 182n11, 187n6, 187n11
Sayre, Kenneth, 9, 182n8
Schrift, Alan, 177n1
Schneider Berrenberg, Rüdiger, 192n42, 202n60
sculpture, 68, 101, 127, 150, 197n7, 201n46, 201n53. *See also* Parthenon, sculptural program of
Sedley, David, 34–35
Segesta, temple at, 124–27, 133, 191n36, 202n57, 205n13
Selinus, Temple A, at 195n73
sensible, 42–48, 56–57, 162, 180n35, 181n4, 187n4, 205n16, 208n50
Shorey, Paul, 184n38
Sialaros, Michalis, 179n27
solids, geometrical, 28, 35–36, 43–44, 187n11
Speusippus, 25, 52–53
standardization, 111, 125, 133–34, 140–41, 194n62, 202n57, 205n13. See also *kanon*
Stevens, Wallace, 21, 186n51
Stewart, Andrew, 120, 122, 200n44, 201n46, 201n47, 201n49, 201n50, 201n51
stylobate, xv, xxxii, 77–80, 83–84, 90–94, 97, 106, 114, 116, 130–33, 136, 138–42, 145, 192n42, 192n47, 192n43, 194n61, 194n63,

INDEX 233

194n67, 195n71, 195n73, 195n75, 202n60, 203n2, 206n30, 207n32, 207n33, 207n34
symmetria, xiii, xv, xvii, 19, 62, 65, 70, 72, 75–79, 82–85, 88, 93–100, 102–107, 111, 119–20, 122–25, 127, 133–36, 138–43, 146–48, 150–53, 176, 191n32, 192n48, 194n61, 194n63, 195n72, 196n85, 200n43, 202n54, 206n27, 207n34, 207n38, 209n59
Symposium (dialogue of Plato), 197n97
Syracuse, 82–83, 183n25
 Temple of Athena, 78, 82, 110, 192n48, 195n73, 198n14
Szabó, Arpad, xx–xxv, xxviii, xxxii, 61, 63–64, 115, 178n9, 178n17, 179n19, 179n20, 188n2, 189n9, 189n10, 189n12, 189n18, 193n58, 199n29, 199n31

Tarrant, Harold, 12
Taylor, A. E., 29, 32, 181n7, 183n23
technē, 55, 63, 68, 84, 88, 90, 106, 152, 161–62, 176. *See also* art
technical, 1, 9–10, 21, 33–36, 39–40, 45, 57, 63–64, 72, 85, 88, 101, 105, 112–16, 122, 127, 150, 152, 158–63, 202n60. *See also* art
tetraktys. See Pythagorean
Theaetetus, xxi–xxv, 43, 178n18
Theaetetus (dialogue of Plato), xxiii–iv, xxxii, 51, 178n16, 193n56
Theodorus, xxii–iv, 178n18
thought (*dianoia*). *See* divided line; knowledge
Timaeus, 8–9, 18, 21, 23–38 *passim,* 56–57, 65, 182n17, 183n23, 186n4, 187n5
Timaeus (dialogue of Plato), 2, 4–5, 8, 12, 23–38 *passim,* 65, 150, 182n9, 183n24, 186n49, 189n19
tone (*tonos*), 64, 95–97, 105, 115, 165. *See also* musical scale
Topics (of Aristotle), xxxii

triglyph, xv–xvi, xxxii, 72, 78, 80, 81, 88–94, 100, 105–107, 110–14, 136, 138–43, 160, 177n6, 191n35, 192n44, 192n48, 192n60, 194n62, 194n63, 194n66, 195n75, 195n76, 206n27, 206n30, 206n31. *See also* frieze
trivium, xiv, 54, 160, 162, 177n2
truth, xxi, 9, 13, 16–17, 20–21, 24, 26–29, 33–37, 44, 49–51, 55, 66, 70, 101, 133, 136, 145, 151, 185n41, 186n4, 208n57
Tübingen School, 7–8, 36

unit, xvi, xix–xx, xxxii, 16, 30–31, 42–43, 53, 62–65, 76, 78, 80, 88, 92–94, 100, 122, 138, 143, 178n18, 193n53, 193n57, 197n7, 202n60, 203n7
unity, xxxii, 20, 30, 43, 68, 70, 75, 90, 102, 106–107, 118–19, 139–45, 148, 163, 207n33, 207n34

value, 29, 42, 51–52, 99, 104, 118, 143, 145, 152, 162, 180n35, 185n39
Vasari, Giorgio, 102
visible, xxxii, 42–44, 47, 53, 72, 80, 90, 93–96, 98, 100, 118–19, 132–33, 139, 142–44, 159–60, 163, 180n35, 186n1, 205n19. *See also* sensible, intelligible
Vitruvius, xix, 108, 124, 130–33, 150, 178n10, 190n23, 202n54, 202n56, 202n57, 203n7, 204n8, 204n9, 205n16, 205n18, 206n21, 208n55
von Fritz, Kurt, 62, 65, 115, 188n4, 188n5, 199n32

Waddell, Gene, 138, 177n6, 191n35, 192n44, 194n61, 194n62, 194n68, 195n71, 196n79, 206n30, 207n33, 207n34
Wesenberg, Burkhardt, 113, 116, 190n23, 193n53, 199n21, 199n22, 200n35, 200n38, 202n60

Wilson Jones, Mark, 75–76, 138, 189n21, 191n30, 191n33, 191n34, 191n35, 191n36, 194n62, 195n75, 198n10, 203n2, 204n10, 206n30, 207n34, 208n57
Winter, F. E., 113, 194n63, 195n72, 195n78, 196n79, 196n81, 199n23, 205n19, 207n34
wisdom, 28, 56, 68, 133, 152
Wölfflin, Heinrich, 102

wonder, 36, 94, 186n49

Yeroulanou, Marina, 199n21

Zhmud, Leonid, 36–37, 46, 54, 177n3, 178n9, 178n13, 179n19, 181n3, 182n8, 183n26, 186n46, 187n5 (Chapter 2), 187n5 (Chapter 3), 188n7
Žižek, Slavoj, 177n1

www.ingramcontent.com/pod-product-compliance
Lightning Source LLC
Chambersburg PA
CBHW030534230426
43665CB00010B/884